Cinematic Interfaces

Film Theory After New Media

Seung-hoon Jeong

Routledge
Taylor & Francis Group

NEW YORK AND LONDON

First published 2013
by Routledge
711 Third Avenue, New York, NY 10017

Simultaneously published in the UK
by Routledge
2 Park Square, Milton Park, Abingdon, Oxfordshire OX14 4RN

First issued in paperback 2014

*Routledge is an imprint of the Taylor and Francis Group,
an informa business*

Library of Congress Cataloging-in-Publication Data

A catalog record has been requested for this book.

ISBN 978-0-415-83315-8 (hbk)
ISBN 978-1-138-84363-9 (pbk)
ISBN 978-0-203-49286-4 (ebk)

Typeset in Sabon
by Apex CoVantage, LLC

For all my symbolic fathers, male or female . . .

Contents

Preface

Interface is at work everywhere. Everywhere it is machines, with all the necessary couplings and connections. It is also quasi-machines immanent in bodies, erupting onto the faces and surfaces of subjects and objects. It is, above all, every systematic frame indispensible for us to map out uncharted territories, to filter off fuzzy and murky noise, to extract useful information and vibrant inspiration out of this chaos, thereby making the world more understandable, accessible, controllable, and enjoyable. Indeed not only the computer but culture and civilization in general are interfacial products. No interface, no experience. But sometimes it strikes back. Thrown into our vision out of the blue, an interface can challenge our self-making capacity for efficient and effective subjectivity and confront us with its beyond that is far larger and deeper than we can organize into our reality. We are attached and intrigued to what it only adumbrates and insinuates. While projecting images, it prohibits our approach to their objects we might desire or protects us from their danger we might (desire to) ignore. That obscure object of desire with such fatal attraction is, conversely, a trip switch to trigger our gradual transmigration to the desert of the real, the plane of immanence, the infinity of otherness, and to that extent our radical transgression of subjectivity. An interface can thus appear as an informative image, beautiful and helpful, yet turning into a transformative screen that both reveals and blocks its unseen ground whose sublime horizon leads us to the edge of our vision and subjectivity. What we see on the interface lets us sense what we cannot see. Now definitely, our life desperately depends on more and more interfaces without which no sense of being embodied and embedded in the world could be formed and kept. But their relation to our subjectivity is as centrifugal as centripetal, while fundamentally asymmetrical, ambivalent, immanent, and multidirectional. Here may be the interfacial fate of subjectivity, its aspiration and agony, paranoia and schizophrenia only indicating that subjectivity is primarily conditioned by interfaciality. Love your fate.

This book is a methodical attempt to formulate such multifaceted interfaciality through cinematic interfaces and film theory. Bringing the notion of interface from media studies back to films and their conceptual studies, I respond to the urgency of now in rethinking and reconfiguring the still

abiding richness of cinematic discourses and by doing so redirecting and retheorizing the discussion on interfaces still limited to the new media realm. For this new cinematic endeavor, the book tries to be as fundamental as possible with ontological and phenomenological viewpoints among others permeating many pages. One might see this approach as purely aesthetical, thus apolitical and ahistorical. Admitted, but it is the position that the book takes rather than I do—this is the case with its critique on some others—for the process of the project to be convincing within the given scope and space. The narrative of the book, however, flows back to the social sphere of the current media environment at the end, though the last chapter at large is the least developed because of logistical limits. Some weak points in the book will thus need to be updated. And my future research will include global cinema viewed from broadly politico-cultural perspectives that could, if partially, reframe and be reframed by interfaciality in a new direction. This process might help to elaborate a general theory of interface from and beyond film and media.

Note that the first two sentences of this preface are stolen with slight change from a couple of key thinkers whose references abound in this book. Also, throughout the text I use double quote marks ("/") for quotations and single quote marks ('/') for my own emphasis.

Acknowledgments

This book came out of my PhD project directed under Dudley Andrew and Thomas Elsaesser, whose long and deep support in and out of class and away from the dissertation was beyond description. All my time shared with them as a whole marked a decisive turning point in my life, inspiring new sets of ideas, introducing new groups of people, and incubating a never imagined new pathway. They were, so to speak, the most influential human interfaces for me. I am also wholeheartedly grateful to the first dissertation readers: John Mackay, Michael Holquist, and Garrett Stewart, whose initial excitement about my draft still resides in my memory. The same gratitude applies to the thrilling reviews of the book proposal by Warren Buckland, Sean Cubitt, and the heartwarmingly generous Vivian Sobchack. And I cannot thank William Brown enough for his sharp comments and detailed corrections on a couple of chapters. In the future I hope to discuss any suggestions that these reviewers kindly offered despite my criticism of some of their works, but that were not fully reflected in this book because of my poor capacity and tough schedule. In fact critical reading was my most fruitful study, and I am indebted to all scholars and authors who taught me at Yale or elsewhere, in speeches or texts, even inspiring me to challenge them. They were all my symbolic fathers regardless of their sex, and English was my "father tongue" that now gives birth to my first book. For its actual publication, I thank Erica Wetter and Margo Irvin for their always positive and patient support. And my last but not least acknowledgment must go to my family who are the farthest from my work yet closest to my life.

Chapter 1 incorporates material with much revision from "Gaze, Suture, Interface: The Suicide Scene in Michael Haneke's Caché," *Cinephile* 5.2 (2009): 54–59; Chapter 2 from "The Body as Interface: Ambivalent Tactility in Expanded Rube Cinema," *Cinema: Journal of Philosophy and the Moving Image* 3 (2012): 229–253; Chapter 3 from "The Surface of the Object: Quasi-Interfaces and Immanent Virtuality," in *Deleuze and Film*, eds. David Martin-Jones and William Brown (Edinburgh: Edinburgh University Press, 2012), 210–226, and "Black Hole in the Sky, Total

Eclipse under the Ground: Apichatpong Weerasethakul and the Ontological Turn of Cinema," in *Dekalog 4: On East Asian Filmmakers,* ed. Kate E. Taylor (London: Wallflower; New York: Columbia University Press, 2011), 140–150; and Chapter 5 from "The Para-Indexicality of the Cinematic Image," *Rivista di Estetica* 46.1 (Turin, 2011): 75–101. I thank the copyright holders of this material for permitting its reuse in a new form.

Introduction

WHAT WAS/IS CINEMA?

Since the 1970s, film studies has taken various turns away from its foundational basis of Grand Theory, which had at its core the 'golden triangle' of semiotics, psychoanalysis, and Marxism based on recent Continental philosophy. Dudley Andrew (2009) among others has offered overviews of these turns along with the larger turn from French to American hegemony in film scholarship, and so let me only name the most remarkable in this context: (1) the ontological turn led by Gilles Deleuze, who with his *Cinema* books (1986; 1989) replaced the dominant Saussurean-Freudian model with Charles Sanders Peirce's and Henri Bergson's schemas on sign and image; (2) the phenomenological turn delivered most prominently by Vivian Sobchack (1992; 2004), who revamped spectatorship theory through Maurice Merleau-Ponty's notion of embodiment; (3) the historicist turn, exemplified by the likes of Tom Gunning (2006) and Charles Musser (1994), which moved from abstract reductive theory to empirical archivist research on early (and "orphan") cinema, studio systems, non-Western films, and so on; (4) the cognitivist turn, led by David Bordwell and Noël Carroll (1996) and Edward Branigan (2006), which attempted to account for how the spectator's mind functions in light of analytical philosophy and brain studies. While Continental philosophy is still significant for the first two turns in expanding film theory, it has been palpably cast into doubt or even abandoned by the Anglophone scholars who directed the last two turns. Facing all these major challenges from the late 1970s to the mid-1990s, Grand Theory gradually lost its grandiosity, though it served as the backdrop for the questions of identity politics, especially concerning race, gender, and class, that still underpin cultural studies today.

Within film studies, however, these upheavals have legitimated a pursuable and independent field of research that dynamically incorporates different methodologies, an 'autopoeitic' scholarly system that consolidates itself through the feedback of an interdisciplinary environment. Indeed, since the new media boom of the 1990s, insurgent media studies have so expanded and even altered the nature and boundary of film studies that it

has reached a point where the field is in danger of ripping itself apart. There is no department of 'Cinema Ontology,' but most film studies programs have been renamed 'Film and Media Studies' (or something similar), just as the Society for Cinema Studies added *media* to its name in 2002. In other words, the most recent turn in the wake of the digital revolution, namely the media studies turn, has both enlarged and threatened the autonomous territory of film (studies) as such. At first, a fascination with this change erupted in the anticipation that digitization would render obvious the death of celluloid cinema, while this diagnosis was put into question or the singularity of the cinema was nostalgically emphasized just in time for its 1995 centennial celebrations—Stefan Jovanovic (2003) reviews this debate around many scholars, critics, and filmmakers in detail. At the same time, around the turn of the millennium, media archeology repositioned cinema in the broader context of pre- and post-celluloid media history rather than declare a radical rupture between photographic and digital images. Work along these lines is exemplified by the likes of William J. Mitchell (1992), Thomas Elsaesser and Kay Hoffmann (1998), Jay David Bolter and Richard Grusin (1999), and Lev Manovich (2001). This shift might indicate that the desire of film studies for autonomy had reached its limit in the postmodern situation of media chaos, which seemingly resonated with a premodern circumstance around the birth of cinema. Visual media studies is now not only remapping the battleground where the media wars have been fought, but also creating multifaceted aesthetics of digitally 'expanded cinema' in Gene Youngblood's (1970) terms and cinematic installation art in relation to net art, software art, virtual reality (VR), and mobile and locative media (for more on this, see, inter alia, Rieser and Zapp 2001; Shaw and Weibel 2003; Marchessault and Lord 2007; Christiane 2008; Murray 2008; Mondloch 2010).

It is obvious that expanded cinema in this context, along with digital cinema in general, implies the logic of 'remediation' as defined by Bolter and Grusin: new media remediate old media by emulating and incorporating them instead of rendering them outmoded. In this way, new media take on a hypermediacy that serves to enhance the immediacy of the media effect on spectators. Cinema, as D. N. Rodowick argues, may not simply disappear but rather become updated through new media, sometimes more "cinematically" than before. That is, although film (i.e., celluloid or polyester film stock) has been disappearing as a material support, cinema as a narrative form, as a figural style, and as a psychological experience continues to be 'remediated' with each new medium (2007a, 181–189). The replacement of the photographic image by a computational simulation does not mean the loss of realism or any cinematic modality of articulating visuality, signification, and desire through space, movement, and time. Rodowick's response to film's virtual life is then: "Film is dead. Long live cinema!" (183). And he adds that the history of film theory is "the most productive conceptual horizon" against which to assess what is new and old in the new media (189). In this sense, the main targets of new media practices and aesthetics—new

relationships between media, imagery, and spectators—still give evidence of the abiding significance of rich discourses on such traditional film studies concepts as *apparatus, image,* and *subjectivity.* Those film-based discourses developed through Grand Theory and the ensuing turns away from it would not become obsolete along the media studies turn, but continue even now to be fundamental for addressing a new visual experience while being aptly adapted to it. For a more encompassing line of thinking 'what *was/is* cinema?' to be successfully credible, it would thus be crucial to reconfigure these notions by actively responding to the challenge of new media studies and retroactively incorporating the changes it has brought to old film studies. Yes, media archeology now needs to be upgraded with an archeology of film theory, of cinematic concepts that should not so much be replaced as 're-placed' in an ever-invigorating feedback circuit between past and present.

WHAT IS INTERFACE?

To revamp the implications of old terminology, however, having a framework that can newly reassemble all aspects of the cinematic experience would be more effective than examining each term individually as in Warren Buckland's (2012) rework on film concepts, which is remarkable but not in the backdrop of media studies. In offering such a wide framework, I propose to creatively appropriate the new media term *interface* so as ultimately to retrofit it through film theory. Broadly speaking, *interface* means the communication boundary or point of interaction between two other parts or systems, while it becomes part of that system, influencing how two parties interplay with each other. It became a popular buzzword in computer science in the 1960s, technically referring to the interface between machine components (hardware or software) and/or between these machines and human users. The latter scenario, called Human-Computer Interface (HCI), has since been used in three major categories: software interfaces (Windows, Mac), hardware interfaces (USB, LCD), and user interfaces (keyboard, mouse)—Florian Cramer and Matthew Fuller (2008) offer a more detailed classification. The HCI translates digital information from computers to humans by making it understandable to us. As this translation allows ongoing communication between computers and users, the interface acts like "a permanently changing billboard onto which both systems [human and machine] draw and write" (Nake and Grabowski 2006, 66). Although the machine side has complex layers that remain obscure to non-specialized users, the current Windows and Web environment are generally understood as user oriented, and interfaces typically mean Graphical User Interfaces (GUI) including buttons, graphics, and words on the screen as well as the screen itself through which we access information. Thus, user-friendly qualities of interface design mainly include anticipation, playability, relevance, efficiency, usefulness, flexibility, immersion, transparency, and so

on (Lowgren 2006, 385). Notably, all of these interfacial 'virtues' center on facilitating connection and structuring knowledge on the user-subject's side.

Unsurprisingly, media researchers and artists have applied the notion of interface to a variety of media beyond the HCI. Taking the center of interface industry lately, "pervasive interfaces" such as mobile phones and other location-based technologies enable people to track others and to be tracked (Gane and Beer 2008). By extension, the so-called interfaceless interface could appear, with electronic tools disappearing, in a new environment in which the user could respond to her needs and actions through ubiquitous computational power by interacting with the objects 'naturally' as she does in the physical world (Bolter and Grusin 1999, 23). "Mobile interfaces" are now considered to include the book and the Walkman as well as pervasive interfaces, and to function as filters, control devices, organizers of social networks, locative technologies, and information access platforms (Silva and Frith 2012). Mobile interface theory then focuses on the "sensory-inscribed" body that engages across material and digital landscapes, while incorporating its sociocultural inscriptions in these emerging spaces (Farman 2011, 13). Steven Johnson's seminal book on "interface culture" (1997) tracks the roots of interface influencing our daily lives back to Victorian novels, early cinema, and even medieval urban planning. Pierre Lévy (2001) understands interfaces not only as technological translators of information and knowledge, but also as cultural ways of representing and organizing them and as producers of meaning. And Manovich suggests the notion of "cultural interface" by which he means that material devices, including books and cinema, frame culture and forge people's interaction with it. Broadly speaking, interface is "social interface" that can "filter information and actively reshape communication relationships, and also reshape the space in which social interaction takes place" (Silva and Frith 2012, 4).

Particularly regarding visual culture, there seem to be three distinguishable yet interrelated adaptations of the interface. First, there are digital "cultural interfaces" that Manovich define as digitally encoding cultural contents, such as websites, CD-ROM and DVD-ROM titles, multimedia encyclopedias, online museums, and computer games. These interfaces take three major forms: a general-purpose HCI, which includes onscreen manipulation, windows, icons, and menus; the printed word (pages, illustrations, contents, index); and cinema, or rather the cinematic mode that comprehends the mobile camera, the representation of space, editing techniques, narrative conventions, and the activity of a spectator. As suggested in Rodowick's "long live cinema," these elements perpetually form part of cinematic perception, language, and reception (Manovich 2001, 62–93). In this way cinema as a cultural interface leads a new life as a "toolbox" for cultural communication, a culturally legitimated set of tools for the user's visual organization of data through abstract operations. The cinematic cultural interface thus enables the subject to construct an informative vision of the world, now a virtual world in the form of a database (254). For example,

YouTube still offers 'cinematic' windows on the world by seemingly remediating numerous films mostly in the early one-reel theater form of projecting ten-minute-long related but discrete films, where this visual 'landscape' primarily exists as a 'datascape' to process.

Second, in addition to cinema being a cultural interface, the cinema screen functions as a perceptual interface. Perceptual interfaces set in motion Erwin Panofsky's (1996) notion of "symbolic form," a schema linking the social, cognitive, psychological, and technical practices of a given culture into harmonious and integrated wholes. The window, for instance, may be regarded as a primal, primitive, precinematic interface that invites the viewer to pass from inside to outside. But its nature has changed over time: while the Renaissance concept of the window defined seeing as "a distanced, abstract, and disembodied method of mapping the world," its modern view sheds light on the physiological interaction between the observer's body and the street's commotion (Eckmann and Koepnick 2007, 17–18). Anne Friedberg (2006) offers a wide and detailed history/archeology of the window from Alberti to Microsoft, seeing the progression from one to the other as a series of replacements and transformations of visualizing symbolic forms. Given this archeology, the cinema screen may appear to be just a special instance of a broader encompassing category, that is, the interface in our term. Its key specificity may be the double process that involves spectators projecting their desire onto the screen world, while the transparency of the screen in turn lures spectators in. As we will see later, film scholars such as Thomas Elsaesser (2006) and Francesco Casetti (1999a,b) refer to the interface especially in light of this interaction between screen and theater spaces, between "fantasy" and "reality." And such media artists as Toni Dove, Jill Scott, and Peter Weibel present the screen as a continuously remediable interface along the evolution of screen technology that apparently culminates in electronic multiple screens facing or even surrounding the viewer (Rieser and Zapp 2001; Shaw and Weibel 2003). Accordingly, interactivity in the context of contemporary 'expanded cinema' has become ever more intensified between the viewer's body and the installed interface, with salient examples being Peter Campus's predigital installation *Prototype of Interface* (1972), Jeffrey Shaw's *The Golden Calf* (1995), and Shaw's interactive cinema team project *T_Visionarium* (2003–2008)—we examine them later. In such works, the body is invited to become a reflected image, a part of the image space itself, an agent that visualizes the object, or a user who arranges scattered surrounding image data. Virtual reality experiments further this trend in the way digital interfaces play the role of translating subject and object into each other in a cybernetic feedback loop. The interface thus functions as a permeable membrane that is not simply between reality and fantasy, that is, actual and virtual worlds, as in cinema, but between body and image, between image and data.

The third type of interface is an extension of this second, perceptual interface, in that the body functions as an interface 'embodied' especially

in the digital environment. As some installation works translate digital information into visible images by virtue of bodily participation, the current interface aesthetics emphasizes that the material interface with digital code often remains meaningless until we access it through our physiological sensory organs. Mark B. N. Hansen furthers this point, criticizing such trailblazing media scholars as Jonathan Crary, Paul Virilio, William J. Mitchell, and Friedrich Kittler for instrumentalizing the notion of interface (Mark Hansen 2006a, 1–20). These theorists, Hansen argues, tend to assume that digitization disembodies information, and only media interfaces capture the immaterial, incorporeal flow of information. Suffering from a similar assumption, Lev Manovich regards the digital image as an analog surface of a digital infrastructure, a disembodied means for the user to intervene in rendering data. In an attempt to go beyond this HCI-oriented instrumentalism, Hansen argues that the "affective" sensorimotor body is a fundamental grounding of "framing" disembodied digital information into embodied concrete information imbued with (human) meaning—with *affect* here being the bond between temporal flow and perceptual event. Drawing on Bergson and Gilbert Simondon, Hansen understands affectivity as the bodily capacity to create the unpredictable, the experimental, the new, and the bodily experience of mediating the individual and the pre-individual, the body and its virtual milieu (Mark Hansen 2006a, 7–8). The digital image appearing through cultural interfaces, then, is already secondary to the primary decoding of the digital code into that image, which can be processed by the 'embodied interface' (Hansen does not use this expression as such). The activity of the body, an "embodied process" that makes information perceivable, is "not to filter a universe of preconstituted images, but actually to *enframe* something (digital information) that is originally formless" (17). This radical restoration of active subjectivity as a framing mechanism relocates the interface within embodied affectivity. The focus therefore shifts from the cybernetic transference of immaterial data to the 'interfacial' virtualization immanent in the sensorimotor schema.[1]

WHY INTERFACE (THEORY)?

In sum, these three expanded interfaces—the cinema as cultural interface, the screen as perceptual interface, and the body as embodied interface—seem to imply a certain direction: from instrument to symbol to organism; from informatics to aesthetics to philosophy. While the shift from cinema to screen shows the specification of the interface within the medium, the shift from screen to body suggests its generalization outside the medium. On one hand, the interface becomes external and artificial; on the other hand it is internal and natural, though haptic technology tends to fuse the former into the latter.[2] But this phenomenon is not limited to digital media. The framing function of the body may concern our overall subconscious translation

of preperceptual information into representational consciousness, just as twenty-four unperceivable separate frames turn into a one-second recognizable moving image on the cinema screen. In fact, the inhuman, immaterial energy in the world is always framed in artificial and embodied interfaces, only on the ground of which our instrumental practice can take place. Here, one may argue that though culturally useful, Manovich's idea of the cinematic toolbox does not necessarily offer us the means with which to investigate this asymmetry or such features inherent in the interfacial (cinematic) mechanism from deeper perspectives, be they ontological, epistemological, phenomenological, or cognitive. And when it comes to screen aesthetics in installation art, VR, games and the Internet, the word *interface* tends to be used as a fuzzy spatial metaphor of a contact 'zone,' 'border,' or 'realm' including the viewer's body. Furthermore, the term is often used differently among researchers, or even randomly within an individual project without being comparatively examined or coherently synthesized. Despite his inspiring vision, Hansen brings his "new philosophy for new media" back to Bergson, Merleau-Ponty, and Walter Benjamin among others, while almost completely ignoring film and the studies thereof that have long yielded related philosophical ideas.

In light of this, I pose the following questions: Could the cinematic medium be reconceptualized as a series of more inwardly specific interfaces including the screen? Could any embodied interface be found with regard to celluloid cinema as well? And could both these ideas of body interface and medium interface help us to reexamine (film studies on) the cinematic apparatus, image, and subjectivity? In effect, while new media interfaces are often sprinkled with postmodern clichés such as *flux, becoming, multiplicity,* and *interconnectivity,* the genuine implications of such terms have already been explored by a diverse set of film theories. The major turns in film studies over the past twenty years, for example, have more or less struggled to replace the semiotic-psychoanalytic model of transcendent subjectivity with the body-centered materialist model of intersubjectivity. Phenomenology of 'embodiment,' ontology of 'affect,' and cognitivism of 'emotion' all address the body that we now readdress as an interface in spite of their independent, even apparently incompatible methodologies. Thus it would be possible to trace disseminated latent constellations of seemingly contradictory ideas and revisit them for a more profound reflection on cinema. This project on *cinematic interfaces,* therefore, aims to rediscover and rearticulate interfacial elements or aspects inherent in/inherited from celluloid (narrative) films and their theories, so as to synthetically theorize what can be called *interfaciality.* It should ultimately serve as a productive meta-critique of film studies and its history.

There seem to be four notable appeals of 'interface' for this task. First, specificity: as a technical term, *interface* can designate a specific facet of a material medium, so the medium of cinema can be considered as consisting of a series of cinematic interfaces including camera, filmstrip, and screen.

Second, flexibility: by its morphology, *interface* is a term that can be applied to the surface of the object/world, and the face of the human/animal can also resemble an interface in certain visual conditions, thereby functioning as a quasi-interface. For these reasons, I shall soon redefine the cinematic apparatus as a comprehensive combination of medium-specific interfaces and quasi-interfaces. The following chapters therefore look at a variety of films to explore how these various interfaces and quasi-interfaces are represented on screen and experienced by characters. Third, universality: the nature of the interface, that is, interfaciality, implies the universal notion of *relationality* broadly explored in academia, if not always in these terms, but especially in cutting-edge studies on mind, psyche, life, posthumanism, aesthetics, individuation, system, network, and so forth (Massumi 2002; S. A. Mitchell 2003; Shaviro 2003). The point is that relationality, not simply synonymous for intersection or interaction, preconditions any image and identity. Likewise, in our ever more expansive networking society, interfaciality is already immanently embodied in subjectivity and objectivity, which are, simply put, nothing but interfaciality. Fourth and finally, intermediality and interdisciplinarity: thanks to its universal nature, the interface can be generalized as any mediating form that assures the principle of connectedness, not only visual but also linguistic, cultural, mechanical, institutional, biological, and so forth, though each case has its own medium specificity. French philosopher of science Gérard Chazal's (2002) ambitious project of regrouping such a variety of interfaces is thus intermedial (interfacing one medium with another) and interdisciplinary (interfacing one discipline with another).

Although I do not have the capacity to embark on such a 'grand' project, we should recognize that an intermedial and interdisciplinary environment of interface studies has already formed, with each field having specialized its own usages of the term and its own methodologies. The most recent work in this regard that takes a fresh direction may be that of Alexander R. Galloway. While crossing art, architecture, and computer games through informatics, media studies, and political/cultural theory, he approaches interfaces not as things but as effects, which are however as complicated and deceptive as they are clear and beautiful. They are often "unworkable" and "unrepresentable," just as the universal protocols of the Web rather unfold a playful plane of the "juridico-geometric sublime" sprawling over complex topologies of aggregation and dissemination (Galloway 2013, 29)—I touch on this effect in the last chapter, and for now just note that his generalization of interfaces as "autonomous zones of activity" (vii) sometimes leaves specific conditions of interfaces left less explored. In view of all this context, I intend to initiate an 'interface theory' through and for film studies by interfacing theories with theories, concepts with concepts, films with films, and images with images, as far as I can within the discipline of the cinematic medium so that this interface theory could then be the practice of interfacing itself. For this purpose, in the next section I clarify the extension or denotation

of the cinematic interface, that is, specify its boundary within the notion of cinematic apparatus. Then in the chapters on cinematic interfaces on screen, I amplify the intention or connotation of the interface by eliciting various implications of interfaciality. This "interface effect," as Galloway calls it, will turn out to be much more than, and even opposed to, pragmatic transparency and programmatic functionality. Through this process, the concept of interface and the category of cinema will refine each other in a sort of hermeneutic circle, if we so choose.

THE CINEMATIC APPARATUS AS 'MYSTIC WRITING INTERFACES'

As a preliminary step, let me briefly introduce the kinds of cinematic interface that can help us to reformulate the cinematic apparatus. The core of Grand Theory was apparatus theory as developed in the journal *Screen*: here (classical Hollywood) cinema functions as an ideological mechanism of suturing the spectator into the dominant narrative form with conservative visual pleasure. In this way, cinema is a sort of what Louis Althusser called an "ideological state apparatus" (1971) or, let's say, an 'ideological industry apparatus.' We later review this standpoint and its critical turns, but for now it would suffice to point out its inherently Marxist usage of the term *apparatus:* state institutions like the school, the church, and the army teach know-how in forms that ensure subjection to the ruling ideology or the mastery of its practice. On the opposite side, an apolitical post-*Screen* theory has often been formulated drawing on analytic philosophy and cognitive science. Branigan (2006), for example, draws on Ludwig Wittgenstein's concept of the language game to explain how the patterns we find in film are projected through our linguistic behavior and a multitude of embodied competing figures of mind. Branigan achieves this by systematically mapping diverse camera functions to expose how the apparatus is typically understood in rather a too camera-centered and mind-oriented fashion. These different definitions of the term *apparatus* resonate with the fact that it corresponds in French to two, *appareil* (machine, device, camera) and *dispositif* (device, but primarily arrangement). The former takes on a mechanical or anatomical sense, whereas the latter takes the antiempiricist position that truths are internal to practices constructing them (Copjec 1982, 57).[3] My suggestion is, then, to reconfigure these theories by recalling the basic definition of the term in English. According to the Merriam-Webster dictionary, an apparatus is "a set of materials or equipment for a particular use; the functional processes by means of which a systematized activity is carried out." This double definition seems to offer the most coherent, synthetic, and materialist range of whatever apparatus we may discuss. Through this double definition, we could shed light on every element of the cinematic apparatus as such a set and process at the most neutral and fundamental level prior to tinting it with any ideology.

Apposite here is the original sense of the interface as well, its first appearance in the Webster dictionary in 1882: "a surface forming a common boundary between two bodies, spaces, phases." *Interfaciality* thus indicates the state or function of interfacing on a surface between two entities. What primarily matters is, therefore, less the informative instrument or immersive space, or the body as a whole, than a specific material surface for contact that accompanies overlapping and distancing, a contact surface of mediation through interval and interstice—however immediate it may look—in terms of space (between object, medium, and subject) and time (between recording, editing, and projection; between perception and memory). Without this spatiotemporal difference and deferment there would be no experience of contact and presence. In other words, only through this ambivalent paradox could the interface proliferate and be disseminated. The cinematic medium should then be viewed not as a single unified apparatus, but as consisting of at least three major interfaces—camera, film, and screen—that place the same image into a process of differentiation, deferral, and remediation. The surface of the object and the subject's eye/skin and mind/brain would also function as interfaces with perception(s) and/or recollection(s) that are embedded in each of them and embodied through each other. Consequently, an interface would be found less between two entities than between two interfaces. There would be no a priori essence outside of interfaciality.

Let me here refer to Sigmund Freud's 1925 essay "A Note upon the 'Mystic Writing-Pad' [*Wunderblock*]," an insightful, psychoanalytic text to which the *Screen* theory hardly paid attention, but which now allows us to imagine "Freud the media theorist" as Elsaesser (2009d) compellingly suggests. Devised for children's writing practice, the writing pad is a slab of dark brown wax with a transparent paper edging, a paper consisting of two detachable layers that are a transparent piece of celluloid and a translucent waxed paper. When one scratches the celluloid surface with a pointed stylus and then lifts it off the waxed sheet, the writing vanishes but its trace is retained upon the wax slab and is legible in suitable lights. For Freud (1961), who was not satisfied with either graphic or optical metaphors for "our mental apparatus" of memory, this children's toy was a perfect model. He argues that our consciousness perceives and transmits sense data like the "ever-ready receptive surface" of the celluloid sheet (while also protecting itself from too many stimuli), whereas some of the data flow that penetrates this filtering surface is unconsciously recorded and stored as "permanent traces" on the lower memory surface like the waxed sheet. At first, the pure presence of conscious feedback creates a circuit with sense data, and then its unconscious inscription is revealed retroactively, through the "deferred action" [*Nachträglichkeit*] that Derrida (1978) emphasizes in his reading of Freud. Thus, the writing pad is a double interface consisting of perception-consciousness and memory-unconsciousness. And if the celluloid perception layer resembles the two-dimensional informative surface of a painting, the waxed memory layer might evoke a sculpture forming the three-dimensional

immersive space in that the inscription of images presumes depth or volume to be carved, no matter how thin it may be.

My intention here is not a mechanical application of Freud's idea, but its flexible 'remix' with other relevant theories, so that we can better review the cinematic apparatus as a chain of 'mystic writing interfaces' that range from the filmic object through the medium (camera-film-screen) to the body (eye-mind). Remarkably, Bergson's theory of perception and memory in *Matter and Memory* (1990) strongly evokes Freud without resorting to psychoanalysis; it combines psychology with philosophy in a much more sophisticated manner, which Deleuze later readjusts to film theory. As is fully discussed later on, Bergson argues that all objects in the material world exist as they appear, as images that receive other images (perception), but that also reflect them simultaneously without retaining any trace or memory (action). Even if we only see a stable, inanimate world, everything thus "photographs" everything else that is nothing but an image surface, an interface between everything else, at every molecular moment. However, this purely perceptual state (pure perception) cannot help entailing the trace of memory when it comes to the living organism that has not only a perception interface (eye) but also a memory interface (brain). Here, I note that Bergson directly engages with the matter-world on one side and the memory-mind on the other, whereas Freud's writing pad could better serve to explain the mechanical interfaces of camera, film, and screen between these two poles.

In this structure, with the object considered as image interface, we can illuminate each of three medium interfaces and two body interfaces. First, the camera is a pure perceptual interface that can receive any object images infinitely, but unlike inorganic matter it filters out anything that exists outside its finite framed field of vision. Just like our eye that selects images fitting our interests and needs, the camera is the primary extension of our organic sensorium, as explicitly expressed in such classical metaphors for cinema as the "camera-eye" of Dziga Vertov and the "camera-pen" of Alexandre Astruc. But the idea of writing by the means of the camera pen needs reinterpretation: it should be no longer the auteurist or avant-garde activity intended by Astruc, but the image trace that never stops being erased through the invisibly rapid process of reframing itself. Unlike photography, the movie camera is like the celluloid sheet of the writing pad, a perpetually available receptive interface that cleans itself up twenty-four times per second. Second, external stimuli that slide over the camera do not evaporate but settle in the film stock, the filmstrip thus functioning as a memory surface. It is notable that although this celluloid strip is different from the celluloid sheet of the writing pad in its function, it takes the form of a single pad with two layers: the transparent base (the shiny side) and the emulsion (the dull side). More importantly, images perceived by the camera are never preserved as such in the original order, but always supposed to be put in the process of cut-and-paste, mixing, compositing, and so on. In short, editing is nothing but deferred action that makes the meanings of perception images

inevitably delayed until being (re)created or (re)animated through the opera-
tion of the "kino-brush" (Manovich 2001, 307)—a particularly powerful
metaphor for animation and digital cinema. Furthermore, it is not only in
relation to the camera, but also to the screen that the filmstrip works as a
wax board of the unconscious mnemonic system. As Thierry Kuntzel says
in his seminal article on the writing pad, notably written as early as 1976, a
frame in the film stock is invisible in the projected film. The film stock is "a
virtual film, the film-beneath-the-film, *the other* film . . . intersecting, over-
lapping, regrouping in configurations, 'never' seen or heard in the order of
unreeling" (1976, 271). Third, what we call the screen is then like another
celluloid sheet that covers the wax sheet of filmstrip on the opposite side
of the camera. Unlike the camera, the screen projects endlessly changing
images instead of perceiving them, but like the camera, it does so without
storing anything. The camera and the screen are two sides of the same coin
that is the filmstrip. This neutral sense of the screen on its own side, from its
own perspective, differs from its other common metaphoric notions such as
window/frame and mirror/mask, which are basically taken from the specta-
tor's subjective position.

And just as the camera takes every image from the world, so too does the
eye as the final celluloid sheet receive every image projected from the screen.
Human perception, at least on the level of the retina, a membrane just like
celluloid, is no other than "the appearance and disappearance of the writ-
ing with the flickering-up and passing-away of consciousness" (Freud 1961,
230). The perceptual interface in turn links to the mind (brain) as another
wax board for memory, now on the part of the human subject. But the
key process between conscious perception and unconscious memory is not
simply that some of the former is preserved as the latter. More significant
is the other way around, that is, the former is actualized through the lat-
ter's intervention. Our recognition of perceived images never occurs utterly
directly, always taking a detour through representation and reconstitution
via the memory stock, however instant the gap between perception and
memory may be. At this point, Bergson could help us again to refine Freud's
dichotomous system. The French philosopher argues that human perception
can never be as pure as that of things in matter, because the intervention
of memory transforms pure perception into actual perception to various
degrees. Our reaction to the perceived object itself is the proof of the fact
that its habitual, voluntary, or involuntary recollection always "contracts"
into the present moment. The multilayered memory as the pure past coexists
with the present, without being past in this sense. It is as if the memory-mind
is a multiple interface in itself, just as the matter-world in which everything
is an interface with everything else is a multiple interface in itself. Apposite
is Bergson's inverted cone model: the cone is the pure past as the Virtual,
the Open Whole full of innumerable memory sheets, like geological strata.
Through these strata, recollection images (interfaces) rotate and, to respond

to stimulating perception images (interfaces), contract into its apex, which touches the bottom ground for perception and action, that is, the present plane of our sensorimotor schema in the Actual. Based on this model, Deleuze builds his taxonomy of images: the movement image expresses the Actual (perception and action, plus affection as the gap between them), and the time image the Virtual (memory)—there seems what can be a Bergson-Deleuzian apparatus theory centering on perception and memory (Esquenazi 1994).

It is now clear that the matter-world and the mind-brain each has its own multiple interface system in terms of pure perception and pure memory, whereas the camera, the screen, and the eye only appear as a perceptual interface whose counterpart for memory is found in the filmstrip, the most central but withdrawn interface. The cinematic apparatus therefore emerges as a conveyer belt of Freudian mystic writing interfaces (perception + memory) that connects the Bergsonian matter interface (pure perception) to mind interface (pure memory). Bergson then helps remediate Freud's anthropocentric one-way circuit of human consciousness and its unconscious storage by grounding human perception on pure perception in matter as such, and by elaborating the multifaceted interaction between human perception and memory. Freud in turn helps elicit the interfaciality immanent in Bergson's monism of image—everything exists as an image, from matter-world to memory-mind—by looking into the multiple remediations of the image through perceptual and mnemonic devices. As a result, both the image and subjectivity could be better understood as immanently interfacial. The image is the image as interface; so is the subject. We will further investigate the different facets of this 'monism of interface,' while interfacing with different theories and concepts as we can renegotiate Freud and Bergson to redefine the cinematic apparatus.

CHAPTER INTERFACES

If the cinematic apparatus as a chain of interfaces can be called the 'infrastructure' of cinema, then the next five chapters unfold cinema's 'superstructure,' consisting as it does of immaterial images yielded by the material apparatus. The shift takes place from cinematic interfaces producing images to produced images of these very interfaces: a camera, filmstrip, and screen, seen on the film screen (in effect, cinema comes to reflect on its own mechanism; it interfaces with its own interfaces). There certainly lurk gaps or links between the invisible but material interfaces (apparatus of images) and their visualized forms, and between these visible but immaterial interfaces (apparatus as images) and the material bodies of film characters who experience them. Moreover, films can create indirect 'interface effects' out of various surfaces and faces instead of directly showing actual interfaces.

These effects can open the cinematic realm of 'quasi-interfaces' that characters' explicit contact with a medium interface cannot reach. To stage all these visual modes of onscreen interfaces on a conceptual spectrum, we can think of corresponding parallel lines, with one line extended along the chain of interfaces and the other indicating the mode of their direct or indirect visualization. Then let's assume that the direct interaction between medium interfaces and (the body of) characters takes the central position of this double axis, around which quasi-interfaces emerge onto the (sur)faces that evoke but do not represent the medium interfaces of camera, filmstrip, and screen.

object	camera	filmstrip	screen	subject	
surface		medium		body	face
indirect		direct		direct	indirect

In Chapters 1 to 4, I arrange diverse modes of interfaciality within a topological taxonomy based on this graph. Chapters 1 and 2 look at the direct appearance of medium interfaces as well as their direct experience by character subjects. Chapters 3 and 4 examine quasi-interface images outside of the medium-body interaction, focusing on the surface of the object world and the face of the (in)human subject respectively. The aim of this research is indeed to rediscover and reinvent the concept of interfaciality through film analysis. Interfaciality will thereby acquire complex implications that go beyond the neutral imbrication of mediations embedded in the conveyer belt of the apparatus. Or rather, it will amplify a radical sense of 'imbrication' which may incubate, I suggest only roughly here, a certain 'inherent disequilibrium,' 'intrinsic dialectics,' 'inhuman dimension,' and 'implosive dynamics' between two sides of an interface. The four chapters will rephrase these inner qualities of the interface as *asymmetrical mutuality, ambivalent tactility, immanent virtuality,* and *multiple directionality*—four key terms that reshape the four corresponding and established terms of *suture, embodiment, illusion,* and *signification.* This enriched notion of interfaciality will pave the way for Chapter 5, which retheorizes the image and subjectivity as such in terms of *para-index* and *indexivity,* a new conceptual pair derived from the concept of the *index(icality),* often regarded as the essence of (analog) cinema.

Each chapter except the last one opens with a close analysis of a 'prelude' film, mostly a specific shot or scene that enables the introduction of a key theoretical concept. Then I trace a sort of archeology of the concept in film studies, revealing controversial gaps or potential connections between theoretical presumptions, parameters, or positions. Engaging with the history of the concept, this process is both a historical and theoretical struggle for developing interface theory. At the end of each chapter, I typically pose

new questions facing the digital age of cinema that involves challenges and changes of the very interfaciality elaborated through film theory. By doing so, I suggest interface theory could serve as a flexible bridge between old and new media studies. Throughout this exploration, I traverse a wide range of canonical and overlooked films regardless of area, period, and genre—from Asian horror to American blockbuster to European art film, from pre-1900 early cinema to post-2000 contemporary cinema—though still centering on Western classical/modern narrative features that have served as the main target of 'film' theory. The baseline is that film theory should not be simply applied, but continuously face concrete images that often inspire and even require us to reload, revisit, and remediate theoretical frames and tools. Interface theory could not come out of interfacing with other theories alone; theories themselves should interface with films. Each chapter therefore attempts in-depth analyses of a few crucial examples, often counter-examples to test theories. These choices could be justified inasmuch as they embody the "concrete universality" of interfaciality, which should in turn be retheorized. As Slavoj Žižek argues, a concrete figure can retroactively "color" the totality of the process, whose universality in turn becomes drawn into the particular content. What brings a true universality is not a patient empirical generalization, but a dialectical analysis of the "exceptional singular case" that allows us to formulate or reshape universality (2001, 13–29).[4] This is why each chapter locates a few 'hegemonizing' films around others regardless of area, period, or genre.

To begin with, Chapter 1 ("The Medium Interface") sheds light on the cinematic interface emerging from an unseen or unknown realm in the film. This concerns not simply the film in/on film, the old modernist motif of self-reflexivity, but problematic cases in which the appearance of a medium interface destabilizes the classical mechanism of *suture* that produces a 'seamless' narrative space and time. The video screen in Michael Haneke's *Caché* [*Hidden*] (2005) impressively testifies to an unidentifiable gaze behind it that resists being sutured. Apposite is Žižek's review of suture as the violent appearance of a 'seam' itself, a perturbing object image that intrudes stable reality in the way of actually 'desuturing' it into its traumatic past or hidden potential. I explore the *asymmetrical mutuality* between two sides of the interface, sutured and unsutured, while locating multiple levels of the suture/desuture dialectics through semiotics and *Screen* theory, Lacanian and Žižekian psychoanalysis, Garrett Stewart's media narratology, and so on. Then, moving to Deleuze's Bergsonian ontology, I find interfaciality not just before, but immanent in the eye; not only the technological medium, but also the eye is an interface, an embodied one sutured from the inhuman gaze immanent in matter. Dziga Vertov's "kino-eye" can be viewed as a suture of this eye in matter. In these ways, suture works no longer as a suspicious ideological mechanism, but rather as a productive agency for renewing film theories.

Chapter 2 ("The Body Interface") draws attention to the body of a char-acter as a spectator in front of an interface, as Roberto Rossellini's *Virginity* [*Illibatezza*] (1963) notably shows. The main character of this short piece touches not only a screen he sees, but also his own body on which the (lost) virgin body of a woman he wooed is projected. The shift from see-ing to touching here signals the shift of spectatorship from transcendent to embodied subjectivity, and it reveals the screen as a material interface that both provokes and frustrates the real contact. To investigate this *ambivalent tactility* of interface, I traverse various spectatorship theories from semiotic psychoanalysis (Jean-Louis Baudry/Christian Metz) through "Rube" films studies (Elsaesser) to the phenomenology of *embodiment* (Sobchack/Han-sen) and even cybernetics/cognitivism. Furthermore, inspired by *Virginity,* I look into two sets of films in terms of the cinema as a double body: a 'screen body' that causes the desire for touch, and a 'body screen' onto which the object of that desire is projected. While the first case leads to discussion of the tactile gaze, the skin as ego, and the bodily transformation into an interface as a failure of touching the real and merging into the other, the second case shows how the impossible penetration can turn into the possible inscription of images onto skin. All this complexity proves the ambivalently tactile skin to be an embodied interface from which the artificial technologi-cal interface turns out to be derived.

The following two chapters extend into quasi-interfaces. Opening with a close analysis of Apichatpong Weerasethakul's *Syndromes and a Century* [*Sang sattawat*] (2006), Chapter 3 ("The Surface of the Object") delves into how the image of an object loses its (*illusion* of) three-dimensionality and purely appears as a two-dimensional surface looking like a camera, film, and screen. The image then appears to literalize interfaciality as *immanent vir-tuality* of the object/world, requiring us to question the aesthetics of illusion dating back to classical Gestalt theory typified by Hugo Münsterberg and Rudolf Arnheim via Bazinian realism. I especially redefine the 'haptic' as the 3D illusion of tactility that perfects the 'total cinema' idea. When a 3D image loses its tactility and looks reduced to its mere 2D surface, however, it can cause the illusion of interfaciality, a new type of illusion that works '*as if* it is becoming interface.' I then analyze three sets of films that let us sense the quasi-camera, quasi-filmstrip, and quasi-screen—the order in which a single camera-looking object gradually leads us to the immanent dimension of the world, that is, shifts us from the actual phenomenal world to the virtual ontological realm. In the last case of quasi-screen, moreover, the world loses its illusionist spatiality while amplifying flatness, fluidity, or florescent effects of the screen, which thereby appears solid, liquid, and gaseous respectively.

On the opposite side of the object's surface, Chapter 4 ("The Face of the Subject") begins with Kim Ki-duk's *Time* [*Shi gan*] (2006) to look at the sub-ject's face particularly shot in close-up as a quasi-interface that can interface with multiple agents in terms of who/what it signifies. The focus then shifts

from the two- or three- dimensional illusionism to an over-three-directional (inter)faciality. To classify this *multiple directionality* in terms of *signification,* I start to draw on Robert Sobieszek and Jacques Aumont's works on the face in photography and cinema, and further review relevant theories in each direction. First, as a 'premodern' metaphor, the face is a transparent window open to interiority, a codified sign of the character's subjectivity (Belá Balázs). Second, in the 'modern' stage, this semiotic transparency gives way to reflectivity, as the face becomes a phenomenological surface onto which to project the viewer's own subjectivity (Jean Epstein, Roland Barthes). Third, the 'postmodern' defacement shows the transformation and deconstruction of the face, which goes ontologically beyond subjectivity toward the multiplicity of its simulacra (Deleuze, Jean Baudrillard). And finally, the face can lead to the infinite of otherness as the unreachable ethical ground of being (Immanuel Lévinas). Looking at diverse films in each case, I demonstrate four different 'significations' of interfaciality (codification, significance, subjectification, infinity) based on semiotics, phenomenology, ontology, and ethics.

Finally, Chapter 5 ("Image and Subjectivity") looks into interfaciality in the image and subjectivity as such by reinterpreting the concept of *indexality* in two ways away from its medium specificity that has defined the ontological nature of the celluloid film image. First, cued by Deleuze's usage of the term, I propose to address the index in terms of epistemological causality, that is, an index as an effect refers to its cause that we can know or not. Hence two types of montage: the 'montage of amalgam' that clearly puts together and even merges cause and effect images, and the 'montage of ricochet' that sets one apart from the other. The latter case especially inspires us to think of the image as what I call the *para-index* that only partially, impossibly indicates its cause as absent but immanent in visual reality. Second, indexicality can take a spectatorial turn to illuminate the spectator-subject's indexical passivity (being passively touched by the image) and indexical activity (taking an action toward the image). While following the degree of this activity from reaction through proaction to production, I argue that our fingers' [digits] tactile experience of digital interfaces, that is, the act of indication for information or participation, inevitably conditions our life in the interface society.

Overall, the reader follows an upward trajectory from the infrastructure of apparatus through the superstructure of onscreen images to the image itself, which leads back down to the material ground of our interface world. In the conclusion, then, a new cognitive mapping of film studies is sketched along the spectrum of cinematic interfaces to renegotiate diverse phenomena and ideas, rediscover their potentials and limits, and reposition new media effects accordingly. Envisioning this direction of future research, the book hopes to be an initial step for a general theory of image and subjectivity through a meta-critical reengagement with film theory.

Chapter	Theme	Content	Concept	Theory	Approach
Introduction	Apparatus	Object (image), medium (camera/film/screen), subject (eye/mind)	Apparatus, interface	Physiology, psychology	Mediology
1	Medium (camera, film, screen)	Medium interfaces	Suture, asymmetrical mutuality	Semiotics, psycho-analysis, photogram-matology, ontology	Hermeneu-tics
2	Body (skin)	Screen-body, body-screen	Embodiment, ambivalent tactility	Psychoanaly-sis, phenom-enology, historicism, technesis	
3	Object (surface)	Quasi-interfaces	Illusion, immanent virtuality	Phenomenol-ogy, ontol-ogy, aesthet-ics	
4	Subject (face)	Face-character, face-viewer, face-facial-ity, face-otherness	Signification, multiple directionality	Semiotics, phenomenol-ogy, ontol-ogy, ethics	
5	Image, subjectivity	Object-(image-interface)-subject	Indexicality, para-index, indexivity	Ontology, epistemology, sociology	Philosophy

1 The Medium Interface

Georges, the host of a highbrow literary talk show, receives suspicious vid-
eotapes that display the peaceful façade of his upper-middle-class house.
It is not clear from the CCTV-like footage, in which nothing ostensibly
happens, who has been watching his family and why. Subsequent tapes,
however, lead Georges first to his provincial childhood home and then to an
unknown suburban apartment, which turns out to be the dingy living space
of his adopted, then abandoned, Algerian brother, Majid. This forgotten
'other' confronts Georges with an uncomfortable truth from the past: young
Georges's jealousy forced Majid to be sent off to an orphanage, whereafter
Majid had to survive without the educational and social benefits given to
Georges. The nature of the video thus changes from provocation to evoca-
tion, from surveillance to reminiscence. Michael Haneke's *Caché* [Hidden]
(2005) uncannily uncovers this hidden trauma that resurfaces in the present.
But my primary question is simple: Why video? That is, why interface?

 That such a cinematic interface appears onscreen might not merit discus-
sion in many cases, but it can play a central role by thwarting or destabilizing
the unity or stability of the narrative. The subjectivity of characters or
spectators can also be shaped or shaken through their encounters with the
interface within the film. A diegetic interface may then affect the 'perception'
and 'memory' chain that interconnects 'image' and 'subjectivity,' while also
potentially drawing attention to the film's apparatus made up of extradi-
egetic material interfaces: camera, filmstrip, screen. Therefore a cinematic
Möbius band, a reflective loop, is formed between two levels: interface as
image and interface as machine, that is, represented onscreen interfaces and
representing offscreen interfaces, the latter enabling the former that can refer
back to the latter. These two levels coincide with the classical semiotic con-
cepts of 'utterance' ('story'/'speech') as narrative instance and 'enunciation'
('discourse'/'speech act') as generating process. Yet, as I will show through
the concept of *suture*—the term for the very dynamics between these levels—
what follows reexamines the classical psychoanalytic model of spectatorship
and rewrites suture theory in light of its own evolution, which may lead to
our conclusion: the interfaciality inherent in image and subjectivity.

THE HIDDEN CAMERA BETWEEN OFFSCREEN AND
ONSCREEN SPACE

As a starting point, *Caché* seems ideal not only because of its video insertions, but because of the consequent revelation of perceptual and mnemonic mechanisms. Among many significant scenes, I take Georges's second visit to Majid's flat as a kernel of the film's structure. Its impressiveness, of course, bursts out of Majid's sudden suicide; Majid lets Georges in, talks for a second, takes out a knife with Georges slightly faltering, and slits his own throat, leaving no room for anticipation (fig. 1.1). The abruptness of this action marks the abruption of Majid's emotion: a remarkable calmness and gentleness not usually found in revenge suspects. It is rather Georges, the white Parisian intellectual, who has always lost his temper in front of his lower-class, dark-skinned brother (and later in front of Majid's son, too); Majid, this Algerian outcast, has reversed the standard image of the brutal invader of the bourgeois family like Max Cady in *Cape Fear* (J. Lee Thompson, 1962; Martin Scorsese, 1991). By killing himself, Majid releases something repressed beneath his tranquil face and fractures the peace of both his *banlieue* home and Georges's bourgeois life. The flash of his blood sprayed onto the wall visualizes this fracture like an unstitched slash; the blood slowly exuding from his throat onto the floor implies that this trauma will only grow like a nightmare in Georges's memory.

In view of other scenes, Majid's bloodstain on the wall triggers a déjà vu that allows us retroactively to recognize the drawings sent to Georges (of a child vomiting blood) as forewarnings of this suicide. And through the same logic of Freudian 'deferred action,' this bloody event serves to repeat and

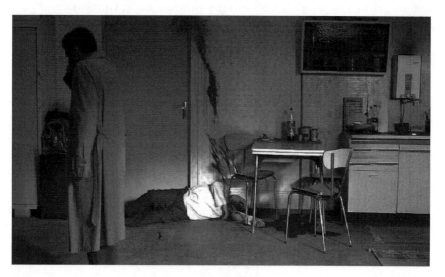

Figure 1.1

recall the film's first flashback of young Majid coughing tubercular blood by a window, and the childhood trauma staged in Georges's nightmare: young Majid kills a cockerel, which also leaves a sharp blood mark, and he approaches Georges with the bloody hatchet. This killing was in fact orchestrated by Georges, but he told his parents that Majid had wanted to scare him, a joking lie that, along with Majid's tuberculosis, ultimately resulted in Majid's expulsion. However, only through recurrent visual traces after the fact does that original scene manifest its latent meaning as Georges's original sin. The question would be how guilty and responsible the child and/or adult Georges is for that tiny 'twisted joke' that had lifelong repercussions/consequences for Majid. One may conclude: "Georges's refusal as an adult to acknowledge the effects of his earlier actions suggests a parallel with the postcolonial metropolitan who is neither wholly responsible for, nor wholly untainted by, past events from which he or she has benefited" (Ezra and Sillars 2007, 219).[1] Or Majid's suicide might bring a deep, if guilty, pleasure to a deeply 'twisted' xenophobe European: "the comforting idea that the colonial native can be made to disappear in an instant through the auto-combustive agency of their own violence" (Gilroy 2007, 234).

Rather than relying on these interpretations, I call attention to the fundamental cinematic mechanism that causes this hermeneutic turmoil around the colonial legacy. The first element that even formalist reviewers miss is the apparently insignificant dialogue. After entering the flat, Georges asks what Majid wants, and hears: "I truly had no idea about the tapes." Georges asks again: "Is that all?" Then Majid utters his last words: "I called you because I wanted you to be present." Georges is required to be a witness, a living index, to Majid's death, just as Majid's blood leaves its physical trace on the wall like a gigantic fingerprint. Indexicality marks the ontological essence of this Bazinian sequence shot with two antagonistic figures, and furthermore, triggers another deferred action. This time, however, the event does not signal the past but the future, wherein Majid seems to call out from beyond the grave: 'Look at me dying like the cockerel, and suffer from your presence at my death when this moment haunts you like a ghost.' How could this present moment appear in the future as the return of the past, but with a hidden camera? Surely, this static long take, framed in long shot, hints at a surveillant gaze that seems to offer the true meaning of Majid's will: 'I actually wanted you to be present in front of the camera that will send you a tape showing your very presence at my death.' Thus Georges is not the witnessing subject, but the object witnessed by a faceless subject, not an index maker but an index image itself.

Nonetheless, we remain unsure of the hidden camera not only because of Majid's strong denial of its presence, but because of the fact that his supposedly recorded suicide is not actually delivered to Georges until the end of the film. The circumstances of this video's delivery are opposite to those surrounding a previous 'surprise' video sent to him directly after his first visit to Majid's apartment. This first video, which depicts Georges's visit

as well as Majid's sobbing after Georges's departure, has the same static, surveillant setup as the suicide video. But Haneke makes it clear to us during that first visit that there is/was no camera(man) present, since all sides of Majid's flat could be seen in the background through shot/reverse-shot exchanges (figs. 1.2–1.3). One could imagine a tiny unrecognizable camera,

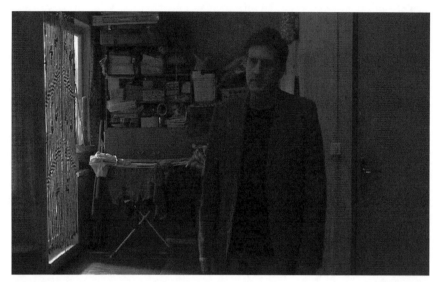

Figure 1.2

Figure 1.3

but the opening scene video was shot from the position of someone who must have stood on the street and fixed a conventional camera firmly on a tripod (though this cameraman is also improbably invisible).

Undoubtedly, this improbable gaze is the aesthetic target of many debates surrounding the film. Libby Saxton, for instance, takes a Deleuzian approach to the offscreen space incubating this hidden gaze. What Deleuze defines as the 'virtual' out of field is a disturbing presence that can be said to "insist" or "subsist" rather than to exist, "a radical Elsewhere, outside homogeneous space and time" (1986, 17).[2] In *Caché,* we experience this radical invisible field as irreducibly present through its visible counterpart, that is, the video, while this "interface" between offscreen and onscreen space becomes "the locus of concerns about personal and collective trauma, guilt and responsibility" (Saxton 2007, 6). At this point, however, what matters seems to be this interface's real meaning. A more specific exploration of the term *interface* may also help elaborate offscreen space and its function. For this task, I will take my cue from Žižek's usage of interface in his remodeling of suture theory—a remodeling that I wish to in turn reconceptualize. The concept that needs an archeological detour is not offscreen space so much as suture, for suture relates to both offscreen and onscreen space.

SUTURE AS META-SUTURE OR DE-SUTURE

The concept of suture was crucial in the heyday of 1970s *Screen* theory (Silverman 1984, 193–236; Rodowick 1995, 180–220). Semiotically, as Žižek says, suture is defined as the process by which "the 'absent one' is transferred from the level of enunciation to the level of diegetic fiction" (2001, 32). *Enunciation* means the process of producing diegesis in which its producer, the enunciator, is not seen, but this absence does not unsettle the spectator because almost every shot appears to be taken from a certain character's perspective as if he or she were the very enunciator of the previous or following shot. Georges's first visit to Majid replays such a classical example of suture (figs. 1.2–1.3): the objective shot of Georges raises the question 'from whose subjective point of view is this filmic enunciation given?', which is smoothly and swiftly answered through its reverse shot showing Majid (the 'absent enunciator' turns into a diegetic figure). Suture designates this turning point through which the fundamental difference between image and its absence is mapped onto the intra-pictorial difference between two shots. In semiotic-psychoanalytic terms, every different shot—not only in the shot/reverse-shot exchange but also in the editing process as a whole—results from the suture of the invisible externality into the chain of visible shots as 'symbolic' signifiers; it thereby keeps stable and seamless the diegesis as an 'imaginary' world so that spectators, for the most part, hardly recognize this mechanism in the middle of identification with characters and immersion into narrative space. It is ultimately the spectator's subjectivity that is

unconsciously sutured into this unified imaginary reality, the subjectively signifying world woven through objective audiovisual signifiers. Suture is nothing but this perpetual operation of signifiers constructing the imaginary, that is, of what Metz called "the imaginary signifier" in plural.

Žižek's intervention occurred when, after its hegemony had declined, 'suture' became vague jargon synonymous with 'closure' that yields the totality of a structure. To reinvigorate this outmoded buzzword, he brings to light the initial radical difference between the onscreen image and the offscreen void. For the threatening intrusion of the latter, the decentering Other, the Absent Cause, can leave its trace onscreen as if not completely sutured. An apparently objective shot turns out to be a subjective one or vice versa in the suturing process, but, as often seen in Hitchcock, we can encounter an inhuman gaze or a monstrous evil that embodies "the impossible/traumatic subjectivity of the Thing itself" (38). The burning Bodega Bay with birds gliding over it in *The Birds* (Alfred Hitchcock, 1963) appears to be shot neither objectively nor subjectively, but semi-subjectively.[3] The invisible Thing can also intrude into a shot, leaving "a blot of the Real" like a bird's attack on Melanie (note the confusion of terminologies: the semiotic "absence/void" is rephrased as or replaced by the psychoanalytic "Thing/the Real," which is not a visible object but the nonsymbolic ground of all beings). If standard suture creates a seamless illusionist narrative space and illusory reality, Žižek's late Lacanian version reveals that the Imaginary-Symbolic conjunction cannot always efface the seam, leaving the trace of the unsymbolized Real that abruptly emerges like a Lacanian stain. Suture thus no longer functions as the undetectable mechanism of signifying representation, but as the unconcealed symptom of its own failure. It is the onscreen appearance of the Real itself, the visualization of the rupture of the suture as such. Conversely, those birds look like a sutured form of the Real, as it were, a 'slashing' suture within the 'slick' suture.

What Žižek calls "interface" concerns a more specific case of suture. It indicates a screen within the screen serving as the direct stand-in for the "absent one," mostly appearing in the form of "a simple condensation of shot and reverse-shot within the same shot" (2001, 52). His typical examples include the beginning of *Blue* (Krzysztof Kieślowski, 1993), when the object of Julie's look, a doctor, appears as a reflection in her own eye, and a scene from *The Lost Highway* (David Lynch, 1996), where Peter encounters Alice both in front of him and as her pornographic image on a big screen. I have to say that the latter is not a rigorous shot/reverse-shot mixture, but a first shot followed by a second, more symptomatic shot that slides over Alice and her porn image without cutting. Such reflected images then lose their sense of reality, as if to visualize the spectral, fantastic Real. That is, an interface is a 'meta-suturing' or, I would say, 'de-suturing' image surface within a shot that self-reflexively visualizes the imperfection of classical suture by 'directly' suturing the Real. Claiming that an interface-artificial moment must suture-stitch the Real, Žižek in effect resutures the notion of

suture into film theory in terms of 'meta-suture' or 'de-suture' that divulges and thereby thwarts the traditional suture itself. Hence, there is what he calls the 'short-circuit' that, I argue, operates on two levels: (1) as a semiotic short circuit between the Imaginary-Symbolic coalition producing reality effects and the external Real inaccessible to the subject; (2) as a psychoanalytic short circuit between objective reality constituted from our subjective viewpoint and the traumatic Real outside this ordinary reality.

Neither subjective nor objective, the *interface as suture* therefore appears in the convolution of reality and the Real. It is like a 'partial *objet petit a*' such as the gaze and voice, which conflates 'master-signifier' with '*objet petit a*' (Žižek 2001, 65). These key terms may need some clarification. The master signifier is a 'signifier without signified,' like the square root of -1, an imaginary number. So is the phallus that only signifies the impossible fullness of meaning, but causes a series of 'normal' signifiers; its meaning is at best a free-floating emptiness, though our subjective desire for it generates the signifying system of sexual or other differences, namely the symbolic order of reality we regard as objective. A clearer example found in Jacques-Alain Miller's initial article on suture, drawn from Gottlob Frege's *The Foundations of Arithmetic* (1884), is the number zero (Miller 1977, 24–34). Zero designates *nothing*, no object but the void itself, and yet this signifier in the metaphorical form of the blank counts for a number, one numerable object/unit, that is, *something* that can be assigned to the concept of 'one.' So, zero is the concept 'not identical with itself.' Then the number two comes in for two objects/units (zero and one), and the next is three for three numbers (zero, one, and two). This chain goes on so that all real things appearing as the confused multitude of impressions can be ordered in the matrix of objective numerical reality. The point is that "the series of numbers, metonymy of the zero, begins with its metaphor," that is, with our initial (classical) suture of the absolute emptiness into its stand-in. In this way the zero lack as nonconceptualizable is conceptualized as the zero number (Žižek 2001, 30–32).[4] The master signifier is therefore the subjective signifying feature or, in the Kantian sense, the "transcendental" conceptualizing stand-in that launches the very objective symbolic structure we need so as to represent our reality (out of the Real).[5]

The *objet (petit) a* is, on the contrary, the objective supplement (from the Real) that sustains subjectivity in the sense that our subjective symbolic movement as a whole can be set in motion only around this object in the Real, only through the effort of suturing it into the Symbolic. But as this suture is not perfect, the object as the remnant of the Real virtually becomes an unsutured hole at the center of the Symbolic, an ineffaceable blot that blurs our picture of would-be objective reality. The *objet a* is this disturbing stain or "bone in the throat" (65) through which we sense the potential of the Real interrupting the practice of the Symbolic, and we thus enter another real dimension with every reality suspended all of a sudden. The *objet a* is therefore the exact opposite of the master signifier, but only insofar as one

may be seen as the other's flip side. That is, they manifest two sides of the same coin: on the side of the subject, zero is a master signifier suturing the Real, a number; on the side of the Real, zero is an *objet a* desuturing the subject, a lack. The starting point of the order is none other than a black hole open to chaos.

When Žižek compares the notion of interface to Joan Copjec's notion of 'partial *objet petit a*' (based on Melanie Klein), its difference from *objet petit a* is not clear enough. Given Lacan's introduction of *objet petit a* as the imaginary 'partial object' or 'part-object'—an element imagined as separable from the rest of the body (gaze, voice, breast)—and given Žižek's confusing usage of the 'Gaze' which is attributed to both *objet a* and partial *objet a* (34, 65), I would suggest the word *partial* be understood as an independent adjective rather than as part of 'part-object.' In other words, the interface is a 'partial' master signifier as well as a 'partial' *objet petit a,* just because it is their very short circuit that partially embodies both of these features. To enhance clarity despite possible reductionism, I draw further attention to this distinction, which Žižek does not make, between the Gaze with a capital G and the gaze with a lowercase g. The former is the pure, invisible *objet petit a* (of the Real); the latter its visualized form, an imaged signifier as a partial *objet petit a* (in reality). This distinction would be necessary and effective in locating an onscreen interface gaze through which we could sense the unlocatable pure Gaze.

In view of Lacan's well-known diagrams on vision (1998, 91–119), does this short circuit not take place when two triangles overlap each other as shown in the third diagram here?

In diagram 1, the "Object" (Thing) is sutured into the "image" (like a master signifier) by our subjective act of seeing and symbolizing it from the "Geometral point" (eye). In diagram 2, the "Point of light" (the Gaze of the Real) positions us a priori in the "Picture" (our visual field) from which we see, while for us it is hidden behind the "screen" as a veil of the Gaze (the visual membrane of *objet petit a*).[6] And in diagram 3, the "Gaze of the Real" is sensed in the visual field of the "subject of representation" when the

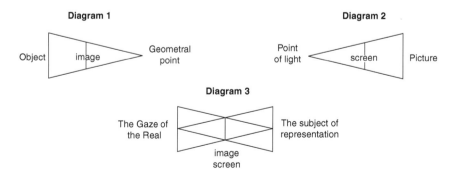

"image" functions as the "screen" of the Real in their short circuit. Apparently dialectical, this schema, however, has nothing to do with the standard version of the Hegelian flowchart of thesis-antithesis-synthesis. What counts is not continuous reciprocity or equal correspondence between the Gaze and the subject's eye, but rather their radical disjunction or nondialectic asymmetry. At the moment of suture becoming desuture, the overlap of the "image" with the "screen" is virtually the replacement of the former with the latter. The eye is already encompassed or preceded by the Gaze, which, never directly looked at by us, is only vaguely sensed when directly sutured in an imaged form of the little-g gaze (as derived but different from the Gaze)—in other words, a visible interface. And it could be said that Lacan's anecdotal example of this little gaze, the sardine can that was floating on the sea and looking at Lacan at the level of the Point of light, is nothing but an interface in nature, a 'natural interface' equivalent to a screen on screen (95). The interface appears as this uneven merge of *image-screen,* making us realize that our subjective eye is 'asymmetrically' conditioned by the immanent status of the Gaze that constitutes our visual field. We *see* and *are* within this field without *seeing* the *being* of its hidden Gaze until an interface hints that we have *been seen* by that very Gaze.[7]

"I AM PHOTOGRAPHED BEFORE I PHOTOGRAPH"

To return to the initial question on *Caché:* Why video? It is now clear that the video as an image-screen incarnates such a perceptual and ontological interface in the properly medium-specific sense of the term. When the opening outdoor image (Shot A: fig. 1.4) suddenly reappears on the TV Georges watches (Shot B: fig. 1.5), the latter functions not as a reverse shot, but as a sort of 'interface shot' with the former sutured into it: a condensation of shot and reverse shot. Sutured in the form of the video interface, the outside of the house or, say, the external Real invades the inside of Georges's reality. The crux of Žižek's suture (which he himself does not highlight) is that it opens this 'outside' within diegesis (and not the extradiegetic space of film-making). As the objective Shot A turns out to be a subjective shot, it must have been shot not directly from the viewpoint of the "extradiegetic" enunciator (i.e., the 'seamless' director), but primarily from the viewpoint of an internal enunciator as a diegetic character who is exterior to all other characters. Neither a "homodiegetic" narrator who takes part in the plot nor a "heterodiegetic" narrator who does not, this cinematic in-between figure thwarts Gérard Genette's literary narratology (1980), which established that dichotomy. While not belonging to the main diegesis, s/he remains "intradiegetic." That is, the video producer can be identified neither as Haneke himself nor as Majid or his son—who also persistently denies Georges's suspicion—but only as somebody else in the 'marginal' narrative space that no other character enters and in the 'liminal' narrative time that lingers in the back of the main character's memory.

Figure 1.4

Figure 1.5

More uniquely, this hidden character manifests neither as a pseudo-subject like an animal or ghost, nor as "standard Gothic elements (apparitions in the fog, magic mirrors)" (Žižek 2001, 39). Instead, it lingers as an image surface of ordinary reality, which persists in complicating the matter of perception and representation. The pure Gaze immanent in Shot A seems sutured into Shot B as a diegetic gaze, yet this in turn only becomes the object of the other character-subject's look as Georges watches it. The unverified subject persists as nothing but the inhuman Gaze itself. So when the objective Shot A turns into a subjective one, this subjectivity should rather be attributed to

characters (and spectators) whose view of reality would fit such a normal perspective of the house; the image taken from the 'geometral point' of the 'subject of representation.' On the contrary, the unseen subject who shot this video turns out to be an 'asubjective' agent of the Gaze that belongs to the 'real' objectivity beyond Georges's and our field of vision. The intradiegetically external viewpoint only hints that there might be no human character to occupy this position except for a nonanthropomorphized camera eye as such.

While *Caché* plays a 'mind-game' vis-à-vis the question of whether or not we see Georges's house in Shot A from within someone's mind, the film provokes a deeper feeling that *"I myself* (i.e., the film's narrator through whom I see the film, my stand-in in the film) *do not exist"* as Žižek suggests (67). Insofar as suture theory concerns spectatorship, suturing as interfacing with the Real does not perfectly suture spectators within the diegetic space, but leaves them wandering around the unsutured Gaze. They are invited to perceive the fictional world through the eyes of an 'experiencing consciousness,' for example, a moral consciousness or super ego of sorts, a lingering remnant in the back of Georges that is always watching him, always terrorizing with its demands. And yet this consciousness is not embodied but disembodied. As Georges's reality of well-being is constituted only through a certain loss of reality, that is, an exclusion of the traumatic Real, the video interfaces with this loss of the Real while also making him realize that what he sees is constituted only through what he cannot see. The same is true of the spectator, whose gaze is sutured not as belonging to a subject-character with whom to identify, but only as becoming the object of the character's look: Georges's diegetic eye that is already both penetrated and surrounded by the invisible Gaze. "Gaze is the condition of possibility of the eye, i.e. of our seeing something in the world (we only see something insofar as an X eludes our eye and 'returns the Gaze')" (Žižek 2001, 65). Lacan says, "I am *photo-graphed"* (by the Point of light) (1998, 106), and I add, 'before I photograph' (from my geometral point).[8]

The suicide scene ultimately refers to the existence of this Gaze whose empty position spectators assume, while it retroactively proves its unsuturability—the resistance of this Gaze to being sutured into reality. This tension yields a genuinely "fantastic" hide-and-seek narrative in Tzvetan Todorov's sense of the term in which an enigma remains inexplicable beyond the end.[9] More notable, however, is the fact that suture takes place only through the material interface, the hygienic high-tech surface of a shadowless image. The suicide shot looks like and functions as a 'quasi-interface' about which we are still uncertain as to whether it is just filmic narration or another would-be inset video. This is the case with the penultimate shot of Georges's apparent dream (followed by his going to bed)—a fixed, extreme long shot of his past presence at Majid's traumatic expulsion from the family (fig. 1.6). It is unclear whether or not the camera position of this shot indicates young Georges's position at the moment, or whose point of view

Figure 1.6

it is that restages this 'primal scene' if neither Georges's nor the director's himself. We could say the Gaze might be internalized in the unconscious of Georges who sends himself a quasi-interface flashback video. But the question only becomes more unsolvable through a 'false connection' to the film's ending (i.e., without any coherence but some uncanny noise continuing)— Majid's son, the only suspect who might have been shooting this school of Georges's son, surprisingly though almost indiscernibly, enters the frame and talks to Georges's son in extreme long shot. Is Majid's son threatening Georges's son or conspiring with him to play a trick on Georges? If the latter is the case, is this the end of the storyline or rather its beginning that even precedes the opening scene? To identify and interpret this visual, semantic conundrum, it is we the audience who must now replay this quasi-interface shot. It also confronts us with our theater space, which may in fact resemble the stairway, with some people still seated and others exiting at the moment the credits close the film (fig. 1.7). Doesn't this interface screen, then, return the hidden Gaze like a mirror of our physical body?

In brief, *Caché* gears sociopolitical and psychoanalytical hermeneutics into the ontology and epistemology of the media/image. It carries the 'whodunit' semiotics based on the communication/enunciation model to an extreme of perception theory. The interface is given as the only possible threshold through which the Gaze is sutured in front of the human look. The latter senses the unsuturable, unsutured former in its own reflexive/retroactive circuit. This is a distorted feedback of two different perceptions—the Gaze and the eye—which are contingently encountered, asymmetrically exchanged, and unfairly renegotiated. So, too, are two different memories entailing deferred actions—memory of the Real and memory in reality—as Georges's

Figure 1.7

once-sutured memory about Majid is reopened like the bloody gash, the deep crack carved into the other side of his reality, at the moment Majid's knife rips through his skin. We only see the (quasi-) interfacial image-screen, but without it we could have no epistemological chance to consider the ontological Gaze that conditions our seeing and being. If Majid embodies a certain agency, it would be less the self-demolition of France's former colony than the inherent disequilibrium between two sides of the interface, their *asymmetrical mutuality*. *Caché* brilliantly discloses how this interfaciality structures subjectivity; the concrete sociohistorical background of the film serves to capture this interfaciality as the "concrete universality" of our perceptual and mnemonic lives.

THE SHORT CIRCUIT OF SEMIOTICS AND PSYCHOANALYSIS

Let me now go back to the aforementioned but untouched problem: the confusion of semiotic and psychoanalytic levels to which Žižek himself pays no attention despite his renovation of classical suture. To tackle this issue, what follows will provide less a mere reminder than a genealogical reframing of a few seminal texts on suture, that is, a meta-theoretical refocusing on different levels on which suture works. This process will ultimately help locate niches for a post-Žižekian revisit to the concept in rediscovering and reinventing its still significant implication.

The term *suture* was first mentioned in passing when Lacan answered questions at the end of his seminar on the aforementioned diagrams, but his densely succinct remark, rather unsurprisingly, has rarely been parsed. He introduces it as mediating the fascinatory "gaze" that terminates movement

and the moment of "seeing" that resumes the movement in temporal prog-
ress. More precisely, the gaze is the *fascinum,* like what we first feel as our
impression of, to take Lacan's example, the Peking Opera punctuated by a
series of gestures that have the effect of "arresting movement" and "killing
life," thereby perhaps creating 'still life' out of the dance. Suture occurs at
the moment seeing intervenes in this "anti-life, anti-movement function" in
the way that the eye conjoins the imaginary and the symbolic of the spectacle
and thus enjoys the forward-moving chain of imaginary signifiers while dis-
possessing the "evil eye" of the gaze (Lacan 1998, 116–119). Encountering
an instant mortal threat posed by the Gaze, I rephrase, the subject immedi-
ately returns this Gaze unawares by means of what it (Gaze) enables, that
is, his look (eye), which belongs to what it (look = eye) in turn enables, that
is, the continuous visual field of the Imaginary-Symbolic conjunction. My
point is that this inauguration of suture in Lacan centers on the structural
mechanism of perception above all.

Jacques-Alain Miller developed this surgical term into the foundational
concept of what he called "the logic of the signifier," namely the logic of the
origin of logic. As already mentioned, his focus falls on the numerical sys-
tem whose origin is the suture of nothingness into the zero as a signifier. But
a psychoanalytic semiotic turn of mathematics seems to take place, when
nothingness as "the not-identical with itself . . . the excess which operates
in the series of numbers" is also named "the subject" (1977, 32). That pure
negative in the Real corresponds to the subject whose empty excessiveness
is and is *real,* but can also be *sutured* into the chain of discourse through
his very act of suturing the Real into the Symbolic. Put another way, the
subject is fundamentally unrepresentable excess, but it turns into the subject
of representation by becoming nothing but the effect of the signifier that
functions as his representative. The subject's relation to the signifying chain
is therefore "a circular, though non-reciprocal, relation," and this also par-
takes of asymmetrical mutuality, which now occurs between the subject and
the symbolic Other invented by himself. The plus sign (+) between signifiers,
which marks their succession constituting the symbolic order, is in this sense
"a sign, no longer of addition, but of that summation of the subject in the
field of the Other, which calls for its annulment" (34). The subject's suture
into the Symbolic, in a word, subjectification, inevitably entails the division
or alienation of the subject from itself.

The case becomes complex when it comes to the cinematic signifier. This
visual discourse is spoken by the director (enunciator) and given to the spec-
tator (addressee), but the director is hardly identified as 'the speaking subject'
(enunciative subject) and only passes himself off as 'the subject of the speech'
(diegetic subject), namely a character.[10] From the spectator's perspective,
as examined before, the invisible speaking subject is de-subjectified as the
Absent One. But to borrow Jean-Pierre Oudart's expression, the diegetic
"filmic field" of "signifying Sum" appears like a "finger" that indicates, and
perhaps even visualizes, this absent unsignified enunciator.[11] Remarkable is

Oudart's sudden rephrasing of the relationship between diegesis and its outside as "the antinomy of reading and *jouissance*" (1977, 36)—undoubtedly *jouissance* as excessive pleasure implies the unrepresented realm of the Real outside the readable boundary. Here, I suspect that this fusion of semiotic and psychoanalytic terms might have led to Žižek's confusion of the intradiegetic traumatic Real and the extradiegetic enunciative Real, if we insist on this word. Conversely, it is notable that neither the intradiegetic difference between ordinary reality and the traumatic Real nor the term Real itself had been seriously at issue in film theory until Žižek's intervention.

When Daniel Dayan calls suture "the tutor-code of classical cinema," he seemingly wards off the psychoanalytic pitfall (though definitely adopting Lacan) and drives off in the direction of ideology critique based on semiotics. For Dayan, the shot/reverse shot is the basic suturing unit in which a shot becomes the signified of the preceding shot and a signifier of the next shot; it 'retroactively' organizes the signified and 'anticipatorily' organizes the signifier. As a result, the film presents itself as "a product without a producer, a discourse without an origin" in which "things speak for themselves and, of course, they tell the truth." By this naturalized process of the image becoming obvious, classical cinema operates as "the ventriloquist of ideology" (Dayan 1974, 31). No doubt the ventriloquist of this Dayan text is Louis Althusser, whose concept of "interpellation" as "hailing" now sounds highly cinematic: when turning to a policeman who hails him, an individual become a *subject* "by this mere one-hundred-and-eighty-degree physical conversion" (Althusser 1971, 174–175), just as a reverse shot responds to the previous shot. As such an organic part of every social totality, ideology embodies our 'imaginary,' that is, spontaneous and transparent relation to reality.

Defining the classical economy of film as dialectic, organic, and structural, Stephen Heath expands the range of suture from the shot/reverse-shot unit to narrativization, the whole symbolic process of the "perpetual retotalization of the imaginary." As the excessive foundation of this process is continuously sutured in a film, the spectator's subjectification, that is, the subject's "construction-reconstruction" is always renewed (1981, 53–54, 62). This way the subject gains *meaning* at the expense of *being; being* is sutured into meaning.

While suture turns out to be instrumental to the cinema as an ideological apparatus that sustains perceptual/signifying mechanism, thereby naturalizing myths of the modern society—the often bourgeois *modus vivendi* with regard to desire, morality, behavior, and so forth—the theory of the suture turns into the critique of the suture. Subsequently, attention is drawn to alternative films that disturb the enclosed suture system: Oudart examines *The Trial of Joan of Arc* (Robert Bresson, 1962), Dayan *Wind from the East* (Jean-Luc Godard, 1970), and Heath looks at *Death by Hanging* (Oshima Nagisa, 1968), among many others. And yet, I argue, these film examples without interface do not seem nearly as 'desuturing' as even the classic 'interface-painting' that Dayan mentions via Foucault (and Žižek mentions

via Dayan): Diego Velázquez's *Las Meninas* (1656). In the middle of its background, the small mirror that reflects the otherwise unseen royal couple represents the reverse shot of the painting itself (Dayan 1974, 26).[12] Kaja Silverman scarcely does better, though she throws into relief intriguing scenes from *Psycho* (Alfred Hitchcock, 1960) such as the final shot of Norman/ mother without a reverse shot, the opening shots invading the hotel from without, and a shot of money taking on a transcendental gaze at an oblivious Marion (1984, 208–211).

However, the question I pose is less how directly interfacial an image can be, than where the unseen begetter of the image is located and how it is relocated in theoretical frameworks. Post-Metzian enunciation theory gives a more specific answer in this regard. Rooted in the communication model, Francesco Casetti among others reveals the deictic elements of filmic discourse by formulating four cases of the shot in terms of how the speaking subject ("I"/enunciator-director) addresses the audience ("you"/addressee-spectator) through the subject of the speech ("he"/narrator-character) (1995, 118–139). This semiotics without psychoanalysis parses the naturalized cinematic utterance, exposing its enunciative grammar in a solid linguistic paradigm. When "interpellation," for example, is named for the case of the character directly looking at the camera ("a *you* installed opposite an *I* combined with a *he*"), what is at stake is neither ideology nor 'desuture'— the interface shot does not belong to Casetti's formulas—but a kind of communication accomplished through the negotiation between screen and spectator. In fact Casetti defines film as interface, "an actual *interface* between the world represented on the screen and the world in which the screen is nothing but one object among many." Organizing signifieds and orienting behaviors, this interface sets up the whole ambit of interpellation and interpretation. It is "a home in which to dwell (the hypothetical *you* becomes a factual *you*) and a surface from which to spring (once seized, the *you* can become *I*)" (129–133). Furthered in Casetti's later, larger work (2002), this approach discerns and connects the diegetic and enunciative situations clearly in terms of social spectatorship, so that it has offered an otherwise overlooked theoretical framework for further empirical reception studies.

This kind of interface is, however, presumed to be a single contact zone between fictional and real spaces, a generic notion of a meeting or switch point. It is thus less medium specific than the onscreen cinematic interface as a multipliable contact surface that convolutes subjectivity into its own inner dimension. Casetti also addresses conditions of visibility, but by "symmetrically superimposing the effective spectator upon the ideal spectator" (1995, 132). The asymmetrical condition of visibility whose interfaces can perplex even the ideal spectator is bracketed off. Then, as François Jost shows, further effort to locate and identify the filmic enunciator tends to result in explaining what the director's ultimate intention is, or how it is obfuscated by an unauthorized or polyphonic narrator (1995a, 164–180;

1995b, 181–191). The bottom line is that there is a subjective message to be delivered and deciphered, even if its enunciation takes on plurality. This line, however, does not take in the disequilibrium inherent in the cinematic interface, through which intradiegetic interfaciality permeates even extradiegetic subjectivity. And although no short circuit of semiotics and psychoanalysis occurs in this enunciation theory, it would not mean they should be separated from each other.

Despite that short circuit, Žižek's interface enables us to spotlight intradiegetic externality as the hinge between diegesis and enunciation, and it is in this regard that Metz could still appeal to us. Finding deictic elements of "I-HERE-NOW" to be less applicable to the cinema—given that enunciator and addressee, or recording and projection are multiply separated and mediated in film—Metz claims that cinematic enunciation rather lies in the (self-) reflexivity of the film that performs "the semiological act by which some parts of a text talk to us about this text as an act" (1995, 146). His dizzying example is *81/2* (Federico Fellini, 1963) as a double mirror construction: it is a film about a film that is also about the cinema, and a film about a director who reflects himself onto his film (230). This meta-filmic device that creates a sort of mise-en-abyme structure lets us shed more light on the multilayeredness of the diegesis, if not on the interface per se. But instead of expanding discussion to the archetypical modernist motif of reflexivity in general, I propose to move from this macro-architectural level of meta-filmic enunciation to its concretely visual level, an underlying micro-layer of interfaciality in a way of renewing the issue of reflexivity from a post-Žižekian perspective on suture. So I ask: How does a film interface (us) with itself materially, and with its materiality?

PHOTOGRAMMATOLOGY AND NARRATOGRAPHY

For another suture theory that would answer this question, let me first quote Dayan again with my emphases. He says: "The *cinematographic level* fools the spectator by connecting him to the *fictional level* rather than to the *filmic level*" (1974, 31). These three levels may provoke a terminological confusion when compared to Oudart's aforementioned dichotomy, because Dayan's "filmic level" refers to Oudart's "Absent One" (enunciation) whereas Oudart's "filmic field" is closer to Dayan's "fictional level" (diegesis). But the level to which I call attention is that which is left alone, the "cinematographic" one.[13] It seems to mean the primary phenomenological aspect of the screen that appeals to sensation and perception prior to being subsumed into the narrativized "fictional level" for interpretation and understanding.

At this point the cinematographic invokes the "cinematic" as one of Garrett Stewart's three axes of the cinema, which definitely fits my division of the cinematic apparatus into three interfaces: the *photographic* (camera),

the *filmic* (filmstrip), and the *cinematic* (screen). Crucial is the distinction between the "filmic" material base, that is, frames on the strip, and the "cinematic" experience, that is, framed images on the screen, given that this filmic aspect was little illuminated in suture theory (Stewart 1999, 3 and 342). Dayan's "filmic level" instead concerns Stewart's "photographic" situation—the enunciative situation in which the director shoots a film with people and things, and which could thus better be called 'profilmic' as opposed to filmic. In fact, any enunciative realm in suture theory has operated between camera and screen and not between filmstrip and screen. What has never been tackled up in terms of suture is what Stewart calls *photosynthesis:* the synthetic perceptual process of our vision that fills in the subliminal blank between single photographic imprints on the celluloid strip, namely photograms. Photosynthesis may then suggest another niche of suturing mechanism, a suture occurring in the most materialist and medium-specific manner. There are only blinks and blanks between photograms on the filmic surface of the signifier of Absence, but on screen, we see "the plus or pulse between (the additive difference)—in other words, the supplement, awaiting the supple mentation of cognitive receipt." So this photosynthetic suture heals a gash between staccato images and effaces the flickering seam "between photographic input and cinematic output." That is, the filmic apparatus erases the photogram and appears as cinema (17–24).[14] It is no coincidence that Miller expressed a similar idea long ago, describing the subject as a "flickering in eclipses" like the movement that opens and closes the chain of numbers, that is, the continual movement of delivering up the lack in the form of a number in order to abolish it in the successor (1977, 34).[15] But if the old suture theory applied this flickering succession to the chain of shots, Stewart's version steps back to the chain of frames though he does not formulate photosynthesis in terms of suture.

'Desuture' would then occur when the cinematic effect of slick motion is debunked by the onscreen surfacing of the filmic trace. Stewart's deconstructionist term *photogrammatology* aims at nothing less than the meta-photosynthetic or counter-photosynthetic search for photogrammatic tropes of stillness that recall "the death-in-life of the cinematic continuum, the negative imprint of its own momentum" (1999, 39). Among such "synecdochic" tropes of the cinematic relation to photography are the photopan, that is, the pan over onscreen photos, and the freeze frame as stop-action image. While the former performs "picturing a picture" (cognate grammar) within diegesis, the latter insinuates "a film picturing itself" (reflexive grammar) through enunciation—an enunciation that exposes not the communicative track between *I* and *you* as in Casetti, but the material track behind and beneath screen effects. Stewart makes every effort to emphasize the importance of the filmic in his criticism of established theories that relate only to the cinematic. Unlike Bordwell's stylistics of visual techniques or the (Metzian) hermeneutics of media's reflexivity, photogrammatology unearths the medium-specific materialized textuality underneath style or

narrative. Unlike Barthes's photogram as the matrix of the *third meaning* that is less seizable in motion than in stillness, Stewart's photogram is a "subsignifying unit," full of no meaning in its own invisibility, which turns into an iconic sign only when "stirred forward" from the photographic into the filmic toward the cinematic (342).[16]

If the photopan 'represents' the interface of film (photogram) to characters and spectators at once, the freeze 'reveals' it only to spectators. The same revelation also occurs through a variety of special effects or tricks that rip, wrinkle, or reshape time such as lap dissolve, superimposition, and jump cuts. While these are still cinematographic techniques that tantalizingly expose the infrastructure of the cinema, some avant-garde filmmakers drastically exfoliate it by stripping the filmstrip down to its bare materiality which is rubbed, scarred, painted, encased, flashed, affixed to, and so on; suffice it to recall Stan Brakhage's handwork of sticking moth wings to the adhesive editing tape, George Landow's deframing/reframing of hypermediated screen strip, or Paul Sharits's epileptic flickering of negative print surfaces.[17] Furthermore, a certain 'cinema of ruins' in the found-footage tradition presents itself as ruins rather than representing ruins. Bill Morrison's reprints of decayed early films, for instance, visualize how time has inscribed natural distortion onto the filmstrip like *Light is Calling* (2004), an optical reprinting of a scene from *The Bells* (James Young, 1926). What Stewart calls the "apocalyptic disclosure" of the photogram occurs not by freezing time, but by redeeming dead celluloid—a redemption that paradoxically proves the film's fatal end, the most materialistic, biochemical, and even organic death, or rather, the mortal life of the inorganic film.

Nevertheless, going to the extreme in this direction might only lead to a dead end of the cinema, given that "a gallery exhibition of motionless frames is like a museum case of pinned butterflies: lovely but dead" (Cubitt 2004, 35).[18] As Cubitt claims, the zero (time) should be viewed not as the discharged void or at best the static copresence of all times, but as the radical nonidentity, relational difference, mobile instability that activates and perpetuates the movement of photograms. What Cubitt calls "the cinema effect" is the "cinematic" for Stewart, the very essence of the onscreen moving image that is always otherwise by renewing narrative space. Thus, it may be worthwhile to shed more critical light on Stewart's 'filmic effect.' At first, he seems to endorse the narrative film perhaps because desuturing moments, which remain less dominant than sporadic, rather efficiently insinuate the dominant mechanism of human consciousness without destroying it in avant-garde ways. Its mechanism is that "a suppressed level of machination whose very suppression, and by the automatism itself, serves the purpose of a realized—and realistically invested—subjectivity in the act of reception" (1999, 35). We perceive the screen image as if natural, by automatically suppressing the stillness of and interstices between photograms on the strip. This primary level of suture easily expands to its higher (classical) level on which our act of reception incorporates not only the perception of the cinematic

'effect,' but also the comprehension of the cinematic 'event.' Put differently, cinema should let us glimpse that it is the suppressive mobilization of photography through the double step of, above all, suturing the 'strip' in stillness into the 'story' in motion, and only then, desuturing the latter back into the former. Desuture, by definition, works only as an ephemeral agency that deconstructs its precondition, that is, the eternal structure of suture. Stewart calls on Heath's acknowledgment of suture as inevitable narrativization, yet differs from his search for the so-called narrative avant-garde as alternative.[19] Stewart persistently looks into more 'commercial' films whose suture is more airtight, and thereby minutely digs out how their narrative crises are expressed through stylistic effects entailing medium-specific desuture. What he suggests by *narratography* is a new methodology that combines narratology, stylistics, and media archeology, aiming to fill in the lack of media studies' hermeneutic engagement in narrative, that is, the lack of the poetic interpretation of narrative moments in relation to media effects.

However, I note, Stewart struggles against semiotic or psychoanalytic hermeneutics and suture theory because of their linguistic paradigm that overlooks its basis, the medium. This does not mean simply to deny the formalist/ structuralist narratologies developed by Genette, Todorov, Bordwell, and so forth; rather, Stewart's narratographic goal is synthetically to incorporate them into the study of narrative's stylistic materialization, its inscription on graphic/grammatological effects, either lexical or filmic or (now) electronic.[20] To update the old terminology, he first adopts that of Michael Riffaterre, especially the triad of *subtext-matrix-model:* "the iteration of an atemporal 'subtext' beneath the forward movement of narrative is generated from the always unsaid 'given' (or 'matrix') of the text by the founding appearance of the 'model'—often, in our terms for cinema, a liminal shot." Rather than the contrast of story (*fabula*) versus plot (*syuzhet*), what matters is the Freudian *après-coup* through which initial traces of a phantom matrix, a first cause of visual material, are swept from narrative until reemerging as subtextual variations on a repressed yet returning theme (Stewart 2007, 61–64). In *Caché*, this deferred action of the matrix, the past trauma, takes the visual form of the video interface whose reticent recurrence manifests a subtext that invades narrative time all over again from the opening "liminal shot" or "model shot." In a sense Stewart's analysis of film beginnings evokes Thierry Kuntzel's memorable reading of figures, especially the door knocker that opens *The Most Dangerous Game* (Ernest B. Schoedsack and Irving Pichel, 1932). The film's paradigmatic constellations of the centaur, the arrow, and the virgin are 'condensed' at the outset as semic clusters later 'displaced' through the syntactic repetition of "working through." Fully charged with poststructuralism, Kuntzel's shot-by-shot dissection à la Barthes's *S/Z* illuminates how this initial figuration of a latent text undergoes *différance* in its manifest text (Kuntzel 1980, 6–69; Rodowick 2001, 80–89). For Stewart, the subtext is nothing other than the recursive, disseminated manifestation of that hidden unconscious which structures a narrative.

Nonetheless, again, Stewart's intervention focuses on the model shot as a pathway to the inscriptive stratum of the medium, the stratum he examines less for some deconstructionist writing than for the visual's materialization. *Caché*'s model shot does not appear to be seen on a TV monitor, that is, the opening shot does not turn out to be video, until we see the horizontal striations of fast-forward and rewind functions. Undecided between narrative film and surveillance video, the ongoing subtext of this interface not only replays the diegetic past, but also is graphically replayed via access to the subunits of the moving image. Thus, the spectator's use of a remote control, taken by the character in *Caché,* becomes part of the film's plot itself (Stewart 2007, 195–197). But I would add one more narratographic element: the model shot in stillness starts with the film credits appearing word by word, line by line, as if they were being written, and given that the negative format of *Caché* is HDTV—although most people don't know and notice the format difference—this inscriptive surface not only interfaces the cinematic with the filmic, but also, in theory, renders the filmic itself materially ambiguous; it resembles a sheet of paper, functions as a videotape, and works digitally. So those horizontal striations are fake video traces created by the digital apparatus, whose unit is no longer the photogram but the pixel, whose temporality is no longer the segmental and mechanical transition from frame to frame, but the fragmental and electronic transformation within the frame. Unlike filmic "seriality," as Stewart points out, this postfilmic "pixilation" has no material gap between one pixiliated state of the image and another, as rewinding a DVD exposes no lines (2–4). In this sense, *Caché* is like a digital simulation of the traumatic past whose analog (?) traces or deferred gaps are basically not allowed to appear in the digital age.[21]

There seems another notable implication of Stewart's impulse toward the filmic (including the digital) as opposed to the cinematic. It is that the narratographic shift occurs from semiotic psychoanalysis on the content of the image to physiological psychology on the perception of the image. The 'depth model' of psychoanalytic topology would then work less hermeneutically between narrative and subtext than materially between the screen image for natural perception and the underneath strip for a different perception; perception is double layered. Proposing a potential revision of Walter Benjamin, Stewart argues that Benjamin's notion of "the optical unconscious" would be not the underside of the phenomenal world as Rosalind Krauss would have it, but that of its visual cognition. That is, it would function as the "pre- or sub-conscious" of perception, a "perception that passes away without recognition—but that passes nonetheless into cognitive experience" (Stewart 1999, 111–114). Below natural perception that enables the conscious recognition of the cinematic effect, a preconscious perception of the filmic material still cognitively lurks and works while (not repressed by the psyche but) suppressed by the cinematic apparatus. Kuntzel's two keywords that account for the figuration/narration of a film text could be taken here to account for the projection of photograms: their slick "condensation" and

swift "displacement" enable natural perception. Then, desuturing moments like freezes may embody what Benjamin thought photography (not the human eye) could do: capture the optical unconscious and arrest preconscious perception such that we become conscious of it.

In short, we now return to the issue of perception examined in the introduction. Miller's notion of subjectivity as "flickering in eclipses" might then appear to resonate with Freud's notion of perception as the "flickering up and fading away" of consciousness (in its tolerance for impressions stored in memory, the unconscious). As Conrad's *The Flicker* (1966) visualizes in an extreme manner, this flickering intermittence, the rapid periodic detachment of the top layer of the Mystic Writing Pad, is similar to "the on/off pulsional transit between film and screen" (Stewart 1999, 127; Doane 2002, 43). Thus, Freud's consciousness perception in its rigorous sense of automatic protection against, or selection and deletion of, external stimuli may be closer to Benjamin's preconscious perception or Henri Bergson's pure perception. What Freud's term seems to incorporate without specification is Benjamin's natural perception or Bergson's actual perception which is, however instantly, memory contracted. And yet questions remain. Is this perceptual grounding all that Stewart's meticulous anatomy 'arrests'? Is it what he ultimately catches and stops at? For all his reevaluation and rhetorical bravura, do photogrammatology and narratography not drive all cinematic experience toward the impasse of the unseen filmic? It would be as if a methodological death drive drove the cinematic to death. However essential the apocalyptic disclosure of the filmic may be, we see a film not on the strip but on the screen, and we see not the screen but the world in the film. It is toward this world that the filmic and cinematic loop may need to be reconfigured.

PHOTOGRAM AS AFFECTIVE EFFECT OR (DE)SUTURING DIVIDUAL

To specify the reversal of the direction, I shift the focus from the medium-specific materialism to the immaterial involvement of the photogram in the world. This turn will call attention to the photogram's other function that is not stuck on the strip but maximizing the potential of the cinematic. Phenomenology and ontology offer a new set of terms here for a wider history of film theory and practice, which ultimately will help to rearrange different units and levels of interfaciality in terms of (de)suture.

The last point on the photogram deserves careful reconsideration via Benjamin. Unlike Stewart's revisionist distinction, Benjamin did not originally discern photographic from cinematic perception. Just as photography opens unconscious optics, so does cinema, even with more dynamic techniques. A familiar act like reaching for a lighter, though "we hardly know what really goes on between hand and metal, not to mention how this fluctuates with

our moods," can be mediated by the movie camera "with the resources of its lowerings and liftings, its interruptions and isolations, its extensions and accelerations, its enlargements and reductions" (1968a, 237; 1980, 203). In other words, the screen enables not just a clearer perception or greater knowledge of an event, but also a hidden possibility of seeing and feeling things differently than naturally given or overlooked. And such a new perceptual 'experience' is triggered by, say, a cinematic 'defamiliarization effect' that can increase less by freezing than by invigorating cinematic movement in duration. So the close-up reveals not merely details but new "structural formations of the subject" (e.g., its alienation from the context). Likewise, slow motion presents not simply accuracy but a certain estrangement of movement (e.g., "the effect of singularly gliding, floating, supernatural motions") (Benjamin 1968a, 236). Belonging neither to the world nor to its perception alone, the optical unconscious might come into being, I say, only as a phenomenological effect through a media-catalyzed perception of the world's potential. Therefore it could be redefined less as the ignored side of *being,* natural or human, than as the interfacing and interfaced *becoming* of this being, the effect of interfaciality that virtually reshapes the actual being. The photographic freeze would be not so much the crux of the optical unconscious as one mode of its revelation.

Not coincidentally, Benjamin's idea resonates with contemporaneous French film theory, despite certain differences. For Jean Epstein (1926), in particular, the camera endowed with inhuman analytical properties is the very defamiliarizing thus epiphanic eye that sees in the face, for example, a movement of the traits that humans, charged with sympathies and antipathies, habits and reflections, can no longer see. Full of close-ups and slow motion, his impressionist films including *The Fall of the House of Usher* (1928) attempt to render visible the immanent continuum and immeasurable mass of diverse forms of existence comprehending the human and the inhuman. He highlights à la Bergson the chiasmus between this matter world and its own spirituality, with the cinema reducing their differences to the limits of our senses (Epstein 1988a, 191–192). We experience this sensed intercourse of the unconscious (spirit) and the optic (matter) through the phenomenological effect actualized from their virtual continuity and communality—namely, interfaciality as the precondition of their being.

In this sense, the optical unconscious seems none other than the visual but virtual playground for *photogénie.* This elusive magic word evokes Deleuze in some of Epstein's fuzzy language. It is a "moral [spiritual] character" enhanced by filmic reproduction like Deleuze's *affect* (the impersonal quality or power of a possible sensation, feeling or idea); "a new leavening; dividend, divisor, and quotient" like Deleuze's *dividual* (neither indivisible nor divisible, but either divided or brought together by changing qualitatively) (Epstein 1988b, 243 and 314; Deleuze 1986, 98-99). Erotic and auratic, a photogenic moment usually occurs via a Deleuzian

differentiation of an image: its affective deviation from the larger chain of images, and its molecular proliferation within itself. Like Deleuze's "affection-image," a photogenic image momentarily halts narrative time space and then drops into another spatiotemporal dimension. It is this conceptual aspect of *photogénie* that leads us from the phenomenological to the ontological potential of the photogram. Taking Stewart's examples from a different perspective will be illuminating: at some point in *Persona* (Ingmar Bergman 1966), Elisabeth looks at a documentary photo of a Jewish boy in the Warsaw ghetto (fig. 1.8). This famous image then becomes detached from the narrative through a process of self-differentiation. The camera successively cuts in to its details as if to make a "protocinematic montage" (Stewart 1999, 76) of the real story between the boy, people, and the Nazis at a micro-diegetic level (fig. 1.9). What seems more important here than the apocalyptic materiality of photograms that break cinematic movement is the immaterial potential of the photogram as an affective dividual. This montage affectively and effectively connects the inset genocide to Elisabeth's infanticide by differentiating that photogram as a single set into its own potentially infinite subsets. This dividual is experienced, if not as phenomenological *photogénie* per se, then as a singularly differentiated cinematic effect as affect—what I would call *affective effect*.

Figure 1.8

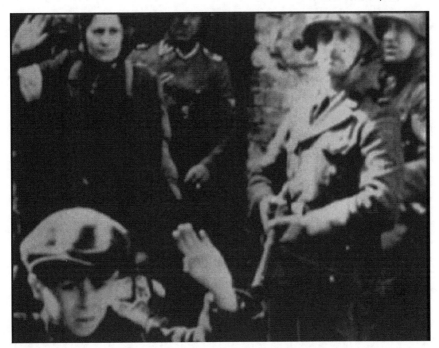

Figure 1.9

Godard uses the same Holocaust picture for an opposite type of montage in *Histoire(s) du cinema*.[22] In its last part, *Les Signes parmi nous* (1998), a still cut from *The Spiral Staircase* (Robert Siodmak, 1945) is followed by the Jewish boy. Siodmak's Hollywood thriller still retains German expressionist style with a candlelit dumb woman allegorizing a Jew-like minority, though he fled to America after making *Menschen am Sontag* (1930), which foreshadowed Nazi Germany. Then a rapid juxtaposition of enigmatic images: traumatic director Fassbinder, who is haunted by riders of *Siegfried* (Fritz Lang 1924), aphasic filmmaker Antonioni, whose gaze cuts to a bird-man in *Judex* (George Franju 1963). This montage peaks in the connection of grotesque *Nosferatu* (F. W. Murnau 1922), romantic *The Crowd* (King Vidor 1927), and provocative subtitles: "L'ennemi du public / le public" (fig. 1.10). This way Nosferatu becomes a multiple symbol, representing not only Hitler the dictator, but also Irving Thalberg the producer of *The Crowd*, indicated as Hollywood's big brother from the start of *Histoire(s) du cinema*, and who vampirized the 'public' (which turned into the 'public enemy' of film art), and synecdochecally Murnau himself (whose art was liquidated by those political and industrial vampires).[23] Offering all this information in his analysis of the film, Jacques Rancière affirms that decoding these figures is less important than the "surface effect" of this heterogeneous connection

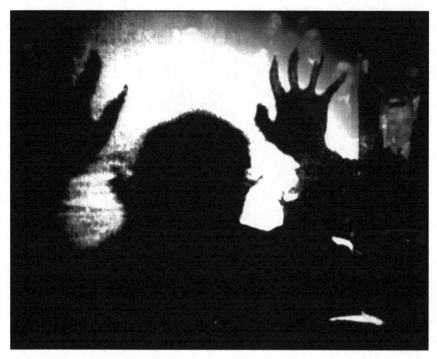

Figure 1.10

that nonetheless insinuates a common missing event: the Holocaust as the invisible kernel of all visual fragments. The traumatic catastrophe is thus, if not represented, still symptomatized in what Rancière names the "sentence-image," a chain of iconic images that hold both the singularity of each image and the discoursivity of a possible text (2007, 51–55). But what counts is that this cinematic parataxis moves us beyond phenomenological experience or semiotic interpretation, toward the unseen interstice, the nonimage as the ontological other of the image itself. Each photogram is not divided into its inner subsets, but (dis)joined with different others that emerge from and submerge into the unsutured, unsuturable Real. Hence the second case of the dividual, not divided but brought together; photograms express the qualitative change of the Whole not in infinite internalization (let's say, 'inward dividual') but in infinite externalization ('outward dividual'). Their open interrelations render the Whole ever changing.

A combination of these two modes of montage/dividual permeates Dziga Vertov's *The Man with a Movie Camera* (1929). In one example, the title role cameraman's shooting a speedy carriage suddenly comes to a halt, giving way to a bracketed two-minute deviation until the film returns to and reanimates the stilled carriage (fig. 1.11). This inserted virtual time unfolds as a relatively inward dividual; the freeze frame of the horse is followed by

Figure 1.11

a few other similar images of frozen people on the street and carriage, while the divided space maintaining still cohesive contiguity. But jumping to two unrelated images of a crowd and a woman, the dividual becomes outward, extending to the filmstrip and reel, whose rotation reignites screen movement. And even the editor appears to work on the strip with scissors, while some kids' cutout frames change into moving images taking up the entire screen (fig. 1.12). This "paralyzed time sequence" (Vertov's term) shifting between the filmic and cinematic levels then raises more issues than Stewart's movement/stillness dichotomy.[24] First, this self-reflexive documentary narrativizes a day of the modern Soviet as a quasi-diegetic space, whose double enunciation of photographing and editing also becomes part of the diegesis. And while the photographer is among the diegetic world of objects he shoots, the editing room partakes of intradiegetic externality which, though 'hidden,' prepares the diegetic images for the screen. Second, this convoluted bifurcation between enunciation and diegesis and within each of them takes place through onscreen interfaces, the camera and the filmstrip, the latter bringing up the question of (de)suture in a triple way: (1) the little girl's still frame desutures photosynthetic movement into which it is soon resutured (figs. 1.13–1.14); (2) the intradiegetic outside (workplace) is then resutured into the diegetic inside (outdoor space), but this process of suture-desuture-resuture continues as followed by another 'interface-photogram' and its full magnification in movement;[25] (3) the diegetic inside itself is desutured by many discontiguous photograms that pulverize it, rendering the dividual

Figure 1.12

Figure 1.13

outward. In short, these three cases indicate three levels of (de)suture exam-
ined via (1) Stewart, (2) Žižek, and (3) Heath. When setting off such a
multilayered montage of self-forking and self-switching diegesis/enuncia-
tion, the photogram could be called the unit of *(de)suturing dividual.*

Figure 1.14

CINEMA OR CHINESE BOXES OF INTERFACIALITY

With the notions of affective effect and (de)suturing dividual, I have elaborated on the inward and outward operations of Deleuze's dividual, which paves the way for getting out of Stewart's photogram. Since this dividual yields multidimensional diegesis, let me finally clarify a variety of (de)suture levels by returning to the issue of why narrative still matters. For instance, Stewart's photogrammatological analysis of *The 400 Blows* (François Truffaut, 1959) misses the hermeneutic possibility that the final freeze might allude to a metadiegetic shift, the unhappy boy's desire to stop the *now* for another time space in which he could live a new cinematic life, given that his movie going was an escape from reality. His frontal face at the end of the world then looks as though he encountered his future self who would belong to the intradiegetic (temporal) outside, or by extension, the extradiegetic director 'interpellating' his past self behind the camera like this: 'Poor boy, don't cry, you will be a filmmaker!' Autobiographical as the film is, this imaginable encounter between the diegetic and the enunciative subjects would not be over the top. Our hermeneutic engagement would thus help recognize and gaze into the function of this frozen photogram, the medium of enunciation. And it is in narrative film that the intradiegetic outside unknown to the character mediates between the spectator and the apparatus of the extradiegetic outside unknown to him.

In terms of interface, it is the 'intradiegetic interface' that draws the spectator's attention from the diegetic inside to the extradiegetic apparatus. And

given that the interface links the intradiegetic outside to extradiegesis in general, the latter includes not only the apparatus but also the movie theater. Then how could the onscreen interface function in the spectator's entrance to diegesis? It would be worthwhile thinking about the role of the diegetic interface from the character's viewpoint, this time, in a larger framework than the Gaze-eye structure. Remarkably, Stewart rephrased what Žižek had once called "inner montage" (Žižek 1991, 95) as "short-circuit" before Žižek theorized it. When the floor-level shot of Kane's death in *Citizen Kane* appears "as if a shot and its reverse shot were . . . sutured together in the same visual field," it presents "a violent short-circuiting of the look" (Stewart 1999, 166–167). In *Framed Time,* he directly refers to Žižek's "interface" and finds its examples in what he calls European uncanny films. Although he does not further theorize it, the interface on screen is somewhat described as the imaginary site for the uncanny Real that breaks up the symbolic narrative chain. That is, the interface is a fracturing contact point that convolutes the Imaginary, the Symbolic, and the Real at the same time. I am even tempted to match Riffaterre with Lacan, given that the interface functions like a "manifest model" (the Imaginary) through which a "recurrent subtext" (let's say, the sub-Symbolic) emerges from its "hidden matrix" (the Real)—this subtext would be a syntactically structured form of the Real, underlying main narrative in parallel. On the main narrative level (the Symbolic), Kuntzel's "figure" seems a classical prefigure of the interface, as Rodowick accounts for it as a "correspondence between three discursive registers—that of narrativity [I say, the Symbolic], of figural representation [the Imaginary], and of the enunciation of phantasy [the Real]—whose boundaries are mobile, permutable, and by no means distinct" (2001, 88). Figure is a superimposition of the Real-Imaginary-Symbolic.

Precinematic interfaces like a painting in many canons can serve as a classical guide. In *The Woman in the Window* (Fritz Lang, 1944), a woman's portrait in the window leads a professor to a long dream as a mise-en-abyme story. The point is, Žižek argues, not that his murder of a rival lover was just a dream and he is normal in reality, but that we all are murderers in our unconscious. He is not simply a bourgeois gentleman who might dream of killing, but deeply a killer who dreams of being a professor in reality. He wakes up to maintain his social reality, escaping from the Real of his desire staged only through the interfaced dream fantasy. So, ordinary reality turns out to be an illusion that depends on the repression of the Real, which can potentially tear apart that Symbolic web of reality (1991, 16–17). For another famous example, a man's murder of his wife staged across from Jeff's flat in *Rear Window* (Hitchcock, 1954) may be Jeff's own reflected fantasy of killing his girlfriend, the unconscious desire doubly resolved through the punishment of the murderer and Jeff's injury. This disguised Real comes through the triple cinematic interface: a quasi-camera (telescope) limiting the spectator's vision; a quasi-screen (the whole surface of the building) exhibiting a sort of spatial montage of diverse people; a quasi-filmstrip on

Figure 1.15

this multiple screen (the murder's flat shown through horizontally aligned windows with interstices) hiding the enigmatic event—this type of quasi-interface will be fully examined in Chapter 3 (fig. 1.15). Needless to say Jeff the voyeur stands for the moviegoer, sitting in the dark, being immobile, 'glancing' over others in his anonymity, while unconsciously 'gazing' into the rear side of his own psyche.[26]

The crux of narrative film lies in such a congruency between diegetic and extradiegetic subjects often channeled through interfaces. After setting up an ordinary platform of the Symbolic, a film stages an Imaginary fantasy that lures these subjects into the Real where their desire and danger reside. It is not that the subject always wants to avert the Real, but rather that "it is only through fantasy that the subject is constituted as desiring" (Žižek 1991, 6; also Cowie 1997, 123–165). An onscreen interface is a pathway toward this fantasy as structurally required in narrative film. And if we further the metaphorical generalization of interfaciality, the intradiegetic fantasy as a whole could be called an expanded form of interface. Moreover, though often sounding clichéd, film as a whole is nothing but a fantasy that constitutes the spectator as a desiring subject. Hence, interfaciality proliferates in self-reflexive and self-encompassing ways between the strictly material interface, the fantasy interfacing with the intradiegetic outside, and the film as a fantastic interface installed in our social reality—the latter is not far from Casetti's interface. The specific interface per se then sutures one shot to another, and thereby desutures the shot/reverse-shot structure; fantasy sutures the character into the intradiegetic outside, thereby desuturing the diegetic inside; film sutures the spectator into the entire diegesis, thereby desuturing one's sense of reality boundary. Interface is materially intensive,

while interfaciality is immaterially extensive. The cinema unfolds like Chinese boxes of interfaciality, and in each of these boxes, the (de)suturing dividual interfaces the inside with the outside in *asymmetrical mutuality*. Therefore, it is at every cinematic level, from the smallest photogram to the full film as such, that we confirm this key principle of the chapter.

"I AM AN INTERFACE BEFORE I HAVE AN INTERFACE"

Now, before moving further, I find it necessary to check the unnoticed presumption that has underlain all my arguments. It is that the interface appears outside of the subject and connects different dimensions of the image (diegesis, enunciation) or of the subject (reality, the Real). The final turn in interfaciality will take place not between such concatenated zones as are anyhow detached from the subject, but from the outside to the inside of subjectivity. It will then lead beyond narrative, not toward a larger social block including the movie theater, but toward the world and the subject as such even without any explicit interface between them, because subjectivity itself will turn out to be equipped with interfaciality. What is needed is then not sociology but ontology.

To begin with, I go back to the initial interface of photogram once more and revisit Stewart's criticism of Deleuze. Reversing Deleuze's critique of Bergson who criticized the cinema for only constructing mechanistic movement through immobile sections, that is, photograms, Stewart argues that only Bergson, by the same token, gave proper attention to the filmic material, whereas Deleuze too quickly turned toward cinematic effect for his "new semiotized phenomenology," a Peircean taxonomy of audiovisual signs unfurled on the Cavellian phenomenological frame (1999, 72). In this "resolutely phenomenalist approach," movement means that of the image plane sectioning space and not the plane strip of image sections. Likewise, time concerns just the content of the shot or between shots, that is, "a [diegetic] sheet of the past" and not "a [photogrammatic] sheet of the present" (141–146). As Raymond Bellour points out, Deleuze's taxonomy excludes the photographic time of *privileged instants* captured in stillness that counter the cinematic movement image composed of *any-instant-whatevers*. Even *time-image* implies more aberrant movement and not the interruption of time, its arrest. But insofar as the pause on/in an image does not stop the automatic progression of photograms, Bellour (and his book title *L'entre-images*) suggests, any frozen moment on screen may be "just a privileged instant *among others*, that is, any-instant-whatever" (my emphasis). Neither photographic nor cinematic per se, such cinematic emergence of the photographic may thus reveal another core of cinematic time and movement as engaged in the contradictory coalition of two media (2002, 110–115).[27] In fact, appreciating Bellour's earlier study on the freeze, Stewart regards the freeze as a unique intersection, "the negative asymptote of the movement-image and the time-image together." If tracking (the movement of the

camera) and montage as editing (the movement between shots) expanded the cinematic movement from within a fixed single shot—seemingly the only cinematic form for Bergson—to the open Whole as Deleuze says, Stewart bases any onscreen movements back on the movement of the unseen track as their material matrix and seems to find the freeze to be the prototype of any form of onscreen desuture (1999, 147–148).

The question I wish to explore is to what degree Deleuze is stuck on the phenomenological screen. His major term *plane of immanence,* as Stewart describes it, might sound like the phenomenological "screen rectangle" that immediately dissolves its artificiality into "the flows of motion intersecting it from every angle—even from the multiple axes of time itself." And yet rigorously, the notion refers beyond *phenomenon* to *noumenon,* to the invisible plane of flowing matter and multiple time, the whole of which the screen rectangle cannot contain but only partially actualize. Beyond the screen is the immanent Whole that is virtually unlimited and qualitatively changeable. As mentioned earlier, Bergson denigrated the cinema because of its failure to represent "a duration which is immanent to the whole universe, which is no longer a set and does not belong to the order of the visible." For him the cinema seemed to offer only the phenomenological illusion of natural perception that elicits the sense of movement from combined immobile sections, that is, mathematical units within the closed set of a fixed single shot (Deleuze 1986, 20 and 1–11).[28] But this closed system of the intra-frame movement of objects is desutured by the two other cinematic movements of tracking and montage, according to Deleuze, the very two techniques that also contributed to classical suture in Heath. No contradiction, however: the invisible out of field is sutured into narrative space, while the same dynamics always renews this visible realm and changes its whole quality in invisible duration. Though established between the parts of each system and between systems, the movement "stirs them all up together and subjects them all to the condition which prevents them from being absolutely closed." Put simply, what is sutured desutures what has been sutured. Deleuze's out of field is therefore neither Bazin/Burch's diegetic outside nor Bonitzer's blinded enunciative field (see note 2); nor is it Žižek's intradiegetic outside nor Stewart's enunciative material. The plane of immanence is a Deleuzian Real as the Virtual, the radical but immanent Elsewhere to all images, their infinite set in which pure images exist in themselves and are assembled into a movement image as a *machinic* "mobile section" instead of *mechanic* immobile sections (58–60).[29] Where the parts and their sets enter into continuities and breaks as mechanical (dis)connections, the Whole intervenes as an Opening of "false continuity [*faux raccord*]," the most fundamental continuum of matter that is sensed only through interstices between mechanical parts and/or sets. We cannot see "this white on white which is impossible to film" (28)—this Carl Dreyer quote by Deleuze may imply that the immanent thus "white" plane as sensed only through interstices cannot be filmed on the "white" visible screen.

In short, machinic ontology cannot be reduced to mechanical phenomenology. Deleuze regards phenomenology as basically centered on natural perception related to existential coordinates that 'anchor' the perceiving subject in the world. For this Husserlian subject, all consciousness is consciousness *of* something; consciousness is like "a beam of light" that draws things out of their native darkness (56).[30] On the contrary, Bergson's first interest is not perception but flowing matter with no anchorage point.

> Things are luminous by themselves without anything illuminating them: all consciousness *is* something . . . a consciousness by right [*en droit*], which is diffused everywhere and yet does not reveal its source [*ne se révèle pas*]: it is indeed a photo which has already been taken and shot in all things and for all points, but which is 'translucent' . . . it is not consciousness which is light, it is the set of images, or the light, which is consciousness, immanent to matter. (Deleuze 1986, 64; see also Bergson 1990, 31–32)

Everything photographs everything else in this plane of immanence, leaving no visible trace of bodies or rigid lines. Only lines or figures of pure light exist as images in themselves in matter without appearing for anyone (eye) but ceaselessly receiving and emitting images at every molecular moment. Thus, light, image, matter, and movement are the same by nature. This pure light, as Sartre puts it in terms of phosphorescence, becomes actually phenomenal, "only by reflecting off certain surfaces which serve simultaneously as the screen for other luminous zones" (1962, 39–40)—Deleuze pinpoints the similarity between Bergson and Sartre, though Sartre's phenomenology ultimately subsumes the image to consciousness. Nothing appears to the eye until light is reflected or stopped; a de facto consciousness is only constituted at and by such a "black screen," namely, *a center of indetermination* like our eye/body that perceives, that is, selects and deletes images and reacts to them by action. The commonsense is reversed, as in Lacan: not that light goes from the conscious subject to the thing, but that a luminosity goes from the thing to the subject. However, Lacan is also reversed. In Bergson, the 'image' is not the subjective suture of an object from the geometral point, but the way everything exists and appears in itself. The 'screen' is not the objective disguise of the point of light, but the subjective system of processing the light.

More importantly, this screen can be not just an interface suturing the Gaze in front of, thus, outside of the eye, but the eye itself as a sutured Gaze if we take the Gaze as that luminosity. Since the virtual state of the eye is in things that are luminous images in themselves, photography is already snapped "in the very interior of things and for all the points of space" (Deleuze 1986, 61). This eye image is a camera only insofar as it is a screen in its most passive sense; its shooting is nothing but receiving images with their refraction, retention, and reflection even at an instant. An organically

actualized form of this virtual interface is the eye, a "point of origin for the attention to life" that characterizes livingness (Burt 2006, 157–179). As Italo Calvino beautifully figures in one of his Bergsonian short stories, the eye as an organ comes into being through the evolutionary desire or efforts to respond to the visible, to all others' images, that is, their potential yet inorganic eyes (1968, 141–153). Actively pursuing and capturing images, it becomes a perceptual interface now found within our body, while the rest of the body operates not only for action (by its exteriority), but also as a black screen (in its interiority) that retains images during a variable degree of interval between perception and action, thereby causing affection. To borrow Deleuze's formula, light-image-matter-movement is replaced by *action* with the idea of a direction (verbs), by *affection* with that of a state (adjectives), by *perception* with that of an object (nouns). It is sutured into action-/affection-/perception-images by our body, a subjective organism that is a sensorimotor system. But this subject system is also part of objects, an organic interface among inorganic interfaces. Hence our Lacanian conclusion ('I am photographed before I photograph') can be reshaped like this: 'I (eye) *am* an interface before I *have* an interface'—*interfaciality immanent in subjectivity.*

If cinema can draw close to the world and perception (like phenomenology) without anchoring the subject and the horizon of the world (unlike phenomenology)—Deleuze says that this is the ambivalence of cinema for phenomenologists (1986, 57–58)—Vertov seems to visualize the best cinematic shift from mechanical phenomenology to machinic ontology. Remarkable is the last part of *The Man with a Movie Camera* in which the film's earlier parts are projected in a theater within the film. It starts with the cameraman on a motorcycle, first framed by a small screen on screen, then by the film's whole screen (fig. 1.16). Compared to the filmstrip image and its magnification examined before (figs. 1.13–1.14), the intradiegetic outside now changes from the editing room to the theater, a receptive rather than enunciative space, while the diegetic inside still comprises the enunciative subject (cameraman) and diegetic objects. But later the editor appears again, convoluting Metz's double mirroring to the extreme: a film within the film is shot, edited, screened simultaneously to be the very framing film through rapid shifts between the photographic, filmic, and cinematic interfaces on screen. Here, I see less the Chinese boxes of interfaciality than the dizzy dispersion of interfacial sectors, and less their hierarchical framings than infinite disseminations of the primary (de)suture equally found in every sector—the world is directly sutured into the eye and desutured from the eye, even before the mediation of material interfaces. When a spectator's eye sees a carriage and this unit of shot and reverse shot proliferates with other vehicles like a car, a motorcycle, and a tram, the vision gradually dissolves into the movement in matter (figs. 1.17–1.18). A train windows passing on the screen, then, not only looks like photograms, but even insinuates the state of things being blurred in this movement. And yet the extreme

Figure 1.16

Figure 1.17

movement would be rather unrecognizable, always already immanent to all molecular images at every molecular moment. The camera eye emerges from such images residing in the infinitesimal as well as utmost movement (fig. 1.19). So does the editor's eye gazing into ungraspable photograms on

Figure 1.18

Figure 1.19

the strip, which is matched with a typical Vertov shot of unstoppable wheels on the railroad. Meanwhile, varied shots of 'every molecular eye' are regularly inserted. Extreme close-ups of a singular eye and extreme long shots of multiple eyes alternate in this accelerated parallel montage, including

an inhuman eye like a pendulum and the multitude of spectators. Then, light, perhaps symbolizing less human consciousness than primordial image matter in movement, is sutured into the eye—the primordial interface with which an artificial interface, the camera's iris, merges as if they were one and the same (figs. 1.20–1.21).

Figure 1.20

Figure 1.21

In brief, manifold suturing effects caused by multiple onscreen interfaces ultimately lead to the ubiquity of the primary suture: the birth of the eye out of the Gaze that is none other than a multitude of potential inorganic eyes, of luminous but invisible images in movement matter. Vertov daringly visualizes this phenomenological ontology (even unawares to himself). *The Man with a Movie Camera* might not be simply about his poetic revolution of "Kino-Eye" as a new vision machine that runs through the Benjaminian optical unconscious and connects all corners of a futuristic Marxist utopia. This modernist paradigm underlies the McLuhanian idea of media as extensions of human senses, which reads that any interface is basically prosthetic.[31] But I propose that the camera in this film may not just represent an instrumental interface enabling a better look into or over the world, but allegorize that the naked eye is an 'embodied' interface embedded in the world. My question is how the asubjective Gaze is sutured not into an objective interface *for* the subjective eye, but into the subjective eye *as* an immanent interface endowed with the framing function in the middle of unframed matter. The eye in matter becomes a kino-eye, inhuman others' eyes beget my eye; *asymmetrical mutuality* works between the former and the latter. Conversely, the organic/mechanic kino-eye's iris interfaces with its desutured plane of inorganic/machinic eye-less eyes. Everything is interfacially pulverized there before becoming a material interface that discerns the subject from the object. If subconscious perception is like a flickering effect, it is because everything interfaces with everything else at such atomic intervals and this interfacing is sutured into our subvision. In brief, the process of not simply exploring but rearticulating all previous theories of interface has been made along this line: from the Lacanian interface as 'image-screen' between the subject and the world, through Stewart's dichotomy of stillness and movement within the material interface, toward the interfaciality of subjectivity, the interfacial becoming of the world into the subject. Onscreen interfaces bring this truth: interface is still suture, but at base, it is our eye.

THE INTERFACIAL HIDE-AND-SEEK BETWEEN SUTURE AND DESUTURE

From the question "why interface on screen?" I have traversed a variety of film theories that engage in diverse levels of suture and its relation to interface. The final turn derived from the Bergson-Deleuze ontology is, however, not the definitive conclusion, though it helps see how interfaciality can be broadly relocated from the outside to the inside of subjectivity with asymmetrical mutuality being still its inner quality. This new interfaciality is based no longer on the triad (Gaze/interface/eye) but on the dyad (matter/interface = eye), and seems to have more significance in that such an imbalanced dualism between the unlimited, unconditioned, unrepresented and its sutured form or suturing interface can reframe many other conceptual operations: from Kant ("noumenon"/"phenomenon") to Lévinas ("infinity"/"totality"),

from Freud ("the unconscious"/"consciousness") to late Merleau-Ponty ("the invisible"/"the visible"). Poststructuralism abounds with similar variations of the asymmetrical pair of terms that more or less evoke the Real versus the Symbolic: Bataille's "general economy"/"restricted economy," Lyotard's "figure"/"discourse," Barthes's "*signifiance*"/"signification," "writable"/"legible," "*punctum*"/"*studium,*" and so forth. In terms of systems theory, all suturing "systems" (*digital*) organize themselves by constraining the "environment" (*analog*), the floating continuum that threatens stable intelligibility.[32] Moreover, the overall sense of the suture mechanism underlies such explicitly symmetrical but implicitly hierarchical dichotomies as "speech" versus "writing." Derrida reveals that, though allegedly prior and superior to writing, speech also results from "archi-writing" as *différance* (pure delay and difference), which in my view is sutured into that dichotomy. Hence what really works is a nonoppositional, nondialectic asymmetry: speech versus writing/*différance* (1976, 141–164).[33] And this is actually the classical suture of reducing the essential difference between a system and its outside to a simple difference within the system. Likewise, for Deleuze, the traditional opposition of "identity" and "difference" cannot represent *difference-in-itself,* which is sutured as just one term of this dichotomy (1994).[34]

In conclusion, I suggest a few possible ways of applying this universal suture to film (theory). First, the basic formula of suture (A → a) enables us to locate a hidden reflexivity that operates in any asymmetrical conceptual replacement. For instance, as noted earlier, Deleuze takes Pasolini's free-indirect shot as just a special case of "solid perception" grounded on a geometric and physical vision (Schwartz 2005, 107–135). This semi-subjective shot by a self-conscious camera reflexively alludes to the fact that any nominal subjective/objective shots, that is, any classically well-sutured shots centered on characters are also actually mediated by a geometrically and physically located camera. The free indirect image is then a sutured form of the solid perception image in general. Likewise, a nominal definition of *subjective* and *objective* is a sutured form of real (Bergsonian) subjectivity ("the images vary in relation to a central and privileged image") and objectivity ("all the images vary in relation to one another"). So, "liquid perception" appears in the French school of *photogénie* when the subjective image dissolves "in the dizzy disappearance of fixed points" with every part tending toward the simultaneity of movements (Deleuze 1986, 76–80). And this tendency reaches an extreme through "gaseous perception" in which "everything is at the service of variation and interaction: slow or high speed shots, superimpositions, fragmentations, deceleration, micro-shooting." Deleuze attributes such a molecular montage to the pure vision of (not even an improved human eye but) a "non-human eye" in things, as seen via Vertov (80–86). Despite oversimplification, I am tempted to suggest that solid perception, desutured, becomes liquid, which, when desutured in turn, becomes gaseous; gaseous perception is sutured into liquid, which in turn is sutured into solid.[35]

Second, suture can illuminate genre formation at the generic ontological level. Deleuze's "action-image" is fundamental in such genres as the Western, the comedy, and any others based on the narrative of "Situation-Action-modified Situation" or its variations (141–142). Then, other aspects of the cinematic image could also be deemed sutured into other genre models. Ghost film, for instance, sutures the ghostliness of the image itself into an audiovisual ghost, whereas less conventional directors desuture the 'ghost film' to the 'film-as-ghost,' as does Apichatpong Weerasethakul, whose work I analyze in Chapter 3. Suture can further function as a hermeneutic lens through which to seize a genre's interfacial mechanism in the diegesis. To take Žižek's cue again, the detective's classical role consists in replacing the inner truth that we all might be the murderer in the unconscious of desire (as in *The Woman in the Window*) with the factual truth that somebody singled out is the murderer and thus guarantees our innocence. Herein lies "a hallucinatory projection of guilt onto a scapegoat" which lets us desire "without paying the price for it" (Žižek 1991, 58–59). By externalizing the realization of desire in a single character, the thriller genre sutures libidinal economy into its conventional solution. Then, does the scapegoat-murderer not function like an interface with our very desire? *Memoirs of an Invisible Man* (John Carpenter, 1992) offers an interesting twist. The invisible hero seems none other than a 'visually' sutured form of our anonymity, as he is 'the man without qualities' who is metaphorically invisible before he becomes physically invisible. And though visually invisible, he feels pursued by the undercover gazes of the CIA. This fantasy-thriller thus alludes to a double suture of invisibility: 'any-man-whoever' → secret agent → invisible man. On the contrary, a South Korean thriller, *Memories of Murder* (Bong Joon-ho, 2003), smartly desutures this model by leaving a serial killer unidentified, thereby suggesting that the real criminal may be the violent but impotent police who only hurt and torture civilians. This is an allegory for the country's past military dictatorship internalized in the police in general. The same director's *The Host* (2006) resutures this collective criminality into an alien-like monster, a fictive singularized 'public enemy' that is defeated according to Hollywood SF/disaster convention. But then, the government tries less to kill the Thing than to just keep it at bay and wield symbolic and physical power to control the entire society. That is, the power paradoxically depends on the monster to maintain itself, like a parasite living on its host. The genre formula is desutured through this antagonistic symbiosis between the system and a visually sutured other that intrudes into it but that it actually needs.

Last but not least, it is time we thought about what happened to suture in the post-celluloid era, as the digital creature of *The Host* is nonreal, a computer-generated suture of the Real. So the question shifts again from the diegetic to the enunciative level, more precisely from historical time to (not filmic but) postfilmic time—not the "frame time" of organic intervals between separable/successive photograms, but the "framed time" of the reversible flex/flux of pixels. This "digitime" has no outside, because it is

"the spatialized configuration of time itself as in its own right a malleable *medium*" (Stewart 2007, 2–15). The digital screen is then an interface with an algorithm beneath the ocular rhythm, Stewart says, less like the Vertovian eye and more like Kubrick's computer Hal in *2001: A Space Odyssey* (1968), which endlessly absorbs information like "an overloaded brain" (267). However, when Deleuze compares Hal to the screen as brain, he means the brain automaton as the whole spirit/memory, the pure Open beyond the limits of human intelligence (Deleuze 1989, 182–215).[36] From this virtual, information comes to us only contingently through irrational intervals and interstices between images and/or sounds. And yet this has nothing to do with digital information that is already encoded as zero and one, that is, that has already sutured the Virtual or even just visible real things into the binary code. If the interfaces of new media frame this immaterial information into the visual image, this "enframing" is the suture of a suture; the former visualizing, the latter encoding. If the human body itself serves as such a framing function (Mark Hansen 2006a), it might be possible to update interfaciality this way: 'I am a *digital* interface before I have one.' But let's put aside this somewhat futuristic subjectivity and focus on the following phenomenon for now: the already realized suture of the (even fictive) world into binary code deprives zero of its status as the master signifier or *objet a,* making of the Real (virtual or real) only two symmetrically enclosed master signifiers without any other signifiers. All possible becoming occurs within this digital 'tutor code' through its own transformation, including a form of change over time space that Stewart names "temportation." The image then has no unsutured outside, the abyss of the visible, because every tiny bit of information is suturable; "digitization arises from no protean, shapeless, totalized, and presignifying unconscious. It is one" (Stewart 2007, 154). I would say that the screen sutures 'zero' and 'one' into just 'one' variable image, that is, 'one' without 'zero,' the single digital universe without any black hole. While we are sutured into ever more sleek and splendid screens without caring about this loss of nothingness, the interfacial hide-and-seek between suture and desuture evolves in this way, inside and beyond the image.

2 The Body Interface

TOUCHABLE INTERFACE, TACTILE EXPERIENCE

On an airplane, a middle-aged American salesperson, Joe, is attracted by
Anna Maria, a beautiful but naïve Italian airhostess. During a stopover in
Bangkok, he films her with a movie camera and keeps after her everywhere
like a child begging maternal affection. While he never stops pestering her,
a psychiatrist gives her fiancé advice that she should act more sluttishly
because Joe is a psychopath fixated on her purity. Anna Maria's sudden pro-
miscuous manner and attire at a bar, then, disappoints Joe so much so that
he laments the loss of his 'dream girl' by projecting her virginal image onto
the wall of his room. He kisses and hugs the mirage, which also glimmers
on his own body, comically yet pathetically (figs. 2.1–2.2).

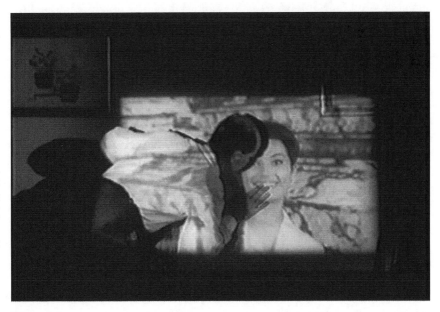

Figure 2.1

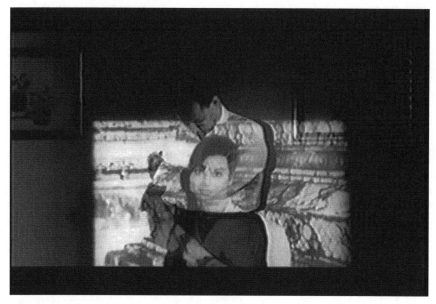

Figure 2.2

Entitled *Virginity* [*Illibatezza*], this is the first episode of a peculiar omnibus film *Ro.Go.Pa.G* (1963)—the acronym that combines the directors' names: Rossellini, Godard, Pasolini, and Gregoretti. These impressive auteurs unfold four unrelated sections about the film's rough premise, "the joyous beginning of the end of the world." Rossellini's *Virginity* received harsh criticism as the film's "weakest and least interesting segment," a "frivolous and dismayingly pedestrian screwball comedy [that] couldn't be further removed in terms of its tone and style from the raw neo-realism with which he made his name" (Themroc 2010). But if we can ever renew film history by redeeming overlooked or dismissed fragments, *Virginity* may be redeemed. Rather than pulling it back to Rossellini's famed realism, however, I will reframe it in terms of the body subject in physical contact with the medium interface, raising new questions about the touchable interface and tactile experience. From the previous to this chapter, my focus thus shifts from eye to body, retina to skin, perception to sensation, vision to action, and suture to *embodiment*. Traversing discourses on embodiment in the historical context of spectatorship theory, I then redefine interfaciality in terms of an intrinsic dialectic between two bodies, an embodied dialectic specified through multiple facets of what I call *ambivalent tactility*. A film within a film, that is, an interface on screen engages us again with this interfaciality that is hardly limited to the old notion of self-reflexivity. This time cinema does not address the subject's passive eye, but activates his body, complicating subjectivity that is the embodied agency of interfaciality.

'WALKING' THROUGH PSYCHOANALYSIS, ACTING 'OUT OF' NARCISSISM

The ending of *Virginity* serves to open our discussion. It obviously visualizes Joe's Jonah complex implied in the film's epigraph, a passage from psychologist Alfred Adler about man's desire for "a refuge which had once protected and nurtured him: the mother's womb." Joe's love is nothing but a regressive search for the pre-Oedipal refuge through his surrogate mother Anna Maria. Furthermore, it is easy to psychoanalyze not just Joe the character but Joe the spectator with vocabulary common in 1970s film studies. Joe's darkened room incarnates the movie theater as "Plato's cave," where his "voyeurism" enjoys the pleasure of "fetishizing" the female body, which is, in this reversed case, not a sexual but a virginal object that looks more real and pure than in reality. In other words, the "suspension of disbelief" works through the "disavowal of the (double) knowledge" that the seen is nonexistent and no longer true. Joe's reintegration of Anna Maria into self-centered imaginary signification is a privilege of the "transcendental subject," the secluded immobile spectator whose eye, however, identifies with the mobile camera that can take the eye of god's floating perspective unnoticed by the object. And in this sense, the theater-cave holds the screen as a "Lacanian mirror" that enables the subject's euphoric self-identity only through his *méconnaissance* of the image-as-other as self. For Joe, the screen reflects not the truth, but the fantasy of Anna Maria's purity and belonging to him, just as in the lost mother-child bind, on both the perceptual and psychological levels.[1]

This classical account, however, presumes the spectator's hyper-perceptive but sub-motor state. Yet what if? he leaves his seat and touches the screen? Joe in fact appears and behaves like a crying baby unadapted to theater etiquette. Paradoxically, his approach to the screen mobilizes the Lacanian Imaginary as the unconscious adhesion to the image, reviving the dormant materiality of the body and the interface. Yet this shift from watching to touch cannot achieve a real touch of the onscreen body because regained corporeality only contacts the apparatus. He experiences "the instrument 'in flesh and blood'" (Baudry 1986a, 296), a tactile disclosure of the material structure ideologically disallowed to the transcendental subject. Joe's assimilation to the image becomes dissimilation when "acting out" turns into "action," just as the audience's crying in sad movies reawakens its being physically situated in a theater (Metz 1982, 102). Through his bodily contact with the bodiless image, Joe finds out the virginal image is not an imaginary hymen his scopophilia can penetrate. That is, the naïve character does not remain a macho spectator, yet neither does he decode the "imaginary signifier" nor he debunks it as an "ideological apparatus." Breaking his shackles, Joe the prisoner moves not to the outside of the cave but rather into its heart, unwittingly revealing the mechanism of illusion. While his desire must be regressive, his body might be progressive.

Nonetheless, my intention is not simply to reverse classical psychoanalysis, but to reveal its inner contradiction and thus link transcendental to embodied spectatorship. In the first place, the subject is said to be positioned at the vanishing point of a god's-eye monocular (Renaissance) perspective—the ideological structure of representation and specularization empowering the subject to constitute and rule the objects ideally (Baudry 1986a, 295). He identifies with the camera, "with himself as a pure act of perception (as wakefulness, alertness): as the condition of possibility of the perceived and hence as a kind of transcendental subject, which comes before every *there is*" (Metz 1982, 48–49). The subject's identification with the object thus takes on his internalization of it, his symbolic command of the world launched only by and after his perception. As Metz suggests, he not only "receives" but also "releases" the film, so only needs close his eyes to suppress it (51). Notable (but not noted by Baudry and Metz) is the perceptual distance that the spectator-subject in the theater-cave takes from the screen mirror, the necessary distance for unfolding the historically Westernized visual field along the Cartesian geometric coordinates. It is through this subjectively transcendental distance that the subject can objectify the world: the subjective objectification from the geometral point of the eye as explained in Chapter 1.

The mirror stage is the cradle of this subjectivity. The screen works as a mirror without reflecting the spectator, because onscreen others appear as his likes and this similarity no longer needs to be "literally *depicted*" as "the primitive undifferentiation of the ego and the non-ego has been overcome" (46). That is, all imaginary signifiers on screen are 'refracted' duplicates of the original imaginary signifier in the mirror that 'reflects' the subject. The original signifier submerged in the Imaginary is, then, the starting point of all imaginary signifiers organizing the Symbolic. The identification shift from camera to character opens the subject's intersubjective or interobjective network, as my first-choice character is not only a subject but also an object for other character subjects. Moreover, going back and forth between different characters, my identification ultimately constitutes the whole diegesis as a unified object, the Object that corresponds to, while integrated into, the transcendental Subject. In short, the screen is a big refractive Mirror (Imaginary Signifier) with its subset mirrors (imaginary signifiers).

Let me now replace Lacan's early model of the Imaginary-Symbolic with his later model of its disjunction with the Real. The original imaginary signifier in the mirror is the first signifier, a 'master signifier' enabling one to represent reality. Then, what would come under its verso, an *objet a* emerging from the Real? Interestingly, Metz sees the screen as a mirror by virtue of the Italian-style perspective, but more directly because "it encourages narcissistic withdrawal and the indulgence of phantasy which, pushed further, enter into the definition of dreaming and sleep" (107). This sounds contradictory, given that perspective is based on distance that the narcissistic screen dream seemingly effaces. Remarkable is the evolution of Baudry's

cave metaphor through his two articles: he first lays out cinema as the "prototypical set for all transcendence and the topological model of idealism" (1986a, 294), and then, as "a representation of the maternal womb, of the matrix into which we are supposed to wish to return" (1986b, 306). In the former the impression of reality means "reality effect," whereas in the latter it is more like a "dream effect," the hallucinatory representation taken as reality, the "more-than-real" that causes "the submersion of the subject in his representations" (1986b, 310). Opposite of the subject's transcendental integration of the other, this submersion implies his corporeal absorption into the womb with no distance between subject and object, perception and representation, active and passive, eating and being eaten. Such "undifferentiation between the limits of the body (body/breast)" renders the film a dreamy mode "anterior to the mirror stage, to the formation of the self, and therefore founded on a permeability, a fusion of the interior with the exterior" (311).

If the theater-cave evokes the uterus, it may be like a warped surrounding screen that is not objectifiable in perspective based on Euclidean geometry, for the dream space encompasses us while neutralizing our sense of distance. "We are what we dream," said Bertram Lewin (1946; 1948), who first coined the dream-screen-breast analogy Baudry repeats: "the dream screen is the dream's hallucinatory representation of the mother's breast on which the child used to fall asleep after nursing" (1986b, 310–311). Freud argues that this child cannot distinguish itself from the mother's breast, the source of "oceanic feeling" that nostalgically refers to the all-embracing intrauterine bond between the ego and the world (Eberwein 1984, 26–27). Julia Kristeva clearly formulates three stages of ego formation: (1) the fetus totally depends on the mother, whose body is like the Platonic *chora*, a nursing receptacle, "an invisible and formless being which receives all things"; (2) for the newborn, the mother turns into the *semiotic chora* as a fixed space with a gap but without outside, providing an axis, a limit, a "projection screen" for its invocation; (3) the *mirror stage* follows in which the breast can appear as an illusion the infant creates like his mirror image (Eberwein 1984, 38–39). These stages display the child's gradual separation from the mother's body experienced as (1) womb screen, (2) breast screen, and (3) mirror screen. This naturally understandable process is unconsciously driven by Kristeva's other notion, *abjection,* the child's attempt to become an independent subject by breaking away from the mother, the *chora* subsequently becoming an *abject*. Abjection is a precondition of narcissism, the self-protective desire of keeping some distance from what now seems to threaten to annihilate one's identity.[2]

The narcissistic nature of the mirror stage then insinuates the turn of the mother (hugging her child in the mirror) from an object (attracting the child-subject) to an abject (causing the horror of the undifferentiated). But the abject is by definition already absent for a narcissist, who refracts every object into an imaginary signifier so that the screen-mirror is relatively

narcissistic. I rather focus on the potential of an imaginary signifier's turning back to a pre-abject object causing desire that entices the ego into the undifferentiated, that is, an *objet a* that opens the Real. The breast is a primal *objet a*, the mother's body part that the child hypnotically sucks and succumbs to. Attracted to the breast-screen, the subject does not remain in static self-satisfaction but goes back to a pre-mirror stage, shifting from "relative" to "primitive" narcissism (Baudry 1986b, 313). The drive toward the image is so strong that it transforms the ego's appropriation of the imaginary signifier into the ego's self-abandonment to the *objet a*. To refer back to Lacan's diagrams in Chapter 1, the breast is a *signifier*-turning-into-*objet a*, an *image*-turning-into-*screen*, that is, *interface*. Interfaciality underlies a double contradiction in psychoanalytic spectatorship theory: (1) there is a rupture between screen-mirror and screen-breast, (2) but it is a permeable rupture because our unconscious adhesion to the image, launching the Imaginary, can also reveal the Real out of it by the self-same force to a higher degree. It is this qualitative change of adhesion that *Virginity* shows. Stepping to the screen, Joe turns the imaginary into real contact, as though Anna Maria's face were his mother's breast to touch, even her womb to enter. This onscreen object is not 'I' but 'non-I,' insofar as there is no self to identify with in the primitive child-mother union, the unconscious submersion in the immeasurable Real. By *walking through* the psychoanalytic theater-cave, Joe *acts out of* the narcissistic screen-mirror.

"I AM 'IN TOUCH WITH' SURROUNDINGS BEFORE I 'TOUCH' SOMETHING"

However, there is a more complex link between Joe and Narcissus. Unlike the common (Freudian) notion of narcissism, Narcissus in Greek mythology falls in love with a reflection in a pool, "not realizing it was his own." Far from configuring his imaginary identity, he is attracted by the unknown other whose dangerous beauty costs him his life. The mirror is less reflecting than attracting. His isolation from the image is not the indispensable condition for securing an ideal ego (misrecognizing the image-as-other as self), but the inevitable trigger of submerging himself into amniotic fluid (misrecognizing the self-as-image as other). This regression to the birth state only leads to death. The mirror stage transforms from the first gate to the Symbolic into a 'rear window' to the Real. Narcissism is not the transcendental ego formation, but the anti-narcissistic embodiment of Eros and Thanatos. Likewise, Joe's perception of the image is transduced into tactile action, the resistance to separation. Yet for this modern Narcissus, erotic death drive bounces back from the solid surface of the screen. He only experiences the technical material interface as a transparent but unbridgeable gap between his body and the other's. His desire thus changes from conscious fetishistic disavowal ('I know it's just an interface but all the same') through unconscious imaginary

adhesion ('I want that body') to (un)conscious tactile ambivalence ('I can't enter it but all the same I can't help touching this interface'). And this desire results in the double bind of neither self-love nor love for another, neither happy life nor tragic death.

Kristeva's three-stage schema and recent skin studies trace the origin of this interfaciality. First, in the womb with no gap between mother and fetus, there is no proper touching but rather the sharing of a common boundary. But on the embryo's ectoderm (the original Body without Organs), the brain and the skin begin to be formed as surfaces of tactile, auditory, and visual organs. Second, after its birth, the newborn learns through the skin where its boundaries are. So "a common skin with the mother" gives way to "a skin of its own, discrete and autonomous" that the infant experiences from both inside and outside (Benthien 2002, 7–8).[3] This corresponds to the 'breast stage' in which pre-spatial unity turns into distinction between self and other, inside and outside. Drawing on Maurice Merleau-Ponty, Mark Hansen explains this primordial materialization of the sensible in terms of the *écart* as "always already differentiated, but differentiated amodally, prior to sensory differentiation (at a more basic level than the separation of the distinct senses)" (2006b, 60). That is, the skin-forming *écart*, the original tactile schism between self and non-self precedes the distinction of tactile and visual senses. The second sensible tactility is, say, a suture of the first foundational tactility, since *before I touch something, my body is always already in touch with its surroundings*. Third, the mirror stage then implies not just the transition of the baby's body from fragments to a gestalt, but "a fundamental, ontological form of being-with, the dedifferentiation of the mirror-image and the image of the other" (57–58). This is what Merleau-Ponty means by *flesh*. The baby sees and feels in the mirror its bodily subjectivity situated in the common embodied space. Therefore, the mirror effect is not illusionistic self-idealization so much as the embodiment of (pre)subjective interfaciality between self and environment. Merleau-Ponty distinguishes the "body image" from the "body schema" through which the feeling body opens out into the space between it and its image. He stresses this tactile schema (originating with the *écart*) over the visual image (originating with the very schema). The latter is, so to speak, a visual suture of the former (Mark Hansen 2006b, 58).[4]

Hansen's radical argument is that if the mirror is a technology that interfaces body with surroundings, this technicity "finds its enabling, sensible-transcendental or infraempirical condition in the *écart* constitutive of sensibility" (59). Technicity is less instrumental than immanent, as the primary *écart* yields the skin, the first interface, whose externalization takes the prosthetic forms of artificial interface such as the mirror and the screen. Just as the eye is an interface immanent in the subject, so the skin is an embodied interface that comprises the retina. Thus, tactility grounds visuality. Now, *Virginity* implies that this primary tactility is reawakened by derivative tactile activity as opposed to visuality, and thereby the skin is reawakened as

the primary interface. Joe's touch of the screen not only equates it with the (m)other's body to which his body vainly tries to attach itself, but also confirms their always-already immanent detachment and disconnection. It presumes an *écart* that both motivates contact and hinders unification. This paradox peaks when her image is projected onto his body, when our attention shifts from her body on screen (screen-as-body) to his body becoming a screen (body-as-screen). His skin's direct overlap with her (image's) skin evokes the womb or breast stage of togetherness, while reconfirming the skin as the first interface that embodies the first *écart*. That his touch only returns to himself further suggests a radically tactile narcissism not in the Freudian sense of *ego-libido* as self-love, but of *object-libido* as self-abandon. Hence a perverted *ego-libido* akin to masturbation.[5] On one hand, the impossibility of becoming other turns into the possibility of becoming interface, which reactivates the immanent being interface. On the other hand, transcendental narcissism turns into the embodiment of anti-narcissism, which in turn arouses corporeal narcissism.

In short, touching the *screen-body* reembodies the otherwise imaginary interfacing with the other, while reactivating not only sensibility but also its enabling condition of *écart* that subsequently disables any real touch of the onscreen body. And since this *ambivalent tactility* of the screen externally redoubles interfaciality immanent in the bodily subject, the *body-screen* realizes the same ambivalent tactility of the skin as a contact zone and unbreakable wall at once. 'Screen interface' turns into or is 'desutured' to 'skin interface,' and it entails 'desuturing' the mirror phase that is the imaginary suture of the self's fragmented real (body) toward the symbolic world (of others). So, rather than showing reflected or refracted narcissistic self-images, the mirror can interface the self with the radical other (Real) to which it belonged prior to solidifying subjectivity, though this longing for the lost other or the loss of the self only brings a pulverized then perverted narcissism back to the solid body-subject. This way, the desuturing imbrication of screen to mirror to skin restages the ongoing drama between the subject and the Real. In Chapter 1, the Real comprehended the intradiegetic outside and extradiegetic material that desutures the classical suture system, with the eye redefined as a visually immanent interface of the world matter. Now, the Real is primarily the uterus or chora, with the skin redefined as a tactilely embodied interface that desutures the classical mirror stage. Going beyond transcendental psychoanalysis and acting out of imaginary narcissism, Joe, the protagonist of this drama, leads us to an embodied phenomenology of the biological interface (skin), whose ambivalent tactility is externalized in the technological interface (screen). His physical confrontation with, and transformation into, a cinematic interface on screen can therefore work as an allegorical performance or performative allegorization of this interfaciality. Undoubtedly, here is room for the redemption of *Virginity* from its oblivion.

THE EVOLUTION OF THE RUBE, 'EXPANDED' RUBE CINEMA

With interfaciality in mind, we may now map the historical context of 'embodied spectatorship.' Its serious theorization started after the sway of the 1970s psychoanalytic theory that has been criticized for having 'disembodied' spectatorship. What I first draw attention to is the *cinema of attractions* discourse in the 1980s historicist turn of film studies and its 2000s reloaded version regarding Rube films in view of media history. But I start with an unexplored point that could bridge the ostensive rupture between semiotic psychoanalysis and media archeology, a point from which to readdress some issues of narratology and enunciation theory.

It is notable that Metz applies Freud's double dream process to the screen by distinguishing the secondary "film story" (what is told, implying an action of narration) from the primary "dream story" (emerging in turmoil or shadow with no narrative agency). The latter is still a story; "clearly or confusedly woven by the images themselves, a succession, whether organized or chaotic, of places, actions, moments, characters" (1982, 125). This distinction adds a significant nuance to the film-dream analogy in that there could be "dream story"-centered films or filmic aspects that disturb the linear narrative of a "film story" unfolding in perspectival space. The spectator's transcendental distance from the story as well as the image can reduce, as his reality check dissolves into the embodied diegesis of what is happening on screen. To borrow the Riffaterre-Stewart theory (Chapter 1), the dream story may look like a sort of oneiric "liminal shot" that visualizes the emergence of an atemporal "subtext" from its untold "matrix" over the given narrative. What is not addressed in this narratology is spectatorship. Like the yelling audience whom Metz compares to speaking somnambulists, Joe in *Virginity* experiences a cinematic event without intellectual knowledge and interpretive reflection; an event less like a neatly integrated film story than like a dream story fully charged with instant and immediate excitations. But again, Joe's body betrays the material mechanism of this "waking daydream" as though he were a walking somnambulist with his finger indicating his own somnambulism.

I am tempted to see this daydream effect in light of the "cinema of attractions." Tom Gunning and André Gaudreault assert that the exhibitionist presentation of visual spectacles overwhelmed the well-organized representation of diegetic stories in the pre-1907 cinema (Gaudreault and Gunning 2006; Gunning 2006). Such an attraction film might look like a dream story (not sedative or narcotic, but stimulating and ecstatic). Joe's energetic reaction reincarnates early spectatorship, which has been mythically typified by the audience's rushing to the exits from a hallucinatory train coming at them into the theater. Yet Charles Musser argues that attractions as nonnarrative aspects can be found in all periods of cinema, just as stars attract the audience while being totally integrated with the story (2006, 411–412). Touched on

by Musser, Laura Mulvey's seminal essay on visual pleasure also addresses this issue within classical narrative cinema. She contrasts narrative-driven voyeurism with fetishistic scopophilia that "can exist outside linear time as the erotic instinct is focused on the look alone" (1986, 205). Moreover, the female body was a central attraction along with the rushing train even before the birth of the cinema. Muybridge's photographs of nude bodies and galloping horses preceded the first Edison and Lumière films, let alone many early films about women and/or trains.[6] Figuratively, the cinema might have come into being through the intercourse of the woman's skin (hymen) and the penetrating animal/machine (phallus), two proto-pornographic attractions, with the latter's piston movement potentially motivating narrative progress. Or Lumière's train might have astonished the audience through its phallic intrusion into the theater-womb, fantastically tearing the screen-skin which actually works as a shield from any such onscreen violence.

The Rube genre inverts this naïve spectatorship and complex interfaciality, in which the viewer's active approach to the screen hampers any contact (Miriam Hansen 1991, 25–30; Strauven 2005; Elsaesser 2006). It is a satire of the maladjusted to new media who cannot tell reality from fantasy, theater space from screen space. In its nascent example *Uncle Josh at the Moving Picture Show* (Edwin Porter, 1902)—a remake of *The Countryman's First Sight of the Animated Pictures* (Robert Paul, 1901)—Josh the rube, like Joe in *Virginity*, is excited by two Edison films showing a woman and a train, whose imaginary sexual coupling seems incarnated as a flirting couple in the next film—a 'primal scene' that Josh, in a fit of Oedipal jealousy, tries to enter only to peel away the screen and becomes embroiled with the projectionist behind it. Made in the same year as *Virginity*, Godard's *Les Carabiniers* (1963) shows a bumpkin touching and kissing a bathing woman on screen until his actions expose the raw apparatus of the illusion. Here, the figure of the womb migrates from the darkened, empty auditorium to the bathtub image, the screen really appearing like a skin to rub and caress. A cutting-edge version of the Rube may be the PreCrime agent in *Minority Report* (Steven Spielberg, 2002); media expert as he is at work, he repeatedly addresses and approaches his lost son and wife who appear in holographic form as if resurrected, in his emotional womb-like home theater.

Although Rubes have engaged with 'new media' interfaces throughout the cinematic century, such credulous characters are found in the seventeenth-century theater like Pierre Corneille's *L'Illusion comique* (1636) that Metz mentions.[7] We could draw a genealogy of the Rube in literature and the arts, going back to Don Quixote or even to Zeuxis and Parrhasius.[8] No doubt Zeuxis's painting was a visual attraction that literally lures animal rubes, while he himself could be seen as the first human Rube deceived not by illusion per se—in which he would have tried not to suspend his disbelief—but rather by the illusionarily turned apparatus, the curtain-looking canvas that is the material basis of disbelief in illusion. In this regard, the double lesson

of this original Rube story seems to evoke the notion of *discipline* on one hand ('you may look but don't touch') and to revoke that of *diegesis* on the other ('you may look but don't believe in its material existence'). These are the two keywords that Thomas Elsaesser reconfigures in his update of the Rube genre study, which I will in turn retackle.

First, the Rube makes "the category mistake of thinking that the civilizational 'quantum leap' from hand to eye is reversible" (Elsaesser 2006, 215). It is a laughable mistake that brings superiority to the audience, who thereby subtly internalize disciplined self-censorship. More precisely, the cinema creates a "cognitive-sensory double-bind" in which both touch and sight are "at once over-stimulated and censored, seduced and chastised, obsessively and systematically tied to the kinds of delays and deferrals we associate with narrative" (213). So the cinema disciplines both senses, reflecting modernity and its eye-teasing commodity displayed in the show window. Building on Benjamin, Elsaesser thus sees the early Rube phenomenon in the frame of modernity and its haptic-optic correlation. At this point, let me recall the Jerry Lewis figure who directs and plays himself, an expanded version of the Rube who seems to incite us to remedi(t)ate Benjamin's meditations through his comic experience of 'old' media like painting and sculpture. In *The Errand Boy* (1961), Lewis pulls a string from a Samson statue with curiosity only to cause its fall and the consequent collapse of the whole display; in *The Bellboy* (1960), Lewis's touch of a woman's clay bust slightly changes her face and his struggle for restoration ends up with a total deformation of the original (fig. 2.3). Far from intending any blasphemy, as Steven Shaviro says, this Rube's rude actions may rather imply "self-abasement before the

Figure 2.3

social prestige of the painting," a masochistic abjection that comes from his hyper-disciplined state; he becomes "an anarchist not in spite of, but because of, his hyperconformism" (1993, 110–111).

How is it that Lewis touches what he knows he must not? Let me rethink Benjamin here. The traditional work of art retains the invisible but material trace of some initial or prior contact, whether the artist's brushing/molding or the patina of age. From this 'indexical' sort of inherent touch exudes the *aura*, "a unique phenomenon of a [temporal] distance, however [spatially] close it may be" (Benjamin 1968b, 243). We might experience this sacred epiphany not just visually but tactilely, as though it touched us by returning our look (Mark Hansen 2000, 120 and 140).[9] But this auratic tactility is still metaphoric insofar as the physical distance between work and spectator is taken for granted. Lewis, however, seems instinctively to reembody this figurative touch in his satirical rather than sacred manner and react to it by literally touching the work. Upon realizing his mistake, he makes every effort to reinstate the sociocultural rule only to exacerbate and debunk it. His unconscious infantilization and conscious overconformism thus incarnates the tacit tactile desire of the object and subject to contact each other. Thus, the cognitive-sensory double-bind seems immanent in all visual arts, though salient in the cinema. Lewis turns it into an entropic vicious cycle until it reaches a comic catastrophe. The impact of modernity might be less revolutionary than evolutionary, accelerating (rather than inaugurating) a tactility that always underlies auratic visuality. For this reason, Lewis's encounter with traditional works has no less significance than his frequent self-reflexive appearance in a TV or film within a film.[10] He makes a mess wherever he goes by touching whatever he encounters in spite of himself, though he often solves problems in spite of himself too. The world undergoes a continuous fluctuation between order and disorder around this mobile Rube.

In this way Lewis evokes Jacques Tati, especially in *Playtime* (1967), where Monsieur Hulot incarnates a Baudelairian *flaneur* not as an urban dandy, but as a typical rustic wandering around ultimate modern Paris. Slick surfaces of products and buildings turn into reflective and attractive interfaces, which the Rube, unaware of their nature, experiences with his skin as well as his eyes. He almost slips on the polished floor, tries the elasticity of a leather chair, and mistakes a glass reflection for the real person appearing from behind him (fig. 2.4). Tati's visual jokes are indeed tactile, even creating a surreal interface effect; when the window that a store person washes slightly tilts back and forth, the bus tourists reflected on it shriek with joy as if on a roller coaster. In the climactic restaurant sequence, Hulot touches the ceiling, which then collapses, turning the pure audiovisual carnival into an enjoyable tactile catastrophe. Merleau-Ponty's notion of *écart* as the primal separation from the world is continuously recalled through the subject's being-in-the-tactile-world. His playtime unfolds through an environmental if not medium-specific interfaciality.

Figure 2.4

Before going further into such 'expanded Rube cinema,' let's check Elsaesser's second point, diegesis. He argues that the Rube film literalizes the cinematic event as a process taking place between the screen and the audience, while the spectators of these films feel directly addressed by the onscreen performer (2006, 215–216). The self-reflective diegesis thus operates deictic marks (I/you/here/now) whose referents depend on each collective audience's spatiotemporal specificity; that is, these enunciative shifters turn each viewing into a distinctive performance. In this sense, Elsaesser expands the notion of diegesis from the self-closed fictional world to the dialectic overlap of narrative integration and its spectatorial experience as attraction. Articulating space/time/agency/subject, it can be understood "as not necessarily 'real,' but nevertheless as constituting a 'world'" while overcoming the dichotomy of attraction and narrative (217). Here, we encounter a double suturing. (1) Like Uncle Josh, the Rube's experience of cinematic attractions is the narrative itself, so the diegesis is constituted by the character's enunciative action as reacting to the diegesis of the film within the film. (2) The audience watches the Rube watching the film within the film, so its enunciative action as reacting to this Rube film (e.g., laughing at the character while being disciplined) constitutes its expanded diegesis including spectatorship.

The implication of (2) is that other media such as TV and video and their spatiotemporal locators/activators can co-constitute distinctive diegetic worlds, while the cinema can confront us with Rube-like characters who engage with different diegeses through different interfaces as in (1). It is in view of (2) that Elsaesser incorporates enunciation into diegesis, as diegeses of TV programs may vary with viewing conditions.[11] But it is in light of (1) that films with the 'expanded diegesis' may appeal to us concretely and aesthetically, because the diegetic reality including the enunciation of a

mise-en-abyme fantasy is also part of the film's diegesis.[12] The point is that attraction and narrative, reality and fantasy form a Möbius strip through the enunciative action that is made not by the enunciator, but by the addressee: not by the sender of a medium as message, but by its receiver in (2); not by the director of a film in the film, but by its spectator as a character in (1). In fact, the mise-en-abyme is a familiar structure, but where such a modernist self-reflexive film as *8½* often centers on the intellectual enunciator-director, the Rube genre retools the model with the emotional 'enunciatee' character. This spectatorship allows us to reappropriate Metz's point (i.e., cinematic enunciation is found less in the deictics that Casetti formulates than in the reflexivity of exposing the film's text as a performative act), while in turn rendering deictic aspects more visible (as Elsaesser says) than Metz argues. In short, the Rube film has a spectatorial enunciation as diegesis desutured, not toward the Žižek's intradiegetic Real or Stewart's narratographic materiality (Chapter 1), but toward the explicit audience space.

Internalizing the externality of enunciation, such expanded diegesis diversifies the narrative of the (contemporary) cinema of attractions, especially when the character's contact with an interface lets him into an internal fantasy or lets someone out of it, instead of revealing material supports. Hollywood has a long list of films in this "marvelous" genre—explicable even if supernatural: *Pleasantville* (Gary Ross, 1998) with teenagers sucked into a TV show set; *The Purple Rose of Cairo* (Woody Allen, 1985) with a movie star walking off the screen, and so on. But the interface experience does not serve only for the smooth transition to a mise-en-abyme diegesis. It can rather draw attention to itself as an event of attraction that fissures the main diegesis, as shown in diverse films from action adventure *The Last Action Hero* (John McTiernan, 1993) to disaster thriller *Déjà Vu* (Tony Scott, 2006). The latter particularly updates the idea of 'possible world' from the *Matrix* type of virtual reality—two spaces, real and virtual, unfold at the same time—by visualizing two time zones, past and present, that coexist in the same place. For instance, the ultramodern Rube-Cop has to adjust to this temporal bifurcation occurring in the road that he passes through, with one naked eye seeing the daytime present and the other interface-equipped eye perceiving the nighttime past of four days ago, while his head continuously receives information from a control tower, information he processes into bodily actions (fig. 2.5). What occurs here cannot be fully analyzed in terms of mere diegetic dichotomies such as actual reality versus virtual reality, or reality versus the Real. The question rather involves the unique experience of interface itself that takes place on the threshold between inner and outer dieges. Before being sutured into this or that world, even the most upgraded Rube's struggle with the most upgraded interface holds the audience between attraction and narrative.

Undoubtedly Hollywood has always remediated itself by deftly integrating the eventfulness of early cinema into "intensified continuity" of still classical narrative in Bordwell's terms (2002). This ongoing cinematic

Figure 2.5

phenomenon accounts for Elsaesser's preference for the 'ontological' term *diegesis* as 'world making' over Manovich's 'technical' equivalent, *interface* (2006, 218). But I would shed light on *interfaciality* in general rather than new media interfaces proper, inasmuch as the Rube film visualizes the cinematic event as nothing but the embodied experience of interface broadly redefined at both specific and generic levels. In this regard, *Déjà Vu* evokes an early Rube feature made on the threshold of classical cinema: Buster Keaton's *Sherlock Jr.* (1924), particularly the scene of Keaton's maladjustment to the screen space, which the *Matrix* series digitally reloads. Just as Neo is perplexed by totally different landscapes unfolding whenever he opens a new door interface in virtual reality, so Sherlock Jr. enters a film in the film leading him (not to film's material base but) first to an interfacial wonderland whose landscape keeps changing. Attracted and distracted, absorbed and disoriented, his body flips, falters, and falls (fig. 2.6).

More discontinuous than standard jump cuts, this vertiginous montage of unrelated backgrounds intimates the limitation of our inertial sensorimotor system in embodying interfaciality that potentially exceeds well-sutured illusionism. That is, this Rube experiences less an artificial interface of 'body image' (though this triggers his initial jump into the screen) than his own immanent 'body schema.' Its malfunction in interfacial surroundings alludes to the primary tactility that results from the primary *écart* from the world. Only after this scene is he sutured into the diegesis of a mise-en-abyme film that takes over the full screen, signaling the transition from attraction to drama, from a Vertovian 'perception image' with little room for relevant bodily reaction, to a Griffithian 'action image' full of Keaton's acrobatic adventure. I would call such a narrative-integrated Rube scene the 'interface scene' in that it marks the threshold to an encapsulated second diegesis while temporarily desuturing it. Hence, we have a crescendo in scale from *interface image* (as seen by Joe in *Virginity*) through *interface shot* (for

Figure 2.6

Georges in *Caché*) to *interface scene* (for the Josh figure in *Sherlock Jr.*).[13] This last Rube, in particular, visualizes not only sensual but immanent tactility fully embodied in his failure of the full embodiment of interfaciality. This performance allegorizes the condition of any spectatorship; our embodied experience of the cinematic interface, including the tactile gap from it, immanently precedes our diegetic immersion, even when we look at the screen without moving like the Rube.

PHENOMENOLOGY REDUX AND HAPTIC CINEMA

Taking the last point as a link, let's move on with 1990s phenomenology beyond Merleau-Ponty. This will also serve as a springboard for more scientific methodologies such as cognitivism, cybernetics, and technesis that have contributed to making 'embodiment' an interdisciplinary buzzword. Their common point is a robust antagonism to the formerly dominant theory, an intentional turn from disembodied to embodied vision, even though real tactility embodied by film characters has not been significantly illuminated. I bring this physical tactility back into relief after a cruise over various approaches to the embodied spectatorship of the still immobile spectator.

Merleau-Ponty's seminal article on film is memorable. It proposes a spectatorial shift from Cartesian analytical intelligence to Gestaltist synthetic perception that involves physiological psychology in a Bergsonian mind-body conjunction. A film is "not a sum total of images but a temporal *gestalt*," a presentation of a whole reality rather than its divisible representation, thus experienced through embodied perception prior to intellectual understanding (1964, 48–59). Drawing attention to this, Dudley Andrew depicts how such an epic film as *Chimes at Midnight* (Orson Welles, 1965) stops historical 'reflections' on the past and spurs sensorial 'reflexes' in the present at such key points as battle scenes (fig. 5.2): "Everything is destined to disintegrate into the mud or fog of formlessness . . . We close our eyes to experience the tactile effect created by an orgy of audio-visual movement" (1992, 18–31). But this virtual tactility of feeling 'as if' we were swept into cinematic turmoil does not turn our subjectivity into an atemporal "tabula rasa." Rather, we embody history that embodies a circular time in one place "where the future rests on the past, the past on the future, and where everything symbolizes everything else." Merleau-Ponty indeed builds on Hegel's dialectics as the "maturation of a future in the present," on Husserl's *Stiftung* [foundation] as "the unlimited fecundity of each present" (1993, 109–110). It reminds us of Benjamin's history not as seamlessly empty but as filled with reverberating contradictions, and of Bergson's 'vertical time' that remains latent in the present as opposed to the 'linear time' with its vanishing present. The French Revolution occurs every day as the origin originates "the continual rebirth of existence" (68).[14]

Oddly, this temporality disappears from later discourse on phenomenology, which gives priority to spatial embodiment. Metz takes Merleau-Ponty in this direction regarding the two following points. First, Merleau-Ponty emphasizes the ontological ground of phenomenology, "the degree zero of spatiality" in which one is immersed in his inside and feels "the fission of Being, a dehiscence of Being" (1993, 138 and 147). This Heideggerian notion implies that invisible Being enables visible beings, just as light is invisible but visualizing. Metz regards Merleau-Ponty as an "idealist" like Bazin in the sense that some sort of ontological transcendence penetrates visible phenomena, so that the essence of cinema is best viewed "as a mystical revelation, as 'truth' or 'reality' unfolding by right, as the apparition of what is [*l'étant*], as an epiphany" (1982, 52). The '*there is*' of phenomenology as an ontic revelation may then refer to a perceiving-subject for which alone can there be anything, the subject of transcendental perceptual *cogito*. For Metz, it is preconditioned by the material apparatus, thus what matters is not so much 'being' a subject as 'knowing' its systematic and ideological construction as a *deluded ego*. This is why the apparatus theory takes on epistemology, keeping more or less critical distance from ontology.[15]

Second, within the visible realm, Merleau-Ponty reinterprets the mirror as "the open circuit between the seeing and the visible body" (1993, 129), further implying that man is a mirror for man and that what is reflected

might be an "oneiric universe of carnal essences, actualized resemblances, mute meanings" (130). His book *The Visible and the Invisible* is all about this reversible, prepersonal universe of flesh: "the seer and the visible reciprocate one another and we no longer know who sees and which is seen. It is this Visibility, this generality of the Sensible in itself, this anonymity innate to Myself that we have previously called flesh" (1968, 139). Like Lacan's gaze, flesh envelops things, clothes them, so "the presence of the world is precisely the presence of its flesh to my flesh" (127–131). As already examined, the mirror stage could then cause less the misrecognized illusion of self-identity than the appearance of the subject as an object in the common environment. Yet this is a delicate point from which the mirror can lead either back to the primordial (con)fusion of the self and the other or toward the social network of intersubjective relationship. Merleau-Ponty seems to oscillate between these two directions, whereas the latter underlies Metz's screen as mirror that reflects the object-character intersubjectively, that is, symbolically. Here we confirm again the increasing externalization of interface: primordial skin (self = other) → mirror (self = the self's image as other) → screen (self = the other's image as pseudo-self).

Heading in this direction, we encounter Vivian Sobchack. Her *Address of the Eye* was born from a discontent with established theories: Deleuze/ Bergson's ontology, she argues, overlooks the dialectics between bodies situated in sensorial space (she emphatically privileges space over time); Husserl's phenomenology focuses only on the transcendental ego without material body; Lacan's psychoanalysis constitutes the Self 'from the outside in' ("the visible *seen* Other originates the visual seer") and submits the structure of being to the structures of language (1992, 31–37). Proposing Merleau-Ponty's existential phenomenology as an alternative (particularly to psychoanalysis), Sobchack argues that Self-consciousness is constituted 'from the inside out,' that is, "the act of seeing originates the visual seer and the visible Other as co-emergent subjects of vision, as both see-able and seen, visual and visible." The mirror stage is, again, endorsed not in terms of *méconnaissance* ("mis-taken knowledge" about the Self in the being seen), but in terms of *reconnaissance* ("knowledge [about the Self] re-taken" through (inter)subjectivity in the seeing being) (119). The subject is then endowed with the active capacity of unfolding the visual field of reciprocity and reversibility.

Yet, how different is this from the *cogito* that 'releases' the world by opening his eyes that Metz critically discussed? Despite her anti-Cartesian stance, Sobchack does not jump into some asubjective realm like Brakhage's "world before the 'beginning was the word'" (Brakhage 1963) that she quotes (Sobchack 1992, 91). Her mirror stage seems closer to the screen stage of self-recognition via the other than to the skin stage of self-resolution into the other. In fact, both Merleau-Ponty and Sobchack are open to preconscious subjectivity in its absolute difference, but their concern is: "How can the Other be differentiated as a subject-for-itself within my subjectivity that perceives and incorporates the Other as a subject-for-me, as my intentional

object" (121). This asymmetrical perception of the Other is still Subject-centered; it prioritizes a sheer subject within which the other is objectified as another subject. She claims that Lacan's notion of *hommelette* (the baby as a 'body without organs' spreading in all directions) has a nucleus of embodied subjectivity (116). As we saw in Chapter 1, however, the subject (eye) in Lacan's diagrams is not simply transcendental, but embodied enough in the asymmetrical field of visibility with subjectivity conditioned by the Object (Gaze). This Object-centered asymmetry based on the Real is more fundamental than that based on the Imaginary of the mirror stage that Sobchack criticizes for leaving the subject passive. But she hardly refers to late Lacan, relating the Real only tangentially to Merleau-Ponty's Flesh without details (107). In this counter-psychoanalytic phenomenology, the subject regains communal corporeality and is more actively self-centered. The body-space relationship would then pave the way for intersubjective socialization (with otherness ultimately becoming symbolic) instead of radical disintegration (with otherness becoming preimaginary). Though closer to the former, psychoanalysis has often been condemned as if it entrapped subjectivity in the latter's passivity. Yet active phenomenological subjectivity also maintains the (psychoanalytic) transcendental distance from radical self-deconstruction, which might not be a mere symptom of regression.[16]

Within this ambivalence, the 1990s film phenomenology redux sophisticates the idea of 'bodily activated subjectivity.' Sobchack seemingly rephrases Bergson's sensorimotor schema of perception and action as perception and "expression" (implying more subjectivity), asserting that selective and combinatory perception itself is an expression of intentionality (1992, 132). It intends an object whose invisible sides, though transcending our vision, exist immanently in the visual field that is immanently embodied by the subject. So again, the "visual" field synthetically incorporates the invisible, which is "a transcendence *of* immanence *in* immanence" (295).[17] The implication is that the subject/object and the world form the Gestaltist figure-ground configuration, and that the figure as a body is like a physical, spatial, finite, durational interface accomplishing vision. This "embodied vision" is a visible activity, as we see a film's vision of the world (93). By the same token, Sobchack argues that the film is also a "lived-body" whose intrasubjective dialectics of perception (camera) and expression (projector) makes an intersubjective dialogical relationship with the spectator-subject in lived space (again, without memory involved). This is the embodied "address of the eye" by the "film's body," which is neither visible nor anthropomorphic, but still material while irreducible to the apparatus. Only through its intentional agency and diacritical motion is the film's body reflexively recognized as "a quasi-subjective and embodied 'eye' that has a discrete—if ordinarily prepersonal and anonymous—existence" (31–37; 99–100). This reflexivity comes before reflection. Sobchack's own "fingers knew" that the obscure figures opening *The Piano* (Jane Campion, 1993) were also fingers. She sensed them as being "subjectively 'here' as well as objectively 'there,' 'mine' as well as the image's" before

the clear reverse shot appeared (Sobchack 2004, 63–66). This way the film's body that mediates between them is also sensed.

It must be noted that Sobchack's *Carnal Thoughts* (2004), which includes this discussion on *Piano,* struggles to amend her '90s phenomenology and move toward a less subject-centered ontology—this shift, along with some of her essays, is occasionally brought later in this chapter and more significantly in the next chapter. For now, however, I focus on her visible influence, especially among female scholars who turned their interest in the body from psychoanalytic feminism to phenomenology of embodiment, if not to the body genre studies represented by Linda Williams. Echoing Sobchack, Laura Marks writes: "The Nose Knows," and attracts new attention to "intercultural cinema" that embodies different senses than vision.[18] Her approach owes much to art historian Alois Riegl, according to whom "optical" representation had been dominant since the Renaissance until the age of modernism that rediscovered the non-Western alternative mode of "haptic" aesthetics rooted way back in ancient Egyptian art—note that well before Marks, Antonia Lant (1995) traced the origin of the "haptical cinema" back in ancient Egyptian-style settings in early cinema in light of Riegl. Unlike the too literal term *tactile,* the alternative term *haptic* is taken to imply our eye's touch of surface graininess and multilayeredness. Here Marks refers and relates "haptic cinema" to the early cinema of attractions, the two-dimensional flat rendition of deep space, and opening-credit sequences that display the object/world like a material texture as in *The English Patient* (Anthony Minghella, 1996; fig. 2.7) (Marks 2000, 162–169).[19]

Jennifer Barker pays similar attention to the haptic contraction of figure and ground shown in *Pather Panchali* (Satyajit Ray, 1955). But invoking Sobchack directly, she also introduces an interesting opening scene, that of

Figure 2.7

Mirror (Andrei Tarkovsky, 1975), in which the shadow of the boom micro-
phone calls her attention as "a visible sign of the film's body performing its
own attention" (Barker 2009, 9).[20] Partly based on Hugo Münsterberg's
cinema-human homology, she proposes such film-viewer correspondence on
three embodied levels: not only haptic (screen/celluloid corresponding to
skin reactions like goose bumps), but also kinesthetic (space/body to mus-
cular reactions like shivering) and proprioceptive (projector/lens to visceral
reactions like internal chill) (2–3). For instance, Keaton's jump into the film
within *Sherlock Jr.* catches "our muscular bodies off guard by incorporating
us bodily, ambivalently, and ironically into the cinematic space"—that is, it
'sutures' us into it (70–71). Barker regards comedy and the musical as body
genres because our bodily reaction performs mimicry based on kinesthetic
memory. No doubt, she expands the notion of identification to embodied
empathy so that suture should be 'embodied' suture, our bodily gullibility
prior to intellectual suspicion of "it's just a movie" (90).

This idea of the 'kinesthetic' seems to refresh rather than reject psychoana-
lytic identification, semiotic enunciation, and even Deleuze's 'narrative-based'
action image, by centering on the spectator's instant bodily reaction. The flip
side is that the film's body is so 'humanized' as if the seamless unification
of its and our sensorimotor schemas were a cinematic ideal that could be
achieved by such action adventures as the chase in *Bullitt* (Peter Yates 1968)
Barker describes and such theme park entertainments as 3D, IMAX, and
ride-theater films. But apart from the fact that 'desuture' and 'affection' are
sublated in this mainstream cinema, none of Barker's examples involves our
real tactile experience of the film's body. Her idea of film's skin is also limited
to Marks's 'visual' haptics in its paradoxical logic that tactility should not
be limited to physical touch (2009, 43–47), the logic Sobchack shares. In
effect, the notion of film's body fleshes out the director's transparent enun-
ciation with an embodied subjectivity. A simple conclusion: film embodies
perception and expression as we do, so we can dialogically interact with it.
This intentional interactivity is supposed to renew the old apparatus theory
and promote our "becoming other than we are" in imaginative ways. This
recalls Donna Haraway's cyborgic body, that is, the film's body turns from
a prosthetic device to a liberational potential of our body (Sobchack 1992,
162–163). Fusion can thus occur without tactile confusion, as Sobchack's
fingers become somebody's fingers on the film's skin. Conversely, even if "I
come to the surface of myself" (Marks), "we don't lose our sense of our-
selves" (Barker 2009, 36).

EMBODYING COGNITIVISM, CYBERNETICS, TECHNESIS

Let me briefly check how this phenomenological embodiment underlies cog-
nitivism and cybernetics as well. Torben Grodal's recent update of cognitivist
film theory combines a top-down "evolutionary bioculturalism" as opposed

to social constructivism and a bottom-up PECMA model of the brain process from Perception, Emotion, Cognition, to Motor Action (2009).[21] Action film is universally popular, for instance, because its strong images bombard our neurons in the visual cortex and chase narrative appeals to the memory of primitive hunting that is still embedded in our civilized body. This theory broadens the cognitive spectrum to corporeal factors that render the Rube's gullibility biologically natural so that intentional efforts are then needed for the suspension of "belief" and not disbelief (185–186). The implication is that mankind's embodiment of perception is long term, so the changing media could not alter it as drastically as the Benjamin school argues. The presumed idea of the body as a mobile system in its stimulating environment also underlies Giuliana Bruno's aesthetic 'travel' of various arts. She delves into "a tangible, tactical role in our communicative 'sense' of spatiality and motility, thus shaping the texture of habitable space and, ultimately, mapping our ways of being in touch with the environment" (2002, 8). Though this touch concerns kinesthesis more than the skin-interface experience, she clarifies how the body functions in its cartographic journey of uncharted raw materiality. The same issue permeates cybernetics based on communication and systems theory, which has been taken more seriously in literature than in film. Katherine Hayles, among others, embraces informatics not for the immortality of disembodied digital effects, but for a new embodiment of complex materiality brought by information technologies and media. Even in virtual reality, "the user's sensory-motor apparatus is being trained to accommodate the computer's responses," and this embodied "functionality" reproduces information as pattern out of noisy environments (1999, 47–49).

In this line of thinking, Mark Hansen takes a unique position. His *Embodying Technesis* is a chain of critiques of the discourses that treat technology only as an object of intentional thought, a Husserlian *noema* for *noesis* (2000). What he calls *technesis* is the intentional process of putting technology into objective discourse as *technema*. Historically this technesis has ignored the radical externality and concrete materiality of technology, reducing it to a mere material support for "instrumentality" (Heidegger's *Zuhandenheit* concerns the usefulness of the tool), "textuality" (Derrida's *différance* operates the text as machine), "subject constitution" (Lacan's *objet a* often appears in mass media as technological effect), and "social organization" (Deleuze's *agencement* means the assemblage of a social machine). Interesting is the comparison of poststructuralist *technesis* to *gynesis,* the discourse that reduces woman in the service of the theoretical deconstruction of modern phallogocentrism (86–87).[22] Like woman, technology is subversive to traditional thought, yet it is 'sutured' into a "relative exteriority" (e.g., the technology of writing and the actualized form of the immanent virtual) through the ontogentic mechanism of *différance, becoming,* and so on. For Hansen, this ontogenesis still does not do justice to technology as real materiality.[23] He pursues, then, a new technesis responsive to this absolute

exteriority of technology that conditions our "noncognitive and nondiscursive *affective* bodily life" (21–30). In this sense, he also argues that systems theory addresses (technological) environment as still 'suturable' into information for cognitive systems including the body (78–81).[24] Bruno Latour's inscription model, for instance, defines recording devices as "quasi-objects" that form our knowledge of things themselves; technology is then sutured in the artificial interface enabling the "epistemological embodiment" of the real (30–47). Hayles pays more attention to immediate materiality, but still subordinates it to the notion of "elusive negativity" underlying the system of discourse (48–49, 94).

This long criticism of established technesis finally leads to Benjamin as Hansen's model thinker. Via Pierre Bourdieu's "practical mimesis" (which suggests that what is learned by body is *not something that one has, like knowledge that can be brandished, but something that one is*), Hansen highlights Benjamin's "mimetic faculty," the assimilative embodiment of prelinguistic stimuli without cognitive representation (Mark Hansen 2000, 51). Not the artifact but the body itself appears here as an experiential interface that physiologically adapts to "the *alien* rhythms of the contemporary mechanosphere" (234). The Real, if any, is technology as "the modern form of *physis* itself, not simply its ontic degradation." Becoming is then mimetic innervation, "not as an imitation (or supplement) of nature but as an irreducible, material element of nature itself" (235). Here, Benjamin's well-known political aesthetics of media technology gives way to his less discussed anthropological materialism of cosmic technology.[25] Notable is Mark Hansen's critique of Miriam Hansen. She argues that both Disney and the Nazis served "technofascism" saturated with purely physiological innervations, which therefore need to be sublated/sublimated toward "a cognitive, emancipatory form" enabling political reflection (Miriam Hansen 1987; 1993). He thinks that this dialectics ultimately subordinates raw innervations to the *social* model of political semiotics in the frame of *technesis* (255–261). The cinema matters not because it is a powerful medium of "vernacular modernism" that could create a revolutionary "public sphere" in Miriam Hansen's terms, but before that, because it is "an open-ended circuit" of dynamic innervations that take part in the embodied 'techno sphere' in Mark Hansen's view. Evolving from language to photography to cinema, interface turns from a medium into the environment that causes affects out of the body interface. That is, two interfaces, body and technology, interpermeate ever more directly to the extent that technology takes on/over the world as in the Bergsonian body-world correlation.

No wonder Mark Hansen centers on Bergson in *New Philosophy for New Media* before moving on to Merleau-Ponty in *Bodies in Code*. He elaborates on "philosophy of embodied technics" by updating phenomenology via systems theory and exploring media arts that signal the evolution of interface into space, of visual representation into tactile participation. Although he refers to no single film, we saw this evolution prefigured by

Rubes whose body language exposes their mimetic faculty of embodying imaged innervations from the cinematic interface. The body is so seamlessly coupled with such interfaces that it seems "*constituted* by an unavoidable and empowering technical deterritorialization . . . *and can only be realized,* in conjunction with technics" (Mark Hansen 2006b, 20). Yet the interface as suture is at the same time desuture, as we also saw a screen in a film, a still artificial interface, revealing the body's tactile gap that externalizes the body's *écart* from the other/world. The primary *écart* yields the enactive "body schema" from which the representational "body image" emanates.[26] This schema and its immanent *écart* is the core of Hansen's notion of *technicity* as well as our notion of *interfaciality,* both internalized in the body and externalized through technology. Thanks to film characters who jump into and bump against interfaces, we can elicit this originary interfaciality of the body, its desuturing *écart,* from external interfaces of a techno-world that sutures us ever more perfectly.

I add that this suture/desuture dialectic can be applied to film as well, because an onscreen interface, if it is a sutured form of the film's body, desutures the supposed illusionary function of this body when betraying its own material tactility within diegesis. That is, the film's immanent interfaciality is externalized through its inner cinematic interface external to the character, convoluting Goethe's message that Merleau-Ponty quotes: "What is inside is also outside" (1964, 59). When contacting and even becoming an interface, the character's body can trigger our fundamental reflection on the film's body, which Sobchack and other phenomenologists experience only in the mode of 'embodied identification' with the director's unseen body and the film's sensible body. This intersubjectivity may repeat anthropomorphism while the primordial flesh ultimately turns into the social structure of intersubjective relations.[27] Admittedly, psychoanalytic theory of spectatorship colored by 'negative' voyeuristic passivity has been 'positively' replaced by phenomenological, cognitivist, and cybernetic theories of spectatorship equipped with intentional activities of body and brain. Merleau-Ponty guides us to the common Flesh that could even resolve the dyad of activity/passivity. Yet his ontological turn could shed more light on film's body through the new lens of *technicity* that certain films concern through the real matter of flesh. In most cases, the usage of embodiment or contact remains still metaphorical; it counters the old dichotomy of eye and hand, yet not literally subverting Kaja Silverman's declaration of "no tactile convergences" (1988, 6)—we 'visually' touch films as mentioned in terms of haptics, or we are 'visually' touched by films, even in Shaviro's radical passivity to be soon examined. The body's direct contact with the interface is then all the more significant because it visualizes the very visual tactility by transforming it into a tangible one. And a number of films promote our reflection on *ambivalent tactility* that underlies and even desutures 'intended intersubjectivity,' thereby opening a more foundational interfaciality of the film's body. With all this in mind, let me explore two sets of films showing a screen as body and a body

as screen, which I investigate in relation to body image and body schema along with various issues rising beyond the Rube genre.

SCREEN BODY: TACTILE GAZE, SKIN EGO, BODY TRANSFORMATION

As sketched through *Virginity,* here is a new formulation of cinema as a double body: a screen body that provokes the desire to touch, and a body screen on which the object of touch is projected. 'Truth telling' (even about Anna Maria's virginity) goes astray in this rearticulation of look and touch, of desire and body, that replaces the dominant realist paradigm of cinema as witness (to which Rossellini was attributed). What matters is less referentiality to reality than the topological, psychosomatic, material ground of being (mediated) and the bodily encounter with another (virtual) body on it.

The first case of screen body is not rare, since (mostly male) characters cannot often resist the temptation to touch a screen as if it were equal to a (mostly female) body. Young Toto's kiss of an onscreen face in *Cinema Paradiso* (Giuseppe Tornatore, 1988) signals this cinematic experience that nourishes not only his romanticism but also cinephilia. It culminates in the finale with old Toto watching all formerly censored kiss scenes, his eyes moistening—the only tactile reaction possible for this now immobile adult viewer in front of the tactile desire performed on screen. With no film screen, the peep show in *Paris, Texas* (Wim Wenders, 1984) is nonetheless highly suggestive of the ambivalence of interface while evoking cinematic metaphors. For the hero, the front glass is a 'rear window' enabling him to look voyeuristically at his estranged wife, now a showgirl. But at some moment his face overlaps with her body on this screen as if she ventriloquized his desire for reunion or vice versa (fig. 2.8). For the heroine, the verso of the same screen is just a mirror, yet her client's intimate talk incites her to move and attach herself to this reflective wall in the vain attempt to look through it. On his side, then, the couple's faces form a ghostly juxtaposition (fig. 2.9). Finally, lights out, her space becomes a darkened theater while the mirror turns into a visual and even tactile screen of his face that remains behind (fig. 2.10). The interface enables one not just to see, but to feel, touch, and be united with the other in the way this desire could be fulfilled virtually, ghostly.

At this point, the notorious *Peeping Tom* (Michael Powell, 1960) may call for our attention to the camera, here, the interface that embodies tactile desire as aggressively as it can be. For the hero, the camera is like a gun from his childhood and the lens frames every woman attracting him in the grid of a target. As the verb *shoot* means both *film* and *fire,* peeping Tom does not just peep, but pierces women when his camera gun changes into a spear, and when his flashbulb anamorphically reflects the victim's sheer horror, the face of the Real (fig. 2.11). As Del Rio says, Peeping Tom's voyeurism sets

Figure 2.8

Figure 2.9

up "not only visual axis, but postural impregnation." His mirror stage (suggested when he shoots the woman shooting him) turns vision into the tactile movement that expresses "his regressive tendency to merge with the seen, and, concurrently, his inability to relate to it as an other" (2000, 119–122).

Figure 2.10

Figure 2.11

Undoubtedly, his camera as a stylus interface embodies the phallus and its self-perpetuating violence releases the ultimate orgasm of his suicide shooting. Feminists could easily contrast this rampant masculine gaze with a maternal gaze entailing intersubjective caress, given that the hero's surrogate mothers "try to suture" him into "the sensual and the linguistic strands of signification" (145).

Steven Connor, however, finds two distinct gazes in two opposed mythical female figures that represent maternal ambivalence: Medusa (whose snaky hair is "a whole cluster of spare penises") and Athena (whose aegis is made up of that monster's skin). One is a penetrating camera gaze, the other a prophylactic screen skin. Even more ambivalent is the latter's protection against the former. The shield can enfold the child in a soft caress against violent intrusion, yet it foils the ultimate desire for bodily reunification by separating the child from the mother, "refusing every effort of re-fusion" (1998, 13–14). This separation evokes the originary *écart* that the child embodies when tenderly surrounded and touched by the mother's breast. Blamed for being psychotic, Tom's phallocentric gaze could be taken as a tactile agent that desires to pass through visual distance even though it cannot help but reconfirm the conditioning boundary between the one, the other, and the image. When a blind woman stretches her hand toward the screen that Tom faces, such a boundary seems sensible in the 'visual' haptic mode of this multilayered surface. Of course this film is realistic; he knows the impossibility of entering women, so he projects their 'dead alive' images and, unlike Joe in *Virginity*, watches them without touching. But this adult spectator's fixed body is agitated enough to betray his repressed desire for being absorbed into a woman's mouth when it is projected like a uterus on screen.

Persona's well-known enigmatic opening has a similarly haptic, but more tactile image of a dreamy mother-child contact. A child spectator rubs a woman's facial image as though his hand were like a mouth sucking the breast. In reality the infant is said to experience the "breast-face as one and indivisible" when it sucks its mother's breast while looking at her face (Eberwein 1984, 29). But this tactile image, apparently too close for the child to retain focus, oscillates between clarity and obscurity (fig. 2.12).[28] Here we see the fundamental incompatibility between the visual and tactile senses that can be put this way: "The eye cannot see the eye as the hand touches the other hand; it can be seen only in a mirror" (Merleau-Ponty 1968, 223–224). To reflect itself, vision needs an external interface whereas touch only needs another part of the same body, an immanent interface. But again, the reversibility of one's touching and touched hands is preceded by the reversibility of one's body and the world that are 'in touch with' each other, that is, in "infratactility" or "intersensoriality" (147–148). This primal tactility is 'sutured' into hand-centered tactility as opposed to distance-based visuality. In other words, the symmetrical opposition between the visual and tactile senses is asymmetrically grounded on infratactility. Moreover, infratactility results from the foundational *écart,* which itself is *in the untouchable* and prevents the body from achieving pure immanence (254). *Persona*'s child stretches out for this pre-*écart* matrix of immanence, but this unconscious effort to annihilate the primary tactility only reconfirms it through the boy's secondary tactility experienced between two skins, the screen and his hand. That is, his body is already separated from the woman's body and this "embodied alterity" is a primary condition of the being of the body" (Mark

Figure 2.12

Hansen 2006b, 74). What the film implies at this moment may be the birth of the skin ego.

Ambivalent as such, the skin both enables and disables connection. Michel Serres says that it is "the milieu of the other senses as milieux," a kind of "common sense" as it intervenes in things and brings about their mingling (1985, 97).[29] This intersensorial skin of primary tactility faces the world as a fabric, "the tissue that lines [things], sustains them, nourishes them, and which, for its part is not a thing, but a possibility, a latency, and a *flesh* of things" (Merleau-Ponty 1968, 132). Just like Merleau-Ponty, Serres describes two hands' reversible subjectivity/objectivity in the case that the left hand trims the right hand's nails (1985, 19). Nothing could better visualize this secondary tactility than M. C. Escher's well-known *Drawing Hands* (1948) with two hands drawing each other. Notably, Luce Irigaray criticizes the inherent male violence of grasping, capturing, cutting in this case, and offers instead a more delicate embodiment such as a prayer's two palms facing each other, "the hands that touch without taking hold—like the lips" (1993, 170).[30] No matter how we take it, however, the skin is a membrane, and in *Persona* it is equivalent to "a surface that resists Bergman's repeated attempts at penetration" (Rugg 2001, 81). In fact, before the child appears in the film, we see a lengthy, sexually charged montage containing several images of penetration: including an erect penis and a vagina-like lips figure, as well as two hands rubbing each other (touch/caress), followed by one

hand violently nailed down (sex/death). Only after these violent allegories of Eros and Thanatos does the child come into being, and he vainly gropes the impenetrable screen as if his skin ego were destined to live within the prison of a membrane. In short, the skin ego results from the penetration of the skin (hymen, body) and this ego might in turn desire to penetrate, while apparently just caressing, the screen skin as a primordial body he belonged to.

A variety of even less realistic examples lead to the cinematic fantasy of one's actual penetration into and through the screen. Sherlock Jr. jumps into the screen and "causes more of a rent in our aesthetic common sense than a tear in the white sheet of screen" (Stewart 1979, 348–367). Then there is the tear of this sheet at the comic end of the early experimental film *Entr'acte* (René Clair, 1924) as a man pops through the word "FIN." A modern video version is seen in the first part of Peter Campus's *Three Transitions* (1973). Superimposing two images shot by two cameras facing two opposite sides of a paper wall, this visual tongue-in-cheek shows Campus cutting the wall and entering it while simultaneously getting out from behind it—as if he is cutting through his own back (fig. 2.13). A contemporary horror version would be the sensational end of *Ringu* (Hideo Nakata, 1998) where a ghost crawls out of a TV monitor, the image becoming a real body, penetrating reality from the screen, and as mentioned in Chapter 1, 'desuturing' ghost film (genre) into film itself as ghost (fig. 2.14). Even

Figure 2.13

Figure 2.14

Lumière's first train film suggests that cinema might have come into being through a kind of intercourse between the self-destructive and the self-defensive power of the screen. The famous act of slicing an eyeball in *An Andalousian Dog* (1929) allegorizes the radical proximity of visuality and tactility by effectively raping the retina as a screen (Krauss 1986, 147–154). Here, to recite Georges Bataille from Rosalind Krauss, "we see that which exceeds the possibility of seeing, that which it is intolerable to see" (1986, 286). The screen as body/skin has often been a fantastic site of obscene cinematic sexual violence.

A perfect example of this fantasy is David Cronenberg's *Videodrome* (1983). On the border between reality and hallucination, a media-holic man literally enters a mouth-vulva in the opposite direction of *Ringu*'s ghost. There in a virtual wonderland, he performs in a sadomasochistic play with a woman in a TV set who bodily reacts when he whips it (fig. 2.15). This phallocentric fantasy calls attention to vision as touch as in *Peeping Tom,* but the initial aggression begins not with the seer but the seen; the TV image, the screen body seizes, seduces, and sucks the spectator into it, with visual distance replaced by tactile proximity.[31] Building on Maurice Blanchot, Shaviro argues that the passion for the image signals radical passivity, "a forced, ecstatic abjection, a form of captivation" (1993, 49). Sobchack also discusses the double meaning of passion, "passive suffering" and "active devotion," embodied by both Jesus Christ and *Videodrome*'s whipped woman.[32] Sexual passion is devotion to another's flesh, often passing through suffering. Furthermore, this process can imply "the sensation of 'touch' not as bodily sensations but as self-displacing, self-transforming objectification . . . pleasure" (Scarry 1985, 166). After penetrating the screen, the hero changes into

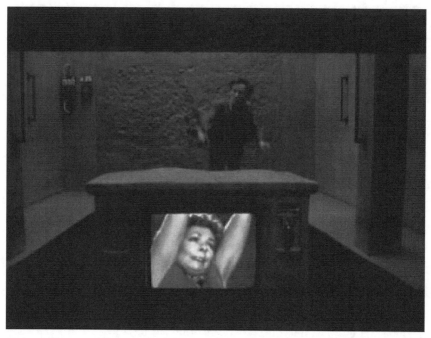

Figure 2.15

a "video-activated body," while reality loses its referentiality and suffers transformation. As his subjective reality becomes hallucinatory, his objective body becomes ever more sexually and technologically transgressive. The slit on his belly is a slot for videocassettes (fig. 2.16)—"a link between surface (skin, membrane, retina, image screen) and volume (the thickness and multiple convolutions of the entrails), and a vaginal orifice, indicating the sexualization and 'feminization' of Max's body" (Shaviro 1993, 139–142). Indeed "interfaces between biology and technology run amok" (144). The embodied desire for radical tactility turns both his hand and TV into a techno-fleshed pistol, until this interfacing leads to self-annihilation just as in *Peeping Tom*. The man's intensive experience of the other on screen thus reaches the impossibility of becoming the other within the possibility of becoming an interface. Becoming other is possible only as becoming interface, which implies becoming abject in this film. This abjection might, however, liberate the subject from its gendered, socialized mortality. No longer a slave to the ideological apparatus, the man is transformed into an abject yet alternative subject through ambivalent passion and tactility. The final manifesto "Death to videodrome, long live the new flesh!" sounds like 'death to the interface, long live the impersonal, inorganic body.' What matters is not reality but interface, not just a new cinema but also a new cinematic body.

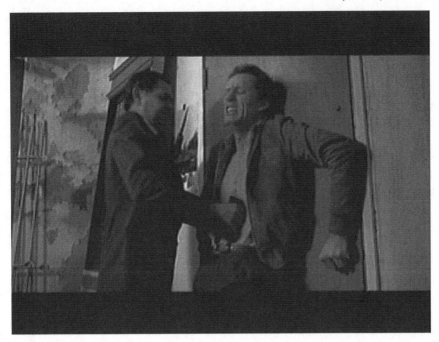

Figure 2.16

In short, ambivalence is double: the subject's apparent aggressivity toward the screen body entails his passive transformation into an interface, and this becoming interface entails abjection and liberation, regression and transgression at once. This is how the most phallocentric desire implodes into transsexuality and even asexuality, and why macho characters provoked by the screen body are paradoxically progressive.[33] This ambivalence concerns bio-ontology at large in Cronenberg's films such as *Scanners* (1981), *The Fly* (1986), and *Dead Ringers* (1988), wherein the human body embodies parasite alterity that is "neither part of me nor apart from me," in forms of other minds or even the nonhuman (Shaviro 1993, 146–147). Becoming interface, biological or technological, is nothing other than this becoming parasite that puts the subject in the double bind between self and other. Radically dispossessed and decentered, subjectivity remains all the more vulnerable and constrained so that its schizophrenic distortions involve bizarre transformations of physical, corporeal, and social space. In a broader history, the evolution of this body transformation on screen could be traced this way, following Shaviro's cue. First, Keaton's body combined with machines represents early capitalist mechanism, practical materialism, subversive Dadaism. Second, Jerry Lewis's body reflects late capitalist simulation, multiple and pulverized mass media images, "as if a mechanics of fluids or gases had replaced Keaton's mechanic of solids" (118). Third, Cronenberg's body

reembodies the late capitalist technology of disembodied information and algorithm by morphing into hybrid, corporeal interfaciality, dismantling old dichotomies of mind/matter, male/female, human/inhuman, and showing the monstrous ambivalence between fascination and disgust. The philosophy of embodiment goes to the extreme here. It not only short-circuits every variation of the Cartesian-Hegelian opposition between active subject and passive object, but also affirms dangerous passivity open to transformation into Bodies without Organs, going beyond Merleau-Pontian phenomenology that tends to retain the active subjectivity of embodiment.[34] Shaviro embraces without reserve "a Bataillean ecstasy of expenditure, of automutilation and self-abandonment—neither Imaginary plenitude nor Symbolic articulation, but the blinding intoxication of contact with the Real" (54).

We enter this Real, a Deleuzian technosphere that amalgamates bodies and interfaces literally into 'desiring machines,' through the passion for passivity, the passionate abandonment of subjectivity or devotion to objectivity, the embracing of suffering, and the enjoyment of that feeling—no wonder it can be called masochism. In effect, Peeping Tom's aggressive filming might hide the masochistic desire to feel his victims' sufferings by watching their death on his screen, his imaginary way of becoming other. And this masochism culminates in his filming/shooting of his own death. *Henry: Portrait of a Serial Killer* (John McNaughton, 1986) has a similar scene in which two psychopathic murderers' sadistic visual pleasure (they watch the snuff films they make) turns into the incredible violence of one's piercing the other's eyes and sawing his body. Perhaps such 'sicko' films testify to the case of one's failure of becoming other without any possibility of becoming interface in the most brutal convolution of visuality and tactility, of sadism and masochism. The body, interfacing with another body, is so vulnerable to the implosive desire for a Body without Organs. In the end, Deleuze evokes Stéphane Mallarmé's poetic lament in *Brise marine* (1865): "*La chair est triste, hélas!*"

BODY SCREEN: AMBIVALENT HYMEN, IMPOSSIBLE PENETRATION, POSSIBLE INSCRIPTION

For an alternative model of becoming other, I move the focus from screen body to body screen, that is, one's skin becoming a screen of his or her desired other. This type of becoming interface seems to render more palpable the other side of masochism: suffering as pleasure. When Joe in *Virginity* hugs himself to hug Anna Maria's image projected on his skin, this masturbatory action bittersweetly transforms suffering from losing her into its perversely narcissistic endurance. As we have seen, this body screen invokes a primordial union with the (m)other on the skin that is equally the internalized interface embodying the primal *écart*. And this performance expresses the mimetic embodiment of imaged stimulations coming from the external cinematic interface.

With these two aspects in mind, let me briefly introduce a key literary antecedent to Joe. *Pierrot Murderer of His Wife*, a mime booklet by M. Paul Margueritte (1882) on which Mallarmé's poem *Mimique* (1897) is based, describes Pierrot's reenactment of tickling his unfaithful wife until she dies of orgasmic laughter. Being a one-man show, he plays the roles of both his wife and himself, her murder turning into his suicide:

> He tickles wild, he tickles fierce, he tickles again, he tickles without mercy, then throws himself off the bed and becomes Columbine. She [he] writhes in horrible gaiety. One of the arms gets loose and frees the other arm, and these two crazed arms start fulminating against Pierrot. She [he] bursts out in a true, strident, mortal laugh; sits bolt upright; tries to jump out of bed; and still her [his] feet are dancing, tickled, tortured, epileptic. It is the death throes. She [he] rises up once or twice—supreme spasm!—opens her [his] mouth for one last curse, and throws back, out of the bed, her [his] drooping head and arms. Pierrot becomes Pierrot again.[35]

With no artificial interface, Pierrot's own body becomes an interface on which the object of his desire and crime is virtually incorporated. Apposite to his action is Benjamin's idea of embodied mimesis, which I am temped to retool via Derrida's reading of Mallarmé, especially of Mallarmé's *hymen*. This word paradoxically means both "marriage" (union) and "maidenhead" (membrane), the former assuming the destruction of the latter, but Derrida argues that Pierrot and Columbine's bodily (con)fusion 'consummates' the crime with no perpetration of actual violence. Thus, we have the orgasm with no penetration of the membrane that is, I say, her [his] skin.[36]

In fact the crime had not been seen by anyone, nor had it even really been committed. Pierrot mimes nothing that preexists his mimicry, annihilating alternatives of the imitating and imitated, the copy and original, the present and past. For Derrida, this deconstructs the traditional (Platonic) notion of mimesis based on the spatiotemporal gap between the representing subject and represented object. "What is marked in this hymen between the future (desire) and the present (fulfillment), between the past (remembrance) and the present (perpetration), between the capacity and the act, etc., is only a series of temporal differences without any central present," all tenses mingling in the spacing between them (1992, 162). Obviously the hymen is another name for this spatiotemporal *différance*, "an operation that *both* sows confusion *between* opposites *and* stands *between* the opposites 'at once'" (164). Derrida connects this in-between-ness, the *entre* in French, with its French homophone *antre* ("cave"; hollow space) that has the same etymology of "interval"/"inter-" as *entrer* ("to enter"). Here I quote Mallarmé: "a hymen (out of which flows Dream) . . . the Mime operates, whose act is confined to a perpetual allusion without breaking the ice or the mirror: he thus sets up a medium, a pure medium, of fiction." Two things follow.

First, the metaphysical hue of Derrida's term *hymen* as empty mediating space colors the ungraspable *écart* embodied in the physical hymen of Pierrot's skin, the primary interface as 'medium' that fuses two bodies 'without being broken,' because its physicality is almost empty, immanent in/between the bodies. Second, the hymen-antre interplay resonates with metaphors of screen skin and theater-cave, all alluding to the double 'dream' body of uterus-embryo, an asubjective Body without Organs that would be, in Mallarmé's words, nothing but "the phantom, white as a yet unwritten page." A BwO therefore emerges not through a violent approach to the other's screen body, but through the performative immersion into one's own body screen. Receding in a dream that mingles past-present-future, Pierrot disorganizes his body and becomes schizophrenic, formless, hallucinated, androgynous, purely affective, and intensive as spasmodic laughter.

Now let me in turn retool Derrida via Benjamin to reexamine another aspect of the mimetic faculty. By mimicry, Benjamin means representing a thing by acting like it when driven by the powerful compulsion "to become and behave like something else," as a child plays at being a windmill or train with its whole body (1978b, 333). "Mimesis is an immanent way of being in the world, whereby the subject comes into being not through abstraction from the world but compassionate involvement in it" (Marks 2000, 141).[37] The subject tactilely embodies the object by eclipsing any transcendental distance that buttresses the visual and linguistic representation based on binary codes such as signifier/signified. As the Rube's body language exhibits a materially innervated body beyond language, some physical causality works in the way the object materially stimulates the subject who in turn materially incorporates the object. In Peircean semiotic terms, a mimetic act is neither just an icon nor a symbol but an index of this corporeality; in Lacan's terminology, its register is neither the pure Imaginary nor the Symbolic but the Real as the material ground of physical action. To decode this embodied mimesis would be to "read what was never written" in established languages (Benjamin 1978b, 336), as Pierrot is nothing but "a yet unwritten page." Derrida says: "The Mime ought only to write himself on the white page he is; he must *himself* inscribe *himself* through gestures and plays of facial expressions." Further: "At once page and quill, Pierrot is both passive and active, matter and form, the author, the means, and the raw material of his mimodrama" (1992, 148). Pierrot's body is a *tabula rasa* where contact draws attention to the sexual performativity of material inscription itself rather than to its ultimate meaning. Playfulness, if any, emerges in this return from the dead end of becoming other by turning the impossibility of penetration into the possibility of inscription.

If we expand this erotics from sexuality to sensuality, apposite is Barthes's idea of the radical pleasure or *jouissance* of the text that concerns less signification as fixed sense than *signifiance* as sense-ation, the sensible effect of material signifiers as mentioned in Chapter 1. The hermeneutic dynamic of Pierrot-Joe's sadomasochistic tragicomedy can then be reviewed from the

perspective of writing as "a dermatological dynamic of abrasions, tears, lesions in imaginary veils and surfaces" (Connor 2004, 53). These are imaginary because they project images, but also real because projection is the indexical inscription of light on the screen, of image on the skin. *The Man who Left his Will on Film* (Oshima Nagisa, 1970) asserts in its title that film is primary inscriptive material. The 'man' projects his film on his girlfriend's naked body and virtually becomes a light/image with letters caressing her skin. Their erotic intercourse (hymen as marriage) on this impenetrable body screen (hymen as membrane) is less sexually explicit than sensually extensive. She tenderly rubs her tactile body as if it is his imaginary body (fig. 2.17). In *Ugetsu monogatari* (1953), Mizoguchi Kenji represents a precinematic, more inscriptive version of body interface; the skin becomes a talisman on which calligraphy is directly written. *The Pillow Book* (Peter Greenaway, 1996) synthetically exposes inscription and projection, the body appearing as paper and screen. It is not the other's body that the subject wants to take, but his/her own body that becomes an asexual interface for the asubjective inscription of visualized tactility (fig. 2.18).

As my last example in this line, a 'puzzle film' *Memento* (Christopher Nolan, 2000) deserves enough space because of its various inscriptive interfaces including the body. A sort of self-hired private dick, Leonard hunts for the rapist and killer of his wife, desperately depending on all possible mnemonic devices to overcome short-term memory loss. His map with such mementos as notes and photos exhibits a paranoiac classical subjectivity that imposes a self-organizing system on the illogical world. This epistemological

Figure 2.17

Figure 2.18

autopoeisis also structures his body with tattoos, making it a linguistic inter-face of inscribed information. Yet, like Pierrot, Leonard is the very murderer of his wife, though unlike Pierrot, his body does not imitate but effaces her body under the false symbolic 'order' in its double sense: all signifiers are arranged around their originary and ultimate signified, a fictive criminal, and this sign system makes him an agent who chases after that absent fig-ure. Not coincidentally, this misrecognized Goal is properly readable only in the mirror ("JOHN G. RAPED AND MURDERED MY WIFE"), evoking that the mirror stage misrecognition is the basis of one's identity. Whether recollected or imagined, an ambiguous shot of his wife looking at his now absent tattoo "I'VE DONE IT" hints that the vengeance is already wrongly perpetrated and erased under the empty signifier G(od(ot)), which fugitively lures him into the serial killing of innocent John G.s he forgets every time (fig. 2.19). This is in effect Leonard's unconscious strategy to survive in the hellish world that breaks down every fifteen minutes in memory. In other words, he masochistically takes full advantage of his distressing amnesia to leave the revenge as a 'mission impossible' in permanent *différance,* thereby paradoxically sustaining his raison d'être. However, the real cause of his trauma is not simply displaced to John G.s, but symptomatically disguised in the name of Jenkis, his former policyholder with the same memory loss and crime history. Leonard repeats the Jenkis story in the unconscious effort to evade the Real of his own guilt by staging and even enjoying his trauma as the other's Imaginary drama. The whole fantasy of Jenkis could thus be

Figure 2.19

called an *interface sequence,* following our aforementioned crescendo in the scale of interface. This ambivalent interfaciality is tactilely inscribed in the tattoo *"remember Sammy Jenkis"* in lowercase cursive letters that do not disappear even when he washes his hand.

We can then shift our focus from the depth of Leonard's memory to the surface of his mementos. This surface is an ever-rewritten palimpsest that is put under erasure as quickly as his brain. His prosthetic memory is thus nothing but another short-term rebooting system. His will to live as a normal subject only enables him to relive as a nonidentical agent drifting in the realm of surplus killing. Yet he unconsciously knows he should endure and even enjoy this Real with no exit, so he playfully adopts his victim's clothes and car as if to change his identity. The textual world of signifiers then turns out to be less a desperate pathway to the unattainable signified than a playground of symptoms that the subject's private *jouissance* invades the symbolic order. Touching his skin sensually, Nathalie—a kind of surrogate mother/wife—carries the erotics of the mirror phase but also of *signifiance,* the pure material beauty of inscribed signifiers. Just as his wife suggests that the same novel can be read repeatedly not for its fixed meaning but for its ever-changing textual play ("I enjoy it, just let me read"), so his skin book may be less "readerly" than "writerly" in Barthes's terms, or say, rewritable and reenjoyable (Barthes 1970, 3–4). Thus the entire network of recording machines including his body is, so to speak, a textual Body without Organs. Instead of dressing a tree-shaped symbolic system or in spite of his desire to do so, all his mementos spread out like rhizomes on a metaphorical skin register larger than his body, and are grafted into others (Teddy, Nathalie) who use him as a smart bomb for their own objectives. Put bluntly, his prosthetic traces do not wholly belong to his classical ego, and his rebirth through these interfaces has little to do with being a fixed self or becoming a fixed other. *Memento* rather insinuates that reliving one's life depends on interfaces that deterritorialize the boundaries between self and other, even between human

and machine, onto an epidermic Real full of contingency and flexibility. The subject then becomes an abject agent whose "productive pathology" typical in what Elsaesser calls mind-game films (2009) yields a new interfacial life even if posthuman or posthumous.

THE SKIN INTERFACE IN THE ELECTRIC/DIGITAL WORLD: DISEMBODIMENT OR (RE)EMBODIMENT?

In sum, our double look into body screen and screen body has led to *Videodrome* and *Memento*, both with a double nuance of a single conclusion: becoming interface either reaches the dead end of death or repeats rebirth in a closed circuit, where the latter might be considered a form of posthumous life triggered by the posthuman desire inherent in the former. Whether overtly terrible or covertly playful, both these cases signal a radical expansion of the body from a single subject to a common if not explicitly corporeal BwO through the apparently pathetic yet virtually productive pathologies of schizophrenia and amnesia. That is, those eccentric heroes' half-hellish masochistic adventures require the full embrace of ontological fragility and the unavoidable abjection of subjectivity into the machinic technosphere of media and prostheses. This is not an option but rather the double bind of *being* that they must accept in spite of themselves. Leonard's taxidermic struggle to restore everything only proves that his identity is ever more disseminated over an epidermic matrix of heterogeneous signs and subjects, just as wielding a Polaroid camera like a weapon does not prevent him from being a programmable weapon used by his friends. He then represents not the classical film noir detective, but the postclassical multitasking player. His dissociative and random reactions are (self-) programmed not through ideology, but through the body as "a technology of recording, storage, and replay: the somatic or pathologized body as an advanced 'neural' or 'biological' medium, in its mental instability and volatility" (Elsaesser 2009a, 29). Likewise, his world could be viewed less as a symbolic order of law/ prohibition that represses the psychoanalytic Real of his traumatic crime than as a spandex-like ontological Real-as-such that is woven through contingent events and agents, flexible procedures, and protocols. These make him reproduce simulacra of his original sin. Efficiently and pervasively, his unconscious follows what Žižek phrases as the postmodern obscene super-ego's order (despite his amnesiac consciousness): "Enjoy your symptom!"

Putting aside judging this immoral Epicureanism, I conclude with some issues related to postclassical subjectivity and its environment. First, the new concept of body or skin as interweaving the subject and world in the BwO mode has been boldly elaborated on in media and performance arts. Stelarc may be the first name in this line. In the provocative *Suspension* series (1978–1985) his naked body strung up in the air exhibits an extreme embodiment of pain that paradoxically achieves "the (symbolic)

overcoming of gravity . . . a state of disembodiment, of nonworldliness." The strings then appear like "the world-spanning web as the 'new skin' of humanity" (Benthien 2002, 233–234). In my view, it is a BwO-like womb in which his adult body becomes a sort of fetus, embryo, that is (part of) BwO. Meanwhile, Stelarc's *The Third Hand* (1981) and Stahl Stenslie's cyber SM/ inter-skin projects (1993–94) create systems of distant touch, an intimacy through such interfaces as Touch Suits that deliver one's touch of his/her body to the other user's sense. The physical and psychological boundaries between subjects thus collapse on the network of teletactility, a common techno-skin for prenarcissist non-separation. "Imagine: a body that is no longer tied to its skin," says Stelarc (Benthien 2002, 234), as if to make his 'embodied' version of Brakhage's aforementioned manifesto. Here it is clear how technology overcomes the notion of skin ego, as the skin now works no longer as the ego-forming interface of *écart,* a closure, but as the ego-expanding interface of intercourse, a trans-bodily hyper-organ dissolving the inner and outer.

But let's be alert to the new ambivalence that the embodiment of interfaciality entails the disembodiment of subjectivity, especially on the Internet. The bidirectional feedback between life systems and the environment occurring on and through the well-bounded biological skin gives way to the multidirectional rapid osmosis among networked users who share the fluid electric skin of the cyberzone. Even before the digital revolution, Marshall McLuhan said, "In the electric age, we wear all mankind as our skin" (2003, 70). As he argues, the industrial revolution expanded our feet through locomotor apparatuses, and the electric revolution expanded our nervous system through light-speed media. The result is "a polymorphous, infinitely mobile and extensible skin of secondary simulations and stimulations," which enhances our versatility by enlarging our psychic surface area with different kinds of experience and also numbs us by "the dazing overload of sensations" from "this synthetic pseudo-skin" (Connor 2004, 65). The BwO evolves into a "body-sieve" with no surface but holes for interconnection in that everything is "a mixture of bodies, and inside the body, interlocking and penetration" (Deleuze 1990, 86–87). Simply, it is nobody's body.

The second point is the more radicalized phase of this ambivalence between embodiment and disembodiment in the digital era. On one hand, a new mode of "humanization" occurs when the self-possessed body is dispersed into "a multiplicity of bodies inhabiting different temporal and spatial sites" (Del Rio 1996). This diagnosis drawn from the videophone dialogue in Atom Egoyan's *Speaking Parts* (1989) could apply to such popular films as *Déjà Vu* where we saw the dazzling electronic reconfiguration of the lived body subject. Jennifer Barker poetically argues that digital films such as *Toy Story* (John Lasseter, 1995) are "digit-ally appealing," triggering our digits' reaction. This is why action adventure or theme park entertainments seem to her to embody the ideal of total cinema that meets all our senses (2009, 136–138). On the other hand, this sort of digital utopia is suspected

to be dystopian. Sobchack argues that the electronic tends to marginalize or trivialize the human body, which thus appears either fatally interrogated ("riddled with holes," "blown away") or superhumanized as a hard body, "a lean, mean, and immortal 'machine'" like those in *The Terminator* (James Cameron, 1984) or *The Matrix*. The body is reconfigured through disembodiment, and consciousness is digitized into the neutral nets and onto the screens of a solely electronic existence so that "we are all in danger of soon becoming merely ghosts in the machine" (2004, 161–162). Sharing Sobchack's concern, Hayles says that computer codes compose self-evolving programs as life forms, whose on/off units privilege abstract information over material instantiation to the extent that "disembodied information becomes the ultimate Platonic Form" like an immortal pure capital without spatiotemporal limits (1999, 9–13). Quantifiable and decontextualized, information itself consists of meaningless signals that interfaces encode into messages materially and visually. Digitization therefore marks the shift from "floating signifiers" (presence/absence, 'fort/da,' male/female) to "flickering signifiers" (binary digits of 'zero or one') (31). The multisensory interaction in virtual reality is a fantastic but pseudo-embodied experience created at the cost of subjectivity that is then dispersed throughout the cybernetic circuit. The user learns, kinesthetically and proprioceptively, that interactive boundaries are defined "less by the skin than by the feedback loops connecting body and simulation in a technobio-integrated circuit" (27).

However, this virtual reality also has the potential of digital reembodiment. For proprioception is the sense of one's own body, of being present with one's body situated in the environment, and new media technologies rediscover this primary tactility in the way the question is not visual but visceral interfaciality. Suggestive is the evolution of Virtual Reality (VR) that Mark Hansen points out: from representationalism to functionalism. The former aims at a total simulacrum of a self-contained illusory space through prosthetic interfaces like head mounted display, causing disembodied transcendence. The latter privileges the perceptuomotor activity of embodied human agency, actualizing intentional tactility for access to the world. The VR evolution accompanies the shift from visual observation to tactile operation, from spatial construction to bodily participation, from virtual content to actual method. Hansen emphasizes that the body can be the very interface that materializes or transforms, namely "enframes" or, say, 'sutures,' unframed and disembodied digital information into a visually concrete and meaningful form. When the user moves around, an information space is activated and reorganized in recent media installation works he analyzes.[38] But then, does this completely solve the problem of disembodiment? How can the reembodiment of information work in the more common reality in which we still need to use technological interfaces to connect with others? Can technology and body, artificial and embodied interfaces, truly become one in the way of resolving the ambivalent tactility immanent in becoming interface?

These questions may urge us to explore a larger context of technology studies developed by Don Ihde, Donna Haraway, Bruno Latour, Ian Hacking,

Figure 2.20

and so on. But leaving this task for later, let me just call attention to a real-istic film on VR, especially cybersex, that makes us face, if not solve, the problem more existentially. As tested primitively in *Videodrome*, cybersex has arguably been the most explicit form of embodying technological inter-face, and Sobchack sharply captures this VR mechanism of the male erotic desire to "jack off" by "jacking in" and playing with a "joy stick." How-ever, this is a contradictory wish "to get rid of the body through technology so as to overcome the material demands and limitations of the flesh—and 'to escape the newly extended body of technological engagement' so as *'to reclaim experience through the flesh'*" (2004, 175). The opening scene of *Thomas in Love* (Pierre-Paul Renders, 2001) shows this paradox through the highly tactile visual representation of Thomas's sex with a cybergirl, which is of course his masturbation (fig. 2.20). But the film is more about his physically constrained agoraphobic life. We only see people he sees on videophone, and this first-person point of view interface totally positions him as an immobile spectator with a remote control by which to switch real-time interactive channels. In short, he is a virtual nomad anchored in an actual place. This is not an SF situation, just as our social relationship becomes ever more elastic and ephemeral, depending on skills for attraction and protection, connection and disconnection at once. However, cybersex, the most secure prostitution, does not prevent a cyber love, which need not be 'cyber' to be love. Thomas's virtual touch of a cybergirl only makes him realize that he cannot touch the real girl he falls in love with on the Internet. When he steps in the sunshine to go out of his apartment at the end, this undead cyber-Dracula looks as if he would soon fall and die. Thus, love is suicide. Or, we should ask: Would love be the only way of reembodying real tactility at the cost of interfaciality?

3 The Surface of the Object

MYSTERIOUS OBJECT, QUASI-INTERFACE

On the grass on a shiny peaceful day, a woman tells Dr. Toey a fable: a long time ago there were two poor farmers who, following a monk's tip, gathered as much gold and silver as they could around a lake (we see an adjoining field that is said to have been the lake); suddenly a solar eclipse occurred, but the farmers didn't stop and one of them came back for more gold (a total eclipse darkens the screen, which consequently loses depth of field); the story ends with thieves robbing the greedy farmer's house and shooting him dead. The lesson is: "No matter what we do, something always watches us" (fig. 3.1).

In this Thai film *Syndromes and a Century* (Apichatpong Weerasethakul, 2006) the eclipsed sun contoured by its thin light in the deep blue sky not

Figure 3.1

only evokes the title of the director's debut feature, *Mysterious Object at Noon* (2000), but it also visualizes the superego gaze, a god's eye, a surveillance camera in the sky, as if interfaciality immanent in the object came up onto its surface which thus appears as what I shall term a cinematic *quasi-interface*. Furthermore, the darkened sun radiates an ineffable aura for a time-freezing moment such that its epiphany does not seem fully represented in the human ethics that the moral story conveys.[1] This surreal image suggests that the visual shift from three-dimensional illusionism to two-dimensional flatness can facilitate a more fundamental shift toward the virtual dimension of the actual world. If we focused on explicit cinematic interfaces and their explicit bodily receptions in the two former chapters, the two following chapters now decentralize this medium-body interplay and expand our view of matter in general. Reengaging with the discourse on *illusion*, this chapter traces its desuture into, say, *immanent virtuality* as another facet of interfaciality by looking 'at' the surface of the world or object and looking 'through' it, as it becomes a pseudo-interface looking 'like' a camera, filmstrip, or screen. What is pursued here is a cinematic experience of the ontologically inhuman matrix of all beings.

'SYNDROMES' OF THE VIRTUAL AND A NEW CINEMATIC 'CENTURY'

Before delving into visual and theoretical specifics, let me explore more of the Apichatpong film in view of his filmography that shows his ongoing experiment on immanent virtuality. Loosely based on the love story of the director's doctor parents, *Syndromes and a Century* takes a bipartite structure: the tranquil, humorous first half unfolds in a rural area (alluding to the 1970s spent in his parents' hospitals), and the somewhat chilly, ultramodern second half represents an urban counterpart (indicative of the new century the director now inhabits). This spatiotemporal shift is salient. The surreal harmony of a huge Buddhist statue and a basketball hoop (part 1) is replaced by the real contrast of a Buddhist statue dwarfed by elevated roads and the bronze statues of modern people (part 2). We see an ecological space where tropical trees gently sway outside a medical office while a young monk plays guitar beside patients who chat leisurely under the afternoon sunshine (part 1). Then, we see photos of a new-tech area, an index of Southeast Asia's transformation into a place prefigured in *Red Desert* (Michelangelo Antonioni, 1964) with such overwhelming, even sublime factories, albeit without the gloomy smoke (part 2). One space-time unit rhymes with another in this film. So when a middle-aged doctor attempts the *chakra* healing process under a fluorescent lamp—a folk remedy channeling the sun's power into the body—this may not be just an absurd joke or a satire on superstition, but rather a link between the natural light shining in part 1 and its artificial counterpart prevailing in part 2. The latter does not

seem to be a mere reversal or displacement of the former, but provokes some radical curiosity: How has the sun been replaced by a fluorescent lamp?

To answer this question, we need to go through a wider web of hidden links. Both parts in fact open with the same scene: Dr. Toey examines Dr. Nohng, though slightly differently, as two forking paths draw roughly similar maps of relationships. Part 1 consists of Toa's love for Dr. Toey, and part 2 shows the Dr. Nohng couple, and his fellow doctors. This is a cinematic fugue played between a rural hospital, the setting for Dr. Toey's love triangle and a homosexual bond, and an urban hospital, the stage for a male doctor's secret love and his homosocial bond. In Buddhist terms, Part 1 is followed by Part 2 in which many things are reborn, gathering their karma. Sure enough, Apichatpong says that love yields recurrent "syndromes" of sickness and a "century" passes like a lifetime (Apichatpong 2010). His belief in reincarnation thus, interestingly, fits into the structuralist coordinate system in which the vertical axis comprises synchronic/semantic elements that are (re)aligned with the horizontal axis of diachronic/syntactic narrative. This is, so to speak, Apichatpong's version of "difference and repetition."[2]

To confirm this, a brief look back on his previous film *Tropical Malady* (2004) suffices. Many connections link the two parts of this *Tropical Malady*: the couple's wandering in a city, a corpse, a singer, urban noise (part 1) and the search for lost love in the jungle, a dead cow, a baboon, natural sound (part 2). These rhymes might insinuate that the city is not separated from the jungle so much as superimposed upon it. Part 2 thus repeats part 1, while deterritorializing its sociohistorical reality to an immanent realm which is, as we will see, experienced phenomenologically, then ontologically—the virtual realm where a legendary ghost animal resides. And it is this ontological shift that makes part 2 not just a diegetic repetition in a different place, but a dynamic leap to a different time, the immemorial past that still coalesces in the present. The audacious intermission of a ten-minute blank screen between two parts precisely foreshadows this rupture: "The time is out of joint."[3]

Now the question is: When and where does the ontological turn occur in the apparently symmetrical structure of *Syndromes and a Century* with no such caesura? Notably, each sub-narrative often digresses rather than progresses, moving in the centrifugal rather than centripetal direction as happens in the aforementioned eclipse scene. We can say that, first, time is out of joint in Dr. Toey's flashback (she tells her admirer Toa about her own past syndrome of single-sided love) though it lasts so long that we might even forget its pastness. Second, the image of the field described as the former lake, which is not represented, evokes the temporal strata deposited underneath it, so that time is rewound, now in the virtual mode. Third, in fact, the sun slowly emerges from behind the moon, leading to a shift in light from dark blue to normal daylight, before the film cuts back to the woman and Dr. Toey. It is as if the eclipse occurred with them on the grass where they sit rather than being an image from a reenacted fable; given the

situation, this nonsensical montage could only suggest that the legendary past is virtually immanent in the ordinary present.

Such a "crystal-image," which for Deleuze renders indiscernible the actual and the virtual, the real and the imaginary (1989, 68–69), the present and the past, reappears in a similar form of quasi-interface at the end of the film. In the basement of a modern hospital, a roaming camera slowly approaches an intake vent until it begins to resemble a huge round black hole sucking in smoke; ultimately it takes up the center of our visual field. The three-dimensional screen space, then, transforms itself into an eclipse-evoking void that gazes at us and absorbs our intellect, vision, and sense (fig. 3.2). To where would these natural and artificial eclipses take us, if not to an ontological ground of the world, the Real as Virtual—whether Lacanian or Deleuzian—in Eternal Return—whether Buddhist or Nietzschean? Furthermore, this unfathomable interface with emptiness abruptly cuts to the film's last scene of a too-ordinary city landscape, whose inhabitants—dating, playing, exercising, and so forth—seem completely unaware of what lurks underground. An ontological rupture occurs through this "irrational cut," as if the black hole of the vent, having engulfed the entire world, now belches it out. Likewise, our daily life might be the actualization of the virtual at every moment or the realization of the world's own unconscious memory we cannot even claim.

Let me call this process of the supersensible becoming sensible, again, "suture" in its largest sense proposed at the end of Chapter 1. Despite the risk of being metaphoric, we could ask how this general idea of suture ontologically brings about our subjectivity and reality, and how its recognition extends our epistemological horizon. For example, isn't the gay romance

Figure 3.2

in *Tropical Malady* a sutured form of the unrepresentable human-animal fusion into an asubjective state of being whose memory is retained only among the souls of trees? In fact, love is hardly Apichatpong's theme. It is, so to speak, a civilizational suture of the impersonal desire and relationship between any disparate types of being. His interest is an open process by which the supposedly autobiographical *Syndromes and a Century* fails to represent his recollections as such, but succeeds in recapturing the 'feeling of the memory' blended with mysterious chance encounters during filmmaking. It thereby becomes a Proustian reminiscence of an imaginary world in which Dr. Nohng and Dr. Toey reenact what the director's parents didn't actually do but could have done, in which they are lost in the net of amorphous relations, reincarnations, old fables, and modern architecture, only to let us sense inhuman eyes viewing all human desires from an ontological ground.

Far from negating love, however, the film suggests that every love is an everyday miracle, like that monk-dentist friendship. But it is miraculous perhaps because even more unrealized relationships underlie it, as the dentist feels his dead brother is reincarnated as the monk. This sense of déjà vu belongs not to his subjective memory so much as the unsutured unconscious of the world itself. When we see green trees softly shining outside the dentist's clinic at night, it is rather those trees that have been watching the empty interior, recording all that transpired for the couple by day, and remaining as evidence of this remembrance as though the past is not even past (fig. 3.3). Rather than simply intimating optical personification, the tiger in *Tropical Malady* also seems to remember even thousands of years' impersonal desires shared by former lives, with humans becoming animals

Figure 3.3

(not the other way around). This is why love is a human "worldly desire"—the title of a short film by the director—that sutures the desire of the entire world as such. Likewise, in *Syndromes and a Century,* the succession of two statue shots—Buddha and the fathers of modern Thai medicine—might imply that the Buddhist 'inter-individual' reincarnation has been sutured into the Western 'intra-individual' remediation. The natural quasi-camera in the sky is sutured into an artificial surveillance camera of CCTV that is inferred by the Dr. Nohng couple's alertness as they leave the hospital. So that we are indeed able to answer the question posed earlier: the fluorescent lamp is a sutured form of the sun!

Not limited to the suture of nature into civilization, the film also suggests that the unsutured ontological kernel still resides within civilizational space, rural or urban, just as a pseudo eclipse takes place in the underground of a modern city. Moreover, the civilizational environment could also be sutured into a system of patterns within civilization, just as a faint industrial noise filling the hospital seems sutured into the cultural form of sugar pop ballads and kitsch techno rhythms. The 'white noise' of civilization thus corresponds to the ambient sound of nature. And it is precisely this natural fuzzy song of softly rustling trees that connects the ending of *Tropical Malady* with the opening of *Syndromes and a Century* (fig. 3.4).

These night and day images shot in low-angle and in long take make visible the invisible "wind in the trees," which has long been an emblem of "cinephilia" that privileges the elusive *photogénie* of contingent details over narrative events or main themes (Keathley 2006).[4] Moreover, given the terms we examined in Chapter 1, any fixed shot containing the subtle but ceaseless movement of objects should not be considered a photographically

Figure 3.4

"privileged instant" (Deleuze dismissed) nor a "freeze frame" as visually privileged yet materially composed of equally 'unprivileged' photograms (Bellour revalued). Rather, another term might be needed for this unexplored type of "movement image" that conveys the cinematic duration of a nearly privileged and nearly still instant. It first seems to embody Bergson's double vision of everything photographing everything else (twigs and leaves perceive and reflect each other's image at every molecular moment) and everything retaining the memory of other images (every molecular moment repeats the same movement of all past moments in a way of becoming a new type of "time-image"). A possible ennui in this movement that opens pure time would also evoke Heidegger's idea of boredom that "removes all things and men and oneself along with it into a remarkable indifference. This boredom reveals being as a whole" (1949, 333–334). Coincidentally, a piece of sky amorphously iris-framed by trees in these typical Apichatpong shots looks like an open empty space in the forest, a Heideggerian "clearing" (*Lichtung*) through which entities other than ourselves can emerge out of hiddenness or are made visible by a bringing into the light—namely, a place or site for the unconcealment of being (*Dasein*).[5]

In short, Apichatpong reveals a series of stages in which the actual state of the world is desutured into its virtual verso through 'interfacial' objects. Our phenomenal experience of their images then leads us to their ontological stage, which is immanent in the screen. We might feel relieved when our uncomfortable encounter with the weird blank stare of the vent under the ground finally dissolves into the peaceful mundane reality on the ground. Yet because of that extraordinary encounter, the closing scene with several master shots of the city, which would otherwise have looked too ordinary, now makes us ask: What on earth is this partly serious, partly ridiculous Third World where everybody does aerobics to the rhythm of a kitsch postmodern techno culture, seemingly embodying the globalized wave of well-being? But let me first bring into relief the power of cinema to drive us into a black hole then send us back to reality, where we are forced to think anew not only about the image, but about the world. Like the basement of the modern hospital, the basis of our life is still under (de)construction. Sensing such syndromes of the virtual, Apichatpong opens a new cinematic century.

SPECTRUM OF INTERFACIALITY: SINGULAR (CAMERA), PLURAL (FILMSTRIP), MOLECULAR (SCREEN)

It is now clear that *Syndromes and a Century* pays more attention to things than to people by interfacing the human with its ecological surroundings. This interfaciality manifests itself according to three figures of the cinematic apparatus. First, as already pointed out, the eclipsed sun and the intake vent serve as a camera that returns our gaze (figs. 3.1–3.2). Second, a series of rectangular windows in the dentist's clinic may serve as a filmstrip, with

its photograms capturing the large green leaves of aligned tropical trees (fig. 3.3). These trees are biologically 'photosynthesizing' and, as Garrett Stewart would say, cinematically 'photosynthesized' into the moving image of their almost immobile movement (fig. 3.4). Third, innumerable leaves in the opening shot are not confined by this quasi-filmstrip consisting of artificial frames, but rather are open to the sky; this natural aperture might then serves as the screen at an unframed window.

This analogy between the objects and the cinematic interfaces might not be clearly convincing, as each quasi-interface has a different degree of visuality. The eclipse image fully resembles the camera, whereas visual similarity is weaker between the lineup of windows and the filmstrip, and even weaker between the sky seen through a jagged iris and the screen. However, this difference in visual clarity itself suggests a multilayered (de)suturing between interfaciality and immanence. Interfaciality is apparently sutured into, or surfacing onto, a quasi-camera in the case of the sun and the vent, when it remains immanent in the sky as if desutured. Perhaps this is because the sun and the vent are conspicuously individual objects, while the windows are structurally correlated, and the sky is in essence infinite. Contrary to the singular sun/vent, those large leaves outside the windows are plural, whereas the tiny leaves in the sky look relatively molecular—the wind passing through these leaves is, say, invisibly molecular, even atomic. The gradation of *singularity-plurality-molecularity* may thus indicate the degree to which objects are less and less translated into our human recognition, and thereby more and more deterritorialized into inhuman immanence.[6] This progression palpably reaffirms the asymmetrical dynamics between the eye and the Gaze/matter investigated in Chapter 1. The (camera) eye capturing reality is a sutured form of the Gaze inherent in the Real or the multitude of inorganic eyes immanent in movement-matter. In other words, the kino-eye standing for our eye's iris is born out of inhuman objects' eye-less eyes, that is, the eye in matter. Of course, the sun as a quasi-camera is not a human eye but this eye-less eye's becoming a quasi-eye. This oxymoronic "eye-less eye" is equivalent to pure perception immanent in the object as image among such objects, which are molecularly dispersed in a quasi-immobile state while virtually emitting their images and receiving other images at every molecular moment, just as do the tiny leaves as singularized eyes. We could even picture that the wind dissolves these minute leaves into the sky whose emptiness is nothing but the most molecularized stage of things, namely 'no-thing-ness.'

This perceptual interfaciality gains a more convincing account when it comes to memory à là Bergson. The sun as a camera watches and records the farmers' greedy act, thus its moral authority would be based on its remembrance of the specific scene of a singular sin that dramatically unfolds as a narrated event. But the (plural leaves outside the) windows seem to retain the memory of whatever occurs in the clinic, whether the daytime potential gay romance or even the nighttime silence with nothing really happening. Like photograms on the filmstrip, the images of the inside in the foreground passing

at the temporal interval of day and night are half-attentively, half-mechanically restored in the spatial seriality of those outdoor objects in the background. Finally, the sky (with molecular leaves) appears totally disinterested in witnessing particular events and detached from recollecting their images. The sky is just out there, as (part of) matter as such whose pure perception renews its content while repeating its form at any instant whatever, just like the screen. Though the phenomenological screen of actual images is not equal to this ontological screen—as examined in Chapter 1—the open whole of all screened images in ceaseless change would form this "plane of immanence." Pure memory is that of this immanence in multilayered temporality, and it appears as already actualized and always present in the case of the sky positioned behind molecularly moving images; it is the case of pure matter. So, paradoxically, this quasi-screen on screen could be viewed as barely 'visualizing' immanence that is in essence invisible and at best indirectly sensible through the change of all images and interstices on the screen (again, this visualized virtual would characterize the new type of movement image or time image).

If this quasi-screen signals the plane of immanence as a body without organs (BwO), all visual 'molecules' like those fine leaves—in the sense of being innumerable rather than plural—would look like infinitesimal organs floating on the screen as a not-yet-organized body.[7] Deleuze and Guattari's concept of BwO does not necessarily mean the absence of organs but concerns potentials of organs, say, quasi-organs that traverse an undifferentiated body in the form of a multiplicity of pure affects, machinic desires, and impersonal intensities. The BwO therefore embodies the virtual of becoming that generates the actual of being. In contrast to the quasi-screen, the quasi-camera could then fit within Slavoj Žižek's notion of "organs without bodies" (OwB). Criticizing the pair of becoming and being for repeating the old dichotomy of production and product, Žižek draws attention to another pair, being and event, found in early Deleuze. The virtual is then redefined as the site of the sense-event, which does not generate actual reality, but which is generated from reality. And the OwB appears through "the virtuality of the pure affect extracted from its embeddedness in a body, like the smile in *Alice in Wonderland* that persists alone, even when the Cheshire cat's body is no longer present" (Žižek 2004, 30).[8] Here, rather than fully following Žižek, I suggest that OwB are equivalent to (disorganized) organs on a BwO, only with the difference that we cannot identify this source body. That is, when apparently detached from a BwO, an organ may look as though it has lost its body, becoming an OwB. And since it is an *objet a*, it interfaces with the unseen Real, its virtual Body. So the eclipsed sun in *Syndromes and a Century* takes on the familiar image of the camera, while its appearance is unfamiliar because we see no body, no cameraman, and no contextual matrix of its emergence. We just experience an uncanny sense of what is behind and beyond this quasi-interface. In short, the spectrum of interface from quasi-camera (to quasi-filmstrip) to quasi-screen implies a pathway from OwB to BwO, the former interfacing with the latter.

For the sun to appear like an OwB, it must be eclipsed or cinematically processed so that light no longer prevents us from facing it head-on and we can look into it. That is, the sun can evoke the OwB on the condition that it looks like an "eye without a face,"[9] or a camera without cameraman. Likewise, the windows need to look like a cluster of photograms, plural quasi-eyes, so as to signal the proliferation of the OwB. And this proliferation continues from the windows to the molecular leaves that pulverize the visual space into the sky-like BwO. In the case of the "grin without a cat," we (are supposed to) directly recognize it as a virtual grin and nothing else, but in our example, we first recognize the actual sun and then take it as a virtual eye or camera. Both the grin and the sun are analogous to the OwB, but the sun needs figuratively to appear as a quasi-interface in the first place. Again, the eclipse or some similar visual effect facilitates this figuration. Such cinematic effects are weaker for the windows/leaves—just a bit eerie when seen at night—and even weaker for the sky/leaves. We could then take one more step from Žižek. His focus on Deleuze shifts from the virtual as BwO (the cause of the actual) to the virtual as OwB (the effect of the actual), emphasizing the rupture between these two virtual dimensions. And the latter virtual presumably occurs within, from, and against the actual (diegetic) world, just like his notion of 'suture' seen in Chapter 1. Yet significant is the cinematic power figuratively to visualize the virtual as sense effect in the form of quasi-interface from the surface of actual things, thereby evoking the virtual as matrix cause. Virtuality therefore comes full circle forming a Möbius strip without any spatiotemporal passage: the immanent virtual generates the actual diegetic world, whose surface turns into the ground of the sensual virtual, which interfaces back with the immanent virtual.

The kernel of this circuit lies in the figurative transformation of things becoming quasi-interfaces and not in the direct appearance of actual interfaces. The images of a single eye, of plural photograms, and of a multitude of molecules turn into a quasi-camera, a quasi-filmstrip, and a quasi-screen respectively. This becoming as figuration is thus a sort of cinematic illusion that enables immanent interfaciality to surface onto visuality. And the gap between interface and immanence decreases along the spectrum from quasi-camera to quasi-screen, so that a quasi-screen, often taking up most or all of the physical screen, appears not detached from the BwO but attached to it as though two virtualities had merged or the immanent BwO were nothing but its own sense effect. This virtuality as "the reality of the virtual itself," therefore, has nothing to do with "virtual reality" (VR) that imitates reality in an artificial medium and thus forms non-immanent actuality in diegesis (Žižek 2004, 3). This truth is obvious but still worth mentioning, because it gives more pertinence to the notion of interfaciality as *immanent virtuality* and thereby opens a new potential of cinematic illusion: not a more perfect imitation of the actual world, but a deeper immersion into its immanence that is virtually on the verge of surfacing to light.

RETRACING ILLUSION THEORY: TWO TRADITIONS AND BEYOND

To refine this new concept of illusion may require us to retrace the history of illusion theory. Unlike such target terms as *suture* and *embodiment, illusion* has penetrated the whole history of film theory from its inception and made it inevitable to address cinema in the much larger context of illusion-making media, pre- and post-cinematic. Yet since my ultimate aim is to shed light on an unprecedented usage of the term, I shall focus on a brief meta-critical engagement with a few seminal ideas.

Schematically, the formative and realist traditions in classical theory reflect two different perspectives on illusion.[10] Formativist theorists such as Hugo Münsterberg and Rudolf Arnheim find illusion less powerful on the silent, black-and-white, and two-dimensional screen than on the theater stage that is full of color, depth, and spoken language. However, this weakness becomes the cinema's strong point for two Neo-Kantian reasons. First, regarding the *phenomenal* realm of sense experience, Gestalt psychology explains that our perception synthetically configures retinal stimuli into a pattern, so the lack of full reality effect in cinema causes our more active mental process to experience the real from the visual stimuli we receive. Illusion then concerns not so much the image in itself as our psychological modulation of it, just as the famous "figure/ground" dilemma reveals.[11] Second, regarding the *noumenal* realm of the value of the object, Kantian aesthetics nourishes the idea that film can be artistic when freed from the imitation of physical nature, by sustaining the autonomy of beauty—what Kant calls "purposiveness without purpose"—thereby sustaining our "disinterested" attention to its inner world. In this regard film imitates our mental world. With the analogy between cinematic and psychic processes (close-up = attention, flashback = memory, etc.), Münsterberg claims that film overcomes the phenomenal rules of time, space, and causality to become an isolated realm of emotion and imagination.[12] Focusing more on abstract and fragmented film material, Arnheim asserts that cinema achieves an artistic triumph not by reproducing reality but by producing medium-specific effects through such techniques as fast/slow/backward motions, fade/dissolve/superimposition, and montage, which breaks the time-space continuum. Thus, the loss of natural perception grounds the gain for aesthetic perception (Arnheim 1957). This might sound like "a negative theory" in that filmic representation is "suppressed" in favor of artistic expression, and thus film is "not so much a window as a prism" (Dudley Andrew 1976a, 31). In sum, on the phenomenal side film represents the material world in a poor fashion that our mind must actively pattern, and on the noumenal side film artistically organizes its own pattern out of reality in ways of joining our mind. Neither phenomenally nor noumenally does cinema address reality as such according to the formative tradition.

Correspondingly, the realist tradition also has two founders, André Bazin and Siegfried Kracauer. But rather than a mere counterpunch to the formative group, the ontology of photographic realism refined by Bazin unfolds multilayered arguments that require careful attention because of his different usage of psychology and aesthetics. For him, "true realism" in the history of painting is an "aesthetic" one that expresses the "world in its concrete aspects and in its essence" like medieval art, which was "both violently realist and highly spiritual" (2009, 6).[13] This view, strikingly, overlaps with formative film aesthetics, which in fact was never solely noumenal: Münsterberg sees the photoplay becoming art "through the perfect unity of plot and pictorial appearance," that is, dismantling the physical time-space conjunction, yet retaining natural reality (Münsterberg 2002b, 190); Arnheim calls for the artistic "equilibrium" between mind and nature rather than ruling out the latter (Arnheim 1969, 31). Their antirealism exemplified as an artistic pattern like a "figure in the carpet" requires the realist carpet from which to elicit a formative perception; that is, it joins Bazin's "true realism." On the contrary, Bazin defines "pseudo-realism" as *trompe l'oeil* (or *trompe l'esprit*) that abandons this aesthetic interplay and only tries to fulfill the "psychological" desire for preserving appearances as such against time. This mimetic desire peaks in perspective, which Bazin infamously condemns as "the original sin of Western painting." Photography freed it from that "complex of [iconic] resemblance" by accepting the burden of this sin and paradoxically achieving the highest (indexical) resemblance (2009, 5–7).

Reserving a look into 'indexicality' for later, let me point out a sort of Bazin's dialectic here: although neither "true realism" nor "pseudo-realism"—both driven by mind—fits photographic realism based on the mechanical exclusion of subjectivity, photography can also be "aesthetic" in fully satisfying the "psychological" illusion of reality. Photographed nature imitates (even surpasses) the artist not by resembling the human mind, but perhaps by "stripping the object of habits and preconceived notions, of all the spiritual detritus that my perception has wrapped it in" (9). This would mean not that the virginity of nature appears beyond any Gestaltism so much as that a virginal perception of any Gestalt can occur.[14] "Every image should be experienced as an object and every object as an image" (9). A photograph, Bazin claims, is a "really existing hallucination" just like Surrealist painting's *trompe l'oeil* and its meticulous detail (10). If so, is his realism no other than surrealism? Does the painted *trompe l'oeil* of surreal objects take on indexicality that the painted *trompe l'oeil* of real objects cannot?[15] Regarding this conundrum, I argue that what really matters in Bazin is not indexicality per se (the term he did not use) so much as the indexical effect ("the machine-like impact of the image on our minds") which Surrealists and later Photorealist and Hyperrealist painters also bring to the viewer, sometimes using the gelatin of the photographic plate (9).[16] In Bazin's realism, therefore, medium specificity would be a little less decisive than has been thought, insofar as the indexical effect is guaranteed.

I should, however, note that Bazin mentions surrealist 'hallucinatory' realism as the "aesthetic potential" (rather than the actual state) of photography in which an indexical effect accompanies the utmost iconic effect. A "total cinema," a perfect illusion of the world in sound, color, and three-dimensionality, is therefore "yet to be invented" (15–17). Neo-Realism was on the way to that ideal, and cinema is thus "the asymptote of reality," aspiring ultimately to be life itself as spectacle (Bazin 2005a, 2:82). If the transition from iconic painting to indexical photography was qualitative, the black-and-white 2D film has ever evolved to emulate the colorful 3D theater experience through the quantitative increase of iconicity in perspective (which Arnheim regarded as a decrease in cinematic artistry).[17] This evolution, touched on in Chapter 2, marks the aesthetic shift from the haptic to the visual, from the early flatness of the screen to classical depth of field, and from "a plastic form linked to the sensation of objects seen in close-up" to "the properly pictorial form linked to a distant and subjective vision of space." Pierre Francastel accounts for this shift in terms of spectatorial topology: the spectator's close proximity (the feeling of being "next to," "around," "inside" the scene) changes into distant perspective ("near," "far," "in front of," "behind").[18] This feeling of distance institutes the ontological gap between theater space and screen space. The spectator is then positioned in a sort of control tower that overviews the whole visual field at once transcendentally and transparently, without belonging to it. Stanley Cavell, whose early work builds on Bazin, claims that the screen "screens me from the world it holds—that is, makes me invisible." This voyeuristic position, so to speak, may relate to "modern privacy or anonymity," a sense of virtual displacement from natural habitation (1971, 24 and 40–41). Though not intended by Cavell (whose view doesn't require psychoanalysis), the so-called transparency theory of illusion runs its course to transcendental subjectivity.

Not surprisingly, Grand Theory criticizes Bazinian realism for being naïve, as critics begin to regard illusion as 'codified' before/into being transparent. Umberto Eco sees cinema as a flow of grain organized into codes of iconic representation, and Christian Metz even says that any natural appeal to resemblance is "a sort of malady of youth" beyond which semiotics should move to decipher the codes that make analogy possible (1972, 153–154). Likewise, the formative psychology of someone like Ernst Gombrich emphasizes the cultural convention of artistic illusion over the biological automatism of natural perception. Rather than the mechanical replay of timeless Gestalt patterns, Gombrich draws attention to the system of 'readable' marks that through use and learning transform sensations into percepts, adjusting these to visual life (Gombrich 1960).[19] In short, the postrealist approaches basically redefine the spectator as a storehouse of physiological constancies, cultural predispositions, and aesthetic strategies. From this roughly common assumption, semiotics combined with psychoanalysis investigates the ideological structuration of transcendental spectatorship, and psychology

combined with cognitivism illustrates the practical operation of scientific spectatorship. We noted inChapter 2 that cognitivism reacted critically to psychoanalysis to shed more light on the cognitive activity of the embodied spectator, and phenomenology even addressed the realm of haptics beyond optics. To take a further step for reembodying spectatorship, we then looked into the spectator's actual tactile touch with the screen. Now I propose another mode of hapticity within the spectator's visual experience, namely, 'illusion of tactility' that can occur through the shift from 2D haptics to 3D optics. Ultimately, this new 3D tactility will in turn, and in contrast, make available the new 2D visuality at issue in which illusion concerns immanent virtuality rather than pseudo-tactile hapticity.

REDEFINING HAPTIC CINEMA, REFIGURING CINEMATIC ICONICITY

The first step in this double shift is to go beyond the mere opposition between 2D and 3D. As mentioned in Chapter 2, Noël Burch's notion of "haptic space" is seminal; it refers to a "composite picture" blending 2D and 3D modes, which emerged around the turn of early to classical cinema as what he calls the "Institutional Mode of Representation." Yet not limited to visual transparency, Burch sees the "conquest of space" in this cohabitation of surface and depth—I emphasize—*as if space could be grasped by hand in its total volume* (Burch 1990b, 162–184).[20] Francastel's sense of tactility as being "next to," "around," "inside" is regained here. In other words, optical illusion might not be solely visual, but entail the kind of tangible effect that Burch calls "the haptic." In most films, we virtually experience not the autonomy and abstraction of pure optics so much as a mixture of optic and haptic illusions, visual and tactile sensations, if not the direct touch with the screen. I argue that even Lumière's 'train' film unfolds within this haptic space and it had been preceded by stereoscopy, a precursor of all optical devices creating the 3D haptic illusion (Trotter 2004, 38–58). Put poetically, the cinematic experience is that of "a movement to and fro between framed theatrical tableau and a foreground full of 'dumb giants,' of bodies in 'high sculptural relief'" as if, let me add, they invited our touch (Lindsay 2000, 68).

Let's look back at Tati's *Playtime* as a modern showcase in this regard, that is, regarding the spectator's *illusion of tactility* and not the character's embodiment of tactility explored in Chapter 2. The film often displays a futuristic high-tech Paris in the Bazinian long-take, deep-focus mise en scène. The spectator has the utmost perceptual freedom to enjoy looking at a multigrounded scene where nothing stands out as central. The sequence shot of Hulot in the foreground waiting for an official who is walking through a long corridor from far back lets us focus on any detail as our eyes roam around this hyper-realistic space; our ears roam too, because Hulot's

murmur is neither louder nor more meaningful than the official's clear foot-falls. The open wholeness of immaculate visuality seems to invite us not simply to peep at "the world viewed" à là Cavell, but to feel it as if we were situated in that world. When Hulot leads us to a huge bureaucratic work-place with numerous compartments as seen from above, no wonder it evokes Caster David Friedrich's masterpiece *Wanderer above the Sea of Fog* (1818), though with significant changes: the sublime emerges not from Romantic nature but within modern architecture, and the transcendental subject turns into a comic Rube (fig. 3.5). Here we see the artificial landscape, as we look over Hulot's shoulder in a free-indirect shot, overwhelmed just as he is, on the threshold between optic perception and haptic immersion. Later, a shot of an enormous, glass-walled apartment multiplies this ambivalent effect through semi-interfaces: all apartment units are separated from each other, while people watch TV as if to look at others in the neighboring unit, and we are separated from them, only peeping in the multiscreen-like building, while the dark street and car noise haptically draws us into the screen space. The merge of perceptual perspectivism and haptic participation peaks in the rotary scene where not only every optic element revolves and resolves into our eye, but we also experience a sort of "haptic hearing" (Marks 2000, 183), with all undifferentiated sounds surrounding us. In this sense hearing might be more haptic than seeing.

A "total cinema" could then be redefined: not just a complete represen-tation of reality, but a complete presentation of our being embedded in a represented reality. Perspective does not merely serve our transcendental perception, nor does it deserve the reductive stigma of 'original sin.' Rather it allows us to virtually embody a sublime technosphere in which the modern rube has no choice but to wander around attractive and distractive tactile

Figure 3.5

stimuli. Needless to say, technology has only improved our illusion of tactility. In cutting-edge IMAX theaters, rock stars and sexy queens fantastically pop out of the huge 3D screen when seen through special glasses. Now *Avatar* (James Cameron, 2009) opens a new era of the total 3D feature film released in standard theaters. Visually, it achieves Bazin's surrealist realism, for instance, with massive rocks afloat in the air that multiply René Magritte's *Castle in The Pyrenees* (1959) or Miyazaki Hayao's *Castle in the Sky* (1986). Yet a more remarkable hallucinatory effect is that the boundary between screen and theater spaces is blurred in a way that characters appear as if they were just within the reach of our hands and say, "Catch me if you can!" This teasing message enables us to relocate the notion of 'haptic cinema' from the 2D surface to the full 3D volume, involving visual tactility.

Now back to Apichatpong. His films often culminate in the traditional celluloid-based illusion of tactility, manifesting a refined example of this redefined haptic cinema without CGI. When a couple in *Blissfully Yours* (2002) makes love in the forest, the camera involves us not only in their psychology, but in the 3D tactile space of subtle yet vivid synesthesia that emerges slowly in the mix of crisp soil, streaming perspiration, sweet berries, whispering breezes, and twigs scratching skin, which swells accordingly. Not limited to any sign system, such contingent effects from the nature-sense circuit bring about a "pure optical and sound" situation (Deleuze 1989, 17) which may be, I add, purely 'tactile' as well: a non-signifying, material surrounding that is too pure for a modern viewer to experience outside of a darkened theater. Not surprisingly, this filmmaker with an architecture degree is also an installation artist experimenting less on the conventional perception of the viewer in a theater than on the embodied sensation of the visitor to a museum; an immersive space for alternative post-avant-garde art that accommodates ever more cineastes working with new media. In *Syndromes and a Century*, it is the excessively hygienic interior of the urban hospital that embodies a museum-like space, through which the viewer-visitor walks following the camera that slides over sleek, immaculate corridors and rooms lighted by fluorescent lamps and surrounded with unidentified ambient noises. Even prior to and beyond our recognition of a thematic element like ultra-Westernization here, our vision becomes 'hapticized' in this glossy labyrinth by virtue of the collective sensation of surface and environmental tactility.

However, it is from this full 3D tactility that Apichatpong often leads us back to 2D visuality. For example, the jungle in *Tropical Malady* is a pure optic/sound matrix where the soldier groping in the dark extends all his sensorial antennae toward the opulent sound, smell, and touch of nature. Yet the ghost-beast he pursues lurks as something that all these saturated senses miss, as a quasi-being that his sensorimotor system fails to capture or barely traces. The multi-sensual immersion in the hyper-real haptic space, then, turns into the supersensible encounter with virtual beings: a tree shining with the glowworm lights, a dead cow rising to life again from its corpse, and a tiger watching him in the middle of the darkness. The film leaps from

the phenomenological impasse to an ontological wonderland. And while the steady panoramic camera unfolds ecological space, a crucial shift often occurs through the cut-in or zoom-in that guides the viewer unaware to the face of a nonhuman gaze. From the tiger lit in an iris frame, the camera cuts in to its persistent but impenetrable gaze in close-up (see fig. 4.21)—the same 2D captivation as in the zoom-in to the vent in *Syndromes and a Century*. Moreover, at the end of the film a low-angle panning of the 3D actual forest suddenly cuts to a horizontal tracking shot of a 2D painted forest. The painting depicts the legend of a tiger absorbing a man, implying pure memory inscribed in immemorial nature. This nature is thus an ontological "zone" as in Tarkovsky's *Stalker* (1979), confronting those who enter it with their own unconscious reverie and desire. They dissolve into an uncanny environment enervating their senses.

Here, the shift from 3D back to 2D reactivates neither the disturbing perspective of haptic aesthetics nor (thereby) any ideological critique of a geometric vision that organizes the totality of Cartesian space. The illusion of depth is disturbed, but it seems to give way to a new 'cinematic' illusion. The tiger's eye works like a camera lurking in nature, the cow's milky flimsy soul shares the quality of the translucent filmstrip, and the tree with numerous glowworms evokes the screen as a plane of molecular images reflecting each other. Such an analogy between actual things and cinematic interfaces might not be always perfect or intended, but it still has the potential of appealing to the spectator. In other words, this *illusion of interfaciality* changes the representation of things more or less immanently or virtually. It does not solely depend on one of the illusion mechanisms Richard Allen lists, for instance: it is neither *trompe l'oeil* entailing a loss of medium awareness, nor "reproductive illusion" created with different sources, nor "sensory illusion" like the duck-rabbit figure (1995, 81–106).[21] However, in somewhat deconstructive ways it could be a *trompe l'oeil* with medium interfaces appearing out of things, a reproductive illusion somehow intended by the director, or a sensory illusion oscillating between depth and surface. The same applies to Allen's own notion of "projective illusion," which implies that an active spectator voluntarily invests belief in the reality effect despite medium awareness. Not very differently, Metz, via Mitry, states that the spectator must accomplish a *"transference"* of reality, "involving a whole affective, perceptual, and intellective *activity*."[22] In this regard I first assert that the illusion of interfaciality could also be a sort of negotiation between the image and the spectator rather than a given hallucination, but then, what matters is that even if so invested, it elicits from the image not transparent reality but immanent virtuality. It does so by changing the 'cinematic iconicity' of that reality, thereby thwarting its transparency without revealing the raw cinematic apparatus.

One could compare this 'interfacial vision' with the Russian formalist notion of "enstrangement" or "defamiliarization" that aims at recovering the sensation of life, making us feel objects through virginal perception. As

Viktor Shklovsky says, "by 'enstranging' objects and complicating form, the device of art makes perception long and 'laborious.' The perceptual process in art has a purpose all its own and ought to be extended to the fullest." It thus delays habitual recognition based on schemata while enabling us to see through what "make a stone feel stony" (Shklovsky 1990, 6). In fact, similar ideas permeate what Malcolm Turvey calls a "revelationist tradition" of film theory, which has underlain the formative and realist approaches of European theorists from the early pioneers (Epstein, Vertov, Balázs, Kracauer, Benjamin) to modern thinkers (Cavell, Deleuze).[23] According to Turvey, all of these theorists commonly assume that cinematic vision escapes the limits of human sight and reveals the true nature of reality. As examined in Chapter 1, this revelation occurs as the "photogenic" epiphany of the "optical unconscious"; it is the interfacial *becoming* of the world's being. Thus the effect of interfaciality can (only) be experienced on and through the screen. The pebble and the coffee captured in Godard's *Week End* (1967) suddenly manifest the shocking alien beauty of their surfaces with scrupulous indifference. The keyword for cinematic perception seems to change from (formative) creation or (realist) discovery to (interfacial) revelation.

I nonetheless emphasize the decisive difference between this revelation effect and the illusion of interfaciality. The latter concerns not the stoniness of a stone, but the immanence of its becoming something other, whose iconicity can surface immediately rather than laboriously; the eclipsed sun resembles a camera. However, the analogy between a thing and a 'quasi-' interface 'immanent' within it is neither pure similarity (metaphor) nor mere contiguity (metonymy), neither the classical imitation of an original nor the postmodern simulation without original. It is rather evocative of what Vivian Sobchack names *simile-ation* or simply *similation*, because a thing appears only *as if* it were an interface, not really but virtually. A pertinent rhetorical term may be *catachresis*: a false, improper metaphor that mediates and conflates the literal and metaphoric, "seeing" and "seeing as," "real" and "as if real," when no proper term is available (Sobchack 2004, 81–84). There are two points to note here. First, what matters is not 'seeing' an image of the sun 'as' the sun, but 'seeing' (an image of) the sun 'as' (an image of) a camera. The former concerns the primary psychological illusion that has been the basic issue of all the theories of illusion, whereas the latter suggests a sort of semiotic, rhetorical illusion, or 'figuration' as often addressed among French critics, which involves our interpretation of the diegetic world. Second, this illusion is not the same catachresis as Sobchack's example of the animal on screen that oscillates between its metaphoric meaning and its physical being as such—what Akira Mizuta Lipitt calls "animetaphor" that does not serve as a figure but rather leads to the extratextual animal beyond language (2002, 9–22). While animetaphor takes an image of an animal to its actual body in full tactility (reembodiment), the illusion of interfaciality leads an image of a thing to its virtual BwO in full interfaciality (disembodiment). The shift from 3D to 2D is crucial in the latter, as it signals losing

actual corporeality and gaining virtual sense effect. In *Syndromes and a Century*, the sun and the vent appearing like quasi-cameras clearly marks the transmutation between the 3D and 2D illusions (figs. 3.1–3.2), just as the tiger in the jungle of *Tropical Malady*. These figures imitate a camera in their whole body, but by becoming bodiless.

In sum, we have reengaged with the concept of illusion by first reformulating the 3D reality effect as a redefined 'haptic' illusion of tactility, and then we have readdressed its shift back into 2D visuality as a new illusion of interfaciality. The illusion of tactility leads to the total cinema of 'virtual reality' that invites us to the saturation of senses and thereby the spectatorial mode of 'phenomenological' embodiment. The illusion of interfaciality, however, hints at an 'ontological' shift of the sensorimotor system to 'immanent virtuality.' The cinematic image as icon then seems to be able to manifest itself as a *quasi-icon*, because it can look more or less similar to something different from itself. It might fail to function as a symbol or allegory, but still succeeds as an insufficient flat icon whose degraded dimensionality rather leads to the virtuality of immanence.

QUASI-CAMERA: THE EYE OF THE CENTURY AND THE UNIVERSE OF EYES

On this theoretical basis, I now look at three sets of film examples that cause more or less the illusion of quasi-interfaces. But rather than imposing a unified viewpoint on every case in a linear direction, my approach goes back and forth between various implications of each interface effect while also identifying multiple interfacial effects of each sample. Overall, this zigzag step will disappear itself into immanent virtuality.

As seen earlier, many circular objects can take on the appearance of the eye and thus of the (quasi-)camera. It is noteworthy that this quasi-camera effect is deeply rooted in film history, just as "Kino-Eye" was less a proper noun attached to Dziga Vertov than a common idea widely shared by his contemporary 'revelationists' with variations. For early experimental filmmakers in particular, a movie camera was a new "eye of the century" that could reveal a universe of eyes.[24] Man Ray's *Emak Bakia* (1926) consists of spinning lights and the repeated imagery of eyes, juxtaposing at some point an eye with headlights of a car on the flattened screen in a Surrealist manner (fig. 3.6). What works here is not an Eisensteinian collage of related images to create metaphors so much as a sort of 'desuture' of objects from their own contexts into a virtual surface on which they become indiscriminate. It is not that an idea is derived and added, but that things lose their 'thing-ness' while proliferating as quasi-interfaces. Made in the same year, Marcel Duchamp's *Anemic Cinema* (1926) mesmerizes us with the endless variation of revolving eyes that proliferate, this time, in the form of infinite regress along with camera-looking objects spread out over the screen as well.

Figure 3.6

In Weimar cinema, both abstraction and expressionism often expose the obsession with the eye, surreal or surveillant, spectacular or scopophilic. Emblematically titled, *Film Study* by Hans Richter (1926) connects numerous floating eyeballs with abstract forms "as part of the world we live in, as its nearest expression underlying the unending manifoldness of appearances" (Mekas 1957, 5). Beams of light crossing the screen are thus a more desutured form of eyes looking back at the camera, which does not just hint at the film's reflexivity but lures our eye into the plane of molecular eyes. Such experimental imagery pops out of narrative films as well, especially when it comes to the spectacle of attractions. The robot Maria's dance scene in *Metropolis* (Fritz Lang, 1927) magnifies her fetish body whose singularity, however, shatters over the surface of a flock of male eyes exploding with testosterone, a multitude of impersonal 'organs without bodies.' *Variety* (Ewald André Dupont, 1925) pulverizes this effect: a trapezist's point of view shot from above accelerates dizziness until the audience space looks like nothing but a sea of a thousand eyes molecularly waving in cubist style (fig. 3.7). Here, I suggest that when proliferating schizophrenically, the entire surface of quasi-cameras can yield the illusion of a quasi-screen.

The implication is, again, the asymmetrical mutuality between the (single) eye and matter (with immanent eyes). But in less experimental films, this Deleuzian dyad is less visually conspicuous than its Lacanian version, that

Figure 3.7

is, the imbalance between the look from the subject and the Gaze from the Real; the latter, of course, appears as the 'gaze' of things that the subject can suddenly feel 'look back.' Looking into Kieslowski's *The Decalogue* (1989), Sobchack sharply captures this gaze from such things as a cracked inkbottle, a spot of blood, and a spread ink stain that recalls Lacan's sardine can (2004, 91–103). This "Lacanian ink" visualizing the notion of *objet a* also resonates with Japanese "flung ink" painting that Norman Bryson addresses in terms of *signifier*. Interestingly, despite Bryson's critique of Lacan, this *signifier* signifies nothing other than *objet a* and recalls our formulation of interface in Chapter 1 as the combination of the Lacanian *signifier* and *objet a* (Bryson 1988, 87–114).[25] "What breaks into the image is the rest of the universe, everything outside the frame" (103). We know that this intrusion of the Real often entails such anamorphosis as Holbein's skull that perturbs our vision. What is more interesting is the reversed case in which we can take the position of the interface and look back at our reality from its point of view. In *Citizen Kane,* Kane's glass ball first appears in his hand in normal 3D perspective, but upon his death, it falls onto the floor and lets us look back at the space now distorted on its convex surface, a sort of postmortem perception of reality. As mentioned in Chapter 1, a shot and its reverse shot are condensed on this interface because we see a housemaid coming in without cutting. Similarly, *The Double Life of Veronique* (Kieslowski, 1991) not only captures the natural return of the gaze (Veronique looks at a leaf, which looks back, etc.) but also enables us to reverse our vision through

a magic glass ball. Reality around this artificial interface dissolves into a formless smear while its fantastic refraction is revealed clearly—but upside down. Žižek's notion of short circuit occurs here as the phantasmatic link between reality and the Real; in Deleuze's term, what is crystallized are the actual, which loses its 3D visual dimension, and the virtual, which gains convex 2D visuality.

If this quasi-convex lens convolutes the eye and the Gaze through its own surface effect, two versions of *The Red Balloon* inspire us to review the issue from two different angles. In Albert Lamorisse's original (1956), a red balloon looks slick and solid without reflecting anything but light. But this charming UFO is not just an object that is discovered, appropriated, abandoned, and redeemed. Even at home, the child hero feels its gaze lingering outside and touches the window screen just like the baby rubbing a woman's image in *Persona* (fig. 3.8). Instead of being a pseudo-face, however, the balloon indeed functions as a quasi-camera that unfolds visual space by following the child like a smart bomb. Moving autonomously, the balloon thus does not merely pursue the subject, but performs the cinematic agency of continually opening our perceptual field where all things are rendered visible around it. Moreover, "the red balloon" as the kid's only friend turns out to be just a single agent among so many colorful ones that come out of their immanent universe. On the contrary, Hou Hsiao-hsien's *Flight of the Red*

Figure 3.8

Balloon (2007) shows fewer scenes with the red quasi-camera floating in the 3D world. Instead, this remake often reframes the quasi-interface in actual interfaces so that the balloon appears like a flat circle or even just a dot. References to the original film are then salient. At some point, the balloon approaches its mirror image painted on the wall, whereas a digitized clip of this self-reflexive event looks as though it showed a rectangular face with two red eyes, a crescent mouth, and a window-shaped ear—an illusion of faciality we explore in Chapter 4. A multilayered interplay occurs here: between two objects (original and copy), two shapes (circle and rectangle), two media (painting and cinema), and two platforms (film and digital), with immanent faciality rising onto the 2D interface. Similarly suggestive is a museum scene in which young students and their teacher interpret an ambiguous painting: the child with a hat might be a boy or a girl; the red balloon on the ground might be its goal to obtain or keep; a couple in the background might be its parents or ghosts. They even talk about the film *Red Balloon,* wondering if the children who shot the balloon were friends or grown-ups. The painting is thus an interface with/between virtual and intertextual potentials, with its surface reflecting visitors. Later, the actual red balloon is seen through the glass ceiling, resembling the eclipsed sun in *Syndromes and a Century* (fig. 3.9). Flattened and framed, it creates the illusion of a 'mysterious eye at noon' that watches us from above, calmly and barely noticed. In terms of the media landscape it slides over from painting to digital, from pre- to post-cinematic interfaces, this quasi-camera seems to stand for the 'eye of the century,' an eye looking back on the cinematic century.

Another remarkable case is that in which the surface of a thing does not reflect the world or return the gaze so much as it absorbs the subject into the

Figure 3.9

virtual, like a black hole. Hollywood SF often shows this phenomenon when depicting the shift between actual and virtual realities. Though not typical of the genre, *Donnie Darko* (Richard Kelly, 2001) attracts our attention to a unique quasi-interface in this regard. At the beginning, a jet engine crashes in Donnie's bedroom while he sleepwalks outside, led by a giant bunny. Back home, he faces the uncanny face or dark eye of that object, which sucks our vision as the camera zooms in. Just like Alice's jump into the rabbit hole of a wonderland, this image marks the starting point of Donnie's adventure in a so-called "Tangent Universe" that will last for twenty-eight days. But the destined end of this virtual world turns out to be a return to the very moment of the 9/11-evoking catastrophe; the presumably same engine falls off from an airplane carrying Donnie's mother and sister. It appears like an inexplicable spot in the middle of the natural sublime unfolding in the Romantic style, but at the same time it rapidly passes through a supernatural wormhole as if submerged into immanence—in short, these two shots present an 'epiphany' as the spatial revelation of temporal reversal (fig. 3.10). Convincingly, the black hole flying within the wormhole is soon matched with the skull image residing within an eye, Escher's *vanitas* print in Donnie's room. Just beside it, Donnie is now sitting on the bed, that is, not sleepwalking, perhaps because he has realized that if he does not escape the crash of the Thing this time, the world could escape the envisaged time loop of the twenty-eight-day wonderland and return to the right track of the "Primary Universe." Set as the juncture of the two universes, he then plays the role of an agent who should be responsive to the interface with the Virtual-Real and ultimately responsible for ending the vicious cycle of traumata including his girlfriend's death. Thus, he dies with his free will within the closed circuit of destined events for the post-catastrophic redemption of the world.

In Spielberg's *War of the Worlds* (2005), an impressive imagery synthetically updates the interfacial modes hitherto examined. It appears not in the

Figure 3.10

Figure 3.11

main narrative—where aliens roll their camera eyes too banally—but in the prologue and epilogue that account for the existence of aliens and their natural extermination on earth.[26] The film opens with a great water drop on a leaf whose convex surface reflects other leaves in high resolution, even bringing the illusion of tactility (fig. 3.11). As the camera zooms in on this quasi-camera, however, it turns into the blue earth while the surrounding green nature gradually becomes 'desutured' to a dark space/surface. The earth here looks less like a camera than like an object seen from outside, namely an *objet a* for aliens that will soon desire/attack it. Our planet then changes into a red traffic light like the red balloon, an eye in the air, as if the outer Gaze were sutured into it. This iconic montage epitomizes the suture/desuture dynamics between nature, the universe, and civilization, with the quasi-interface looking not only 'back' but also 'beyond,' and/or enabling us to do so. The ending of the film is more radical: while the narrator explains how bacteria defeated aliens, the camera focuses on another big water drop, before zooming into it to show similar-looking bacteria cells within. 3D tactility thus gives way to 2D interfaciality accordingly, while the quasi-camera is magnified until it operates as a quasi-microscope that lets us look 'into' it. This immersion into biological immanence continues, disorganizing eye-looking bacteria (OwB) into a sheer empty plane with floating strings of microbial molecules alone (BwO) (fig. 3.12). The microscopic plane then transforms into the macroscopic one, with strings becoming stars—visually, a universe of eyes. Our subjective vision is then liberated to the wider frame of visuality based on emptiness, blankness, openness. This already suggests a sort of quasi-screen, but before that, we examine the middle stage of our spectrum.

Figure 3.12

QUASI-FILMSTRIP: AMUSEMENT PARKS AND A DOUBLE BIND OF THE CINEMA

When it comes to quasi-filmstrip, I do not directly intend to investigate how film reveals its own materiality on screen. This investigation is anti-illusionist and medium specific, though it can be as subtle and flexible as Garrett Stewart's photogrammatology or narratography (which I explored in Chapter 1 and partly share here). My concern is not the illusion of movement, narrative, or reality that has been put into question by critical artists and writers, but the illusion of a quasi-filmstrip that appears from what it is not, regardless of media or material. Iconic in essence, this illusion, or optical allusion to a virtual interface immanent in the surface of the object, can also desuture the classical illusion from within, into immanent virtuality, in its own ways. That is, noncinematic objects on screen can seamlessly simulate, thereby revealing the filmstrip, but without necessarily breaking or freezing the filmic movement. Apposite is the moving picture displayed in a simulated train car in *Letter from an Unknown Woman* (Max Ophüls, 1948), which Stewart also mentions: "pay-by-the-mile vistas on a painted protofilmic scroll sweep past their curtain-framed window" (1999, 40). I add that the 3D effect of those exotic landscapes is threatened by their flattened continual seriality, though there are no bars that divide the quasi-filmstrip into plural photograms. For the same reason, however, this quasi-theater simulates the screen as window rather than frame despite the fact that it shows paintings that are not indexical and less realistic than photographs. The couple perhaps 'simulates' projective illusion here rather than just project illusion, because what they want must be not to feel the false world tour as real, but to feel as if they were in the theater 'in the mood for love.'

This spectatorial negotiation with the projected illusion of reality does not occur in a similar amusement park scene of *The 400 Blows*, because Truffaut's young persona experiences an automatic illusion of interfaciality. Clearly, the huge entertaining "Rotor" evokes the zoetrope, and this spinning drum consists of photogram-like rectangular panels. Its rotary motion accelerates our virtual relocation to the inside of the projector. More impressive is the reverse shot taken from Antoine's point of view, which gives us the impression that onlookers look like frames or bars between them as well. A cinematic whirl of the world itself then yields the illusion of a moving filmstrip, with the 3D perspective diffusing into a 2D optical immanence. It turns "the spectators' fleeting images into photogrammatic stand-ins—each for the other and all together, for the whole apparatus being emblematized, as well as for an adult world of dizzying irrelevance to the adolescent on the run" (Stewart 1999, 137).

Let's jump to another amusement park that is now a miniature of the entire world: Jia Zhanke's *The World* (2004) stages a postmodern simulation of global landmarks on the outskirts of Beijing—or it is a postcolonial emulation of the West by the East. But it also reveals an unintentional simulation of the opening of *The 400 Blows*: the Eiffel Tower seen through the window of a running car. Also unintentionally, the Tower is seen through gaps and intervals between bar-looking trees, as if the tree-lined street 'similiated' a running filmstrip. The same illusion effect, though mitigated, occurs when the Tower is seen from an elevator that passes by demarcated boundaries between floors, and when a world map is seen through a series of window frames from a subway train in animation. On one hand, then, it is as though *The World*, a landmark film of contemporary world cinema, nostalgically reflects on cinema by virtue of a landmark of the cine-city of Paris. On the other hand, it might suggest that the world has now become no different from a theme park, a spectacle world that could no longer have meaning without being mediated or simulated by the cinematic apparatus. Ironically, Jia Zhanke depicts how gloomy the globalized park looks. We see, for instance, almost no spectators of the splendid multicultural variety shows held there. His digital realism therefore seems a modest critique of the "society of the spectacle" that Guy Debord radically debunks,[27] and fundamentally, an ironic critique of what Martin Heidegger calls the "world picture," not a picture of the world but "the world conceived and grasped as picture," that is, as habitual image.[28] Yet conversely, doesn't this stance intimate a sort of ontological double bind that cinema could neither fully embrace nor abandon the image world?

Rather than trying to leave this double bind, some films seem to intimate two intrinsic ways of struggling with it through interfacial illusion: creating spectacles that do not effectively offer the world picture or that even thwart it, and destroying interfaces within diegesis. At the beginning of *Don't Look Now* (Nicolas Roeg, 1973), a girl's fatal accident resonates with a red ink stain spreading over her father's slide (fig. 3.13). This uncanny

Figure 3.13

visual symptom suddenly awakens us to the realization that the church on
screen was not a 3D real space, but a 2D photographic image on a thin,
transparent glass (showing the colorful stained glass). It is this membrane
effect that causes the illusion of a quasi-filmstrip, which is not visualized
with frames or boundaries, but hapticized by the double layering, with the
upper ink layer looking really belonging to our space as if we could just feel
its liquidity by fingering it. If this shot only insinuates the singular form of
the virtual membrane, it is later divided into plural sections on the surface of
actual things: two blind eyes of a mystic woman, her tripartite mirror image,
multiple strips of a shade that 'screens' her face, and so on. Interestingly, this
process is the proliferation of opaque veils, of quasi-interfaces that do not
facilitate our view of the diegetic world, but rather interrupt, blur, confuse,
and hide it by surfacing onto our vision with the contradictory message:
"don't look now!" There is thus a double maze: one is the diegetic location
of Venice, and the other its visual interfaces given to us. However, the main
character is our stand-in who is also entrapped in a horrible amusement
park of a sort that forces him to play an enigmatic game of hide-and-seek.
To get out of it, one might then have to break interfaces, though many glass-
breaking moments in this film threaten the subject.

An extreme interface effect and its destruction take place in the perhaps
most amazing amusement park found in film history: the Magic Mirror
Maze in Welles's *The Lady from Shanghai* (1947). But earlier in the film, I
note, an aquarium where the main characters meet shows the double hap-
tic layer of the glass surface and the black profile. This large flatness is
comparable to the multiple oblique shadows of bars in the entryway to the

Maze, which look like haphazardly hung filmstrips, and which also recall the spidery curves decorating the wall of Dr. Caligari's cabinet—both disorganize represented depth by pictorial lines stretching in similar expressionist style.[29] Within the Maze, then, every shot resembles a series of sliced mirrors, that is, a 2D quasi-filmstrip of photograms in plural. A barely possible distinction between the heroine and her images soon gives way to the total indiscerniblity between the actual villain and his virtual doubles. Moreover, the condensation of a shot and its reverse shot between these two characters proliferates both within a shot and through shots, continuously deranging the classical suture system (fig. 3.14). There are three references to make here. First, the seriality of Welles's images reflected from slightly different angels undoubtedly reminds us of motion photograms captured by a precinematic zoetrope or zoopraxiscope, as well as in postcinematic bullet-time shots, though not in motion as in *The 400 Blows*. Second, quite apposite is Jean Epstein's poetic experience of a pit walled with mirrors in Mount Etna: "There are as many different and autonomous positions between a profile and a three-quarter back as there are tears in an eye . . . Each one of these mirrors presented me with a perversion of myself" (1926, 135–136).[30] Third, such an image of "tears in an eye" that cause "perversion" would be a perfect "crystal image," the smallest internal circuit in which the actual and its virtual image are in continual exchange. Within this circuit, as Deleuze

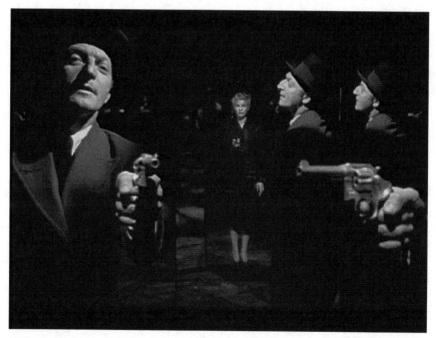

Figure 3.14

explains in reference to Welles's maze scene, the two characters "will only be able to win it back by smashing all [mirrors], finding themselves side by side and each killing the other" (Deleuze 1989, 70). In short, the entire scene creates and reinforces an amazing maze of quasi-filmstrips until the crystallization of the actual and the virtual unbearably confuses the subject, both character and spectator, who may need a minimum of the actual world picture. So the interface of cinematic metaphors, Magic-Mirror-Maze, is cracked, though still within diegesis. Then would the multiplication of interfaces end up leading to its own dead end?

QUASI-SCREEN: FROM THE WORLD PICTURE TO SOLID, LIQUID, AND GASEOUS INTERFACES

To imagine a more radical way of liberating cinema from the world picture, I first point out that the impasse outlined previously partly results from the state or quality of the interface. The virtual certainly surfaces onto a maze of mirrors, but these are solid, thus confining and breakable. That being said, if I borrow Deleuze's three types of perception image, cinema could change the world picture not just physically into a "solid" interface with its own dilemma, but chemically into a "liquid," even "gaseous" interface that opens an unbounded and unbreakable plane of immanent virtuality. This qualitative shift would maximize the illusion of interfaciality as the cinematic potential to draw a "line of flight" from the world picture, yet only by starting from its surface and then moving into its immanence. Instead of leaving or destroying the world picture, we could still see it while experiencing the illusion of its transformation into, this time, a quasi-screen.

Before looking at liquid and gaseous screens, let me begin with two suggestive scenes that bring about the illusion of solid quasi-screens in alterative ways. First, Dariush Mehrjui's *Cow* (1969) has a moment when villagers, looking through a window, watch the hero who is about to enter a pit in his barn. Since the loss of his beloved cow and a nervous breakdown, he has gradually gone insane and slowly believes that he is the cow, whereas the truth is that his fellows covered up the evidence of the cow's death during his absence and told him upon his return that it had run away. We then watch them as if their fear and concern were projected on a well-framed, solid quasi-screen, which shrinks later as if to confine them even more palpably (fig. 3.15). That is, although the cow-man apparently recedes into the black hole of his own delusion, by "becoming animal" he could follow a line of flight from the human world and its social rules, habits, and relationships that might be rather constrictive. It is not he but they who look imprisoned here, while he is fleeing from that world picture.[31]

Second, among many riveting scenes in Tarkovsky's *Mirror* (1975) is a long take that epitomizes the screen metaphor. It first shows a kitchen-like room with furniture and an open window as the camera pulls back slowly,

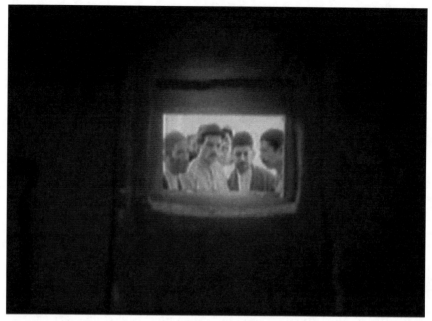

Figure 3.15

though not as fast as two children who run out of the frame. The screen is a mobile 'window,' that is, an undetermined mask that hides the out of field, revealing only part of the world, yet never stopping the renewal of this limited revelation. It delivers the aura of the space in duration until a bottle magically falls with a revelatory clock sound off the table and onto the ground. Then the camera pans to the left and pauses on the children in front of an open door, which soon turns out to be a mirror reflection, evoking the idea of screen as 'mirror.' Then, finally, the camera finds its fixed position from which to transform the screen into a symmetrically contoured 'frame.' We see a man and a woman, with a small building burning in the upper middle third of the frame as if it was an altar and they were conducting or attending a ritual (fig. 3.16). We recognize rainwater dripping here, though not heavily, from the eaves; it brings a subtle effect of a liquid screen that consists of molecular drops without a solid surface, distinguishing and protecting us from this fire. But at the same time, we are allowed to see and feel the alchemic superimpositions of the solid and the liquid, of the hot and the cold, and of the burning Real out there and our safe reality here. One of the children reflects our spectatorial desire to get close to the Real. Passing over the boundary between offscreen and onscreen spaces, he enters the amalgam of Window-Mirror-Frame.

Now I move on to East Asian films that saliently display this 'screen chemistry' in completely different manners and contexts. Hong Kong noir,

Figure 3.16

for example, has brought to the screen its own visual aesthetics with a variety of stylistic action images. A mall scene in *The Mission* (Johnnie To, 1999) almost consists of a series of *tableau vivants*—another kind of quasi-screen as a painterly frame. The extreme tension and suspense nearly stops every motion of characters so that the movement-image of the film is punctuated by photographic 'privileged instances.' At such moments, pictorial expressionism reigns, as killers look like 2D shadows in dark profile, making black holes in the empty, slick, hygienic 3D space. In the middle of this silent stillness, shooting is initiated and mediated through the interface effect when the surface of a steel cart reflects a gunman. This type of mirroring penetrates the core characteristic of a new millennium noir *Infernal Affairs* (Lau Wai-keung Lau and Mak Alan, 2002). The title refers to the never-ending war between the police and the local mafia, but it implies that one is the other's double. A cop working as a mole in the mafia and a mafia member infiltrating the police become doppelgangers, each of whose image is also split whenever reflected on any reflective surface. As their older counterparts race against time to expose the mole in their midst, both the moles feel the stresses of their double lives though there is no exit. Notably, the final showdown occurs on a quasi-screen, as a slight distortion of the image is reflected on the glass wall of a building; it not only splits a figure but also warps the surroundings like choppy waters of an ocean (fig. 3.17). It is as though

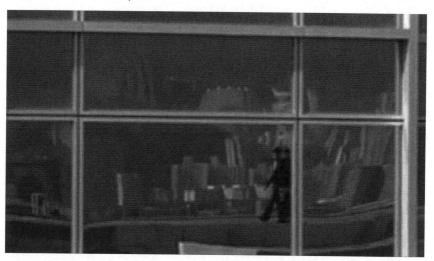

Figure 3.17

solidity is about to take on liquidity, and as though the heroes could resist the world only through this virtual impact on the world picture, however minute, contingent, and unconscious it may be.

The same liquidity is found at the end of *Taipei Story* (Edward Yang, 1985). The main character faces her mirror image in front of a window, when the solid quasi-screen exposes an anamorphic effect due to the mirroring wall on the opposite side. The last shot fully shows that wall looking like a partly liquid screen on which cars run as if to ride the surf. Though not furthering fluidity, Yang's *Yi Yi: A One and a Two* (2000) updates his observation of doubling in every aspect of Taiwan's postmodern life and on every level of the film's structure including the title. For example, a nighttime office shot through its window overlaps the inside and outside, the right and left units, and 3D and 2D, all appearing only as 'shadows' on 'windows' whose actual locations are hardly discernible (fig. 3.18). When the characters step in the dark, their silhouette takes on more than the pictorial flatness of *The Mission;* they look even ghostly, as part of multilayered simulacra—everything virtually onscreen is actually offscreen. The quasi-screen deranges the world picture this way, still solid yet multiple and ephemeral, which means that its crystal image does not necessarily recall the breakability of interfaces, but almost naturally encases subjects in interfacial circumstances. Hong Kong director Wong Kar-wai also embodies this aesthetic in his films. The depth of field and the surface of reflection typically overlaps, intimating the prevalent motive of the double in *Chungking Express* (1994)—another film of fissure and fusion, but this time, between two parts, two loves, two cities (HK and LA), and allusively, two eras (before and after HK's retrocession to China). In fact, the split national identity underlies all these pan-Chinese obsessions

Figure 3.18

with the mirror image. Wong's signature of step printing, then, adds another effect to the solid screen; it starts to become gaseous at its dizzy speed. The subject is not statically poised in the interfacial environment, but dynamically fused into it.

At this point, it would be better to check more explicit liquid screens prior to hardcore gaseous screens. The mirror is crucial in this regard, as the surface of water that reflects Narcissus is also a mirror, that is, not far from a liquid quasi-screen. A memorable shift of the mirror from a solid to a liquid screen can be found again in Welles. The famous crystal image in *Citizen Kane*, the shot of Kane passing between two facing mirrors, is a sort of solid multi-split screen rather than a quasi-filmstrip. For the illusion of filmstrip basically results from flatness, whereas the multiscreen implies molecularity as visualized here in the form of the infinite regress of screens. But in *The Lady from Shanghai*, we should not forget a magic mirror standing in the hallway to the real maze. It is just a single mirror without subdivided slices, but it reflects Welles in fluidity; his solid body stretches and shrinks as comically as it does haphazardly. This type of liquid screen effect dates back at least to Abel Gance's *La Folie du docteur Tube* (1916), for instance. Gance is certainly a magician, the successor of Méliès. If Méliès mechanically devised unreal situations in front of the camera, though, Gance operates surreal effects by chemically manipulating the camera lens; in other words, the former was mostly pro-filmic, the latter highly filmic. The 3D stage as an object of the camera then becomes a 2D screen, an extremely malleable membrane-like mirror that bends, folds, twists, and distorts the world as if it were just a design on a spandex swimsuit one can wear, soak, or throw into a washing machine (fig. 3.19).[32] Moreover, this liquidity results from

Figure 3.19

Dr. Tube's experiment rather than just being inserted by Gance. The diegesis affects the apparatus (screen), which in turn affects characters to the extent that what counts are no longer simply diegetic events, but their immanent plane as nothing other than the surface of the apparatus. And taking the form of slapstick, this self-circuit magic nurtures some early Pathé comedies and prefigures Gance's own *Help!* (1924) and even the window-cleaning scene of Tati's *Playtime* seen in Chapter 2.

When it comes to the gaseousness of a quasi-screen, it does not always result from special cinematographic techniques, nor does it always pass through liquidity. *Hindle Wakes* (Maurice Elvey, 1927) has another impressive amusement park scene in which the entire world picture turns into both a solid and gaseous interfaces. At night, the entertainment complex appears only as a clearly lit contour as if on a completely even, solid blackboard. In the inside of a dance hall, meanwhile, the flatness of the whole space continuously shimmers with the molecular movement of human particles just like leaves minutely swaying in the wind (fig. 3.20). Here, we do not see any unified figure that the liquid quasi-screen retains even in anamorphic distortions. All subjectivity is shattered on the huge plane of interfaciality, whose infinitesimal restructuration at every molecular moment is its consistency. Deleuze takes Vertov's "montage" as "gaseous" because of the extremely disorganic relations between shots (Deleuze 1986, 80–86). I add that

Figure 3.20

Vertov's shot, and even just one photogram within it, can be perceived as gaseous because of the extremely disorganic relations between human molecules on the evaporating surface of the world. "All that is solid melts into the air"—Marx's Communist Manifesto might also sound like an Interface Manifesto in Vertov. Not coincidentally, early avant-garde cinema in general innovatively experimented on/with this unspoken manifesto. Among others is László Moholy-Nagy's *Lightplay: Black-White-Gray* (1930), a product of a 3D device that is less complex than its 2D visual effect. A small set of rotating iron poles, balls, holes, and mirrors casts much greater reflections that almost erase their metal body in multilayered shadows. Even in close-up, the device dissolves into an illusion of flattened fluidity. Furthermore, the liquid surface becomes gaseous as "black, white, and gray" facets of light circulate on the whole screen as if in the air (fig. 3.21). Visual illusion then melts the reality effect of the solid substance into the screen effect of substance-less surfaces that are already immanent in it, yet more immense than it.[33]

 Contemporary experimentalists continue to explore the potential of the 'object-becoming-screen.' Franco Piavoli's *The Blue Planet* (1981), a stunning love poem to mother nature, captures the surface of the world that looks as though it changed into all the three types of quasi-screen.[34] A solid screen: the dark yellow sky appears just like a canvas, a frame of the unlimited space with a sharp trace of its immanent verso. A liquid screen: not

Figure 3.21

rushing of water, but its reflection of light, casts a hypnotic spell of fluidity on to its waving surface. And a gaseous screen: again, the wind in the trees is emblematic of the slow, lingering, but continuous and relentless movement of matter at every moment. A similar symphony of nature, or of the nature of things, is played in a more 'enstranging' way by Nathaniel Dorsky. *Sarabande* (2008) updates Dorsky's typical captivating guide to the immanent virtuality of our ordinary reality. When a show window space of a furniture store is displayed from an oblique angle, simple decorative balls suddenly look like planets afloat in space without any ground of gravity. With all its 3D spatiality, the image disorients our habitual sense of topology as if we were looking at the cosmos. The tactile sense of solid substance in this shot, then, rather disappears when the camera looks into the slightly liquid surface of red leaves and expressionist black lines that look like worms wriggling out of leaves or abstract waves flooding out of immanence. This still inorganic life force between pattern and environment evokes the notion of the "dynamic sublime" in German Expressionism, only now on the microscopic scale.[35] But Dorsky's imagery is quite static rather than literally dynamic. A shot from *Threnody* (2006) elicits from a spidery entanglement of twigs and branches an illusion of an 'action painting' *à là* Jackson Pollock (fig. 3.22). In complete stillness, the 2D surface of our vision somewhat takes on gaseousness here, because of those haphazard inorganic lines—still dynamic in

Figure 3.22

essence rather than in actuality—and interstices that take over every molecular space of the screen. The world picture calmly evaporates there.

VIRTUAL REALITY, VIRTUAL SCREEN, THE VIRTUAL ON SCREEN

The illusion of a quasi-screen causes an imagination of the world's transformation. It amplifies the flatness, fluidity, and fluorescent effects of the surface of objects—reflected or refracted, natural or artificial—which thereby enables the screen to sway, flow, and evaporate with inorganic particles. The world then reveals itself as an interface that is a cinematic plane of immanence. If this is one way of liberating the world picture, then this leads me briefly to discuss the possibilities of and for interfaciality in the digital era.

There are two major tendencies regarding virtuality here. First, VR is still a dominant concept in digitization. The efficiency of the world picture is rather reinforced through the digital approach to reality, still based on Alberti's perspective for the world of the picture itself to be a virtual space. As mentioned previously, it is vividly immersive space that facilitates the illusion of tactility in the continuum of actual and virtual realities. However, its limitations are still palpable as the existence of the frame distinguishes two realities anyhow, and the spectator's enhanced identification with virtual

characters is somewhat owed to his sense of safety and distance from VR (Morse 1998, 19). Moreover, Human-Computer Interfaces (HCIs), as the apparatus of VR, display their own spatiality that combines haptic and optic spaces, not within VR but on the monitor in reality. That is, we have the sense of "space medium" of the interface that we use, which is different from the 3D totality we want to enter. Simply put, computer windows overlap each other, constantly awakening their utilitarian nature. In addition, far from being 'post-symbolic,' VR must also find its symbolic means, conventions, and signifiers, whether they be adopted from other media practices or newly developed over time (Lister 2005, 38–47).

Second, perhaps as an attempt to overcome these conditions of VR, there is a tendency to liberate the notion of screen from its usual location. The point is not to make a virtual space, but to take any actual space as a virtual screen for projection. Many installations' media artworks now develop this screen-creating capacity by projecting images on the walls of public buildings and so on. As one might trace the primal screen back to the mother's breast, it would be possible to think of the evolution of the screen in its largest sense regarding such expanded cinema (Connor 2004, 59 and 285). More profoundly, this might suggest that the projected image implies, elicits, or creates its own immanent screen rather than the screen first exists and shows the image. Therefore, we meet again with the idea of immanent interfaciality here.

Still, we could discuss the virtual on screen in its own dimension rather than confusing it with VR or virtual screen. The digital update of the illusion of interfaciality thus deserves attention. *Genesis* (Nuridsany and Pérennou, 2004) will serve well as our final example. Resonating with Piavoli's and Dorsky's films, this cinematic bravura goes back to immemorial time and translates it into spatial immanence. The title tells everything: in the beginning was no Word, but a wordless Big Bang. The first shot is nothing other than a cosmic gaseous screen with nameless particles floating through light, their innumerable crashes and atomic dances, faceless surfaces of undetermined brown waves (fig. 3.23). Then, we see the birth of the earth, the sea and the heaven, which is followed by the indefinable force of a water drop that horizontally traverses a transparent wall of the world, that is, a liquid quasi-screen. Germs of life appear in the form of eye-looking cells, or quasi-cameras that look back, and through which we look beyond on a rather solid dark screen. This chiasmus of microcosm and macrocosm, all that dynamism of chaosmos, godless struggles, and inhuman drives in the originless and goal-less world, is now replayed after digitization and on sleek digital interfaces. The digital infiltrates into the immanence of our vision and illusion this way. There now unfolds, so to speak, digital immanence.

In sum, the illusion of 3D tactility leads to the total cinema or VR that invites us to the saturation of the senses in the spectatorial mode of phenomenological embodiment. The illusion of 2D interfaciality, however, hints at the ontological shift of the sensorimotor system to the cinematic plane of

Figure 3.23

immanent virtuality. These two illusions are not only being updated on the digital surface of the cinematic image, but they are also visually invigorating both the actual—even within VR—and the virtual as such—even within this actual. While the former will never stop fascinating our eyes, the latter will remain a playground for our continuous rethinking of cinema.

4 The Face of the Subject

THAT OBSCURE 'SUBJECT' OF DESIRE

Seh-hee feels that her boyfriend, Ji-woo, may be making eyes at other women, as time has eroded their relationship into an unpleasant affair marked by routine and sexual debacle. Unable to get over her jealousy, she undergoes a radical plastic surgery in the hope of reigniting his love through her new identity named Sai-hee. Her plan is successful only until he confesses that he still loves the missing Seh-hee, who Sai-hee finally reveals she is with jealousy of her own past self. Shocked by this truth, Ji-woo in turn ends up deciding to undergo cosmetic surgery so that he will return to her later with a completely new face. Five months later, however, Sai-hee vainly searches for Ji-woo among several men evoking him. And one of them, whom she senses must be Ji-woo, flees from her desperate chase only to be hit by a truck and expose an unrecognizably bleeding face. In deep trouble, Sai-hee changes her face back to Seh-hee's.

Korean filmmaker Kim Ki-duk's *Time* [*Shi gan*] (2006) relates this perverted love story in his typically rough rhythm. What counts for him, as usual and usually controversial, is less diegetic probability than direct provocation with such an explicit question: Does our image really determine our identity and relationship? Yes or no, the answer could not be limited to a moral lesson or social critique of the vanity of plastic surgery, which intervenes here less for a prettier face than for a different one—in Godard's phrase, "not a just image but just an image."[1] Indeed the essential question is not aesthetical (beauty versus ugliness) but ontological (sameness versus difference) through the phenomenological (face as surface). And it starts with Seh-hee's epistemological anxiety about knowing what Ji-woo truly wants, about having a face that could permanently fulfill his volatile desire.[2] Obscure is that 'subject' of desire (not its object as in a Buñuel film with this title), as long as Seh-hee's desire is only to become the very object of the genuine subject Ji-woo. He doesn't seem sure whom he loves, whether he wants another face, who he is, and what identity (signified) he pursues by changing his own face (signifier). The face hardly remains a one-dimensional semiotic sign for one's singularity; it is also a surface whose effect depends

on others' reaction to it, and furthermore, a gateway to the abyss of other-ness and subjectivity that cannot be fully located in the notion of identity. This *multiple directionality* accounts for the implosive dynamics of the mul-tifaceted face, which this chapter proposes as the other quasi-interface on the opposite side of the surface of the object. Simply, what do we see from the face and where does it lead us?

FACE AND IMAGE, DESIRE AND TIME: FROM DOUBLE BIND TO INTERFACIALITY

A closer look at *Time* may sharpen the point. The film opens with an eye that opens and onto which eye-looking lights are reflected just like an interface shot; its reversed interface shot appears later with Seh-hee's face reflected in a mirror surrounded by mirror-looking bulbs in the operating room. The face here has little to do with her interiority, associated or replaced with its mini-simulacra whose surfaces reflect each other in the embodied form (eye) and artificial form (mirror/bulb). The following raw images of surgery grue-somely manifest that the face is also a tactile surface susceptible to design, puncture, stitch, cut and paste—in terms of *embodied interface* (Chapter 2), the body now undergoes 'transformation' and 'inscription' at once in a way that looks bearably painful and barely playful. That is, the surgery initiates a completely realistic face game of 'no pain no gain.'

What is not realistic is the subsequent cinematic trick. Out of the clinic (whose Janus-evoking door advertises a face divided into its two halves before and after the magic of surgery) comes a masked woman, who presumably has had the operation shown in the documentary opening scene, and she is bumped into by another woman carelessly passing by. Later, they turn out to be Sai-hee and Seh-hee, the same heroine after and before her face change. Apologizing for breaking Sai-hee's photo frame, Seh-hee says she will soon repair it without knowing that it shows her own portrait that Sai-hee may have wanted to preserve as her past image embalmed against the passage of time (fig. 4.1). Notably, talking to Seh-hee in a café, Ji-woo comments that the unknown woman in the photo looks like a lunatic with her scary smile. Unconsciously describing his girlfriend, this comment foreshadows the later moment when Sai-hee reveals her secret by wearing a photo mask of the uncannily smiling Seh-hee in a ridiculous yet compelling manner, as if the latter had returned like a ghost. This schizophrenically intertwined temporality forms an irrational narrative loop with a double irony. First, the broken photo may stand for an irreversible crack in her identity, so its repair will not be possible (nor does the film show Seh-hee repairing the frame). Second, after realizing the ultimate loss of Ji-woo, Sai-hee actually repairs/retrieves her lost face, yet when leaving the clinic she is run into by a woman we have seen as Seh-hee—that is, the end of the film repeats its beginning with the same photo broken again, but with two women having supposedly

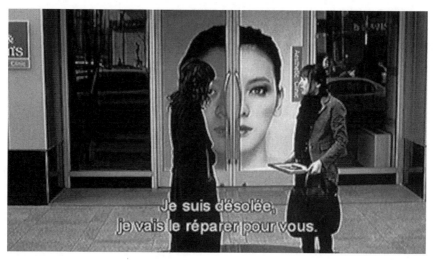

Figure 4.1

the same face of Seh-hee this time.[3] By ending just there without untangling who's who and who repairs/replaces whom, the film leaves us in the middle of a double bind: we can assume neither that the whole story with the same characters will repeat like a Möbius strip, nor that the reappearing masked woman is just anonymous and unrelated to the main characters.

To explain this type of narrative twist, which is insinuated through recurring or surrealistic details in Kim Ki-duk's other films such as *Bad Guy* (2001) and *3-Iron* (2004) as well, some critics suggest that the main narrative could be thought of as a character's fantasy or daydream. However, such a barely logical attribution of the narrative enigma to a single character would not enrich our understanding of complex issues like, in the case of *Time,* the irreducible crack between the figure and its face. So let me keep reviewing this theme from diverse angles without rushing to an easy conclusion. To begin with, it is noteworthy that plastic surgery, or more generally, changing one's face has been a familiar subject matter as we will see later, in a variety of films from artistically idiosyncratic (*Eyes without a Face, The Face of Another, Open Your Eyes*) to commercially genre-bound (*Dark Passage, Faceless, Face/Off*). The implied assumption is that the face represents one's self, therefore its change could also change the self, positively or negatively. The possibility of this change through actual technology or virtual imagination is now indeed postmodern, but the original equation of 'face = self' is classical and even mythical as the (artificial) face is actually skin deep compared to one's total identity. In reality, not surprisingly, Sai-hee's inner makeup remains every bit as grasping, jealous, melodramatic, and paranoid as Seh-hee was before the surgery. No scalpel on her looks can carve higher self-esteem or make her any less troublesome.

Then was Seh-hee too naïve to overlook this obvious truth? Should she have tried changing not her appearance but her identity as such, for example, by erasing her memory of Ji-woo as in such mind-game films as *Eternal Sunshine of the Spotless Mind* (Michel Gondry, 2004)?[4] But we could give her the benefit of the doubt in that deleting memory is still not feasible in reality whereas a new romance enabled by her new face could have lasted while wearing out her old identity little by little. And since Ji-woo's memory of Seh-hee consists of recollection images about her that she can't change, her choice to bring him a new image through her new face might deserve the cost of any trauma that would remain underneath it for a while. Far from avoiding trauma in self-defensive abstinence, she willingly imposes and accepts trauma on herself in the hope that it will be overcome, shattered, or forgotten spontaneously in the end. Trauma is created and covered, then deposited into the flow of time.

The problem is that time can dissolve not only trauma but also desire, and this is the case with Ji-woo, the more real and realistic subject of desire. Time hardly allows desire to anchor at a certain object-face in its never-ending passage, for desire is the name of time with a 'thousand and one' faces (in all virtual senses of this dead metaphor including the deferral of the end through a multitude of variations as in *1001 Nights*). At first glance, Seh-hee and Ji-woo might be seen as representing romance and sex, love and libido, classical and postmodern subjectivities respectively. But she seems to have no choice but to embody sexuality sliding over the face even to go beyond it. Notably, her motivation for transformation comes through a sexual tragicomedy: to arouse him, she encourages him to imagine a different woman in his bed, but then she becomes both angry for his doing so and sorry for "always having the same face," while covering her face with the white sheet as if to erase it (fig. 4.2). This image directly evokes René Magritte's *The Lovers* (1928)—among his other paintings with faces surrealistically replaced by an apple, a dove, a torso, and so forth—which in turn incites our imagination of the couple's kiss to each other's blank face, as they both will undergo surgery later. Here, the facial *tabula rasa* as an immanent plane, Body without Organ, counters yet corresponds to the collage of different facial elements derived from different face sources, which implies the infinite potential of facial reconfiguration (fig. 4.2). The face is, thus, deterritorialized then reterritorialized. A single face becomes nothingness, then a multiple face, that is, shifting from one through zero to many. And it is re-deterritorialized when a photographic simulacrum of Seh-hee's traumatic face becomes a detachable mask that anybody can try on for a playful masquerade (fig. 4.3)—one may say, "first as tragedy, then as farce." We cannot lightheartedly enjoy this farce, however, as the film focuses back on both parties of the pathetic couple who continue to wander while having us wonder whether the face is just a replaceable floating signifier of seduction, or still the sole origin of identity that should not and cannot be rewritten. The final adventure they embark on after his disappearance is nothing but

Désolée d'avoir toujours la même tête.

Figure 4.2

Figure 4.3

a pitiable effort to fill the void left behind by their libidinal movement, a desperate search for dispersed family members through the tactile memory of each other's hands which may survive the visual rebooting of their faces. Nonetheless they are not permitted to have the finale of reunion. Is this because there could be no redemption from the evil power of the image they pursue, the image that rather sweeps them up into unstoppable time?

Maybe not, at least in the film, but there is a delicate point that could further inspire us. Intriguing is the transition period of six months between his/her old and new faces. During that time of disappearance, Seh-hee/Sai-hee

emerges around Ji-woo first as a jealous phantom that shockingly disturbs his sexual affairs with other women without appearing, then as an attractive stranger with a mask and sunglasses whom he wants to capture and preserve as a digital mummy. This ghost effect takes on the degree zero of being, but she ultimately oscillates between two individual faces corresponding to two distinctive signifiers of Seh-hee and Sai-hee.[5] Although Ji-woo's post-surgery appearance also starts with haunting Sai-hee's surroundings by terrifying other men whom she meets in search for him, yet his becoming ghost is more radical. Instead of returning as a charming person with a new name, he appears only as a shadow-like face over the window, then after Sai-hee's chase, as a bloodily erased face. We cannot identify if that faceless man is Ji-woo, whose new unseen face might be no other than any nameless face in the crowd image following the accident. In short, the double facet of facial surgery is not beauty and ugliness, but the hysterical paranoia of retained subjectivity (Seh-hee/Sai-hee) and the atomic schizophrenia of limitlessly spread anonymity (Ji-woo/?). If the former switches between one human image and another, the latter shifts from zero to the infinite, the ontological ground of the former. The face is barely sutured in the most subjective and traumatic manner on one hand, and daringly desutured in the most impersonal and terroristic manner on the other. The ideal state of the sutured face is only anchored in a photograph of their embalmed origin of love, two subjects face to face with each other nestling in a beautiful sculpture of two tender hands. Yes this utopian past is submerged under the wave of passing time, which leaves only one inhuman hand with nobody seating a 'stairway to heaven'—this icon now stretches toward the unrepresentable non-being whose face, its absolute otherness, is out of our vision and subjectivity (fig. 4.4). Looking like Kim Ki-duk's visual signature imbued with

Figure 4.4

both symbolic aestheticism and manneristic transcendentalism, this closing shot struggles to go beyond the seen. The image is on the verge of becoming an interface.

The question may now take a more critical turn. Even though the film debunks our face-centric image empire, doesn't it lead to the double impasse where the mere switch of two faces only forms a closed loop and the more ontological defacement explodes itself without return? Neither the repetition of becoming a different face nor its transcendence through facelessness offers a positive negotiation with the image, which is therefore either anxiously pursued or abandoned in disillusionment. Here the image could be equated with time, whose ceaseless flow causes the double desire: to catch up with it by updating the face (also capturing its moments by camera) or to get over its ephemerality by jumping into some faceless eternity. This is the negative vision of time and image that we should question, groping for any potential of their turning into, say, time image, an alternative mode of their being together. In fact *Time* carves such an image in Kim Ki-duk's intuitive way, notably in the sculpture park scene where a *memento-mori* table in the shape of a big skull serves a pleasant date, and heads of statues have holes around and through which characters move (fig. 4.5). What we feel here is not the tension between dead and living, nonhuman and human, or the fossilized past and the vivid present, but their weird yet warm coexistence. Sculptures are visitors' surrounding others, whose void faces however do not simply expunge concrete materiality. And the aforementioned final shot might look as if the sea caresses, rather than engulfs the statuary, if we see it not as an ephemeral wave of time but as the eternal ebb and flow of time in itself that is always there tenderly face to face with the village of

Figure 4.5

stone- and bronze-made people. Then, fundamental otherness is found less between two flirting characters than between the human beings and the inhuman sculptures or nature. The characters could have seen these fundamental others as their ontological bottom, thereby learning from them to embrace—without obsessively pinning down—each other.

Time thus leaves room for us to imagine a way out from the double bind in which neither changing nor erasing the face can be a solution. As a resonant reference, in Kim Ki-duk's other film *3-Iron* (2004), the heroine has a double face of a beautiful model and an abused wife, and the hero, a drifter, takes pictures of his face along with anonymous families whose houses he squats in as if to squat in their faces without any fixed identity. A unique turning point arrives when their romantic and nomadic elopement bounces back to the society with which, this time, they learn to negotiate by embodying a new mode of being. Like Ji-woo, the drifter named Tae-suk becomes a terrifying pseudo-ghost, but he finally settles in his lover's house as a shadow subject who can remain undetected behind her husband, while still facing and mutely loving her; and her smile in turn pleases the patriarch. Not leading to a bankrupt face and its transcendence, he rather succeeds in maintaining his face by adapting to an immanent plane of reality through his becoming ghost. The result is a total rearrangement of reality in which all three people in the love triangle can be happy together without entirely possessing each other (fig. 4.6). After proliferating as photographic simulacra and receding to ghostly invisibility, the hero's face thus returns as genuine otherness beyond the reach of her egocentric touch, but within the desiring subject's reach of immanent co-belongingness. It deterritorializes the face of identity while reterritorializing (virtual) subjectivity that unfolds an immanent playground on which other subjects can re-deterritorialize

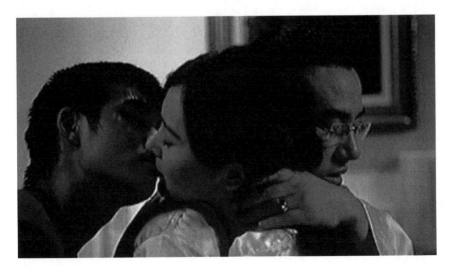

Figure 4.6

their actual relationship. In light of *Time,* this immanence may also be that of time as such, the pure past that is not past in which the other resides with an immanent face, an interface with immanence. Interestingly, Ji-woo in *Time* plays the role of the director of *3-Iron,* as if Kim Ki-duk's avatar, seen editing some scenes including Tae-suk's becoming ghost. But this cinematic reflexivity never develops as if *Time* lost its pure past where *3-Iron* belongs.

The message is as follows. The face of the other is a well-sutured, desire-driven, time-bound "image," whether natural or plastic, original or simulated; here let's be reminded that *suture* is primarily a surgical term. But this face can turn into a "screen" of pure otherness whose visual form may appear either absolutely desutured (Ji-woo) or immanently resutured (Tae-suk). The face as this "image-screen," that is, an interface, thus vibrates between one's different identities, between self and simulacra, between subject and object, between past and present, between human and inhuman, between reality and immanence. While *3-Iron* is more surreal than *Time,* the latter falls short of the former's imaginative awakening that immanent otherness underlies physically sutured others, and that subjects could desire less to belong to each other than to co-belong to immanence as interfaciality. In front of the face, we are eventually forced to face its interfaciality often leading to such an unthought realm.

But this interfaciality is multidirectional. Immanence is not the only terminus to which the face takes us, and we arrive there after examining different directions of faciality in this chapter. If Kim Ki-duk offers a unique case study on the face against the backdrop of postmodern East Asia, the next step will be then to enlarge our scope toward a variety of onscreen faces by exploring theoretical approaches to the face in film history. And if an ultimate question on the face is how to be 'happy together' with that image that is already part of our body, the fundamental question will be how film struggles with the image through the image that is its body.

PARADIGMS OF THE FACE ON SCREEN AND THEIR PROBLEMS

To begin this historical inquiry, I propose to use the term *paradigm* for designating a set of assumptions, concepts, and practices that constitute a systematic way of viewing and visualizing the face on screen. As a sort of framework, the paradigm is more value-laden and perspective-driven than the neutral terms of era, age, or period. Guarding against a schematic approach, we should, however, draw paradigms creatively and flexibly without dismissing historical situations in which they operate. After all, the so-called paradigm shift implies concrete contingency reframing the previous paradigm—the idea popularized by Thomas Kuhn in science. This is more palpable in art, so the task is to elicit certain paradigms and their shifts by looking at facial images that have come and gone throughout film history.[6]

Among serious studies on this topic is Jacques Aumont's insightful monograph *Du Visage au cinema*. It starts with a look at Jean-Luc Godard's well-known homage to Carl Dreyer: in *Vivre sa vie* (1962), the Anna Karina figure watches in tears the overwhelmingly spiritual face of Maria Falconetti, the title role actress in *The Passion of Joan of Arc* (1928). This silent masterpiece renders visible "the alarming and essential nudity of soul and its face," realizing a "utopian perfection of the human face, its transparency" (Aumont 1992, 10). According to Aumont, the absolute face of "internal man" embodies humanism in the *modern* era, or say, the *modern* paradigm in which visibility, enhanced through technology, can partake in absolute beauty or sublimity. As Roland Barthes sees it, Greta Garbo's face may epitomize a platonic idea of modernized divine beauty "which could be neither reached nor renounced" (1957, 56). The face is thus a surface open to what is behind or, rather, below it in terms of what Fredric Jameson calls "depth models" in modernism. These are rooted in the hierarchical dichotomy: the hermeneutic model (inside/outside), the dialectic model (essence/appearance), the Freudian model (latent/manifest), the existential model (authenticity/inauthenticity), and the semiotic model (signified/signifier) (1991, 12). Aumont, then, moves on to Ingmar Bergman's *Persona*. The heroine of this film neither forgets nor recognizes her suffering, which is shared and embodied by her nurse while both of their faces begin to look like one another. The 'truth' of one's identity appears as "only an intangible wavelike pattern [*moiré*], passing from face to face without ever stopping" (Aumont 1992, 11). This inhuman lack of singular depth insinuates the *postmodern* paradigm in which the face becomes nothing but a malleable mask, a surface susceptible to assimilation and simulation, contamination and replication, regardless of what lies beneath. Against this postmodern backdrop, Aumont views the traditional cinephiles' lament for the death of the cinema in terms of the loss of the face.

Although one may question how "transparent" Joan of Arc's face is, or whether *Persona*'s traumatized souls can be reduced to masqueraders, the paradigm shift Aumont scans throughout the history of filmed faces deserves a more detailed summary. The *modern (humanist) paradigm* appears along four steps: (1) the "primitive face" attached to the body of codified pantomime signals in early cinema; (2) the "face in close-up" mostly found in 1920s silent cinema; (3) the "ordinary face" established through the 1930–40s classical Hollywood system that, thanks to the talkie, replaced primitive body language by natural verbal language; and (4) the "human portrait" of genuine human nature, something initiated by Italian Neorealism, which influenced the modern cinema of the 1950s–60s. The last tendency to which *Persona* belongs, on the other hand, begins to stage expressionless or instrumental faces deprived of interiority, and as a result, after the 1970s, the *postmodern paradigm* emerges with the "deconstructed face" or *dé-visage* that is excessively fetishized or deliberately transformed. More broadly, the loss of the human face proper is accelerated in the substructure of art where

banal images of facial typology, anonymity, commercialization, and certain specialized ideas associated with the (anti-facial) mask circulate in conflict and conflation with each other. After this 'cognitive mapping' of cinematic faces, Aumont expresses a slight nostalgia for the 'human all too human' face that is disappearing from the screen.

Dividing facial paradigms, however, depends on the observer's viewpoint and the media in question. Let me here introduce another significant contribution to this project. Looking into photography, Robert Sobieszek suggests three facial phases by adding the *premodern* to Aumont's modern/postmodern dichotomy. The *premodern* era attracts our attention to anonymous facial types catalogued by Jean-Martin Charcot and Duchenne de Boulogne (Sobieszek 1999, 36–79)—the nineteenth-century physiological psychologists whom Aumont mentions as prefiguring (post)modern facial experiments (Aumont 1992, 185). Sobieszek's point is that the premodern approach to individual expressivity related less to anonymity than to typicality in the presumption that the shape of a skull may represent a certain internal characteristic as if something inherent in a killer made him look like a 'natural born killer.' At the peak of the pre-twentieth-century pseudo-science, Boulogne's electroshock physiognomy is rooted in the mythical belief that there is a one-to-one match between each inner emotion and each outer combination of facial muscles. Such a systematic register of mental and physical pairs may belong to what Michel Foucault names the pre-nineteenth-century "classical episteme" that replaced the Renaissance imagination of "resemblance" by the *tabula* of "representation," a taxonomical sign system based on the transparent connection between each signifier and signified.[7] Hence emerges an encyclopedic archivism of the face, including its physiognomy, phrenology, and pathognomy.

Paradoxically, the arbitrariness of the Saussurean sign may be embedded in facial linguistics since Boulogne's pictures, without captions, could be read as expressing quite a variety of feelings. Detached from what it is supposed to represent, the face becomes an artificial mask that is multiple and manipulable. It is uncertain whether a Janus-faced mother under Boulogne's electro-direction shows joy or sorrow in front of her baby. And just as literary signifiers obtained autonomy throughout the nineteenth century according to Foucault, so photographs of expressionless faces begin less to signify the subjectivity of the photographed than to invite the projection of viewer-artists' subjectivity who 'misread' or even 'misuse' them through the mid-twentieth century. For Sobieszek, this change marks the paradigm shift to the *modern(-ist)* era represented by Andy Warhol (who also opened up the postmodern one). Comparatively, Aumont's postmodernism concerns a certain social aspect of this modern paradigm, a "bureaucratic-clerical-statistical system of 'intelligence'" including social taxonomy and criminology that enlists the face under an authoritative control indifferent to individual interiority (Sekula 1986, 16).

Since "modern science and medicine first dissolved this guarantor [of signification] into pure physical materiality or a welter of chaotic symptoms" (Gunning 1997, 29), positivism may have facilitated the user-oriented modern control system of the face, and further, foreshadowed the postmodern condition. This is why Charcot's photo-psychiatry of hysteria appeals to both Aumont and Sobieszek in terms of performance rather than documentation. So the *postmodern* face carries to extremes some self-mutative potential of (pre)modernism, which is not simply denied nor overcome but rather confronted with its own immanent power of deterritorialization. "The once-inviolable surface of the human countenance" is now selected from a menu of multiple choices and established as "a participatory theater of false smiles, feigned psyches, faked characterizations, and fictional souls" (Sobieszek 1999, 174). Thus the notion of subjectivity itself experiences self-deconstruction, traversing cultural (post-)modernity filled with futility, discontinuity, ambiguity, and irony. What remains is a pantomiming face, a *tabula rasa* on which autonomous signifiers (re)produce textual plays that reveal nothing but a schizophrenic 'depthless' model. Like Aumont, Sobieszek does not forget to worry over this antihumanist postmodernism as if it were somewhat intolerable. He says: "Despite everything we have done to cast doubt on it, however, the belief persists that something on the order of a human soul exists" (1999, 285).

Aumont and Sobieszek leave us with some problems in determining paradigms of the face. In Aumont, most analyses are oriented to film style, whereas he ignores the issue of spectatorship that is crucial in Sobieszek's modernism. Aumont's cinematic modern face, based on communication, *photogenie,* and existentialism, has little to do with Sobieszek's photographic modern face as the glossy advertising surface luring the viewer's desire, which fits Aumont's postmodernism. And Sobieszek's samples that spread across premodern, modern, and postmodern paradigms often expose quite similar styles. Not surprisingly, the Victorian novella *The Strange Case of Dr. Jekyll and Mr. Hyde* prefigures the postmodern personality, depicting a double face of good and evil exactly on the basis of premodern physiognomy (Sobieszek 1999, 182–183).[8] In fact, as Sobieszek acknowledges, premodern physiognomy, phrenology, and pathognomy respectively relate to (premodern) individual expressions, (modern) social control, and (postmodern) theatrical performance, whereas each of these three paradigms is incorporated into Aumont's postmodernism in terms of typifying, surfacing, and deforming the face. All these incongruities result from the wide range of implications attributed to modernity/modernism (and their difference). From eighteenth-century scientific visibility to twentieth-century anonymous fluidity, what is called *modern* is used like a measuring tape that is too flexible to be measured itself. There is a big gap even between modernity and modern cinema in Aumont, while Sobieszek's photo paradigms dissect the modern too specifically.

To distinguish cinematic facial paradigms without running into these 'period problems,' I propose to readjust Sobieszek's brilliant metaphor for the cinema. He compares the human face to a *cristal oscuro,* a dark glass that can be transparent (with a light behind it), reflexive (with a light in front of it), and fractured (when broken, with each shard being transparent or reflexive) (1999, 13). Each facet corresponds to: an expressive face showing something behind, a blank face reflecting the viewer, and a fictive face becoming multiple. This triad inspires me not to directly draw three distinct facial periods out of film history, but to reexamine the face in the multiple directions of: (1) the character-subject, (2) the spectator-subject, and (3) subjectivity itself. In addition, there could be one more direction on the reverse side of the third one: (4) otherness. Rather than being rigidly aligned, each facet of this cinematic *cristal oscuro* finds itself at dispersed historical moments while a general sense of paradigm shift remains, yet flexibly restructured. In other words, what matters is not to rely on some grand history of premodern, modern, and postmodern faces, but to revisit the complex directionality of the face. More dynamic than the term three-*dimensionality* of cinematic illusion examined in Chapter 3, this three-*directionality* comprises a nonconscious or unconscious dynamism absent in the phenomenological notion of subject-driven *intentionality.* Now from what the face signifies in this regard, I elicit four directions of the concept *signification,* which correspond to the four activities of the facial subjects: (1) socio-semiotic (codification), (2) psycho-phenomenological (signifiance), (3) ontological (subjectification), and (4) ethical (infinity).[9] Given the increasing complexity of ideas, the second direction may require more space than the first, and the third more than the second. The entanglement of film and theory now interfaces with the face.[10]

READERLY WINDOW: THE SOCIO-SEMIOTIC FACE OF THE CHARACTER-SUBJECT

In relation to the character, let me sum up three points largely based on the classical paradigm. First, the face takes the most privileged place in the body. It brings the five senses as well as breath and speech into unity, complexity, superiority, and immobility, while oscillating between physical and metaphysical, that is, between visible exteriority and invisible interiority. Exemplary of the depth models, it is "a malleable shell that encompasses and reveals the unnamable ghost(s) residing within each of us" (Sobieszek 1999, 13). Some ghostly human 'software'—from soul, self, character, personality, and consciousness to thoughts and feelings—lurks behind the face that is therefore an "organized centered unity showing spirituality" (Simmel 1959, 276–281). Obviously it has been compared to an open book, a deep text, a mental map on which to read individuality and inner states, with the possibilities of misreading accompanied. It should suffice to recall expressionist

faces in silent film such as Joan of Arc's. Second, the face manifests the social role, type, or objectified identity based mostly on gender, race, and class. John Cassavetes fills *Opening Night* (1977) with numerous psychological close-ups of a woman 'under the influence,' but her possessed midlife face is also juxtaposed with the virginal face of a seventeen-year-old ghost girl and the wrinkled face of an exotic old woman in a black-and-white photograph (fig. 4.7). In this way her obsession addresses not just a sense of guilt for not saving the girl from an untimely accidental death, but the universal issue of suffering and aging that unfolds along the spectrum of socioethnically distinct faces. Third, the face works as the most common basis for intersubjective communication, not merely because of its linguistic competence but more fundamentally because of its comprehensive operation among other surrounding faces. In Bergson and Deleuze's terms, the face functions as the center of the human organism, its core mechanism because it is a small "sensory-motor system" posited in the social network, receiving other people's gazes, words, gestures, and the like, while simultaneously sending back correspondent reactions. At every moment when two or more characters appear in a film, we can indeed catch infinitely dissectible exchanges of such stimuli and responses, which are readable in a few stills from *Opening Night* as well. In short, in these three aspects—individual, social, communicable— the face appears as the prominent semiotic power plant that generates signs to be interpreted by the spectator.

In light of this triple function, the face, especially captured in close-up, could be compared to the cinematic metaphor of 'window' in a double sense. Like the Bazininan screen as *cache,* it first presumes offscreen space that usually consists of other parts of the character's body (so the face is only a

Figure 4.7

detail, part, micro-cosmos) or of other characters' faces. These "ordinary faces" exchange language and looks, not so much entering each other's interiority as activating a diegetic network through the shot/reverse-shot system. But the window metaphor is more convincing when it comes to individual expression or objective identity rather than social communication, as Aumont argues that the face in close-up originally appeared as a window to the soul and appealed to the character's internality. A gigantically magnified face on screen then becomes itself a whole or macro-cosmos, and Balázs's physiognomy attempts to "see there something that we cannot see," like soul. He says: "The invisible face behind the visible had made its appearance, the invisible face visible only to the one person to whom it addresses itself—and to the audience" (1970, 76). It would thus appear as a hieroglyph that orients the addressee to its beyond on the supposed guarantee of the existence of a certain profound ultimate meaning to be reached and revealed. This face is a *readerly window* to borrow Barthes's notion of 'readerly,' that is, 'able to decode' (Barthes 1974). Notable is the cinematic nature of this facial language. Its 'readability' primarily comes as 'visibility' beyond linguistic rationality, because the face is not the substitute for words but the "visual corollary of human souls immediately made flesh" and "the actor in the silent film spoke in a way intelligible to the eyes, not the ears" (Balázs 1970, 68).[11]

Aumont defines the Neorealist "human portrait" as the first humanist face that, neither readable nor visible, exists only for direct communication with the audience instead of other characters (1992, 185). As the myth of nonprofessional acting suggests, the undressed face confronted with postwar miseries takes off the "glamour," the powerful sensuality 'added' to the "ordinary face" and pumped up by the Hollywood star system (62–64).[12] But again, at the end of *The Bicycle Thief* (Vittorio De Sica, 1948) when the shamed father and his son plod along with the poor crowd, our direct communication including disarmed sympathy for them, for instance, could not be set apart from our 'reading' of their explicit social identity as well as implicit existential pathos through their 'visible' faces. The same applies to the title role character of another De Sica film, *Umberto D* (1952), whose face epitomizes the social outcast's existential marginality, which is metonymically embodied in a dog's face as well (fig. 4.8). In other words, Barthes's "first meaning" (informative denotation) and the "second meaning" (symbolic connotation) match together through the double *signification* in the most basic sense of the semiotic term: first, the face-*signifier* denotes a *signified* social identity, and second, this codified face as a *sign* itself turns into a singular signifier to join a second level signified of the subject's interiority. Signification is no more than naturalized codification in this sense, the ground of any further interpretation.[13] Admiring the inner beauty of the Neorealist face, Aumont still views it in some Balázsian manner of reading physiognomic soul that is tacitly codified as pure, immediate, and uncontaminated. Likewise, he posits beside the Neorealist human face that of

Figure 4.8

Robert Bresson's unique redefinition of actor as "model" who should take off the theatrical (Hollywood) gown of standard method acting and show a sort of naked face.[14]

Unlike De Sica, however, Bresson does not seem to let the readable social background overshadow the face that should reveal "the enigma peculiar to each living creature" (1977, 39–43). The eponymous girl's expression-less face in *Mouchette* (1967) compellingly leads to this enigmatic otherness that disturbs any seamless humanistic face reading by deterritorializing identity politics, by becoming a sort of animal in the human society, a 'bare life' that eventually fleets to bare nature. Bresson's faces thus escape the socio-semiotics of first-second meanings, moving in an ontological direction. I look into this later, but now, look at a face that is seemingly locatable between the semiotic and ontological directions: in Hitchcock' *The Wrong Man* (1956), Henry Fonda's motionless resignation at times embodies Bresson's ideal model, while his humanistic face still fully exudes the legible existential truth of a social being—a tender, thoughtful husband, and an innocent citizen caught in a Kafkaesque situation. Jean Luc Godard depicts this "essence on existence" as "the most perfect, the most exemplary, of documentaries" in his longest film review; however, this realistic authenticity results less from the pure 'model' outside the studio system than from the 'wrong man's "exact truth" of social identity in crisis (1986, 49). On

the other hand, his face is open to our interpretation all the more delicately because of his subtle, mixed feelings that sway between the wish for restoring his threatened identity and the sense of some insurmountable abyss growing within his being. And perhaps from this complex emotional gap emerges the spectator's desire in response to the image, some subjective intention to fill in the gap in ways that meanings are formed or projected rather than merely discovered or decoded on the surface of an undecided faciality. This new aspect of signification changes the direction of signification from the relatively obvious codification of the character-subject's socio-semiotic face. Simply put, the face on screen is now detached from its owner and attached to its viewer.

WRITERLY MIRROR: THE PSYCHO-PHENOMENOLOGICAL FACE FOR THE SPECTATOR-SUBJECT

As spectatorship has obtained ever more importance, film studies has seen richer theories and practices on the face than its somewhat naïve reception as a readerly window of the character's identity or interiority. The static iconography of the face then gives way to the spectator's dynamic experience of it. To explore this experience, I pursue a series of overlapping stages marked with typical films. Back to the humanist face, there seems a yet-to-be-examined difference between reading the character's identity and identifying with it. When the former is intellectual, the latter is all the more emotional. We not only see through the window of the character but also feel its interiority inside us as if looking inside the mirror. The Neorealist or existentialist face particularly appeals to the spectator's empathy or sympathy as mentioned earlier, and Anna Karina incarnates this spectatorship in *Vivre sa vie*, face to face with Joan of Arc in tears. Sensibility or affectivity matters here depending on each spectator's subjective reception of the onscreen situation (at a different level than Deleuze's affection image or the ethical ontology we see later). Joan of Arc's affects, for instance, have the privileged connection to her own God, so an atheist like me might face her large flat face only as an impenetrable wall and not a mirror (even if it can still be a window to her intellectually understood spirituality). Instead, she resonates in my heart when she eventually 'chooses' her unavoidable death as a suffering human being rather than as a superheroic daughter of God. What moves me is her existential acceptance of something unacceptable, like Sisyphus's repetitive response to a merciless god's punishment. And in my sympathy her mute act resounds as the only way she can paradoxically protest God's order, just as Sisyphus's never-dying loyalty to his absurd god expresses nothing but his utmost "resistance," "freedom," and "passion" à là Albert Camus.[15] This kind of 'interpretation' is completely plausible and feasible despite or regardless of any hidden signified proper to the character's identity or the director's intention. More crucial than a correct understanding of the medieval French

woman's religious faith is my wholehearted embracement of her being as such. She is my double, at least for the moment.

From this viewpoint, however, Joan of Arc's face remains a cover of her absolute God, something I might sense but can hardly reach, grasp, or embody. It is a quasi-interface as an ontological threshold of the other. But we can also review it in the psychoanalytic frame of Chapter 2. First, the screen as a Lacanian mirror unconsciously grounds the palpable effect of the spectator's identification with the 'image-as-other as self.' Second, the (classical) Hollywood cinema typically presents the female body as the object of male voyeurism, so the face obviously emerges as a sensual or sexual attraction, a glamorous spectacle detached from the character's subjectivity. Notable is the paradox that this provocative power is often enhanced when the face is not transparent. In *Shanghai Express* (Joseph von Sternberg, 1932), Marlene Dietrich's face is frequently veiled by a black fabric, by the smoke from her cigarette, and even by her husky voice, while stimulating the macho audience's desire to unveil and penetrate it. This visual seduction results from the fundamental ambiguity immanent in facing the woman: to see her is "to envy her, to recognize that what she represents is desirable," but at the same time to know that "the woman embodies a 'completeness closed upon itself'" (Doane 1991, 69). Desire is provoked and prohibited. The veil only doubles this fate of desire, as it is a transformed hymen, a virgin's membrane that appears to hide the origin or goal of desire, there to be (vainly) lifted, torn, and entered as seen in Chapter 2. That is, the veil is like an artificial interface that awakens the deeper truth that the face itself is already an immanent interface. Dietrich's bewitching face is typically an embodied veil of what the male viewer desires, rather than a spiritual window open to what she has inside. This is a perverted variant of the 'depth model,' which has caused a variety of male thinkers' responses to the woman as the Other. Nietzsche and Derrida, among others, see the face concealing "the secret that there is no secret"; it is the signifier without signified like the phallus, the signifier whose signified has no other mode of existence than perpetual *différance,* always triggering but nevertheless thwarting desire to fix and fill it in.[16] Of course, a feminist critic would not fail to point out that this philosophy of "undecidability or *jouissance*" still idealizes the woman's face, which thus becomes a "fetish of philosophy" (Doane 1991, 62).

But as argued in Chapter 2, the desire for penetration, more radically, may lead us to the ambivalent tactility of the body interface beyond sexuality-based psychoanalysis or cultural studies. We are then directed back to the phenomenology of embodiment accompanied by the spectatorial shift from eye to hand, from watching and interpreting the character's face to touching and "poaching" the facial image through the spectator's projection of his own desire.[17] Such tactile response symptomatically appears in Jean Epstein, a precursor of the phenomenology of embodiment. Epstein's poetics on close-up goes beyond his general empowerment of the eye: "The close-up modifies the drama by the impact of proximity. Pain is within reach. If I

stretch out my arm I touch you, and that is intimacy. I can count the eyelashes of this suffering. I would be able to taste the tears" (1977, 13). Photogenic ineffability incorporates the spectator's embodiment of nervous ecstasy on skin. Psychoanalytic identification is supplied with and supplanted by this psychosomatic embodiment (which is thus a 'supplement'). This psycho-phenomenological reception of the face is found from the inception of film history. *The Big Swallow* (James Williamson, 1901), presumably the first close-up film, ingeniously enables us to feel as though we were absorbed into the black hole of the mouth of the actor who moves forward until swallowing the camera. The face is here not a transparent window to the character's interiority, but an opaque entrance to his corporeality stimulating the spectator's bodily response.[18]

From the phenomenological standpoint, the close-up is therefore said to reassert "the corporeality of the classically disembodied spectator" (Doane 2003, 108). At this point, let's be reminded of our previous discussion about the screen as a double body, and about how the impossibility of penetration of the screen body could turn into the possibility of inscription on the body screen. The face could then be viewed less as a hole than as a façade that causes the 'surface effect' of visibility, detached from its internality or diegetic reality and geared into nondiegetic spectatorial embodiment. In a photo of Andy Warhol's face covered by his hands, for example, we are invited to see not his invisible face, but the magnified material surface of his hands looking like rugged trees that stretch out ten branches, thereby disturbing the usual facial privilege in portraiture. This kind of defamiliarization for perceptual alterity focuses on the visible over the readable, experience over interpretation, feelings over concepts. Roughly speaking, as examined in Chapter 3, it resonates in the philosophical turn from the hierarchy of intelligibility embedded in German idealism—the teleological ladder from perception to representation, to conceptualization, to interpretation—back to the unmediated and instantaneous sensation of materiality reevaluated in French phenomenology.

This fascination with visibility seems clearer in Europe than in America, as the French word for close-up, *gros-plan* [grand plane], implies largeness rather than closeness. Sergei Eisenstein's emphasis on "the 'zoom' effect of ever-increasing close-ups" also alludes to the amplification of the surface (1988a, 96). Not necessarily reduced to tactile desire, Epstein's *photogénie* epitomizes this tendency to amplify the visual potential of the face, his favorite example being Sessue Hayakawa's:

> The orography of the face vacillates. Seismic shocks begin. Capillary wrinkles try to split the fault. A wave carries them away. Crescendo. A muscle bridles. The lip is laced with tics like a theater curtain. Everything is movement, imbalance, crisis. Crack. The mouth gives way, like a ripe fruit splitting open. As if slit by a scalpel, a keyboard-like smile cuts laterally into the corner of the lips. (1977, 9)

Losing its link to the character's subjectivity, this magnified face offers an almost hallucinatory tour of a sublime landscape, shaking and shocking, with organs signifying something else like a curtain, a fruit, and a keyboard. This semiotics of *photogénie* is thus phenomenological, unfolding on the sensorial level of signifiers as ephemeral cinematic effects (Chapter 1). It evokes Barthes's "third meaning," not any informative or symbolic *signification*, but what he calls *signifiance*, the operation of signifiers without signified. Added to the first and second *obvious* meanings, the third one is an *obtuse* "supplement" that is "at once persistent and fleeting, smooth and elusive." Causing viscerally subjective responses, it "simply *designates* what one loves" (Barthes 1977, 59) as Barthes describes a unique facial cosmetics in *Ivan the Terrible* (Eisenstein, 1944; fig. 4.9).[19] The face is then an aesthetic, fetishistic, erotic object of the Barthesian spectator, namely a *writerly mirror* in light of Barthes's dichotomy *readerly/writerly*. Differing from the readerly window, it reflects the spectator's creative subjectivity without being limited to the psychoanalytic mirror metaphor. The writerly mirror enables *photogénie*, the *obtuse*, and furthermore, *punctum* (despite its sharpness), to leave room for spectatorial *signifiance*.

The point would be, however, not to make a film out of faces without glamour, but to experience the revelation of *photogénie* even in glamorous faces. Regardless of film style, every camera has its own mechanical "intelligence" that lets what eludes our ordinary perception spring up with a sparkle of photogenic epiphany. And every spectator has the potential to

Figure 4.9

become a "clairvoyant" just as Epstein enjoys the photogenic in Hayaka-wa's banal Hollywood melodramas. Doane asks if the close-up can really abstract all things from the spatiotemporal coordinates, since most films scarcely pause to give us atemporal *jouissance* or the pleasure of *signifiance,* which, as noted in Chapter 1, Barthes elicits from still images (Doane 2003, 97–98). Conversely, however, this intensive capture of the surplus might be possible only through the flux of time, yet further reaching the inner layer of a more fundamental flux. This is the moment of dropping down from the "superficial continuity" of a story toward the "pre-material continuity" of the whole universe in molecular duration (Epstein 1977, 22–25). A specta-tor who makes his own mental film in this way may be called a 'cinephile.'

In this sense Epstein takes us beyond Barthes's erotics of 'writing' a sub-jective face toward our next stage. Epstein's animistic vision and poetic spiritualism has little to do with humanism or religion. As noted in Chap-ter 1, it rather evokes the Bergsonian-Deleuzian ontology of asubjective monism between spirit/mind/soul/memory and matter/body/object/real, neither of these two axes being limited to the human. The "pre-material continuity" concerns the plane of consistency immanent in both the face and the earth, and their photogenic change into others insinuates the inor-ganic life of things and their "spiritual" characters like Deleuze's affects. This affect, expressed potentiality, is impersonal but singular and indivis-ible. On the face, Deleuze says, it emerges as a reflecting unity, a common quality, or as an intensive power that passes from one quality to another. Particularly in the latter case, it causes micro-movements of facial muscles occurring between perception and action, bringing a momentary breakdown of the sensorimotor system (1986, 95–101). In other words, it is not that the subject expresses an affect so much as that the affect expresses itself by interrupting subjectivity. Epstein loves: "the mouth which is about to speak and holds back, the gesture which hesitates between right and left, the recoil before the leap, and the moment before landing, the becoming, the hesitation, the taut spring, the prelude, and even more than all these, the piano being tuned before the overture" (1977, 9). An affect traverses a piano as well as a face, revealing "the spirit's appearances as well as the spirit of appearances" (Epstein 1988a, 192). The affection image interfaces with such pure affects as quality powers, their ideal singularities and virtual conjunctions, at the risk of being reduced to readerly human(ized) emotions on the actual screen. Whether showing a face or not, any close-up can be a privileged place for an affection image in this Deleuzian sense, since it cap-tures a sentiment-thing or absolute change by deterritorializing the "action image" chain of "ordinary faces" speaking human language and taking human actions. By putting Joan of Arc often outside the shot/reverse-shot exchange, Dreyer draws out of her face a pure spirituality that might not be confined to Joan herself.

Epstein's films are exemplary. In *The Fall of the House of Usher* (1928), Usher's face embodies two modes of affection image, reflecting pure qualities

Figure 4.10

of admiration and surprise at every moment when he paints his wife's portrait, and exposes intensive movements of desire as well (fig. 4.10).[20] Moreover, all things in close-up from pendulums to frogs, the slow motion with the mesmerizing leitmotivs of music, and the wife's painted face that absorbs life and becomes a still life as in Edgar Allen Poe's *The Oval Portrait* correspond with each other to exude and circulate certain effects beyond humanism, immersing the house into the virtual realm of primordial monism. In the director's short *Le Tempestaire* (1947), the woman's face and the sea alternate not just to yield a Kuleshov effect to indicate that she misses her man at sea, but to suggest that her reflective image is also a surface of affects like lapping waves.[21] The mechanical intelligence of cinema overlaps such distant surfaces and allows us to sense the affect that laps both the human and inhuman. More important is the sensation of not the character but the spectator who perceives both the character and the landscape, experiencing openness to the asubjective whole. Rather than shooting the kind of "landscape film" that Epstein criticizes for anthropomorphizing the sea with picturesque glamour, he succeeds in turning both the face and the sea into any space whatever that loses its coordinates so as to participate in a photogenic "landscape's dance" (Epstein 1977, 11). Similarly, his *Three-Sided Mirror* [*La glace à trois faces*] (1927) experiments with velocity and movement, dispersing images until the moment of the hero's death when his face seems to face the photogenic virtual. He projects a life (on the plane) of

immanence where all things are "living their mysterious, silent lives, alien to the human sensibility" (Epstein 1988b, 317).

Therefore, the semiotic phenomenology of *signifiance* gives way to the ontology of (a)subjectivity and (in)human immanence. Spectatorship is no issue for Deleuze, but the unthought in cinema he introduces inspires the spectator to think on the ontological plane beyond or below subjectivity. Though enabling the Barthesian *punctum,* the screen is indeed not fully absorbed into phenomenological self-aestheticization. Even evoking Edgar Morin's (2005) primordial correspondence of macro- and micro-cosmoses, it still goes further than such archetypical anthropomorphism. Serving as the Metzian imaginary signifier, it nevertheless opens a materialist rather than imaginary universe filled with intensities and potentials. And this universe has a face.

MACHINIC SIMULACRUM: THE ONTOLOGICAL FACE IN SUBJECTIVITY

Until now there has been a tacit presupposition: the universal form and quality of the human face remains intact even if cinematic techniques relate it to any space whatever. But this minimal level of human 'faciality' might be destabilized in some cases that question the relationship between the face and subjectivity or faciality as such. Any physical or visual impacts on facial universality, or say, the deconstruction of the face, would then need to be reviewed based on a more fundamental inquiry on how faciality has been constructed, whether there have been problems in that process, and if so, what a new faciality would be like.

As for the origin of humanistic faciality—the face as window to soul—the Bible offers some illuminating passages. Moses hears God's awesome voice: "Thou canst not see my face: for there shall no man see me, and live" (Exod. 33:20). In the New Testament, however, St. Paul is much more optimistic: "For now we see through a glass, darkly; but then face to face" (1 Cor. 13:12). God's face is unwatchable or at most faintly reflected, but promising its presence: "We all, with open face beholding as in a glass the glory of the Lord, are changed into the same image from glory to glory, *even* as by the Spirit of the Lord" (2 Cor. 3:18). This glorious change implies resembling God, whose model is reflected and whose invisible spirit is therefore transferred onto the human face. Claude Lévi-Strauss recounts an anecdote of a missionary who regarded the facial paintings of the Caduveo tribe in Brazil as an insult to divinity because in his Christianity, the face was the place of God's immediate presence that no artifact should touch (1973, 178–197). This theological-humanistic faciality is rooted in the origin of Western idealism. From Plato's era on, resemblance has been considered as more than an external correspondence; it "proceeds less from one thing to another than from a thing to an Idea" (Deleuze 1983, 48). Undoubtedly this idealistic copying is the principle of representation in general: that a sign could refer

to "the depth of meaning," and that something could guarantee this—"God, of course" (Baudrillard 1981, 5).

Conversely, the anthropological lesson is that there are just different ways of facing the face and the missionary's depth model is in no way universal or absolute. The notion of *simulacrum* that attracts both Deleuze and Baudrillard could be addressed in this respect. A compelling example may be Werner Herzog's *Wodaabe: Herdsmen of the Sun* (1989), a documentary on a nomadic group living along the southern edge of the Sahara. Like the Caduveo, Wodaabe clans have a unique tradition of painting on the face, and it plays a role in their mating ceremony. The young men, with elaborate make-up, feathers, and other adornments, dance and sing to impress marriageable women, especially by rolling their white eyes and showing their teeth. The ritual consists of a series of barters over marriage and contests where women judge the men's beauty and skills (fig. 4.11). The Western culture of female beauty as the object of male look is reversed here, but there is more than that. Their facial paintings are not "iconic copies" as secondhand possessors of their own ideal self, but "phantasmatic simulacra" as false claimants or perversions whose model, if any, is what the Other desires. There come a series of interiorized dissimilarities, divergent reverberations, and amplified movements. The disparity is judged in and of itself, not prejudged based on any previous identity. An extreme message we could draw here, if not intended by Herzog, might be: "that deep down God never

Figure 4.11

existed, that only the simulacrum ever existed, even that God himself was never anything but his own simulacrum" (Baudrillard 1981, 4).[22] Rising to the surface, simulation causes the depth-oriented codification and representation to fall under "the power of the false (phantasm)" and sets up "the world of nomadic distributions and consecrated anarchy"—this is all the more palpable in the case of the Wodaabe's polygamy. Swallowing up all territorial foundations, "it assures a universal collapse, but as a positive and joyous event, as de-founding" (Deleuze 1983, 53).

I note here that although the masquerade depends much on spectatorship, the Wodaabe's cosmetics do not remain the spectator-subject's writerly mirror for *signifiance* as Barthes enjoys the third-meaning makeup in *Ivan the Terrible.* By excessiveness the simulation of explosive faces rather exhibits certain autonomy of faciality itself, which belongs neither to the owner nor to the viewer of the face. It expresses its own power of being detached from its territory and becoming different, even if temporarily, but through that ephemeral effect, it opens up the virtual of faciality. Bearing no relation to any reality in essence, the simulacrum is "its own pure simulacrum" according to Baudrillard. From the traditional semiotic perspective, it is a sign that dissimulates not something but the fact that there is nothing behind.[23] A copy without origin, it is the very origin of itself only insofar as it never remains self-same.

In this regard Deleuze and Guattari's notion of faciality seems compelling. They argue that concrete faces are engendered by an "abstract machine of faciality" that gives the signifier its white wall and subjectivity its black holes. As remarkable cinematic metaphors, the white wall dresses "the frame or screen" that projects facial signifiers, while the black hole functions as "the camera, the third eye" that leads to the spiritual signified. But we should "not expect the abstract machine to resemble what it produces," because this machine is "something absolutely inhuman." In this sense, the ontological face is a *machinic simulacrum* of faciality as such rather than its mechanic representation. Faciality without faces, namely BwO, is organized into human faces only through a certain assemblage of power (Deleuze and Guattari 1987, 167–169). The socio-semiotic face results from this kind of power operation that consists of *signifiance* and subjectification based on their one-to-one matching system. Here, what Deleuze and Guattari call *signifiance* is not the Barthes notion, but nothing other than signification as codification. And from this logic we now elicit the third, ontological definition of signification as *subjectification.* More than codification, subjectification implies the comprehensive process of organizing BwO into an individual human organism and any quasi-BwO into humanized forms. Drawing on Deleuze and Guattari, I mention three cases of this subjectification. First, it makes the grid of facial types corresponding to social identities as in Duchenne's methodology. Second, it enables us to see landscape as facial, that is, to naturalize the face or facialize nature.[24] And finally, as the origin of both these two facial effects, it generates a specific face that has

expanded its territory everywhere as if universal: the face of Jesus Christ superstar, born in the year 'zero,' representative of the typical European and White Man at once in that it relates not simply to white men but to the white-wall/black-hole system sutured into the theological-humanist face.[25]

If faciality comes out of such a largely political assemblage and has thereby rigidified a certain repressive system of signifying subjectivity, it would be also political to disassemble the face as a sort of liberation project. "Yes, the face has a great future, but only if it is destroyed, dismantled. On the road to the asignifying and asujbective" (Deleuze and Guattari 1987, 179–181). Hence the so-called postmodern face: a fluid matrix, a switching center that deterritorializes any fixed, unified subjectivity. Regardless of period, a number of films retain some symptoms of such 'defaciality' mostly by affecting the sheer face or transforming facial visibility through cinematic techniques. To map this tendency, let me start with a few samples that explicitly play on the autonomous potential of the face by amplifying and/or fragmenting it. Georges Méliès' *Man with the Rubber Head* (1901), for instance, proves that the cinema was born not only as a facializing machine but also as a defacializing laboratory. A head without soul, cut off from the body, is swollen and reduced through antihuman, pseudoscientific, materialist imagination (fig. 4.12). In modern cinema, excessively amplified facial images like Kane's gigantic electoral poster in *Citizen Kane* (Orson Welles, 1941) often appear as a Žižekian interface that spectrally overshadows ordinary reality (Žižek 2001, 39). *The Parallax View* (Alan Pakula, 1974) and *The Terrorisers* (Edward Yang, 1986) show similarly huge face photos, which are also cut into pieces, as if to enlarge and shatter their identity at once. In a more postmodern context, Woody

Figure 4.12

Allen's "Oedipus Wrecks" in *New York Stories* (1989) stages his mother's enormous face in the sky, a face that looks like both a BwO, given its marvelous expansion, and an OwB, given its monstrous detachment from spatial coordinates. In this regard, amplified faces could be reviewed in relation to fragmented faces in those films that magnify only a part of the face, a segment without expressive subjectivity or relational context. *Mauvais sang* (Leos Carax, 1986) displays the eyes, the front, and the ears often tightly framed even within an extreme close-up, which Aumont finds typical of postmodern style. More corporeal are the sensual lips on video in *Videodrome;* and more physical than that, not imaginary at all, is the ear in *Blue Velvet* (David Lynch, 1986) abandoned on the ground, cut off from an unknown head. Such organs without bodies on screen are as detached as the moving nose in Gogol's *The Nose,* a literary precedent. But they often invade reality much more gruesomely by drawing the character into an enigmatic, dark world, with a facial part turning into an interface to the Real.

One common aspect of these films is that they show a face remaining someone's identical face, whether aggrandized or fragmented. Now, we could take a further step to see the change of that visual identity, its transformation and even substitution. In early cinema, *Photographing a Female Crook* (Biograph, 1904) seems as suggestive as the Méliès film: a woman photographed by the police expresses bodily anguish, somewhat evoking Laocoon's spasmic suffering. But far from incarnating sublime humanity, she rather tries to conceal her identity in the mug shot by desperately revealing fake identities with her twisted faces (fig. 4.13). This comic contortion looks

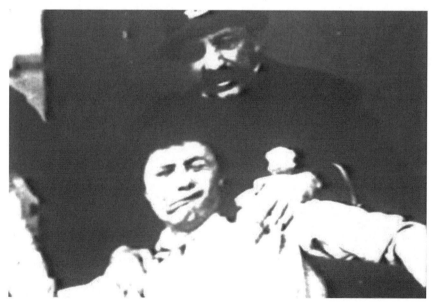

Figure 4.13

like an ironic parody of the myth of facial expression, a hysterical resistance to social control based on physiognomic photography, and a schizophrenic distortion of facial unity organized through humanist subjectification. Simply, she performs an extreme self-masquerade with facial simulacra. If a 'dead mask' is an index copying identity, this 'living mask' is an anti-face overwriting identity with an artificial icon of another identity that belongs to nobody. Interestingly, her entire body reflects, imitates, or embodies this facial movement as if it retrieved the primitive face-body unity. If faciality is produced when the head is "decoded" from the primordial, polyphonic body and then "overcodified" as the face (Deleuze and Guattari 1987, 170), it is now 'desutured' into that body. The face as a machinic simulacrum leads back to the BwO.

Though limited to the muscular movement, this facial simulation prefigures artificial, technological transformations of the face prevalent in (post) modern films. We could retackle plastic surgery in this context, to trace a cultural genealogy of *Time*. In fact the issue of creating a new face leads us back to the Frankenstein myth with its theological concern over the relationship between the creator and the creature. If the creator is neither God nor the biological father, the iconic chain of the creature's resemblance to the creator will be broken. In *Time*, the surgeon tells Ji-woo: "I can change your face and even your parents couldn't recognize you." The surgeon is a modern god who molds an origin-less simulacrum that at best copies scattered mass media images. Significantly, Dr. Frankenstein's monster results from a sort of *bricolage* assembled from different parts of different corpses—a jumbled origin in the form of anonymous, amorphous, anamorphic multitude. When the surgeon in Franju's *Eyes without a Face* (1960) 'stitches up' kidnapped women's faces into his daughter's, he seems not a creator so much as a simulation agent who 'sutures' the dispersed multitude into a single surface. Notable is the genre convention that eventually imposes moral anxiety or punishment on this transgressive biopower. Such B-movies as *Faceless* (Jesus Franco, 1987) vary the psychopathic crime story: the male agent's desire to restore his woman's damaged face hardly brings back her happy identity, partly owing to the very inherent paradox that the original is only resurrected as a simulacrum woven through grafted fragments.

The ultimate failure of facial restoration is an ongoing theme. A contemporary mind-game film *Open Your Eyes* (Alejandro Amenabar, 1997)—and its Hollywood copycat *Vanilla Sky* (Cameron Crowe, 2001)—stages a playboy who, after losing his handsome face, desperately sticks to the dream of regaining his face with plastic surgery. The point is, however, not the inner tension between original and simulacrum but the effect of facial recovery that repeats the adhesion to the identical image. Hiroshi Teshigahara's *The Face of Another* (1966) refracts this Imaginary by drawing attention to the potential of facial machinism (rather than simulation) in that the main character's plastic surgery after an accident does not allow him to regain his old identity but to gain a new, sexually empowered one (fig. 4.14). This turn,

Figure 4.14

if not always positive, at least sheds light on how facial change could bring about becoming other. The same director's *The Man without a Map* (1968), though not about the face, stages a similarly compelling story: a detective searches in vain for a missing man while his own life begins to resemble that of the man he follows, indirectly assuming the figurative identity.

The old paradigm that the face represents identity still lurks here, but what matters is facial machinism, one step further down to faciality, wherein the potential of change itself rather than changed identity catches our eyes. In this aspect the face in thriller films often activates a sort of agency that the subject needs to use as deftly as possible. *Dark Passage* (Delmer Daves, 1947) shows a criminal having a new face after plastic surgery and hiding away from the police easily. In *The Jigsaw Man* (Terence Young, 1983) a British secret agent who defected to Russia is sent back to Britain by the KGB to retrieve vital documents after the surgery. *Face/off* (John Woo, 1997) transplants a criminal's face onto an agent and stages the chiasmus of their identities, updating the doppelganger motif. Some SF films even present facial change as a spectacle embodying the contemporary cinema of attractions. Biomechanical or cyborgian transformation appears instantly but magically in such films as *Minority Report* (Steven Spielberg, 2002) and *Total Recall* (Paul Verhoeven, 1990), empowering the character-subject as an agent to better respond and adapt to contingent situations. We may even sense the degree of facial malleability as we discussed the solidity, liquidity, and gaseousity of quasi-interfaces. James Cameron's *The Terminator* (1984) and its sequel (1991) exhibit a memorable pair of inhuman faces. The original Terminator reveals a robust robot face under human skin, an

iron skull taking on immortal alterity, an undying *memento mori*. This solid mechanic cyborg contrasts with a liquid metal Terminator in the sequel who can change to anybody else in appearance. When this liquid cyborg falls into a melting pot at the end, other characters' faces it has simulated resurface onto its face successively in the throes of death until melting away into its amorphous BwO (fig. 4.15).

Visually, such extreme malleability is realized through splendid CGI, inspiring us to think about the digital phase of (inter)faciality. As examined at the end of each former chapter, the digital image surface changes its form continuously irrespective of the physical law governing the actual body. There is only one variable image, or variability itself through which the digital face can take on the nature of BwO or at least simulate what it might be like on screen. Obviously, digitization urges us to reframe the ontology of the body in terms of the ontology of the image. Photoshop, let alone digital cinema, has enabled anyone to perform, say, digital plastic surgery on digital facial images by composing, reprocessing, embellishing, or distorting them. Manipulation is another name for this kind of multiplication, seemingly making the face on the monitor look like a prominent machinic simulacrum. The Lacanian 'imago' that appears in the single vertical mirror is replaced by "the contemporary 'me'" that proffers the synthetic theatricality of multiple agencies emoted by "the postmodern 'we.'" The human face gives way to the 'posthuman' synthetic selection from an unprecedented

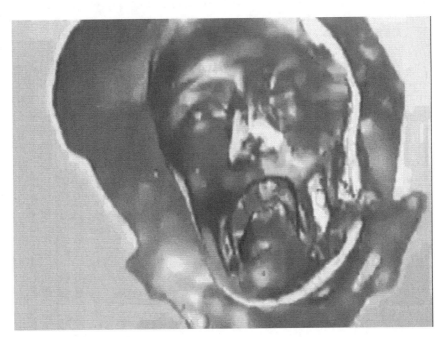

Figure 4.15

menu of options for facial transformation and substitution (Sobieszek 1999, 182–187). Though Sobieszek draws this diagnosis from art photography, it accounts for the new media culture in general.[26]

Rather than concluding the chapter further in this direction, however, let me hark back to a few historical points based on analog faciality but resonating with the digital, which indicate a dilemma of the postmodern face. Theoretically, as argued by new media scholars, digitization in post-filmic production privileges composition over discovery, fantasy over reality, icon over index, "Kino-Brush" over "Kino-Eye," such that cinema is readdressed in terms of painting or animation (Manovich 2001, 252–259). Eisenstein captured the significance of animation as early as Disney's drawings, where he saw "a rejection of once-and-forever allotted form, freedom from ossification, the ability to dynamically assume any form," namely "plasmaticness" (1988b, 21–22). It is no coincidence that the rubber head in the aforesaid Méliès film looks like an animated one because of its fluidity or liquidity. Somewhat differently, predigital expanded cinema also experimented on the face in ways of drawing and effacing it. Peter Campus's *Three Transitions* may be exemplary again, since in its second part he rubs his face only to expose another one. The face here is a self-mirror whose double foil peels and retains its 'image' at the same time. Effacing it is nothing other than redrawing it, facing the self as nothing but a double (even infinitely replicable) surface with no substance. In the third part, his face is reflected on a plasmatic paper-mirror that his hands burn. Perishing in the fire, this deadpan face looks at itself completely detached from any subjectivity and perhaps interfaces only with the 'nothingness' into which it is gradually absorbed and dissolved (fig. 4.16). Unlike this kind of experiment, however, a problem seems to come out of genre conventions that trivialize this machinic simulacrum by turning its immanent multiplicity or nothingness into a mere visual element. Hollywood superheroes from Zorro to Batman often appear with a mask, a new face empowering them, which reduces the machinic potential of the face to the mechanical exchange of fixed identities. As typically caricatured in *The Mask* (Chuck Russell, 1994), wearing/ dropping a mask functions like an on/off facial switch that sutures BwO into a form of just another (more powerful) identity. In short, this process reterritorializes the deterritorializing faciality into genre clichés. Plastic surgery or any facial transformation, for instance, does not represent the character's physical pain so much as it serves the spectator's visual pleasure. Despite postmodernist implications, the majority of self-changing faces staged in the film industry still appeal to the familiar motif of double identity amplified through its splendid (digital) visual effect. Does this not signal an aesthetic stalemate in which the face as machinic simulcrum tends to become a postmodern cliché on screen? Is the ontology of the face not overwhelmed or overshadowed by some visual phenomenology in the contemporary media environment? Can there be another direction in thinking the face?

Figure 4.16

UNCANNY ICON: THE ETHICAL FACE TOWARD OTHERNESS

To answer the last question as our final agenda, I begin with an art film that may gear us to a different dimension of faciality. Inspired by Jean-Luc Nancy's memoire of his heart transplant, Claire Denis's *The Intruder* (2004) follows an old man who has heart problems, seeks a transplant, and searches for a son, traveling around the world from the French-Swiss border to South Korea to Tahiti. This road movie setting seems to betray an interesting difference between the original text and its cinematic adaptation. Nancy's essay is about his biological mutation of becoming a sort of "science-fiction android, or the living-dead" through the incorporation of a heart that is not his own, something other that had intruded into his body, yet upon which his life now depends desperately. The philosopher meditates on self and other.

> The *intrus* is no other than me, my self; none other than man himself.
> No other than the one, the same, always identical to itself and yet that
> is never done with altering itself. At the same time sharp and spent,
> stripped bare and over-equipped, intruding upon the world and upon
> itself: a disquieting upsurge of the strange, *conatus* of an infinite excres-
> cence. (2002, 13)

The heart from a stranger is thus not simply a curing organ attached to his body, but an uncanny intruder that vertically settles down at the center of his self. It is a Derridean *supplement* that both complements and replaces entity, identity, authenticity, subjectivity, and so forth. Nancy's philosophical journey into this deeply rooted other suggests how otherness is always already immanent to the self. A dilemma occurs when this ontological otherness has to be visually translated on screen. Since the camera cannot enter the body, it captures a heart beating alone in the snow at some point like a gruesome OwB. Owing to the nature of the medium, moreover, the film takes the strategy to shift the focus from the vertically embodied other to horizontally encountered others by showing different ethnic faces along the Western hero's worldwide itinerary. While the film palpably portrays diverse landscapes and their auratic atmospheres, it is inevitable that ontologically fundamental otherness cannot help experiencing a sort of phenomenological reduction here, somewhat as in the aforementioned case of genre films. The invisible difference between self and other within one's body is therefore sutured into visible facial differences in color—and tactile locational differences in temperature—although their sensuous aspect could be the film's phenomenological achievement.

Conversely, however, it might make sense to see the others' concrete faces as interfacial with fundamental otherness that can ground the subject even by intruding him. We may need to theoretically generalize this self-other relationship that seemingly raises an ontological issue different than from the face-BwO relationship. What is missing in Deleuze and Guattari's approach is the face of the other and not the subject, a face that appears in front of the subject. This other's face is neither accounted for in terms of 'machinic simulacrum' concerning subjectivity alone nor in terms of 'readerly window' or 'writerly mirror.' It has more to do with the subject who sees it as a spectator (i.e., less to do with the other's socio-semiotic codes), and yet it does so not in the psycho-phenomenological way of the subject's playing significance on it, but in a new ontological way that the subject discovers and accepts its otherness itself as both radically different from and foundational for subjectivity. In this sense it rather appears as an *ethical face* that positions the subject in front of otherness in general, that is, absolute otherness. Emmanuel Lévinas says that the differences between the Other and me depend neither on different "properties" inherent in each nor on different "psychological dispositions" caused in their encounter. "They are due to the I-Other conjuncture, to the inevitable orientation of being 'starting from oneself' toward 'the Other'" (1979, 215).

This orientation, I see, serves as the fourth direction of the face as a quasi-interface, a direction taken not from the face (as in the three former cases) but toward it. Differences between two symmetrical facial entities are grounded on and preceded by the asymmetrical structure in which I am fundamentally oriented to the Other as "difference-in-itself" in Deleuze's terms (not Deleuze and Guattari's). As mentioned in Chapter 1, difference in itself is 'sutured' into visible differences including facial ones so that, conversely,

the other's face appears to be an interface with that primary difference in itself. Now the point is that this interfaciality comes through the I-Other relation prior to such ontology based on one's own BwO. Understandably, Lévinas regards ethics as *meontology,* a study of what remains outside of ontology rather than what does not exist. The Other has a meaning beyond being, a mode of nonbeing that nonetheless needs to be affirmed. It is neither 'something,' nor 'nothing,' but that which one might think can be reached, yet becomes nothing when reached. Its 'atopical' signification—our final redefinition of signification—may be therefore *infinity* as opposed to totality. While totality refers to the subject's self-closed set of meanings into which the Other is incorporated as just an other, this centripetal subjectivity is desutured when facing the Other as centrifugal infinity. Totality is asymmetrically related to infinity; the former sutures the latter.[27]

Lévinas's notion of face sounds equivalent to the "Other as such" in theory. The face is present in its refusal to be contained, comprehended, or encompassed. "It is neither seen nor touched—for in visual or tactile sensation the identity of the I envelops the alterity of the object, which becomes precisely a content" (1979, 194). That is, the sensual actualization of the Other changes it into a mere other. But "in its epiphany, in expression, the sensible, still graspable, turns into total resistance to the grasp." In Lévinas's Judaic background, this resistance to possession only demands: "thou shalt not kill me," prior to any reaction or assertion of freedom by me, the subject. The face traces where God passes, installing the subject's positive and nonviolent response to a faceless God. Thus ethics comes before and goes beyond any "morality" based on a set of rules in social situations (197). The face of the Other is essentially "naked" like Bresson's socially decodified models, an icon that shows nothing actual but a tautological singularity of "you are you" (86–87). Updating Lévinas's, face, Judith Butler sees through it the "precarious life" whose vulnerable otherness might biologically provoke the subject to kill it but ethically orders him to protect it (2004, 128–151). We could rephrase this in Giorgio Agamben's term "bare life," whose sociopolitically suspended subjectivity makes it *homo sacer* that anybody may kill with impunity (1998, 71–86). Yet as anybody can be *homo sacer* once put in the state of exception in which this killing may not be regarded as murder, this naked otherness is not simply external but deeply internal to the self's subjectivity. Lévinas's emphasis on the separation between the subject and the Other thus evokes Freud's uncanny. The ethical face is an *uncanny icon* insofar as something unfamiliar in front of us leads us back to something inside of us, originally familiar but unconsciously buried. That identity is formed through and opened toward alterity assumes the latter's intrusion into the former. The Other's naked face requires the subject's response-ability toward what is not only actually out there, but virtually immanent in him. What is exterior is interior. Indeed, the precariousness of bare life is our shared bottom of life. Perhaps we could not kill it without having some sense of committing suicide. Ethics starts from the degree zero of being.

We could further ask, then, if there are other cinematic ways of expressing uncanny otherness than through facial differences as in *The Intruder*. Or the question should be whether there are more radical facial differences than in terms of class, sex, or race, which is prevalent in the identity politics of cultural studies. An inspiring idea comes back from Deleuze and Guattari. They say that the face in 'close-up' looks like a 'grand plane' [*gros-plan*, i.e., 'close-up' as said before] of "the inhuman in human beings . . . with its inanimate white surfaces, its shining black holes, its emptiness and boredom" (1987, 209).[28] Faciality partakes of inhumanity yet to be subjectified into an organism, only subsisting as the potential of becoming other. Rimbaud's declaration "*Je est un autre*" may concern not identity shift so much as that impersonal, asubjective power; not an other but the Other. The BwO is thus an inhuman body within the human, implying the fundamental continuum of human and inhuman. Two remarks can be made in view of Lévinas here. On one hand, as noted, Deleuze and Guattari's ontology treats this immanent otherness from the perspective of the subject who owns it, relatively detached from the ethical dynamics between subject and object. On the other hand, immanent inhumanity can directly take the visual form of inhuman faces that embody extreme otherness. Here come the faces of the human's 'ontological others' such as ghosts and animals beyond cultural differences.

First of all, ghosts in most horror films show stereotyped faces with special effects, but I briefly note two nonconventional Korean examples. *Memento Mori* (Kim Tae-yong and Min Kyu-dong, 1999) depicts a dead lesbian girl's return to her repressive school in the form of a huge face gazing from above and not a whole body. Her face looks less like an integral subject's face revenging itself on an object than like a fragmented but magnified surface traversed by terrified students' chaotic movements. Put bluntly, it is an OwB that, in extreme close-up, visualizes the social BwO of the schizophrenically deterritorialized school system (fig. 4.17). But at the same time, this ghost face remains sadly calm without resorting to violence, as if she only wanted to be understood by people who victimized her by treating her desire as perverted and intolerable. Given that homosexuality is more or less immanent in everyone, her sole message may be: "look at my face!" as implying "look into yourself!" But nobody except her ex-girlfriend dares to face her face and be responsible for that uncanny otherness. In a different way, the heroine of *Faceless Beauty* (Kim In-shik, 2004), torn into pieces in an accident after being hypnotized by a psychiatrist, comes back to him as a headless bloody ghost whose body barely retains the trace of subjectivity. He is panicked, though her defacement might imply that her only purpose is to remind him of her trauma related to his, toward which he should take some ethical attitude.

Often, a normal face also appears ghostly in a certain mise-en-scène. In Andy Warhol's *Blow Job* (1963), the only character seen in black-and-white close-up somewhat evokes Joan of Arc, but strips away her metaphysical

Figure 4.17

aura through his physical sensations apparently aroused by offscreen fellatio. Eros, however, mingles with and gives way to Thanatos, as his face looks like a dead man's skeleton when facing the camera, like the 'skull-beneath-the-skin' (fig. 4.18).[29] We are then frustrated less for the unseen oral sex than for the unseen face, because "we cannot see him looking at us . . . We cannot make eye contact . . . This face is not for us." Virtually unseen, it looks back at us while enabling "an ethics of anti-voyeuristic looking" which leads us beyond scopophilia (Crimp 1999, 115). This is a ghost face with the darkened eyes receding from subjectivity back to the invisible. It is not a mirror for projecting a viewer's bodily desire pornographically, but an interface with the uncanny death drive. Likewise, Edie Sedgwick's face on video in Warhol's *Outer and Inner Space* (1966) looks at nobody. Her ghost double, it is shown only in profile and stuck in a short circuit of unmatched shot and reverse shot. It consists of no substance but the ontological qualities of the image itself: flatness, fragility, ephemerality, and spectrality.

A more explicit embodiment of ghostliness is found in a variety of genre films featuring monsters as pseudo-ghosts. When *Nosferatu* (F. W. Murnau, 1922) comes in out of the dark background, the white wall of his face shines with all the intensity of whiteness—a Deleuzian example of affect as pure quality. In its remake by Herzog (1979), the ghost-like vampire not only enhances this ontological faciality, but exhibits a certain animality as he apparently looks like a grey rat with its two conspicuous front teeth—notably, the film is full of rats that spread disease and decay all over the world in molecular fashion. There are also many cases that directly visualize bizarre animal-like creatures or beings that become such 'others' as in the true story of *The Elephant Man* (David Lynch, 1980) or a SF film like *The Fly* (David Cronenberg, 1985). Such changing faces or changed faces, natural or artificial, question

Figure 4.18

the humanist boundary between normal and abnormal, while urging us to change our attitude toward ontological others that are radically different yet uncannily derived from our human form and quality. Their faces, apparently horrible, but often pitiable, are therefore inevitably ethical.

Let us now move on to the face of the animal as another major ontological other. Obviously our concern is not the personified animal whose face only reflects the human face as in Disney animations, but the opposite direction in which the inhuman face can uncannily open to infinity. More often than not, this direction emerges mixed with the other directions of faciality examined so far. *Au Hasard Balthazar* (Bresson, 1966), for example, lures us into reading anthropomorphically codified emotions of the eponymous donkey. This might seem to happen through the Kuleshov effect since the film shows the donkey's face followed by the human events that it seems to observe. But in Bresson's contemplative close-up, the animal may also allow us to obtain some "obtuse meaning" from the sensuous texture of its skin as an autono-mous surface as a site for *signifiance*. On the other hand the thingness of this surface seems to confirm the impenetrable otherness of the obstinate animal though it still belongs to the human world as both an observer and victim. In other words, the animal's undressed visage is certainly coated with some

mournful effect of cruel humanity while it nevertheless leads us to something that could not be fully interpreted in terms of moral lessons.

The ontological other's eye that witnesses the human world is often on this threshold between morality and ethics, between codification and infinity. Federico Fellini's autobiographic *Amarcord* (1973) represents his hometown through animal eyes at some points as a peacock looks back at us in the snow like a beautiful *objet a*. If this magical animal still imbues the artist's nostalgic world with aesthetic lyricism, Julio Medem's *Vacas* (1992) takes the cow as an inhuman observer. Interestingly, at some point, it is put beside with the camera, a symbol of modernity and technology, which also seems to stand for the machine as another ontological other. The scene that shows the animal, human, and mechanical eyes together then evokes one of our earlier issues, the consecutive suture of gaze from natural to human to artificial interfaces (fig. 4.19). Despite the long tragic rivalry of two families depicted in the film, the title is the "cow," provoking an approach to history that is more fundamental than humanist.

The animal gaze is truly interfacial. Bill Viola's *I Do Not Know What It Is I am Like* (1986) is an experimental journey into the inner states and connections to animal consciousness we all possess. In a chapter the camera zooms in the face of an owl until one of its eyes takes the whole screen with the cameraman reflected on its retina. Rather than a mere mirror, this relentlessly glaring eye with no readable emotion could be viewed as an ethical interface that enables us to discover ourselves uncannily within the object we face. A more complex case is a bear's bare visage in *Grizzly Man* (Herzog, 2005); a bear disperses its empty dark stare over the camera and nature, and will soon have killed the grizzly man who has wanted to be the best friend and protector of bears (fig. 4.20). Herzog's narration says that this ungraspable, impenetrable stare reveals "overwhelming indifference of

Figure 4.19

Figure 4.20

nature . . . only the half-bored interest in food," reminding us of the profound boredom Heidegger sees in the animal. The openness of the world is closed to the animal that, living by instinct, "has gone beyond the difference between being and beings" (Agamben 2004, 91).[30] When the grizzly man exhibits his performative passion for animals with his face hidden by sunglasses, the grizzly bear exhibits nothing while its face remains totally naked. This stark contrast, with all the man's effort to incorporate the ontological other, leaves unresolved the ethical question of how to approach infinite otherness. One may recollect a fantastic forest scene from *The Intruder* here, a scene of the clearing in which the old man takes a peaceful rest with wolves, naked like them. But is this coexistence with the ontological other not a rather utopian imagination presented as in just a dream?

Tropical Malady (Apitchatpong Weerasethakul, 2004) is, finally, more convincingly inspiring in this regard. At the end of the film, a tiger appears from the dark and looks directly forward with its calm, fixed, silent sublimity. Thickly concealed in itself, its face with closed mouth looks as though it only speaks in an inhuman, immemorial language (fig. 4.21). A man in desperate search of his lost lover, who became an animal-ghost, now is about to become in turn an animal-ghost without any easy escape to fantasy. Though he kneels down and moves like a beast, this gesture may not signal a return to representing animality, but expressively present "a very spiritual and particular becoming-animal" which draws a life-changing line of flight toward "the marvelous of a non human life" (Deleuze and Guattari 1987,

Figure 4.21

231–234). He loses his face that is as dark as the jungle, but he enters the uncanny plane of infinite, immanent connectedness to the animal, the ghost, namely all virtual life, while becoming naked, imperceptible, and clandestine. Cinema then stops facializing the landscape. We see not a film but rather a cinematic interface that amalgamates ontological others, staring blankly into the disappearing trace of faces.

5 Image and Subjectivity

INDEXICALITY REVISITED

When the "death of cinema" became a buzzword in the wake of the "digital dark age"—to recall Paolo Cherchi Usai's 2001 book title—what was believed to be dead was the material connection between object and image, the image as index like a fingerprint.[1] It has been a longtime truism that photographic *indexicality* is the ontological essence of the cinematic image, its medium specificity, since Bazin's famous declaration we examined: photography had achieved the utmost realism through the mechanical reproduction of the object on film and thereby freed Western painting from the old obsession with imitation (Bazin 2009, 5–7). The point is not this new medium's apparently perfected iconic capacity, but its indexical process of inscribing light from the object onto the chemical celluloid. Even without referring to Peirce or the term *index* at all, Bazin then became the representative of Peircean indexicality, especially in the Anglophone film academia.[2] The so-called Bazinian realism has been considered to revolve around film's documentary value of being indexical witness to real events rather than their iconic representation. Furthermore, indexicality may concern the cinematic experience of seeing celluloid on a big screen to be overwhelmed by authentic and even auratic reality projected in full scale. It is no wonder that traditional cinephiles and cineastes often insist on preserving this 'true' experience of cinema against the invasion of digitized imagery through new media platforms in varied, mostly miniaturized sizes.

Apparently, according to Lev Manovich as we saw, "the language of new media" has turned the nature of the cinematic image from being inherently photographic back to reembodying painting and painted cinema, that is, animation—its inherent mobility itself, in Gunning's expression, "moving away from the index" (2007), contributes more essentially to the impression of reality in cinema. Unlike an analog photograph bound in a "fragile integrity" from which discrete information cannot be extracted without violating the evidentiary value of the image (W. J. Mitchell 1992, 6), the digital image is a visual product of numerical algorithm that replaces indexicality with the electronic binary code. The digital revolution results from the malleability

and independence of this code that enable one not only to replicate and manipulate the image of objects with more enhanced iconicity, but also to compose and create objects that do not even exist in the actual world like the computer-generated dinosaurs in *Jurassic Park* (Spielberg, 1993). In this paradox, digital simulation is less than iconic imitation because there is no original while at the same time more than iconic imitation, again, because there is no original. Able to copy without original, the digital thereby frees cinema from the obsession with truth claim.

However, it would not be productive to repeat the hot but old debate on digital photography or postcinema in this oversimplified way. Given the wide spectrum between two extremes of pure indexicality and pure simulation, the cinephiliac lament for the death of cinema or its hurried confiscation in the language of new media might have rigidified the ontological stalemate of 'film' studies, which has meanwhile been more and more subsumed under (comparative) 'media' studies. Two points then seem to deserve noting, away from the overemphasis on the digital turn as a historical rupture. First, technically, the production of the digital image also maintains the indexical processing of light-sensitive particles to some extent. In light of this fact the difference between photographic and digital transparency may be less in essence than in degree (Rosen 2001, 305–309). Second, theoretically, such scholars as Gregory Currie and Richard Allen (1997) based on analytic philosophy have questioned if the indexical causality as the ontological relation of object and image is the sufficient condition for our transparent perception of "seeing" the world "through" photographs. The doubt sheds light on the difference between the object-image link and the image-perception link, the latter not necessarily enabled or limited by the former. Warren Buckland (1999) shifts this question from the material to diegetic level, embracing the digital's nonindexical capacity for seamlessly presenting "possible worlds" that can be ontologically nonactual but perceptually no less real than the actual world. The possible world inhabited with dinosaurs is presented as if they exist in the real world and have simply been recorded by the optical camera, and digital realism is more real than photographic realism thanks to its improved power of creating another cultural *vraisemblance* (Elsaesser and Buckland 2002, 209–219). The implication is that what genuinely matters should be not the objective status of the image per se so much as our subjective experience of what it (re)presents. Bluntly put, we do not care too much about whether what we see is photographic or digital, while in effect digitization brings to us ever more truthful fake reality.

To build on this turning point critically, I make two further points. First, what material indexicality primarily proves is the actual nondiegetic state of the profilmic object. *The Terminator* is, for example, undeniable evidence for the real existence of Arnold Schwarzenegger as a muscular actor and future governor of California, which is hardly essential in our filmic cognition of the cyborg character he plays. When applied to fictional film, the rigorous sense of indexicality has little to do with what we come to know

and should know from cinematic events on screen. Second, the emphasis on perception over indexicality suggested by these scholars seems still concerned with the old cognitive-psychoanalytic question that has haunted both analytic and Continental theories, famously formulated in terms of the "suspension of disbelief" and "fetishist disavowal": that is, how is it possible that 'I know (it's just a film) but all the same (I believe it's real)'? The issue of knowledge here is limited to the illusion mechanism of mainly fictional film and its reality effect, but it might turn out to be as little crucial as the difference between photographic and digital. In short, neither the cinema as 'ideological apparatus' forming our spectatorial belief nor the cinema as, say, the 'indexical apparatus' based on medium-specific materiality seem to determine our concrete cinematic experience as much as have been assumed.

Then would the notion of indexicality no longer be meaningful or useful? As an answer, I propose its new conceptualization in these two terms: first, *para-index* by which to suggest an epistemological concern about the ontological state or place of the diegetic object instead of the nondiegetic medium-specific nature of its image; second, *indexivity* by which to suggest an epistemological concern about the phenomenological activity of the subject coping with the image.[3] By *epistemology* I mean that what we want to know from an index is primarily what it refers to, its referent— whether ontologically present or absent, or whether phenomenologically clear or obscure—within the given diegesis that may be documentary or fictional. What my consciousness does constantly, to the extent of being instantly unconscious, is not to oscillate between belief and disbelief in true or fake imagery, but above all to see images and know or sometimes do not know what they indicate, or say, what they *interface* with, regardless of my absorption into or alienation from the screen world. In this frame, I first discuss the image as para-index and then subjectivity as indexivity. Indexicality redefined in each case is then attributed to interfaciality as its final notion to illuminate in our project.

FROM MEDIUM SPECIFICITY TO DIEGETIC CAUSALITY

The first part on image aims at revamping film semiotics. It is obvious that our initial cognition of an image is to take it as literally indicating its object assumed in the diegetic context. This visual sign is given basically as an indexical result of its referent that precedes or generates it, however close they may be in space and time. The indexicality of cause and effect here underlies the denotation of the image prior to its connotation, and to that extent it involves metonymy based on contiguity rather than metaphor based on similarity, which rather fits iconicity—the foot touches the ground and leaves a trace, the pointing finger indicates an adjoining site, and so forth (Doane 2002, 91–92). But the degree of this indexical contiguity can vary along with connotation it can also include. A step-by-step examination

is thus needed to demonstrate that seemingly metaphoric connotation might also be fundamentally metonymic. This process will allow us to enrich the connotation of the image through indexicality and even the connotation of indexicality itself, which will ultimately lead back to the ontology of the image and its retheorization.

Let me start with a few examples taken from F. W. Murnau's *Nosferatu* (1922). If an image of the vampire eerily appearing out of the door is a direct index to his whole body without any ambiguity, the film's signature shot of his gigantic shadow projected alone onto the wall could be seen as an indirect index in that it is his metonymical part referring to his offscreen presence, which is still in physical connection. At some point, we see the shadow of his hand approach Nina and its virtual grab of her heart cause her actual spasm (fig. 5.1). The point is that even this supernatural action-reaction link takes on indexical causality, no matter how fake it may be. In more subtle cases we only see the effect of an offscreen event or situation that requires our rapid inference. A famous deep-focus shot in *Citizen Kane* induces us to consider the bottle of drugs in the foreground as an index of the lying woman's (Kane's wife) suicide attempt. This is precisely what Gilles

Figure 5.1

Deleuze calls the "index of lack" that indicates an implicit situation deduced from the seen action, a gap in the narrative corresponding to the French word *ellipse* in the sense of ellipsis (1986, 160–161). If the image is given as the effect of its cause that can be an object, event, or situation in this case, the opposite case is that an image or its connection to other images can cause the change of the object, event, situation, even if one may not immediately or ultimately identify this effect. Deleuze's "index of equivocity" means such an image whose indexical result is undecidable. As seen in Chapter 2, the opening shot of *Piano* remains vague until its object turns out to be fingers in the following reverse shot. In *Memento*, more seriously, the tattoo of "I'VE DONE IT" provokes such a puzzle: What has he done? The murder of his wife who is fingering this index here or the vengeance on her fictive murderer? Then is this his memory or fantasy? (fig. 2.19). An index can thus cause a sort of butterfly effect: "a very slight difference in the action, or between two actions, leads to a very great distance between two situations" (Deleuze 1986, 161–162). Here comes the second sense of *ellipse*, a geometrical figure, since two distant situations are like a double center of this circle. Deleuze emphasizes this enigmatic quality of an index over its actual result, but it seems also important that equivocity disrupts and delays our reasoning, putting it in the connection of indices more radically than in the case of the index of lack. In essence the very lack can be perpetually put in deferral and the physical causality can be infinitely weakened to the extent that the index would better work as, so to speak, an inferential interface, the point of contact between the metonymic given and the causal explanations lying behind it. Could it still be called index? To build on Deleuze's adaption of Peirce, it could, insofar as the minimum physical causality is maintained between the visual sign and its invisible cause or effect.

In the larger unit of scene or sequence, the proximity of cause and effect is often found when it is filled with tactile violence. The battle scenes in *Chimes at Midnight* mentioned in Chapter 2 mingle every action and reaction, killing and death, as if all causes and effects were superimposed without gap within their short-circuit duration as a sort of show time for attractive spectacle (fig. 5.2). Film, then, indexicalizes the duration of causality that photography cannot capture and the mixture of sensations that language cannot deliver, while the spectator virtually mingles with the unfolding of tactile as well as audiovisual images. What works here is, I would say, the *montage of amalgam*. Its cinematic experience enables a shift of indexicality from the epistemological to phenomenological dimension because we recognize every detail happening in the causal link and our senses experience it as if we were situated in the same phenomenal world as on screen. And this indexicality is not denied but rather enhanced by the 3D digital technology. Much of Cameron's *Avatar* (2009) is a sort of bravura animation with the cutting-edge CGI, but its totally nonactual world, the virtual reality it creates, still desperately desires to reembody our notion of indexicality as we understand in the actual world and phenomenological tactility, which we

Figure 5.2

want to experience even under the weight of special 3D glasses. The battle scenes in *Avatar* bring the entirety of indexical impacts as in *Chimes at Midnight*, even through much clearer visuality that leaves nothing ambiguous for our immediate immersion into the causal succession of splendid shocks. By the same token, this montage of amalgam typical in Hollywood action film leaves nothing unexplained and uncomfortable that might haunt our mind after leaving the theater. Our cinematic experience completely ends with the ending credits.

In the opposite direction I suggest the second type of montage, the *montage of ricochet* in its analogy to the act of skipping stones across a pond. That is, what we see is a succession of the lack of a cause or effect, entailing the various degree of equivocity. The master of this montage is undoubtedly Bresson. The ending of *Mouchette* shows the eponymous girl rolling down, twice, then not exactly her body falling into water but its sound and visual trace of waves lasting until the end of the film, while leaving us the psychological trail of this index. The opening of *A Gentle Woman* (1969) cuts to a falling chair, to a falling veil, then to a woman who is not falling but already fallen onto the ground. The omission of decisive, dramatic, and traumatic actions, in both of these cases embodied by the falling female body, does not just occur in a few scenes, but significantly forms Bresson's rhetorical principle of montage that consists of gaps, skips, and lapses, often thwarting our epistemic process.

Conversely, understanding film language often implies filling in such indexical holes dispersed over the narrative. In Fritz Lang's *M* (1931), the Murderer of children indexically lurks in the offscreen space during the most

Figure 5.3

of the film. Toward the beginning, a child bounces a ball on the ground, then on the poster that calls attention to the murderer, whose shadow is cast on it at the moment. The murder is scarcely visible: he buys her a balloon, her mother's anxiety over her absence is shown a while, and then, we suddenly see her ball and balloon alone, that is, her metonymic indices that now indicate her death along with the following newspaper boys and the same poster, this time showing the prize money (fig. 5.3). Haneke's *The White Ribbon* (2009) is more complex, set against the backdrop of a small town in Germany just before the Weimar period that Lang depicts. A series of subtle but enigmatic events occur, only showing their effects as symptoms of educational, psychological, and religious repressions, but without any clear representation of clues and motivations. This microscopic chaos lasts until the macroscopic catastrophe of World War I is announced, which is also without visualization. It is as though those small-scale events in turn became a string of uncanny indexical causes that suddenly provoke the global disaster with all the middle-level links missing. And this loss of indexicality is never filled in.

Peter Greenaway's fake documentary *The Falls* (1980) is another case that shows only a seemingly endless list of effects whose cause already belongs to the precinematic time.[4] Without visually representing the Violent Unknown

Event (VUE) as the origin of all that is seen, the film presents ninety-two victims of that fallout-evoking catastrophe, whose surnames begin with the letters FALL. Some literally "fall" from buildings and Icarus-style homemade wings, others become "falls" such as a human waterfall and a man renamed Niagara, and others show various symptoms of man's metamorphosis into bird. In this nonactual, postapocalyptic setting, the VUE, an attack of the Real like the birds' attack in Hitchcock, is the indexical cause that rather produces somewhat jovial disorder of the organic world, drawing multiple "lines of flight": diverse half-formed languages, changes of sex and identity, physical deformities, and even a dog's becoming a bird. Such a collective schizophrenia would lead to the molecular revolution of deterritorializing all boundaries to a global Body without Organs, which only embodies the eternal return of becoming as such. In Kant's terms, the "dynamically sub-lime" of the VUE that is uncontrollable by human power brings about the "mathematically sublime" of numerous human beings becoming numerous human birds (fig. 5.4).[5] The crucial thing is that the immeasurable quantity of this mathematical sublime is the indexical trace that draws our attention to the insurmountable power of the unseen dynamic sublime. The phenomenological effect in the montage of amalgam is then weakened, while our epistemological concern grows about what really happened. This concern is also ontological, given the posthuman effects of the unseen cause.

Figure 5.4

PARA-INDEX, PARA-ONTOLOGY

At this point I dwell back on Bazin, but his view of adventure film that is not the action adventure but the cinema of exploration.[6] He particularly admires Thor Heyerdahl's documentary *Kon-Tiki* (1950), whose amateur filmmaking was an adventure that truly reenacts the hypothetic migration of ancient Peruvians to Polynesia. Far from grooming nature to play the background in a drama of human heroism, the 16mm camera serves as objective witness to danger in a way that is inseparable from the cameraman's (and spectator's) subjective participation in it. At the limit, recording this voyage is so difficult that final images show almost nothing. But according to Bazin, "its faults are equally witness to its authenticity. The missing documents are the negative imprints of the expedition—its inscription chiselled deep" (2005b, 1:162). Then we invest our belief not merely in what is present but in what is absent. Bazinian indexicality can thus be readdressed semiotically, epistemologically, and ontologically. The cinematic image is not the trace of fullness, but the imperfect trace of an ambiguous world. It is an index not just of a "gain in reality," but of a "loss of reality"; an index of what should have been represented but couldn't be. An index of its own failure, let's call it a *para-index*, indicating the absence of something beside it, something beyond its visualization. No longer an index record of the visible, the para-index indicates the invisible, but only through failed indexicality can the image still lead us to what is missing. Inspiring us to think this way, Bazin moves from photographic indexicality to para-indexicality, though he never used these terms.

The animal then appears on the threshold between the seen and the unseen, between positive and negative imprints, between subjectivity and nothingness (fig. 5.5). Bazin says: "when an exciting moment arrives, say a whale hurling itself at the raft, the footage is so short that you have to process it ten times over in the optical printer before you can even spot what is happening" (2005b, 1:160–161). 'Blowing up' this illegible image à là Antonioni would only confirm its *para-indexicality* that indicates the 'para-ontological' state of the animal. The whale is part of the sea, apparent without appearing, like the "phasmid," that stick insect Georges Didi-Huberman describes whose body perfectly resembles twigs or leaves so as to incorporate rather than imitate its environment, and whose etymology implies "phantasm" and "apparition" that can in a trice mutate into a dangerous beast, sweeping us into the abyss that effaces all ontological boundaries (1998, 15–20). 'That obscure object' is nothing but the Lacanian *objet a* that lurks below the Real and suddenly attacks, thwarting the subject's mise en scène and drawing him into the *mise en abyme* of sublime depth and more sublime death. The ultimate difference is then no longer between two things within reality, but between this representable reality and the unrepresentable Real that could be at best barely indicated.[7] Serge Daney reads Bazin through this Lacanian lens: "Whoever passes through the screen and meets reality

Figure 5.5

on the other side has gone beyond jouissance . . . The screen, the skin, the celluloid, the surface of the pan, exposed to the fire of the real and on which is going to be inscribed—metaphorically and figuratively—everything that could burst them" (2002, 34–35). He compares this flimsy screen to the Derridean "hymen" we saw in Chapter 2, the virgin's membrane that when ripped institutes marriage, the fusion of two others; thus, sexual orgasm stands as the little death of one's unity. Para-index takes as its referent what destroys it, "the fire of the real."

While many fictional films represent the para-ontological dimension, modern auteurs often address it through para-indices. The spasmic opening of *Persona* seen in Chapter 2 goes on until the title shot with an instant insertion of a man who burns himself as a political act against American imperialism (fig. 5.6). This incident is tangentially mentioned on TV later with no connection to the diegesis. We can only grope for the dark link between this real political trauma and the heroines' pathological trauma in the initial montage of ricochet. Likewise, the photo of the Warsaw ghetto examined in Chapter 1 only disperses para-indexical links between the main diegesis and the 'inwardly dividual' micro-diegesis, between these diegeses and the unseen Holocaust (see figs. 1.8–1.9). Jean Luc Godard's 'outward dividual' using the same photo shows a more salient montage of ricochet

Figure 5.6

with images radically disseminated around the empty center of visuality, the unrepresentable catastrophe that the cinema should have captured instead of fleeing away to the Hollywood dream factory (see fig. 1.10). For Godard, this is the ethics of cinema, whose sin and redemption story might intimate the para-indexical fate of film history.

In fact the Holocaust causes such agony over the image. For Daney, the tracking shot in *Kapo* (Gillo Pontecorvo, 1959) that shows the Emmanuel Riva figure suicidally throwing herself on electric barbed wire in a concentration camp is nothing but "'artistic' pornography" that aestheticizes the sublime of death to a voyeuristically "beautiful" spectacle (fig. 5.7). Alain Resnais's *Night and Fog* (1955) documenting a camp is, on the contrary, an ethically "just" film whose visible sphere is limited with "gaps and holes, necessary hollows and superfluous plenitude, forever missing images and always defective gazes" (Daney 2007, 24–25). Here too, the tracking shot is a key technique as Resnais's signature, but it only slides over the peaceful wall of the camp in the present seen in color, vainly knocking on its seemingly impenetrable memory of the terrible past. Lots of black-and-white footage exhibiting stripped prisoners in the past might look more pornographic, yet what we see are not nude but literally naked lives, their mathematically sublime amount of dying flesh and dead corpses, hair, and bones (fig. 5.8). All these abject debris are visual remnants of the dynamically sublime Event that never comes into our direct look. And would there be anything more

Figure 5.7

Figure 5.8

para-indexical than finger scratches on the wall of a gas chamber left by the prisoners squirming in their death agonies? In *Hiroshima mon amour* (1959), Resnais depicts Riva leaving such finger traces in a camp-evoking basement where she is imprisoned for loving a German soldier and thus betraying her country as a scapegoat of the French version of fascism—her

finger movement seemingly repeats on her Japanese lover's sweaty naked back when they make love. But this time, what we see is not Riva's visual certainty but her endless oscillation between vision and blindness, memory and oblivion (she says, "I saw everything"; he says, "You saw nothing"). Facing such liminal experience, the subject indeed cannot help being torn apart by the double desire to remember and forget it, and the image cannot help being stuck in the double bind of neither approaching nor avoiding it. This dilemma is the para-indexical interfaciality of the image, projecting the subject's will to access the Real yet also protecting him from the excess of the very fire that would burn his vision. Then why do we need the image? It orients. It does not show everything, but without it we could not sense what it could not show. The failure of index is thus the index of failure, only through which we confront us with its beyond. In spite of all its impotence, this powerlessness itself is the true power of the image.[8]

My final example is Bill Morrison.[9] In the found footage tradition, as mentioned in Chapter 1, he explores the "cinema of ruins" by optically reprinting early half-decayed films as seen through the rolling emulsion of the nitrate cellulose itself—the material that is no longer used because of the vinegar syndrome, the irreversible chemical process of decomposition. His *Decasia* (2004) exposes this poetic archeology of cinema from the title. It rediscovers and resurrects not just one short film, but a bunch of 'orphan' films in the way that this redemption of dead celluloid only proves the real death of that chemical material. This paradox implies a double facet. First, *Decasia* itself is an impressive montage of ricochet that connects diverse images, going back and forth between diegetic and nondiegetic, fictional and documentary, concrete and abstract, real and surreal. This chaotic yet synthetic combination partly revolves around the frequent image of turn and spin, which may symbolize the rotation of the film reel that unfolds an endless series of scenes, shots, and frames. In other words, it is the mathematical sublime that we could locate along this horizontal axis of the editing and montage in general, of the filmstrip itself, and of its temporality on screen. The succession of images is thus quantitatively additive and theoretically infinite. Second, however, all these seemingly undead images cannot help but experience a kind of qualitative leap in its vertical temporality. The fundamental change of their "ontological state from undead to rotten," then, expresses what the director calls "a non-human intervention . . . Higher Power," namely the dynamic sublime of death. When a boxer who 'was' training in the source footage 'looks' here desperate to untangle himself from this sublime destiny, the original narration gives way to, or rather takes afresh on ruination (fig. 5.9). All the "visual noise" that time has inscribed on the filmstrip, along with negative, flickering, or blurring effects, transforms the stable screen of the solid world into a liquid screen with ecto-plasmic bubbling blobs (Habib 2004a,b). All that is organic melts into this inorganic Body without Organs, while the inorganic film turns out to have had a quasi-organic life that would dissolve into the same inorganic state

Figure 5.9

along with what it would dissolve. The filmstrip is thus a Möbius strip of organic and inorganic lives. In short, this is a post-index to the image as the effect of its own catastrophe, and a meta-index to time as the cause of the very catastrophe of the image as index. Furthermore, one may say: "every image is, always, simultaneously, an image of ruin, an image about the ruin of the image." Any catastrophe represented on screen may be nothing but a para-index of the potential catastrophe immanent in the organic life of the film.

From all these cases, it would be worthwhile to formulate para-indexicality in multiple dimensions. I started with photographic indexicality, which implies the image appears like nothing other than its object itself. That superb realism is, for Bazin, almost surrealism because of its hallucinatory power as examined in Chapter 3. In *Camera Lucida* (1981) Barthes suggests that what he sees in a photograph of his dead mother is just his living mother who is still present in her past. Maurice Blanchot rather phrases this effect as the persistence of the object, which Steven Shaviro rephrases in this way: "an uncanny, excessive residue of being that subsists when all *should* be lacking. It is not the index of something that is missing, but the insistence of something that refuses to disappear" (1993, 17).[10] It is the ghost-like trace of the profilmic real. Conversely, however, I would emphasize that the excessive denotation of a thing prior to any connotation paradoxically

proves its persistence as ghostliness that is not representable so much as only sensed and barely indicated, which is thus a sort of para-indexical connotation of the image. Bazin compares photography to the Shroud of Turin, a centuries-old linen cloth believed to bear the image of a crucified man, Jesus Christ (2009, 12). The indexical question would be whether it is a real proof of his body wrapped upon his death or a medieval forgery like digital composition that only proves a "religious miracle as special effects" as Hent de Vries would have it (2001). But the para-indexical point of view slightly shifts the question: whoever it may embody, this image, whose visuality itself has worn away, seems to struggle to represent that which is apparent without appearing like Didi-Huberman's phasmid, or more dead alive than *post mortem* like the Freudian totemic father.

If we further the point, every index, including that of the image itself as in *Decasia,* might also be seen as basically para-indexical. Peirce's initial notion that the index, like the weathercock indicating the direction of the wind, has no resemblance to its object indeed reflects the fact that it is "a hollowed-out sign" evacuated of content, a potential meaninglessness (Doane 2002, 92). As a singular contingent trace, the index therefore assumes the actual spatiotemporal gap or interval from its own cause that is now absent there, virtually impossible to reach and pin down. A paradoxical trace that cannot really trace back to the very thing in its entire interfaciality—that is the index as para-index. Especially in the case of photographing death that intrinsically belongs to the unrepresentable, any excess of its representation bounces back to its own failure as Zeno's two paradoxes. First, like the Racetrack Paradox, we can never reach the indexical fullness of death just because we are already dead when experiencing it, and so cannot represent it. As Bazin suggests, regarding the cameramen who cannot deliver the full recording of fatal adventures, we should excuse them for having returned from the Real without jumping into death. Second, like the Arrow Paradox, every moment of representing the death of the other is immobile and unable to capture the subjective moment of one's shift from life to death (Jeong and Andrew 2008, 2–3). The most indexical moment is thus the most para-indexical, the image becoming like a corpse as Blanchot sees it, an "abject" that, for Julia Kristeva, is neither flesh nor fleshless, absolute 'thing-ness' then 'no-thing-ness' indicating the Kantian or Lacanian Thing with the capital T. To put it in Lacanian or Deleuzian terms, the para-index only partially, impossibly indicates the unthinkable, fingering the absent but immanent Real or Virtual.

And in this sense, para-indexicality may enable us to relocate iconicity from Peircean semiotics even to Lévinasian ethics in terms of Jean-Luc Marion's distinction between the icon and the idol. The idol reflects our subjective look and self-satisfaction with a given visibility; as long as God's face in Western art resembles the white man's face, this idol then rather fits Peirce's notion of icon based on similarity even if it is imagined. But the icon as opposed to idol points our look to the invisible, the infinite, whether God or not, by going beyond itself and never stopping or settling at the point of

visibility. In doing so, it appears as a visible reference to the invisible and makes visible the gaze of the invisible Other who in turn looks at one's gaze, or whose gaze cannot be looked at because it breaks off visibility by excess (Marion 1995, 12–18). Your 'beautiful' face I see is an icon, a para-index of this unfigured sublime to which it connects immanently if not practically. That is, absolute untouchable otherness is immanent in your tactile face, for me, a quasi-interface as argued in Chapter 4. A para-indexical interface resolves itself into an immanent state this way.

Instead of going further in the matrix of philosophy, let me conclude with a few schematic formulas. First, a single image is an index indicating its referent like an arrow sign (which is also a Percean index), but it is fundamentally a para-index indicating its unrepresentable origin, immanence, even the impossibility of indication itself (Index: $1 \rightarrow 1$, Para-Index: $1 \rightarrow 0$). Second, this notion can apply to the cinematic montage whose principle is the indexical succession of (para-) indexical images. If the standard montage as in classical Hollywood cinema connects one shot to another to indicate a total situation as in the shot-reverse-shot mechanism (Standard montage: $1 + 1 \rightarrow 2$), Sergei Eisenstein's montage of attraction, which I have not mentioned but has been important in film studies, emphasizes a chemistry of two colliding shots that elicits a new meaning from the spectator, whether political, psychological, intellectual, or emotional. This meaning is often iconic and symbolic in the sense of being metaphorical and allegorical (Montage of attraction: $1 + 1 \rightarrow 3$). But as I suggest, two other montages deal with indexicality more fundamentally. The montage of amalgam mingles images into their undifferentiated state in the phenomenological manner of visualizing the ontological plane of immanence (Montage of amalgam: $1 + 1 \rightarrow 1$), whereas the montage of ricochet incites us epistemologically to be curious about that ontological kernel which is missing and even unrepresentable, but around which every shot revolves (Montage of ricochet: $1 + 1 \rightarrow 0$). And this is a para-indexical montage par excellence in which every image can maximize its interfaciality, while it also implies that para-indexicality is the very condition of every montage as an endless indexical succession, whose end does not reveal or represent but only lets us sense nothingness as its ontological interstice. As it is the very immanent plane, the virtual ground of all actual images, its topological figure could be like an irrational fraction with the denominator zero.

$$\text{Interfaciality: } 1 + 1 + 1 + \ldots + n \rightarrow 0$$
$$\frac{1 + 1 + 1 + \ldots + n}{0}$$

Then could we review *Decasia* as the case in which this degree zero erupts onto the visual surface in the form of film's own catastrophe that devastates every image? But then doesn't the digital restoration of this film to DVD in turn render the film really undead? Doesn't this digital film

splendidly redeem celluloid from its death because the zero quality is now transformed or sutured into part of the digital binary code that revisualizes every image? Is that immaterial matrix of innumerable zeros and ones, the mathematical sublime of the digital, the immortal dream space for the postmortem life of cinema? These naïve questions lead back to the issue of materiality, but after passing through the web of para-indexicality, I find it not simple to answer them even at this moment my digits, which will someday decay, are now putting digital codes into this antiseptic computer screen (Jeong 2009).

A SPECTATORIAL TURN OF DIGITAL INDEXICALITY

Keeping in mind this last point, I now propose to move on to the other indexicality on the subject's side and thereby get out of the digital impasse while reactivating indexicality in a new turn. Let me briefly mention Philip Rosen's diagnosis that the seeming oxymoron "digital indexicality" would be all the more necessary because, as already mentioned, the digital camera retains indexical import as a light-sensing device and digitization can obtain informational value from preexisting referents anyhow (2001, 307). Although each indexically generated pixel is an independent variable subject to manipulation, we typically take digital photos of things and events in everyday life and store them in the computer or post them online to remember or exhibit what we actually experienced. In other words, most digital images play the role of indication directly and truthfully enough.

I here draw attention to the coincidence that the word *digit* originally means the 'finger' and we use our 'index finger' (not the middle one!) to indicate something—needless to say it is an icon for index (☞). Far from being oxymoronic, the term *digital indexicality* thus sounds etymologically tautological. Noteworthy is that in his concise version of art history, Gilles Deleuze calls the pure optical mode the *digital* with regards to the relationship between eye and hand, sight and touch. In the ideal optical space, he says, the hand tends to be reduced to nothing but the finger to choose the units that correspond to pure visual forms. This referential function may have been perfectly realized through such original perspective drawings as Jan Vredeman de Vries's *Perspective* (1604–1605), which itself represents all three figures' hands as no other than index fingers indicating something or some positions in a cubic space geometrically designed, sectioned, and grasped in total opticality (fig. 5.10) (Deleuze 2003, 154–161).[11] To put it differently, the subordination of touch to sight within the Cartesian ocular-centric objectivism inherently embodies the subjectively engaged function of 'fingering' as the designating and guiding principle of the very field of vision. In view of this, the established dichotomy of 'indexical versus digital' seems to have only been concerned with the objective status of the image and not

Figure 5.10

with the subjective relation to it. Conversely, the focus can shift from the digital image as a fingerprint to the act of fingering with our corporeal digit; from an objective event to the subjective engagement or participation in it through the interface; and broadly from the relationship between object and image to that between image and subject—namely from ontology to spectatorship.

Finger as a verb, on the other hand, also means 'touch' as real contact beyond 'designate.' Its use not only functions as indication to draw attention or get information epistemologically, but also enables intimate interaction or immersion into indicated objects or events phenomenologically. This tactility is what implicitly lurks or explicitly works in fingering, and its relationship with visuality is not simply oppositional but complexly mutual. As proposed earlier in the chapter, I here propose a new concept, *indexivity,* by which to mean the actualization of this tactility through fingering. It comprehends *indexical passivity* and *indexical activity,* the former being preliminary to the latter, the main concept to illuminate. The necessity of this neologism may lie in the possibility that this spectatorial turn of indexicality, so to speak, could offer a way out of the ontological stalemate of film studies caused by digitization and, further, shed productive light on the hitherto unthought relationship between indexicality and embodiment in their theoretical matrix of ontology, epistemology, and phenomenology, as well as in the broad context of media archeology and sociology. With this in mind, I elicit the notion of indexivity from film history and theory

first (mainly looking at spectator-characters in notable films), and then particularly illustrate how digital interfaces do not make a rupture but rather promote indexivity in the form of new 'screen attachments' in and outside films, challenging and changing the old spectatorship of immobile passivity from aesthetic and sociopolitical perspectives. The latter perspective, as will be taken to examine a series of recent revolutionary movements, may especially inspire us to retheorize subjectivity itself as interfaciality. To reframe the digital revolution dynamically, I thus start by freeing indexicality from the obsession with medium specificity.

INDEXICAL PASSIVITY: VISION AS TOUCH

The primary assumption I propose is that 'indexical passivity' is the precondition of indexical activity. It can refer to the mode of the subject being passively touched by the (gaze of) image without physical contact in the way that indexical effect could be said to be immanent to this vision as touch. The idea of vision as touch is in fact deeply and diversely rooted in film theory, so let me just offer a schematic spectrum of different yet interrelated levels with a few examples.

First, technically, the film(strip) is 'touched' by light and 'touches' us back; the Bazinian indexicality is based on the trace of light's touch on the celluloid surface, from which light in turn comes out to touch our eye. Although this second touch leaves no apparent physical trace, I suggest we view it at this stage as a potentially tactile effect, however attenuated, caused by the image, thus still working in the logic of causality, that is, the necessary condition of indexicality. Second, shifting from this literal level to a more figural one, Roland Barthes's (1981) term *punctum* characterizes this photographic touch as pointed as it can make a psychological "puncture" to which the spectator submits passively. A photo of his dead mother, or even a tiny detail of it, can "pierce" his dormant memory, bringing to him an absolutely individual meaning detached from the common cultural meaning of the image he calls *studium*.[12] It can also entail *affect* in its Bergsonian sense, rupturing our sensorimotor schema and erupting from within the body. Deleuze's concept of affection image expresses such affect as typically shown in Maria Falconetti's alienated spiritual face (*The Passion of Joan of Arc*) and also Anna Karina's teary face affected by the very onscreen face (*Vivre Sa Vie*) as we saw in Chapter 4 (Deleuze 1986, 106–108). The metaphoric usage of the word *touch* is directly visualized here ('I am touched by her sufferings'), which implies that one's tears or even just a slight inner tremor felt upon encountering an image could be biologically indexical effects as physical traces of the image as cause. Third, Walter Benjamin offers a physiological account for such indexical passivity in terms of "shock effect." Unlike the painter or string puppeteer who keeps distance from his object, the cameraman is compared to a surgeon whose penetration of the world hits "the

spectator like a bullet . . . acquiring a tactile quality" (1968a, 238).[13] Film almost "drills" man—which sounds like holing the eye as well as disciplining vision—in new apperceptions and reactions enabled in modernity. Sure enough, as mentioned in Chapter 2, the English word *shoot* applies to both filming and firing. The cameraman is a gunman as represented or allegorized in a wide range of films from Rossellini's *Machine to Kill Bad People* (1952) where a photographer acquires the ability to kill his subjects by re-photographing their portraits, to Harun Farocki's documentary *I Thought I was Seeing Convicts* (2000), where a surveillance camera and a gun are put right next to each other in a prison. Finally, it would suffice to note that from these fundamental levels, one could go further on to all the discourses drawing on phenomenological embodiment, which we investigated in Chapter 2 so would not have to repeat.

The point is that while the process of 'capturing' the world through the camera inevitably 'sutures' tactility into visuality, the spectator can experience images back in their inherent tactility that indexically causes bodily innervations, the reflexive embodiment of tactile stimuli without reflection, so that one could even suffer, as it were, violence perpetrated against the eye. It is not that two oppositional senses of sight and touch are dialectically merged, but that the optical opens the tactile, which is more foundational in effect, as argued by Vivian Sobchack, Mark Hansen, and so on, in the name of phenomenology of embodiment just mentioned. This process of 'image-turning-into-shock' on the spectator's side suggests that there is a remainder in the body, a carnal surplus, or at least its potential that cannot disappear in the smooth process of perceiving, recognizing, and understanding images. The turn could be rephrased as 'icon-turning-into-index' if we take Peirce in terms of spectatorship. The icon is limited to the spectator's optical identification of/with an image based on its resemblance to its object (which applies to both painting and photography, irrespective of their medium-specific iconicity and indexicality), whereas the medium-specific indexical causality between object and image (which applies only to photography) may still remain in theory, however potential it may be, between image and subject in the spectatorial form of the subject's corporeal reaction to the image. We could even call this turn 'the Imaginary-turning-into-the Real' the Real as the unconscious plane of embodied tactility irreducible to the Symbolic of linguistic representation—this unconscious should be understood not psychoanalytically per se, but ontologically as the material ground of our experience that we don't always consciously recognize.[14] Then Benjamin's notion of the optical unconscious may take on another nuance than in Chapter 1: cinema, or visual interfaces in general, unfold an apparently optical yet immanently 'tactile unconscious.' It is a world in which "our own embodied reception of the image as shock" or "our embodied being in the world itself becomes the material support, the medium, for the 'contact sensuousity' restored by modern mimetic machines" (Mark Hansen 2000, 248).

INDEXICAL ACTIVITIES: REACTIVE AND PROACTIVE

Indexical passivity runs its course to *indexical activity* in which tactility can be, this time, activated entailing the spectator-subject's actual contact with visual interfaces—again, I reframe points explored particularly in Chapter 2 in terms of indexicality. There seem to be three types or degrees of this activity from weak to strong: specifically, from *reactive* through *proactive* to *productive*. The last stage deserves the closest attention, but it is necessary to start from the first one, *reactive activity*—let me use this clumsy term to make it clearly positioned within the three-level scheme.

As examined before, innervation is basically a bodily response to external stimuli, yet instead of remaining passive this reaction can cause a kinetic action through what Benjamin calls "mimetic faculty" (Chapter 2). Again, this is the human's primordial ability to imitate things by acting like them, as a child plays at being an airplane by moving its whole body just like performing body language.[15] What matters in this mimesis is neither symbolic representation nor iconic resemblance, but indexical causality, in other words, the stimulus-response feedback. More precisely, any possible iconic/visual similarity between the imitating subject and the imitated object here results from the subject's desire for tactile incorporation of the object. The spectator's innervation reactive to the image shock could then be viewed as an immanent form of its tactile imitation, if not apparently imitative, at least suggestive of the physiological basis of mimetic faculty. Innervation and its further development into mimetic action thus imply not his interpretive suture of imaginary icons into linguistic symbols, but his participatory desuture of them into tactile indices he wants to designate and also touch by his own index-finger-body. Exemplary is the Rube figure that we fully illuminated. To recall it, this credulous spectator within a film often tries to touch (image objects on) the screen he sees as if his innervated body fuses the prelinguistic body language into the world. This rearticulation of look and touch, desire and body, shakes the dominant spectatorship of being seated, immobile, transcendental, and disciplined not to break the rule of social behavior. Psychosomatically agitated, the subject rather experiences the material ground of being (mediated) through the bodily encounter with another (virtual) body. This embodied spectatorship puts in motion his psychosomatic reaction to the pseudo-tactile image. And now reformulating this reaction as indexical activity, we see more room for the term *indexicality* to shift from medium specificity to fingering subjectivity.

Yet in this case, the apparently aggressive reaction is still passive in that the spectator follows illusion without resistance. The reactive activity is an immediate attention to imaginary attraction, and a submissive immersion into subconscious immanence as seen in a child spectator's rubbing a woman's facial image in *Persona,* and its adult version in *Videodrome* (Chapter 2). Indeed, as we saw, passion means not only active devotion but also passive suffering, and this latter aspect underlies indexical reactive

activity. It can push subjectivity to the extreme of, say, 'abjectivity,' the state of being cast off and losing oneself.

In the opposite direction, the second type of indexical activity that I call *proactive activity* can emerge for the protection and reinforcement of subjectivity. The degree of indexical activity increases here to the extent of changing the spectator from passive to active, with hegemony shifting from the image to the subject. In other words, a sort of quantity-quality dialectics occurs in the way that, at a certain point, the enhanced act of fingering turns the subject from the state of losing oneself to that of controlling oneself. For this transition, let me bring back the interface-scene of *Sherlock Jr.* When jumping into the screen, the eponymous character first finds himself not in the film he was seeing but in the middle of nowhere (see fig. 2.6). Then, along the background jump cuts from a city street to a mountain to a desert, and so on, he comically collapses not because of new media as in the case of the traditional Rube, but because of a new environment in the way of urging us to expand the notion of Rube, just as *Playtime* stages a *flâneur* updated to a bumpkin-tourist in ultramodern Paris (Chapter 2). Only through this perplexing initiation is Sherlock Jr. seamlessly 'sutured' into the dramatic space he was seeing in the theater. The early cinema mode of exhibiting discrete attractive vignettes then gives way to the classical style of integrating visual elements in an organic narrative. The threshold scene may then allegorize modernity, its speedy time-space compression and diffusion, experienced like a vertiginous cinematic montage in which attention and attraction causes not only immersion and absorption but also distraction and disorientation. Sherlock Jr. apparently fails in adjusting to this disorganized series of attractive shock effects.

However, Benjamin suggests that the failure of the shock defense can develop into creative activity instead of leading to the self-abandon of subjectivity, just as Baudelaire compares the poet who combats language to the fencer who battles the crowd, getting hurt yet also "parrying its blows" (Benjamin 1968c, 163–165; Mark Hansen 2000, 231–163). The embodiment of the environs can position the body on the threshold between active and passive, manipulator and manipulated if one actively defends oneself in the middle of being attracted and distracted at once. Then, Sherlock Jr.'s disorientation could rather be viewed as his struggle for self-orientation to this embodiment of modernity. This dynamics in terms of media environment implies that one needs to learn how to ward off, thereby select out external stimuli that are useful and meaningful for self-maintenance instead of surrendering to them. Through this new 'discipline' of spectatorship, the body can be trained as a dexterous sensorimotor system in the feedback with chaotic images by controlling, interpreting, and processing them. One might see here the transition from the programming-centered to viewer-activated notions of "flow" as known in television studies. Conversely, images require the body to obtain new motor skills and hand-eye coordination, a proactive handling of the new media world, a spectatorial action like 'zapping' on

TV—this includes pausing the flow and holding the image on VCR/DVD as Laura Mulvey suggests in terms of "possessive spectator."[16] More precisely, among predigital cine-media, VCR enabled the time shift by 'recording' programs and the zipping by fast-forward/fast-reverse, and then cable TV brought zapping and muting to the spectator. As digital cine-media, DVD/LCD/Blu-ray enhanced this editorial function to the utmost so that the spectator became no longer a traditional film viewer but a skillful media user (Friedberg 2000).

Virtually, then, we could imagine ourselves as a sadistic zapper who changes Sherlock Jr.'s backgrounds just as we do TV channels. Actually, for example, *Thomas in Love* is a film entirely edited in the mode of zapping and even the first-person shooting in video games. As already examined, it only shows people what the title character sees on the videophone, a real-time interactive interface. As a kind of immobile spectator equipped only with a remote control or joystick, this agoraphobic geek is immersed into a highly tactile screen body for cybersex ('shooting' her sexually) while switching channels as quickly as his masturbation ends ('zapping' to others). Apposite to Thomas is Thomas Elsaesser's description of the zapper: "the canny user, the disabused and uncommitted skeptic, who surveys all, brushes or grazes the media world with the lightest of touches, before deciding who or what to engage with, and for how long" (2009c, 11). Indeed our social relationship becomes ever more elastic and ephemeral, depending heavily on the flexible use of social network platforms, technically, with our fingers dancing on digital interfaces for connection and disconnection, aggression and protection, seduction and distantiation, reaction and proaction at once.

The initiation to proactive activity is often implied or explicitly integrated in films that belong to what I call the Rube-Cop genre (not Robocop, but not excluding it either). Familiar in Hollywood cinema, this type of action thriller shows a police or agent who has to adapt to cutting-edge media interfaces to fulfill his mission. And as we saw in *Déjà Vu,* the Rube-Cop's learning process itself is often exhibited as a cinematic attraction, a show time for boasting of visual technology on the director's side, while it takes a necessary part in the narrative on the side of the cop character and the spectator who also needs an introduction to often too-futuristic interfaces rather than just laughing at the cop as a rube. In *Minority Report,* though a Rube at home, the agent shows splendid mastery over such interfaces. Effectively handling digital indices with his digits, his hands do not imitate objects yet indicate interfaces to mine data proactively from the utopian PreCrime system that predicts impending crimes that should be stopped in advance. Not a composer of digital images, he is a conductor of digital interfaces. The ultramodern cop evolves from the reactive Rube to the proactive conductor.

And here, this proaction resonates perfectly with the film's logic of "premediation" as defined by Richard Grusin. He argues not only that the past is always already mediated (remediation), but also that premediation now insists that "the future can be remediated before it happens"—a political

logic developed in the media regime of preemptive war in post-9/11 America for tracking down and preventing terrorism (2010, 38–50). More precisely, premediation marks a desire that the immediate experience of catastrophe could not happen again, that it should have always already have been premediated; a desire to see the future not as it emerges immediately into the present but before it ever happens. In this sense, rather than getting the future right, premediation prevents the traumatic effect of future events by generating all possible scenarios including a low level of anxiety as prophylactic.[17] But instead of going further this way, let me just note that while premediation dominantly through news media in the actual world cannot actually prevent things from happening (but only previsualizing them), it often serves as the primary step toward the actual prevention of catastrophe in the virtual world of cinema. And since premediation is remediation applied to the future, we need to confirm that proactive activity is basically active mediation. In Johnnie To's *Breaking News* (2004), while camera-equipped guns literally merge optical recording and tactile killing, both the police and the mafia plug in the video call system that works as a sort of visual 'matrix' without which they could not encounter, negotiate, and act. An image on this video screen then functions as a digit to enhance both information about the other side and immersion into it. And this digital indexicality is only upgraded by digitization, which achieves a higher degree of indication with a greater degree of immediacy through hypermediacy as put 'under erasure'—the proper logic of remediation.

INDEXICAL ACTIVITY: PRODUCTIVE ACTIVITY

In this direction, *productive activity* can be proposed as the utmost degree of indexical activity by which the spectator becomes a producer of images, not remaining their reactive or proactive consumer. Before looking at explicit examples, I draw attention to a suggestive film. In Julian Schnabel's *The Diving Bell and the Butterfly* (2007), the main character's single eye, his only sensorimotor organ that has survived a stroke, becomes a unique embodied interface that enables communication with other people. By blinking—one blink means 'yes' and two blinks 'no'—he chooses, confirms, or deletes a letter from the alphabet his therapist team continues to recite so that he can make a phrase (fig. 5.11). Blinking is thus clicking, and his eye is a 'digital' mouse in all its senses: using the binary code of yes/no (based on the primary binary code of opening/closing, which makes the eye look like 'zero' and 'one' respectively) and working as a finger for indexical activity. This is productive activity; the eye as a vision machine, an embodied screen reflecting his visual memory and imagination, turns into a writing machine, an embodied typewriter translating the very imaginary vision into words, symbolic signs, which will ultimately compose an autobiographical book.[18] As shown in the film, the eye can only dream and recollect without saving

Figure 5.11

a 'diving bell' that falls in the sea with the hero's paralyzed body inside, but its blinking can be associated with the tactile flapping of the 'butterfly' that flies high and brings an emotional butterfly effect to the audience. This 'fingering' eye is, for example, far from the eye treated only as a 'fingerprint' in *Blade Runner* (Ridley Scott, 1982) by which to tell humans from replicants through the dystopian surveillance system. From fingerprint to fingering, from indexicality to indexivity, the interfaciality between image and subjectivity evolves.

If the Schnabel film exceptionally showcases the eye *as* finger, a typical productive activity occurs through the shift from eye *to* finger, from optical recording with the camera to tactile editing on the filmstrip. In fact this shift underlies the postproduction process in general on the part of professional filmmakers, whose indexical activity I only roughly sketch with a few historical examples examined in Chapter 1. To begin with early experimental film, *Man with a Movie Camera* often shows, along with the title cameramen (Vertov's brother), a 'woman with scissors' (Vertov's wife and editor) dexterously cutting and pasting raw photographic indices by her indices. What is included in the film is not just the image of the hand, but the material condition of cinematic enunciation that should be excluded from the optical utterance of the content in usual cases. The mid-twentieth century sees the eruption of the avant-garde attitude toward the drastic exposure of the cinematic apparatus through the direct trace of handwork, that is, a visual index to the corporeal index. As we saw, Brakhage, Landow, Sharits, and the like directly expose the skin of the film, not fleshing out but peeling out the illusion mechanism of cinema by their hands. In the age of video,

Godard and Harun Farocki among others handle the video archive as an electronic synthesizer, a digital graphic program, a CD-ROM for rearranging image sources to write film history by film, or a new machine for dynamic coexistence of different temporalities from which to draw a Benjaminian constellation of revolutionary remnants (Silverman 2002). The point is that this professional activity has paved way to nonprofessional spectators' becoming producers beyond the cinematic domain we will soon see.

But before then, let me also mention the "expanded cinema" in the post-medium condition that changes not simply the production mode but also the exhibition venue, typically moving cinema from the theater to the museum where productive interactivity between eye and hand, between image and viewer is considerably promoted. Peter Greenaway, for example, transforms his film trilogy of *The Tulse Luper Suitcases* (2003–2004) into its gallery version *A Life in Suitcases* (2005), which he himself performs as video jockey. Evoking the Pre-Crime agent in *Minority Report,* he appears like a conductor whose fingering operates its double function, 'indicating' digital interfaces by 'touching' the control box. This possessed tactility prefigured in the remote control now peaks in media art projects such as, to name just one representative, *T_Visionarium* (2003–2008) designed by Jeffrey Shaw among others.[19] In this 360-degree interface space like a rotating Borgesian archive, the viewer is invited to become a doer, user, player, and even a director who can recompose a new film out of numerous film fragments by wielding a scissors-like joystick (fig. 5.12). Not coincidently, the image of scissors, which is a criminal's weapon, appears between interfaces in *Minority Report,* as if it served as a tool of the agent who is no other than a creator-editor. The more digital images we have, the more digits we need

Figure 5.12

to index them, to reshuffle and rearrange interfaces. As mentioned in Chapter 2, Virtual Reality projects epitomize this turn of spectatorship. No longer remaining a dreamer of a fantasy world simulated on a head-mounted-display, the VR user now becomes a navigator whose embodied human agency, motor intentionality and tactility actualizes access to a real space, a "space full of information [that can be] activated, revealed, reorganized and recombined, added to and transformed" as he navigates it (Mark Hansen 2006b, 1–22). The turn is clear: from optic observation to haptic operation, from digital imagery to digit-using subjectivity, from passive reaction to active production. Following this trend, research on the interconnection between technology and tactility, particularly in media art, has gradually emerged in academia (Kerckhove 1995; Wegenstein 2006; Paterson 2007).

Furthering this turn, however, let me now look for a way of enlarging the scope of productive activity from the cinematic to social domain, that is, from the techno-aesthetic closet—"black box" (theater) or "white cube" (gallery) as Raymond Bellour suggests (2003)—to the open environment, including the public sphere. Relevant is Nicolas Bourriaud's concept of "relational aesthetics"; he asserts that art should form not imaginary and utopian realities but "ways of living and models of action within the existing real" (2002, 13). Relational artists engage in the social context of human relations rather than an independent and private space, under the influence of DIY, Internet, and user-friendly culture. In fact, the slogan of "art becoming life" has a long tradition as Jacques Rancière sees in what he calls the "aesthetic regime" of modernism. Futurism and constructivism in the early twentieth century mark a salient point in this regime.[20] What is new around the turn of the millennium is the emergence of new screen attachments through which two different usages of the screen are combined: "a surface that arrests light (in the cinema) and an interface on which information is written" (Bourriaud 2002, 66). The implication is that the cinematic phenomenology of embodiment can go well with, and even serve for, the social epistemology of information, because productive activity produces information about the life world through embodied interfaces. In this aspect, far from disembodying the subject by digitization, the digital camera brings better reflexes in performing the photographic act as a concrete encounter with an event, as a configuration of viewer, camera, and object in the momentary of 'engineering' social situations. This type of actor network can be realized not simply by artists but by anybody instrumentally reliant on the creation of social interactions. And this activity is doubly indexical not only because it means indicating something to acquire knowledge about it, but also because the authenticity of the indicated results from medium-specific indexicality. The digital image works as a full evidence of the subject's being physically related to a real situation, that is, its full embodiment. Now, we can reformulate digital indexicality as applicable to both the objective state of the image and the subjective activity of making the very image. It is ontologically truthful and epistemologically useful.[21]

In this way productive indexical activity goes global, not limited to the cutting-edge Western (relational) art world. It is more widely palpable among amateur documentarists working in the globalized Third World, which I spotlight in the backdrop of recent political upheavals that occurred almost annually and contingently. First, *Burma VJ: Reporting from a Closed Country* (Anders Østergaard, 2008) is a product of Burmese reporters who face down death to expose the military dictatorship reigning over their country. When peaceful Buddhist monks led a massive antigovernment rebellion in 2007, the repressive regime banned foreign journalists and shut down the Internet. But the film shows a tenacious band of street journalists whose tactical leader oversees operations in Thailand via secret phone calls. He dispenses his video warriors armed with pocket-sized digital cameras, and these Burma VJs capture dynamic events happening in Burma and smuggle their footage into Thailand. Then it is shipped to Norway and broadcast back to Burma and the world via satellite so that it can spark repercussions within and around the country. This digital guerrilla movement plays like a thriller, but the shaky handheld footage only enriches indexical authenticity while the indexical activity combines the optical witness to and tactile participation in real events (fig. 5.13).[22] The film renders visible a global circuit of local digital images as a feedback loop of productive indexical activity, though the circuit is not yet based on the World Wide Web because of its blockage by the local government.

In comparison, huge demonstrations in South Korea in 2008 were limited to a local circuit, which however accelerated the circulation of the image and indexical activity to the utmost. Among diverse demonstrators against the government's import of U.S. beef, suspicious of mad cow disease, was the so-called Web 2.0 generation. Amateur Broadcasting Jockeys, now BJs, connected their camcorders to their laptops on the spot, calling their friends with cell phones, and uploading stills and moving images to the Internet. Unprecedented live

Figure 5.13

broadcasting sites served as on-air platforms where viewers could 'zap' on multiple channels that transferred BJs' raw images of detailed incidents, especially the riot police's excessive violence against civilians, which mainstream media miss, omit, and distort. Netizens reproduced and distributed these images through various online interfaces, often immediately prompting other viewers to rush to the streets. The government tried in vain to stigmatize these anonymous, amorphous activists as anti-U.S. leftists, when their concern over communal life was more than political. That is, the government's political logic of dividing up the nation into the Right and the Left, 'pro' and 'anti,' began to be replaced with people's ethical logic of protecting the whole community from the external threat.[23] In this community, even if national at largest, the spatiotemporal gap between indexical activity and its digital product became remarkably reduced. Far from bringing back aesthetic and ontological concerns over manipulation or recomposition, the digital image was delivered in a flash from street fighters' digits to online spectators' digits, which reproduced it without losing transparency and thereby reinvigorated the actual demonstration. Technically, this quick feedback seems indebted to the absence of celluloid that requires the chemical process of development. Without that cumbersome cinematic interface, the digital image shifts from camera to screen directly, and then to all sorts of screen-based interfaces including portal sites, broadcasting media, blogs, and social networks.

In 2009, the Iranian election protests signaled a sort of combination of the Burma and Korea cases. The image circuit was broadened internationally while the speed of circulation also increased impressively. And without doubt, what drew global attention to this national event most dramatically was the sensational video of the death of Neda Agha-Soltan. In the short footage captured by bystanders and broadcast over the Internet, the young innocent woman is shot in the street, falls, bleeds, and loses consciousness within less than two minutes. Every second of this real death penetrated into people's eyes in front of various interfaces, stimulated their guts, and provoked their digits to disperse her digitized body image through the World Wide Web. As someone says, Neda's death may be the most widely witnessed death in human history with such a close distance without any anticipation. Completely embedded in the contingent situation, it was shot by an "accidental gaze" that was also an "endangered gaze" exposed to the risk of being shot (Sobchack 2004, 249–257). And when it comes to documentary filmmaking, as we have discussed para-indexicality, such risk itself guarantees the authenticity of the photographic image, its full realism, even if the visual quality hardly allows us to see reality clearly. In short, the loss of reality paradoxically assures the gain of reality. What is updated from Bazin's period is that the digital interface performs this paradox more flexibly and swiftly by replacing celluloid-centered indexicality with the actually improved indexicality of the digital image and the indexical activity of the subject.[24]

The Web 2.0 generation may be indeed the name of today's youth culture, whose political potential pervades the global network of the Internet. These

young men and women brought Barack Obama to the first black presidency in the United States, and no less dramatically ended Hosni Mubarak's three decades of dictatorship in Egypt. The latter case is all the more noteworthy because, although the unpredicted democratization of such an underdeveloped authoritarian regime in the Middle East may be viewed as belated modernization, this modernization now appears to be the result of its next step, that is, globalization that has already settled there. The immanent global effect was the cause of the modern desire for democracy. Google executive Wael Ghonim played the role of the most spotlighted activist who ignited this unique reverse of the linear historical development; he called his country's change "Revolution 2.0," attributing its success to Facebook and Twitter, and asserted that the revolution could not have occurred without such social network services. His online organization of protests and his emotional TV interview touched his generation's mind and fingers, transmitted at a speed far exceeding their government's control. More importantly, the battle line was drawn truly all over the globe. What was going on in Tahrir Square, the actual agora, was going on in numerous virtual squares without borders while Facebook friends and Twitter users globally engaged in the local modernization project with their digits on the keyboard busy with productive indexical activity. And fully aware of this enlarged image circuit, protesters not only resisted their actual government, but also appealed to anonymous virtual comrades in the streets by often unfolding messages that identify Egyptians with the Internet users and Egypt with the Internet as such (fig. 5.14)—consequently, Mubarak had to fight the virtual as well as actual protesters.

This new type of actual virtual feedback also had a spiral effect. Netizens' consensus on the universal value of freedom and human rights led them to

Figure 5.14

blame their own democratic countries including the United States for having long backed up the Third World dictatorial regime on behalf of national interests.[25] The world has, however, changed to the extent in which its subdivision to the first, second, and third worlds seems more or less outmoded, at least in terms of interface culture. Western governments finally had to turn their back from the old corrupted regime, following their own citizens' virtual coalition with Egyptians. Then, Egypt could be viewed not so much as a nation but as a contingent agent that happened to trigger a certain globally immanent consensus to erupt on the surface of the global network. Tunisia was the first agent, whose effect split over one of its neighbors, but this contiguous contingency would not necessarily be confined in the regional context. We would never know where a local event would bring about a global butterfly effect.

INTERFACIAL SUBJECTIVITY IN THE NETWORKED WORLD

In sum I have tried drawing multilayered lines in terms of indexicality from ontology to spectatorship, and within the latter, from indexical passivity to activity, and within the latter, from reaction through proaction to production. Aesthetically, as in the case of *T_Visionarium,* one may say that the subject as spectator is composed at the very moment of his compositing images floating on interfaces, for there is no a priori plan for what he will make. The creation of an object to look at is nothing other than the constitution of the subject who touches interfaces from which an object will come into being only along with him. Indexical activity on and through embodied interfaces is the foundational agency of subjectivity. And since it is grounded on indexical passivity, the conscious agency of subjectivity as the product of the synthesis of actions may not be separated from the ongoing product of an unconscious passive synthesis. An individual subject is caught up in a multiplicity of actions and passions. Furthermore, the temporal transition between actions and passions (even between reactive, proactive, and productive actions) becomes ever more rapid, while the spatial distance between subject and interface decreases along the development of screen attachments technology. The evolution of Human-Computer Interface from the keyboard to the mouse to the touch screen indicates this trend of 'embodying' interface through indexical activity. The IT industry might soon enable the user to control the screen by brain stimulation; or the screen might be attached immanently to the brain, becoming "only one switch in an infinity of possible sensory configurations and reconfigurations" (Connor 2004, 68).

But at this point, we might need to critically address implications of this trend from larger perspectives. For today's *modus vivendi* that one can apparently enjoy the infinite freedom to surf the interface ocean is grounded on the *modus operandi* of the networked world in which one is often encouraged and even required to consume, if not always pay for, information and entertainment to be connected to the society. What if the ultimate enjoyment of creating a movie in *T_Visionarium* is a certain enforcement of the

exhaustive law that does not interdict but rather orders the subject to enjoy pleasure principle as he pleases? What if, as Žižek argues, "Enjoy!" is the order of the perverted postmodern Super Ego that never prohibits? Excessive pleasure surrounds and watches the subject, as though he were imprisoned in a new, electronic panopticon. A similar paradox occurs in the public sphere as well when we celebrate global democratization through the collective indexical activity that goes back and forth between the actual and virtual agoras. In his essay entitled "Death Every Afternoon" (2002), Bazin points out the ontological dilemma that the film of a bullfight repeats the unrepresentable nature of death mechanically. Now Neda, the "voice of Iran," dies whenever her YouTube clip is opened, performing 'death every click,' thereby becoming immortal. The undeadness of the image (the digital image is more undead since it doesn't decay like celluloid), then, causes a social dilemma that her dying body is so sensationally dispersed and reproduced over the electronic global village that its unrepresentable subjectivity and the human rights it embodies are rather trivialized or negated, with some viewers only instantly shocked but soon permanently inert. In other words, its tactility is disembodied as well as embodied when indexical activity allows the subject to 'parry the blows' too proactively. The more shocking an image is, the less affective it can be in the image circuit. This numbing effect makes Susan Sontag say that "we become callous" in the world hyper-saturated with images. "Consumers droop. They need to be stimulated, jump-started, again and again. Content is no more than one of these stimulants" (2004, 105–106). Every aspect of life, sexual or political, from bodily sensation to human rights, is thus like TV channels to switch or software programs that one can download and even upgrade as soon as a new version is sharable. Meanwhile it is also trivialized by the oversaturation with stimuli that may expire immediately like mere commodities in this electronic society.

The implication is that social control, if any, does not simply appear as the matter between a programmer and a user. Profoundly, it now shifts to an anonymous collective plane composed of metadata programmers and filtering technology including various search engines and adaptive interfaces (Uricchio 2004).[26] As Deleuze argues, "control" is no longer a synonym for Foucauldian "discipline" based on long-term confinement, but a free-floating modulation that is short-term, with rapid turnover, yet continuous and limitless. It is like "a self-transforming molding continually changing from one moment to the next, or like a sieve whose mesh varies from point to another" (1995, 179). In the current societies of control, then, subjectivity may be not a single unified entity, identity, substance, and the like, but an autopoietic system of agencies that never cease to emerge onto and submerge under the surface of networks while being replaced and exchanged with each other depending on interests and situations. If this signals the 'posthuman' condition, it should be understood not so much as the deprivation of humanity, but as the critique of its centrality and the repositioning of the human organism in the feedback loop of the unorganized interface environment. "Subjectivity is emergent rather than given, distributed rather

than located solely in consciousness, emerging from and integrated into a chaotic world rather than occupying a position of mastery and control removed from it" (Hayles 1999, 291). And face to face with interfaces, the subject lives and works as an agent who synthesizes indexical actions (cor)responding to contingent events. If an event triggers such actions, it can globally diffuse over the Web as the attractive and distractive experience of the 'live'—mediated, yet immediate, which predominates. This global effect does not so much follow any logical causality, but rather insinuates that the whole globe is immanently oversaturated with stimuli always ready to erupt at certain spatiotemporal point through, and in the form of, a contingent event embodied in interfaces.

By extension, I would say that the more expansive a network is, the more explosive the potential of catastrophe is along the network, just as contingent triggers—from volcano ash, diseases like SARS or the swine flu, to computer viruses—swipe the global networks, actual or virtual, airlines or the Internet. Immeasurable connection implies insurmountable contamination. This is the self-contradictory nature of the interface society and culture. We use interfaces to map, frame, and organize the world, but the world of interfaces often goes beyond our mapping and framing inorganically, with global catastrophe potentially roaming anywhere anytime. Hence a double bind of global interfaciality. On one hand, horizontally, the mathematical sublime of networking extends inclusively to every corner of the globe and thereby, paradoxically, challenges our imagination of its whole dynamics and our capacity for representing its entire territory—maps of the Internet attempt to visualize this virtual land and it appears almost like a disorganized brain cell or an unreachable galaxy, namely a body without organs (fig. 5.15) (Galloway 2013, 78–83). On the other hand, vertically, this ever-more encompassing empire of interfaces à là Hardt and Negri barely or vainly tames and represses the dynamic sublime of catastrophic power the empire itself generates inherently and inevitably, yet also uncontrollably and unpredictably. This double sublime of interfacial globalization results from the very omnipresent interfaciality that is already immanent in the world and the subject.

Let me try a wrap up. This interface world formed through software expansions and networked interactions definitely embodies what Galloway calls today's "ludic capitalism," with which we players engage without realizing that the more we play, the more we are in control. But even its realization would not allow us to escape it because there is no outside of interfaciality. Indeed, control is pleasure, and only in its excess, becomes *jouissance*. Our organic subjectivity enjoys (or is ordered to enjoy) the symptom of liberating itself and connecting fragmentary others by living interfaciality, with our image and information taking the form of another interface that might float like a detached organ over the inorganic body of networks forever. Then we need to rethink what life is like here. Greenaway's *Life in Suitcases* might sound like 'life in interfaces.' Standing for the innumerability of the mathematical sublime, ninety-two suitcases appear like infinite digital interfaces he touches with his digits in ways of being incorporated into a

Figure 5.15

new public sphere, an ever-rebooting feedback circuit of multiple param-
eters and flexible modulations. Apparently reinforced as an active producer
of a new assemblage of images, the subject staged here might then undergo a
new-media version of the postmortem desuture of life. As only by 'plugging
in' the network can Luper's and the viewer's life be activated together, the
subject is just an agent put in the objective net of inorganic contingencies.
Subjectivity and objectivity are such relational effects of interfaciality, visu-
alized as interfacial images that surround life and immerse it into the undead
world. Yet we live this undead life only on the immeasurable surface of
interfaces under which the insurmountable apocalyptic magma might lurk
to exterminate everything. Then would postapocalyptic redemption be just
another reset of ever-more chaosmatic networks with the eternal return of
apocalypse (Jeong 2011a, 184–185)?

With no more space to struggle with this sublime question, I leave it for
future discussion. Meanwhile I may keep facing this conundrum in front of
my computer, a digital interface coded in zero and one, which look like the
eye and the finger. It is blinking, signaling that subjectivity is nothing but
interfaciality.

Conclusion

INTERFACE FOR A GENERAL THEORY

To close our theoretical journey, let us recall the closing page of Deleuze's two-volume magnum opus on cinema. Facing increasing doubt on the usefulness of film theory, the philosopher asserts that philosophical theory, rather than ready-made philosophy, is itself a practice that "must be judged in the light of the other practices with which it interferes." He continues: "A theory of cinema is not 'about' cinema, but about the concepts that cinema gives rise to and which are themselves related to other concepts corresponding to other practices. It is at the level of the interference of many practices that things happen" (1989, 280). In our words, it is at the level of 'interfacing' with many conceptual practices that a new theory could emerge as a new cinematic practice.

With this vision in mind, if not perfectly realized, I began with the cinematic apparatus extended along the chain of perceptual and/or mnemonic interfaces from the single object (image) through the triple medium (camera/film/screen) to the dual subject (eye/mind). If this physio-psychological baseline was introduced for a medialogical approach to the 'hardware' of the interface, the ensuing five chapters unfolded hermeneutic analyses of its diverse visualizations in ways that illuminated its 'software' aspect, that is, its multifaceted interfaciality. The thematic focus accordingly went back and forth between two sides of object and subject, while each side expanded from direct interfaces (medium/body) to quasi-interfaces (surface/face) and, ultimately, to image and subjectivity as such. And each of these instances entailed, as it were, 'concept wars' over *suture, embodiment, illusion, signification,* and *indexicality,* the key terms put under continuous reframing, retooling, and reshaping, at the crossroads of film and interdisciplinary theories: the ontology of the image, the narratology of the material, the psychoanalysis of the real, the phenomenology of the body, the cognitivism of the mind, the ethics of the other, the aesthetics of appearance, and the sociology of the digital. Meanwhile, the concept wars in turn enabled the production of new concepts that could shed light on the unexamined niches or possible links between established notions or theories. Often motivated by films and images that challenge the given terminology, I thus attempted to coin or combine words in various ways: 'affective effect,' '(de)suturing dividual,' 'screen body,' 'body screen,' 'illusion of tactility/interfaciality,' 'readerly

window,' 'writerly mirror,' 'machinic simulacrum,' 'uncanny icon,' 'para-index,' and 'indexical passivity/activity.' All these concepts revolve around the umbrella notion of interfaciality, which finally urged me to refigure the image on the threshold of visibility and to reconfigure subjectivity in need of an upgraded critique of the digital interface world. More philosophically here, the ontology of what an image *is* mingles with the epistemology of how it *interfacializes* subject with object in a new social way. Thereby my upward trajectory from the infrastructure of apparatus through the superstructure of onscreen images to the apex of image itself goes back down to the actual ground of interface, geared up to our new media world and the study thereof that I bracketed at the beginning. In short, the chart below could now be re-viewed as a sort of narrative of this entire project.

Chapter	Theme	Content	Concept	Theory	Approach
Introduction	Apparatus	Object (image), medium (camera/film/screen), subject (eye/mind)	Apparatus, interface	Physiology, psychology	Mediology
1	Medium (camera, film, screen)	Medium interfaces	Suture, asymmetrical mutuality	Semiotics, psycho-analysis, photogram-matology, ontology	Hermeneutics
2	Body (skin)	Screen-body, body-screen	Embodiment, ambivalent tactility	Psychoanaly-sis, phenom-enology, historicism, technesis	
3	Object (surface)	Quasi-interfaces	Illusion, immanent virtuality	Phenomenol-ogy, ontol-ogy, aesthet-ics	
4	Subject (face)	Face-character, face-viewer, face-facial-ity, face-otherness	Signification, multiple directionality	Semiotics, phenomenol-ogy, ontol-ogy, ethics	
5	Image, subjectivity	Object-(image-interface)-subject	Indexicality, para-index, indexivity	Ontology, epistemology, sociology	Philosophy

Ultimately, then, we must again ask: What is an interface? Are we now in an assured position firmly to grasp this multiply interfaced notion? Perhaps only in that we experience the interface as the 'constructively instable' threshold between its two sides, one of which is ours. Apparently an interface is given as a useful tool, a sensorimotor extension of our body and mind toward information, knowledge, community, and society, in short, the world in general. But cinematic interfaces on screen have persistently put into question this communication model prevalent in media studies as well as taken for granted in our daily life. What occurs around the interface at stake is not simply a two-way smooth interaction or actual autopoeitic feedback. Sometimes intruding on our perception and memory from without, the interface interfaces with the Real as both the constitutive kernel of and a destructive threat to what we believe is reality. Put differently, the interface is necessitated by the subject's suture of the Real into reality, which in turn can be put under 'desuture' by the very interface. What it renders palpable is thus the inherent disequilibrium between reality and the Real, between the actual and the virtual. This *asymmetrical mutuality* further awakens us to the unthought truth that our eye, the center for perceptual subjectivity, is itself an embodied interface that is sutured from disembodied matter, and by extension, suturable into the camera, a technological interface. Likewise, the screen both mobilizes and thwarts our physical contact with the body image, the subject's fundamental desire for the Other, while the body itself may be a primordial interface out of which the skin-ego's tactile desire is born, and because of which the radical unification with the Other is in turn blocked. This *ambivalent tactility* underlies the intrinsic dialectics of the interface, technical or embodied. When it comes to quasi-interfaces, a more generalized form of the interface, interfaciality takes on more nuances. Just the surface of an ordinary object can resemble an interface, an "organ without body" that leads to the ontological plane of the "body without organs," the inhuman dimension of *immanent virtuality* that we could not otherwise sense without the illusion of interfaciality. Similarly, the *multiple directionality* of what the face signifies implies the implosive dynamics of the interface. The face, human or inhuman, is not only oriented to the subject, character, or viewer, but also directed to its own immanence from which subjectivity is organized, and to the infinite otherness to which subjectivity is opened.

Along with the generalization of interface, interfaciality in general could then serve as a springboard concept for a general theory of image and subjectivity. As we saw, the cinematic image does not always appear as an index to an actual object, but sometimes emerges as a *para-index* to the para-ontological being, animal, or ghost, that submerges into the margin of our vision and knowledge. The subject may want to finger it with his index, to capture it with his indexical camera, to suture it into his epistemological frame. *Indexical activity* understood in this sense, reactive or proactive or

productive, forges the subject's relationship with the object-image, that is, subjectivity as such. The actual interface enables and embodies the virtual interfaciality that conditions subjectivity and objectivity in this way. Without referring to interface, film theory has named it in metaphorical forms for cinematic interfaces: the camera as eye, pen, brush; the screen as window, frame, mirror. Now, interface theory could and should reconfigure partial interfacialities sketched in these terms, to synthesize their complex, controversial, convoluted correlation and elicit a more encompassing viewfinder of the world and our life in it.

Indeed, the interface guides the subject while confining him, protects him from the "fire of the real" yet also provoking him to go beyond. It facilitates yet frustrates, develops yet disrupts the subject's ontological, phenomenological, epistemological relationship to the other, the image, and the world. It oscillates between visible and invisible, touchable and untouchable, representable and unrepresentable, meaning and meaningless, being and nothingness, but on the condition that the relationship between these apparently oppositional terms is, again, asymmetrically mutual, ambivalently tactile, immanently virtual, multiply directional, para-indexical, and indexically activated. It inscribes the noumenal within the phenomenal, the sublime within the beautiful, sometimes traumatically and at other times epiphanically. It registers the subject on the interfacial network whereas my point, however, lies less in efficient communication or effective connectivity than in an interfaciality as such that entails all its contingent side effects including noise, viruses, breakdowns, and other catastrophes. Modules we use on the interface modulate our activity, and controls we inject onto the interface control our life, no matter how supple, flexible, liberal, and even productive both the interface and we may be. We may love the beauty of 'interface culture' designed on Facebook, YouTube, and so on, but we can do so only insofar as we cannot help but live on the 'interfacial sublime' of immeasurable networking and insurmountable entropy. Today, God responds to our question in the name of Google with endless answers with which we are swamped and to which we are limited at the same time.

In short, there is nothing outside interface, evoking Derrida's infamous "text." As the principle of textuality that structures different signs with their meaning put in deferment, Derrida's *différance* was proposed as *the* concept of all systems and structures, their ontological condition, because "that which produces different things, that which differentiates, is the common root of all the oppositional concepts" (2002, 7). We know Hansen's critique of this originally linguistic notion is that it deprives the technological world of concrete material externality. However, what if anything in the material world, that is, anything outside the linguistic web, is also immanently interfacial as we have seen? The concept of interfaciality is not derived from the binary symbolic code of marked and unmarked, signifier and signified,

sign and referent, and the like. I traced its origin back to the image of being as such, object or subject, in light of Bergson's view of the image as the most ontologically fundamental mode of being. And above all, the notion of suture that generates interfaces was generalized as the very process of differentiation in such an asymmetrical structure of concepts as 'speech versus writing/*différance.*' The idea of interfaciality thus does not reduce the robust external real to an abstract framework or operational protocol, but rather serves for our comprehensive understanding of how that ontological Real is epistemologically framed into our reality, illuminating the immanent interconnectivity between subjectivity and objectivity.

A SYNTHETIC REASSEMBLAGE OF FILM STUDIES

Instead of further generalizing interfaciality, let me here go back to film studies because a general theory of interface would be possible, from our disciplinary position, when actively we reengaged with film theories in ways of discovering and creating a way to going beyond them toward interdisciplinary discourse rather than import and transplant non-film theories to film. And to re-interface with film theories, a meta-critical approach would be necessary on the level of remapping them.

In fact, a meta-theoretical position is more or less taken by any theoretical engagement in previous theories that are examined as references, especially when a certain methodology is polemically if not politically addressed against another. Every major turn in film studies has resulted from such polemics, with perhaps the hottest debate held between the Continental and analytic schools. After the polemics of Heath and Carroll and the 'post-theory' battle between Žižek and Bordwell, Rodowick defends the Deleuze-Cavell line of philosophical tradition against cognitivist attacks in his "elegy for theory," which is in turn put to harsh (but partly misleading) criticism by Malcolm Turvey from the rival perspective (Rodowick 2007b; Turvey 2007). But my concern at this point is more about dealing with plural theories on a larger scale than such a dichotomous and factional structure would suggest. Putting aside anthologies of key texts, there seem to have been three major tendencies in this meta-critical approach to film theories. First, chronological ordering: Robert Stam's encyclopedic survey, for example, includes more than forty short entries from pre- to post-cinematic film theories (2000); Casetti focuses on three paradigms or generations across the fifty years of postwar theory, namely the ontological, methodological, and field theories (Casetti 1999b). Second, methodological classification: while Andrew's first classic theory book chronologically follows a series of theorists in formalist, realist, and contemporary categories (1976a), its sequel takes the opposite

approach by tracing the history of a concept in each chapter from perception to interpretation (1984). Third, thematic assemblage: Casetti's latest book rearranges mostly classical theories in terms of different aspects or functions of the cinematic vision named "eye of the century" (2008); more extensively, Elsaesser and Hagener reposition virtually all film theories on the map of such sense organs as eye, skin, ear, and brain, which correspond to the major cinematic metaphors (2010).

Although the order of these tendencies may not necessarily indicate a certain evolution of the meta-critique of film theory, the last example is notable in its fresh framework of the body-cinema rearticulation while not simply centering on theories of embodiment. Rather, reassembling bodily and cinematic agencies, the book envisions the cinema's potential to propose "a new way of knowing the world, also a new way of 'being in the world,' and thus demanding from film theory, next to a new epistemology also a new ontology"; namely, a "general theory" of body and mind (12). Indeed we encounter a sort of diagnosis of interfaciality in its conclusion: our subjectivity is fashioned by "objects that more often behave like subjects that actively shape their environment rather than as simple tools we control and bend to our will" (181). Again, this philosophical streak does not directly result from applying philosophy to film theory, but comes through film theories that continue to be reshuffled along with film analyses and other disciplines in the way film theory ends up becoming a form of film philosophy. While the old Grand Theory partook of a top-down imposition of borrowed but limited methodologies on film, a new one, if any, could and should be a bottom-up reassemblage of homegrown as well as interdisciplinary concepts and ideas, or, say, theoretical agencies interfacing with film images.

To make such a reassemblage more synthetic and coherent, I have proposed *interface* as the umbrella term under which to rethink both the body and cinema in view of crucial concepts and relevant films. This somewhat adventurous project is, however, only one way of interfacing with film studies, while many gaps and lapses undoubtedly are left open. Hoping for future updates, finally, I would like to suggest a map that might enable a meta-critical taxonomy and archeology of film theories and practices as broadly as possible. Let me go back to the cinematic apparatus as a conveyer belt of cinematic interfaces and ask what we can do. A quick glance of cinematic metaphors may be useful as their nature could be reviewed in terms of which interfaces are at issue. For instance, Bazin's idea of the screen as frame or window may turn out to concern the relationship between matter and camera, whereas Metz's mirror metaphor may fall somewhere between screen and eye/mind. Likewise, we could remap all kinds of film theory and research along the line of interfaces, so that a new vision of cinema and its discourse could be envisioned.

Matter	Camera	Film	Screen	Eye	Mind
object/world	"eye/pen"	"brush/keyboard"	"window/frame/mirror"	body/skin	subject/brain
– Ontology (Bergson, Deleuze)	– Narratology	– Narratography	– Semiotic psychoanalysis (Metz, Baudry)		– Memory (Freud, Bergson)
– French impressionism	– Montage theory	– Media archeology	– Marxist feminism		– Skepticism (Cavell)
– Realism (Bazin)	– Movement image	– Big screens (cinemascope, IMAX, 3D)	– Apparatus theory		– Time-image
– Cultural studies	– Avant-garde film (structural materialism)	– Small screens (TV, computer, mobile interfaces)	– Spectatorship		– Cognitivism, neurobiology
– Identity politics	– Hand-work film	– Museum, gallery	– Cinema of attractions		– Systems theory
– Reality/Real (Žižek)	– Video art	– Virtual reality (immersion)	– Rube film		– Informatics
– German expressionism	– Found footage tradition		– Perception		– Mind-game film
– Studio system (Bordwell)	– Digital cinema		– Phenomenology		
– Virtual reality (matrix)					
– Theme park					

The first column comprehensively relates to the question of how and what kind of the world or reality is captured or represented by the camera. On one hand, there have been quite a few approaches to the actual world in such diverse ways as philosophical, aesthetics, sociopolitical, and psychoanalytical: the Bergson-Deleuze philosophy, French impressionism, Italian Neo-realism, cultural studies along with identity politics, and even Žižek's psychoanalysis rooted in late Lacan. On the other hand, the creation of fictional worlds has also been at issue through German Expressionism, historical research on the Hollywood studio system, virtual reality as a matrix, and even theme parks as simulacra. The second column deals with the ways cinematographic perception is processed onto the memory surface of filmstrip. If traditional narratology concealed this material base, avant-garde film, especially the 1960s and 1970s structural films, exposed the strip of celluloid itself in a way that the very material substrate becomes a profilmic event as seen in Chapter 1. And the relationship between the invisible filmstrip and the screen falls in the third column; the issues range from the screen size to the museum as a new cinematic space without projection. In the fourth column on the relationship between screen and eye (often including mind), we have the most heated debates in film academia, from Grand Theory to its historicist turn triggered by the cinema of attractions theory because, however different they may seem, their primary concern is spectatorship. And partly in relation to this issue, the final column concerns the most impenetrable realm of mind and memory.

This remapping of established theories may let us locate some possibilities of new film research. First, what has been believed to be incompatible or what has left unrelated could be rearticulated. With regard to mind, not only Freudian psychoanalysis and Bergsonian ontology, but also cognitive science, neurobiology, media studies, and information/systems theory could be seen more clearly as cooperative partners—in fact these disciplines have interacted outside film, and their interdisciplinary influence on film studies also exists, but what I suggest is the instrumentality of the mapping for better visualizing any potential connectivity among different branches in film studies. Second, the mapping might render holes and niches locatable within each of the branches. For example, it would not be difficult to look at how Deleuze almost entirely dismisses the critical subjects of projection and spectatorship, and what kind of links would be needed to fill such gaps to better understand the apparatus and interfacial functions. Last but not least, we should face the fact that this celluloid-based interface theory itself is now to be updated. Consisting of the flux of computed pixels, digital cinema endangers the fundamental interface of filmstrip made up of a series of frames. Expanded cinema combined with new media/installation art renews the places of the screen and the subject among others. But through this remapping of celluloid film theories, we could also remediate the narrow communication model in new media studies. In sum, this kind of 'cognitive mapping' can help (1) rearticulate different and incompatible ideas or

approaches in a cooperative way to better understand the cinema; (2) rediscover with which interfaces an established theory especially engages, and research alternatives to what it fails to clarify; and (3) reposition diverse effects of the digital/new media along this cinematic model at large.

Hopefully, though sketched as an initial attempt, this interface theory in film might contribute to better addressing the rest of film studies and the effect of new media studies. Postmortem film studies could indeed resurrect its life by virtue of our efforts to retheorize it.

Notes

INTRODUCTION

1. Similarly, D. N. Rodowick sees interfaces as necessary for accessing information that is otherwise hardly perceptible. But he does not limit the interface to the digital one. The film projector is also an interface magnifying the image and reconstituting movement, as is the analog video monitor (2007a, 113).

2. It is remarkable that computer interfaces have developed toward embodiment, being more and more incorporated into the body in the following order: command line (punch card), mouse, touchpad, touch screen, gesture sensing (tapping the phone to play music), force feedback (phone vibrating when switched to silent), voice recognition, augmented reality (GPS), spatial interfaces (iNap that monitors the user's position), and Brain-Computer Interfaces (controlling the device through cerebral stimulation). An input device for creating a cybernetic feedback loop thus comes into the body, where the machine registers the user's behavior (Graham-Rowe 2009).

3. That is why *dispositif* is basically ideological in the context of Continental philosophy. Giorgio Agamben traces its origin back to antiquity, following Michel Foucault's biopolitics, and generalizes the apparatus as that which enables any process of subjectification: "a set of practices, bodies of knowledge, measures, and institutions that aim to manage, govern, control, and orient—in a way that purports to be useful—the behaviors, gestures, and thoughts of human beings" (2009, 12).

4. According to Slavoj Žižek, "post-theorists" such as Bordwell and Carroll (1996) treat a "dialectical" history as the gradual progress of our relative knowledge through the testing of hypotheses based on contingent events. The universality of a phenomenon, for example a film technique, is then proved only empirically by objective observers detached from this history of "contingent universals." In this view, the abstract and deductive Grand Theory nourished by Continental philosophy could not be universally accepted. However, Žižek criticizes post-theory for taking such a standard, naive version of dialectics, opposing it to his genuine Hegelian dialectics in terms of "concrete universality." Although I do not downplay the value of empirical historicism as well as the risk of the Žižekian sampling, my film selection will try to embody the concrete universality of interfaciality.

NOTES TO CHAPTER 1

1. The *Screen* issue referenced here has a dossier on *Caché*, with most of the authors taking the postcolonial perspective with the reference to the Paris massacre of 1961: on October 17, 1961, the French police attacked a

peaceful protest of about thirty thousand Algerians, which later brought the Algerian war to metropolitan France. After thirty-seven years of denial, the French government acknowledged forty deaths though there are estimates of more than two hundred.

2. Before discussing Deleuze, Saxton introduces a mini-history of the discourse on offscreen space: from André Bazin's window metaphor and Noël Burch's 'actual' offscreen space to Pascal Bonitzer's "field of blindness" including the production space (2007, 5–17).

3. Deleuze would have called this shot a "free indirect discourse," following Pasolini, in that the camera views both birds and what these monsters view (1986, 74–76). As a type of "perception-image," the free indirect viewpoint embodies "a perception [camera eye] in the frame of another perception [character eye]" (291), or the Gaze within a gaze in Lacanian terms I will examine.

4. Referring to Frege, though not to Miller, Sean Cubitt takes the zero ("both a numerical sign within the system and the origin of that system") as the starting point of cinematic movement (2004, 33–40). This sense of zero as launching the closed numerical system belongs to analytic philosophy, as does Frege, whereas Continental philosophy adopts it to emphasize its verso, the lack that makes the system incomplete. Interface intimates that Continental appropriation of this analytic concept. Žižek's revisit to suture could be seen in this philosophical backdrop (Buckland 2012, 149–165).

5. Given Žižek's connection of Lacan to German idealism, the Real here sounds more ontological than psychoanalytic. It may be the realm less of the traumatic Thing than of, à là Kant, things as a multitude of appearances prior to being symbolized as numbers. Kant regards the number as a unity synthesizing the manifold of a homogeneous intuition, therefore as a "concept" emerging solely in "the radical faculty of all our [subjective] cognition, namely, transcendental apperception" (1998, 236, 274).

6. This veil somewhat evokes the memory cover of Freud's "mystic writing pad" examined in the introduction, and also Stanley Cavell's idea of the screen as a barrier in his linguistic game that turns the noun into a verb: "what does the silver screen *screen?*" (1971, 24). I will return to Cavell in Chapter 3.

7. Explaining these diagrams, Kaja Silverman supplements Lacan's ahistorical notion of the screen with Jonathan Crary's historical relativism of the camera and vice versa. The screen is redefined as a cultural "conduit" or "repertoire" of ideological images through which subjects are constituted and differentiated in relation to class, race, sexuality, and so forth. Furthermore, the camera is the primary metaphor for the gaze that Crary omits, as both "a representational system and a network of material practices" that frame the Western subject, preconditioning a historical specificity of the screen (Silverman 1996, 131–136). But while overlooking the visual materiality of the screen, she seems to over-politicize it from this somewhat Althusserian perspective. The screen then appears like an ideological apparatus in which the gaze emerges as sociotechnologically determined, rather than like an opaque barrier of the ontological Real. I would emphasize that the Gaze (Real) and the eye (reality) are in a fundamentally 'asubjective' relationship, and only within reality can the screen as such a 'symbolic form' stage our sociohistorical subjectivity.

8. Simply, "I am seen before I see," and this 'before' implies the logical if not chronological condition of perception; I see because I am positioned in the visual field in which I am seen. Saxton reaches this point as well, though not via Lacan-Žižek. "[O]ur blind spots—not only to personal and collective

traumas . . . but also to the sites of non-seeing which structure cinema and spectatorship . . . the margins of blindness, which frame and limit our look, but are also, it suggests, a condition of our seeing" (2007, 15).

9. "The uncanny (*l'étrange*)" is eventually explicable according to natural laws, and "the marvelous (*le merveilleux*)" requires supernatural laws but is 'realistic' about the supernatural. Both of these remain acceptable as the real or 'the unreal as real,' that is, referential to genres of reality. But "the fantastic" as such has no frame of reference by which to determine it as uncanny or marvelous; it refers to the unrepresentable in presentation itself (Todorov 1973).

10. The influential distinction between the speaking subject [*le sujet de l'énonciation*] and the subject of the speech [*le sujet de l'énoncé*] originates from Émile Benveniste's linguistics (Benveniste 1971, 218).

11. "To make a film always means outlining a field which evokes another field, in which a finger rises to designate—by hiding them—its objects as the signifier of its insignificance, before having them reappear—and die—as a signifying Sum" (Oudart 1977, 43). Originally, the first "field" seems filmic, while the second enunciative, in which objects are still insignificant until being filmed, that is, until being sutured to the signifying chain. But I suggest that it would be clearer to reposition this "finger" metaphor in the filmic field that always indicates and lets us anticipate its enunciative outside that will come in to it.

12. Žižek's idea of interface seems to owe much to two famous 'painting' readings: Foucault's complex analysis of *Las Meninas* and Lacan's awry view of Hans Holbein's *The Ambassadors* (1533) (Foucault 1973, 3–16; Lacan 1998, 92). Nothing could be more 'interfacial' than an imaginable collage in which the royal faces in the former's mirror is replaced with the *memento mori* of the latter's anamorphic skull.

13. It is the translation of *cinématographique,* which can relate to Robert Bresson's *cinématographe* as a new language of images and sounds (not the *cinéma* as filmed theater), as well as the normal adjective *cinematic*. See "Introductory Note" in the *Screen* dossier on suture ("Dossier Suture: Introductory Note" 1977, 23).

14. This suture involves two technical and psychological processes: critical flicker fusion (the projector's shutter breaks the light twice per frame so that we see not a pulsating light but a continuous beam) and apparent motion (a visual display is changed rapidly enough to fool our eyes into seeing movement) (Bordwell and Thompson 2010, 10).

15. In fact, Stewart elaborated, via Frege, on the "flickering-in-eclipse" of the phonemic chain in one of his earlier books, from which such wordplay as "supple/mentation" derives (1990).

16. As Barthes confesses the difficulty of capturing the "third meaning" on screen, it would be taken in by a pensive spectator who contemplates the photographic without being engulfed in the cinematic. Denotation and connotation are "obvious" even in motion, whereas the third meaning disappears from the signifying movement of iconic signs and appears through the atemporal "obtuseness" of signifiers as such—material, fetishistic, nonlinguistic, and nonrepresentational. Barthes calls cinematic essence "the filmic" that resides not in the moving picture but in the "photogram." However, the following clarification is necessary: meaningless photograms on the filmstrip (Stewart) only serve the moving image for the first and second meanings, from which third meaningful stills (Barthes's photograms) can be detached for Barthes's notion of the filmic (1977, 52–68). I elaborate on the third meaning in Chapter 4.

17. Respectively, Stan Brakhage, *Mothlight* (1963); George Landow, *Film in Which There Appear Sprocket Holes, Edge Lettering, Dirt Particles, etc.* (1966); Paul Sharits, *T,O,U,C,H,I,N,G* (1968). One might argue that rigorously speaking, these examples show not the filmstrip itself but marks *on* it. The strip as the inscription base is always right there before our eyes but exceeds vision, not because it is beyond the frame but in the frame. Under this condition, nonetheless, such marks refer to the filmstrip in the most direct way possible and could be said to reveal it.

18. For an interesting example, Tony Conrad not only projects on screen films that are 'cooked' and 'boiled,' but preserves in boxes and bottles 'roasted' and 'pickled' filmstrips that look like aliens' brains, continuously changing in color as if suborganically alive.

19. The avant-garde film at stake is not the 'visionary' American romanticism, but the 'structural-materialist' film that obstreperously and boisterously decenters perceptual space and jumps into self-closed formalism. Unlike this "closet hobby," the "narrative avant-garde" refers to works of Jean-Marie Straub/Danièle Huillet, Laura Mulvey/Peter Wollen, Marguerite Duras, and even some works of Oshima or Welles, and so forth, which still work with and on codes while practicing theoretical issues (Andrew 1984, 124–127). For the structural materialism, see Peter Gidal's seminal text (1976) and P. Adams Sitney's related parts (2002) along with Rodowick's thorough review (1995).

20. Stewart's ambitious project starts with the analogy of filmic photogram and lexical "phonogram" put under the continual churning of wording in modernist literature, and grows to investigate the shift from the filmic to the postfilmic in his next book (2007). In this sense some stylistic analyses of literary works in Russian formalism (Roman Jakobson, Victor Shklovsky, etc.) might be noteworthy, as they first paid systematic attention to the dialectic of meaning and materiality on the phonetic level.

21. Stewart takes a similar example of the fake "antiquing" from the last newsreel footage of *The Golden Bowl* (James Ivory, 2000) (2007, 48–51). Throughout film history, one could also refer to such famous fake newsreels as in *Forrest Gump* (Robert Zemeckis, 1994), *Zelig* (Woody Allen, 1983), and an element even in the "News on the March" sequence from *Citizen Kane* (Orson Welles, 1941).

22. Before then, notably, the same type of montage was used in Godard's two-minute short *Je vous salue, Sarajevo* (1993), a series of multiple framings of one single photograph that depicts soldiers and victims.

23. During the sequence, Godard's ghostly voice recites Foucault's inaugural lecture at the Collège de France that says his speech is in the middle of connections with predecessors, as if his voice ventriloquized them—just like Godard's. Then sound turns to the recitation of *Simple agonie,* a poem by Jules Laforgue, who was nurtured by German culture but died very young.

24. Mulvey also examines this sequence, but still centering on the binary of movement/stillness though she does not refer to Stewart at this point (2006, 13–16).

25. Here, the 'interface-photogram within the screen' is sutured in form of the full screen, whereas in *Caché* the outdoor space is sutured in form of the 'interface-shot within the screen.' But as Haneke's interface shot actually desutures diegetic reality by evoking unsuturable intradiegetic externality, Vertov's screen-sized shot is also desuturing when continuing to confront the diegetic inside with the intradiegetic outside.

26. To wrap up the ideas of Tom Gunning, Miriam Hansen, and Timothy Corrigan on two modes of reception, *glance* implies confrontation, astonishment, and distraction, whereas *gaze* involves attention, absorption, and

concentration. Historically, these two oppositions correspond to two modes of film production: preclassical/postmodern cinema of "attractions" and classical/modern cinema of "narrative" (Staiger 2000, 11–27). The distinction between glance and gaze originates from Norman Bryson's work on vision and painting (Bryson 1986). See also major readings of the cinematic allegories in *Rear Window* (Stam and Pearson 1986, 193–206; Belton 2000).

27. Besides this article, another notable reference for Stewart is Philip Dubois's "Photo tremblée et le cinéma suspendu" (1987), which itself builds on Bellour's earlier work "The Unattainable Text" (2000, 21–27). Bellour's concern over the freeze/stillness starts from that semiotic effort to capture the fugitive movement and attain a quotable text.

28. For this reason, Martin Jay argues, Bergson damns "the ocularcentric bias" of Western metaphysics and modern science while suspecting visual primacy that extended to its new technologies (1994, 210).

29. As opposed to 'mechanism' in the Actual, 'machinism' indicates the unbound working of the Virtual that deterritorializes into the plane of immanence where desire ("desiring machine") works in and for itself and (re)(dis)connects with others without organizing a fixed entity. Totalized subjectivity then "becomes other" through the rearrangement of pure qualities and impersonal intensities (Deleuze and Guattari 1987).

30. In fact, as Vivian Sobchack points out, Deleuze does not take in Merleau-Ponty's later phenomenology, which seems to me to be not that far from the Bergson/Deleuze ontology. The next chapter looks into this subject as well as Sobchack's cinematic phenomelogy of embodiment.

31. Vertov's becoming machine ("I am the machine that reveals the world to you as only I alone am able to see it") often sounds 'mechanic' rather than 'machinic,' in that the kino-equipped eye enhances perceptual power to conquer time and space. This primitive cyborgism shared by Benjamin and Epstein also permeates his exalted film manifesto (Vertov 1984), though it is quite open to a 'machinic' reading. One may read Vertov via Donna Haraway's contemporary cyborgism (Schaub 1998). However, let me be clear about the significance of historical contexts. Undoubtedly Vertov made the film at a time when both 'world' and 'subject' were considered as objects of radical construction, and Deleuze relevantly points out Vertov's "dialectic" between a nonhuman matter and a superhuman eye in terms of "the identity of a community of matter and a communism of man" (Deleuze 1986, 39–40). In what follows I do not propose a pure theory beyond any historical practices and conjunctures, but a sort of theoretical dialectic by which to start from Vertov's Marxist constructivism, reframe it in prosthetic modernity, and imagine the ontological basis of the very modern paradigm. In turn, my reading of Vertov must be an outcome of the historical environment in which my subjective reconfiguration of theories on asubjectivity is possible.

32. Niklas Luhmann explores various social systems in the sense of system as *autopoiesis* (self-making) organized in feedback with environment (1995). Anthony Wilden offers a broad-range chart of analog/digital dichotomies (1972, 155–190).

33. As speech is another writing that is *différée* and *différante,* so the "intelligible" is a differed-differing "sensible"; "concept" a differed-differing "intuition"; "culture" a differed-differing "nature." *Différance* as a common noun is immanent both to a term and between two terms of any binary code. It suggests: "all opposition is the theoretical fiction" (Derrida 1982, 1–28).

34. Here, Deleuze rehabilitates Bergson via Nietzsche and Freud, asserting that *time-in-itself* as the pure past/unconscious is the Virtual that eternally returns

to be actualized in every different way. Later, the virtual is updated as the Real of "desiring machines" as mentioned previously, deterritorializing any imaginary/symbolic structures bounded by the oedipal triangle such as the bourgeois/capitalist subject, family, and state. If Derrida finds a deconstructive 'agent' upon which the structure of a system depends, Deleuze opens an event 'horizon' onto which "arborescent" systems are dissolved into "rhizomatic" networks (Deleuze and Guattari 1987).

35. In relation to the gaseous, Sean Cubitt personally noted that there is the "plasma" state where ions circulate free from otherwise constituting atoms. Free ions, importantly, translate photons into electrons in various cinematographic devices. Plasma inspires us to think of the dividual as ontological state with its components being probabilistic, and of the digitemporal as both a universal now and a perpetual Bergsonian flux. In this instance, the cinematic concerns the singular which, in its concreteness, refuses probability. This may open a future debate on my conclusion about the digital effect.

36. Deleuze's screen brain is a double metaphor: the brain automaton concerns the rather inhuman time-image dimension, but its counterpart is what we have already examined, that is, the screen = body/brain as a center of indetermination, a sensorimotor system working in the movement-image dimension.

NOTES TO CHAPTER 2

1. See, among others, Jean-Louis Baudry's two classic articles, "Ideological Effects of the Basic Cinematic Apparatus" (1986a) and "The Apparatus" (1986b), along with Metz's *The Imaginary Signifier* (1982).

2. The woman, the mother's body in particular, is often represented as abject: excremental (threatens identity from the outside) and menstrual (threatens from within). To "ward off the subject's fear of his very own identity sinking irretrievably into the mother" is to cut off this abject and enter the father's symbolic authority (Kristeva 1982, 64). This concept particularly invigorated horror film analysis (Creed 1993).

3. Benthien cites here Paul Valéry: "the human as an 'ectoderm' whose real profundity, paradoxically, is his skin," and refers to Freud's mention of consciousness as the "surface of the mental apparatus" and the ego as "surface entity." Developing this idea, Didier Anzieu coins the notion of "skin ego": a "mental image of which the Ego of the child makes use . . . to represent itself as an Ego containing psychical contents, on the basis of its experience of the surface of the body." A sort of 'embodied' mirror-stage ego, this notion concerns the skin as "a unifying envelope," "a protective barrier," "a filter of exchanges and a surface of inscription" (1989, 98). We examine it again later.

4. The body image is the represented body as an object (noema) of intentional consciousness (noesis), whereas the body schema refers to "a 'prenoetic' function, a kind of infraempirical or sensible-transcendental basis for intentional operation." The latter is preconscious, subpersonal, tacitly keyed into the environment and dynamically governing posture and movement (Mark Hansen 2006b, 39–40).

5. In this sense Joe evokes a pornography spectator whose watching is more or less intended to provoke touching that cannot help but bounce from the screen-body back to his own body-screen. This self-caress or self-love is a radical type of embodied spectatorship, central for internet porn and cybersex technology.

6. Linda Williams positions Muybridge in the history of pornography, which nourished the "the frenzy of the visible," a "drive for knowledge" (Koch) aimed at *scientia sexualis* (Foucault). Far from a narrative form in the "masquerade of femininity" (Doane), hard core is "the one film genre that always tries to strip this mask away and see the visible 'truth' of sexual pleasure itself" (Williams 1999, 48–50). Mary Ann Doane argued that female spectators only masquerade to take the male gaze that fetishizes the female body (1991, 31–32). My point is, however, that the female body is shot and seen as the most fundamental attraction on screen whether for visual knowledge or pleasure. The difference lies in the degree of narrativization. Pornography's minimal story progresses along with the sexual piston movement whereas narrative film's minimal attraction temporarily disrupts the movement of the story.

7. It shows a "*naïf*, who does not know what theatre is, and *for whom*, by a reversal foreseen in Corneille's plot itself, the representation of the play is given. By a partial identification with this character, the spectators can sustain their credulousness in all incredulousness" (Metz 1982, 72–73).

8. A well-known Greek episode tells that Zeuxis's painting of grapes so lusciously invited birds that they flew down to peck at the fruit, but when he asked Parrhasius to pull aside the curtain from his painting, the curtain itself turned out to be a painting. Parrhasius deceived Zeuxis who deceived the birds. Regarding this myth, Lacan points out that while animals are attracted to superficial appearances, humans are enticed by the idea of that which is hidden (Lacan 1998, 103). Interestingly, the mural paintings of sixth-century Korean artist Sol Geo are also reported to have fatally attracted birds.

9. This work-eye relationship could be compared to the gaze-look relationship in Lacan, with the gaze now incorporating tactility. A broader range of ideas on vision as touch is examined in detail in Chapter 5.

10. He appears among the audience of a golf game on TV (*The Bellboy*) and as an errand boy making a billboard of Jerry Lewis the movie star (*The Errand Boy*). In the latter, his dream is to be 'closer' to Hollywood while he experiences tough reality there. So the touching remark, "you can't have it because you are closer to it," evokes the ambivalent interfaciality of the screen world. But it is a Hollywood film with this dream finally coming true as he takes over the star's role, becoming a star himself.

11. As Elsaesser notes, Noël Burch tackled diegesis in the shift from film to TV (Burch 1990a). In passing, I mention Žižek takes, without reference, Burch's three examples for the spectator's failed identification with (diegetic) characters and the (enunciative) camera as three types of psychosis: *Lady in the Lake* (Robert Montgomery, 1947), *Rope* (Alfred Hitchcock, 1948) and *The Thief* (Russell Rouse, 1952) prohibit the objective shot (paranoia), montage (*passage à l'acte*), and the voice (autism) (1991, 41–43).

12. This is the so-called Branigan's Paradox. Whatever Brechtian device that debunks the illusionism of a film in the film still belongs to this latter film's diegesis, as if there is an infinite regress of diegesis (Branigan 1986, 37–54)— in my terms proposed in Chapter 1, 'Chinese boxes of (diegetic) interfaciality.'

13. In some sense Georges seems like a tragic version of the Rube, traumatized by the unknown medium. As for *Sherlock Jr.*, Casetti precisely describes the scene at issue as the trope of early spectatorship, of unpredictable 'modern' experience, after which the character adapts to the world that the film discloses. This process is called "filmic experience" as *attendance* that passes through three instances: the experience of a place (theater), of a situation (real/unreal), and of a world (diegesis). Thus, cinema is "an interface between two worlds" (Casetti 2009, 60–61). My intervention is to subdivide

this interface into three scales (image/shot/scene) and interrogate the suture-desutic dialectic down to the body-world relationship.

14. Well before the recent revival of Merleau-Ponty, Andrew memorably traced French phenomenology in relation to existentialism, filmology, psychology of Amédée Ayfre, Henry Agel, Gilbert Cohen-Séat, and Jean Mitry (1976a, 179–254). He contrasts semiotics with phenomenology like 'structuralism vs. poststructuralism': explanatory versus descriptive, synchronic (system) versus diachronic (origins), distanced (objective) versus immersed (experimental), communication (rhetoric) versus expression (art), analytic (revolutionary) versus synthetic (revelatory), text versus self (1976b, 627).

15. Allan Casebier (1991) makes an opposite distinction: realism (its extreme case is Bazin's "transparency theory," that is, image = reality) versus idealism-nominalism (Metz/Barthes's "transactionalism" of spectator with text, that is, representation = construction governed by cultural, cinematic codes). Between these two, he sees Husserl's phenomenology as a "realist epistemology" that suggests the represented object exists independently in transcendence over consciousness, but our transcendental intention mediates representation. According to him, Baudry misunderstood Husserl's 'reduction' as bracketing off real objects and making impressions of reality, whereas its original notion rather means bracketing off "our natural standpoint assumptions" to approach things themselves existing independently. Casebier's peculiar rediscovery of Husserl has however been outmoded by Vivian Sobchack's influential rediscovery of Merleau-Ponty, as we will see. Casebier's spectatorship theory seems to me often too schematic and dogmatic based on limited examples, while still appealing to some traditional aesthetics of appearance.

16. Lyotard sharply criticizes Merleau-Ponty for still supposing the intending subject's transcendence over the object and thus "falling prey to the illusion of unitary discourse" that retrieves the Other into the Same. Phenomenology moves from the 'I' to the 'One,' but the distance remains between 'One' and 'That,' that is, between the Flesh and the Real (Lyotard 1993, 310–313). If this Real, or, the plane of immanence is centrifugal from subjectivity, the Flesh is centripetal to intersubjectivity. However, there are also attempts to shed more light on the similarity between Deleuze and Merleau-Ponty in terms of late Merleau-Ponty's notion of being as infinite (Del Rio 2005, 62–78) and in terms of affect ("a feeling as a property of the object, not as a state of my being") as the catalyst of intersubjectivity (Dufrenne 1989, esp. 442).

17. 'Transcendence' is thus the invisible 'actual,' objectively transcending our subjective consciousness. Sobchack later suggests its more 'virtual' notion evoking Bergson-Deleuze: "not the transcendental (religious miracles, uncanny supernatural mysteries) but the transcendence of the world, the 'secret metaphysics' of its immanence (quantum indeterminacy, chaos theory)" (2004, 103). But intentional or not, her usage is opposite to its common (Kantian) usage that defines *transcendent* as beyond human knowledge, and *transcendental* as about our cognitive faculty like pure reason with regard to how objects are possible a priori. The transcendental subject struggles with the transcendent.

18. Marks also mentions Deleuze's criticism of phenomenology, but relevantly notes that Merleau-Ponty 'upgraded' Bergson while offering more room for spectatorship theory. Like Sobchack, however, Marks rejects Lacan's mirror stage while ignoring late Lacan, and differs from Shaviro in that "yielding-knowing, more than (but as well as) shattering" of subjectivity seems more important to her (2000, 150–151). In doing so, she rather expands phenomenology to art history and postcolonial studies, drawing on Deleuze-Guattari's

"minority literature," Teshome Gabriel's "third-cinema," and such cultural studies.

19. I note that Marks's "haptic erotics" goes further from the phenomenological 'totality' of being tied to the other, toward the ethical 'infinity' of Lévinas's inaccessible other. This suggests late Merleau-Ponty's connection to Lévinas, an issue discussed in Chapter 4.

20. We may now conceive a genealogy of the opening sequence study, with keywords: from semiotic interpretation (Kuntzel's 'figure') to material narratography (Stewart's 'filmstrip') to sensible phenomenology (Sobchack's 'finger')—the last would comprise Marks and Barker's examples.

21. If Deleuze applied Bergson's cone model to the film's body, Grodal's model accounts for the spectator's body in a similar way. Bergson's affection is, however, less emotion emerging from perception than the interruption of the perception-action link; a pathway to memory that resides not in the brain but in time in itself. Like most cognitivists, Grodal sets up a normative model of spectatorship for the universal standard (i.e., Hollywood 'movement image'), while regarding art film ('time image') as derivative and less notable.

22. Alice Jardine's point (1985) is not that poststructuralists ignore or misunderstand woman, but that their obsession with the indecidable, unlocatable, unthinkable rather idealizes femininity as embodying such otherness in the way woman is sophisticatedly sutured into their anti-phallogocentric 'male' philosophy.

23. This critique seems arguable. First, Hansen (over)interprets the 'text' (Derrida) and 'mass media' (Lacan) as evidence of the "machine reduction of technology," though his quotes from these thinkers do not even contain the word *technology*. Second, he also reduces any ontogenesis to his own model of technesis, where we could ask how his notion of material technology is ontologically produced if not mechanically.

24. The expression "metaleptic suture" (Mark Hansen 2000, 95) is notable: "metalepsis is the textual expression or symptom of the system's (i.e., linguistic theory's) built-in inability to recognize its environment" (183). Hansen refers to Anthony Wilden's 'trope of suture' (Wilden 1972, 134).

25. Accordingly, the main Benjamin reference is not his "Work of Art" essay but "On Some Motifs in Baudelaire" (1968c), along with the final section of "One-Way Street" that envisages mankind's collective innervation in the technological cosmos (1978a, 92–94).

26. Merleau-Ponty's theory of body schema shows his turn from Husserlian phenomenology to ontology (Mark Hansen 2006b, 54). It resonates with the "body without an image" (Brian Massumi) and "infralinguistic body" (José Gil), having the potential of proprioception and movement in embodying the act of producing the body image (39–40). Bergson's sensorimotor schema is no less than the body schema, open even to time/memory which, I repeat, is missing in the phenomenology of spatial embodiment.

27. Like Lyotard's critique of Merleau-Ponty, Daniel Frampton points out that Sobchack limits film's body to human-like terms (subject, vision, experience, expression). As an alternative, he takes a Deleuzian rather than Lyotardian inhumanism, proposing "filmosophy" that investigates not how film reveals our consciousness but how we might describe its own "filmind." Film is not "subjectively having a world" but "transsubjectively being a world" (2006, 46–47).

28. Notably, the woman is not single but double (as the film is two doppelganger women's psychodrama), closing her eyes at the end. The face effaces identity and visibility, receding into opaque interiority like Merleau-Ponty's flesh or unreachable immanence like Lévinas's otherness—faciality seen in Chapter 4.

29. On a microscopic level, this mingling occurs through "the fragile films of atoms which are striped[1] off bodies and fly to the other bodies" (Connor 2004, 27–28). 'Film' as a thin layer suggests that the screen (projected film) resembles the skin not just metaphorically but materially, not by its image but by its body.

30. For Irigaray, male tactility originally takes the narcissistic autist desire to annihilate the boundary and come into the womb. Merleau-Ponty's "tissue" is "a maternal, maternalizing flesh, reproduction, substance there of the amniotic, placental tissue, which enveloped subject and things prior to birth, of tenderness and the milieu that constituted the atmosphere of the nursling, the infant, still of the adult" (Irigaray 1993, 159). She argues that this flesh leaves no room for female subjectivity and mature intersubjectivity.

31. Apposite is this passage: "What happens when what is seen imposes itself on your gaze, as though the gaze had been seized, touched, put in contact with appearance?" (Blanchot 1981, 75).

32. On the level of pre-reflective and passive material, passive suffering engages us with "response-ability," and active devotion with "sense-ability." On the level of reflective and active consciousness, these correspond to the ethical and aesthetical concepts of responsibility and sensibility"[2] (Sobchack 2004, 289–290). Responsibility/sensibility may be the suture of their primordial states, response-ability/sense-ability.

33. Shaviro puts the point clearly: "It is the excess of male fantasy, and not a critical reduction of it, that leads to its destruction, just as it is from deep within postmodern technology of domination, and not at a utopian remove from them, that an irrecuperable *other* to power can be affirmed" (1993, 156).

34. For Shaviro, the old tradition to overcome includes metaphysics of presence, phenomenology of intentionality, Baktine's dialogism, and Lacan's symbolic structure (1993, 47). His abandon of psychoanalysis is the most explicit ever ("utterly bankrupt; it needs not to be refined and reformed, but to be discarded altogether" (ix). Fifteen years after *The Cinematic Body,* however, he confesses that this abandon was wrongly polemical and violently reductive, only limited to the 1970–80s theory and outside the Žižekian re-account of Lacan. Following this renewed psychoanalysis, he casts no less unhindered criticism of post-theory and Bordwellian cognitivism, yet this time too, for example, without referring to updated cognitivism of embodiment. But again, his idea of embodiment in *The Cinematic Body* seems more radical than its later boom to which he thinks he contributed as a precursor (Shaviro 2008, 48–54).

35. After this moment, Pierrot has an illusion that Columbine's portrait becomes animate and bursts out in laughter. Tickling again with trepidation, he finally dies at the feet of his "painted victim laughing still." See Derrida's first part of "The Double Session" (1992) where he deconstructs Plato through Mallarmé. The quotation appears on 151–152, Mallarmé's poem on 130, and the original booklet information on 145–147.

36. Here is *Mimique* (my emphasis in bold): "*Ainsi ce PIERROT ASSASSIN DE SA FEMME composé et rédigé par lui-même, solique muet que, tout du long à son âme tient et du visage et des gestes* **le fantôme blanc comme une page pas encore écrite** . . . *Voici –* «*La scène n'illustre que l'idée, pas une action effective,* **dans un hymen** (d'où procède le Rêve), *vicieux mais sacré, entre le désir et l'accomplissement, la perpétration et son souvenir : ici devançant, là remémorant, au futur, au passé, sous une apparence fausse de présent.* **Tel opère le Mime, dont le jeu se borne à une allusion perpétuelle sans briser la glace : il installe, ainsi, un milieu, pur, de fiction.**»"

37. Laura Marks traces Benjamin's mimesis in a larger context of embodiment: Erich Auerbach has touched on the reader's embodied response; Derrida discussed the "tactile production of speech, embodied representation" as the sensible ground of philosophy; Bergson viewed "habit" as "mimetic knowledge"; Merleau-Ponty saw "indirect language" in contact with "brute and wild being," and so forth (2000, 138–145).

38. A notable predigital installation work in this regard is Anthony McCall's *Line Describing a Cone* (1973). The spectator's body is invited to a haptic space and projected onto the screen when interacting with a visible but also tangible light. The body activates light, the invisible and insubstantial basis of the material world just like digital codes, as a visual and tactile object inscribable on the surface of the dark.

NOTES TO CHAPTER 3

1. In fact it is not the sun that inflicts punishment for greed. The narrator brings up the story as a sort of weird joke responding to a fortune teller's words. Dr. Toey jokingly conveys that she would have "many boyfriends from all races"; the shy girlish doctor is, in other words, advised against greedily pursuing men, as the narrator says: "Like you coming here, it knows all about you." This "it" (pseudo-camera above), however, would not necessarily wield moral power against love fever, a pure 'syndrome' at best.

2. By this Deleuze book title, I imply that this chapter will be the most Deleuzian as his vocabulary will permeate it if not always referred to in the original form, like 'immanent virtuality.'

3. In Shakespeare's *Hamlet* (Act 1 Scene 5), the hero utters this line after being visited by the ghost of his father, who was murdered by his uncle. This shocking supernatural event alters the way Hamlet perceives the world and the state, which he now needs to fix. Derrida however argues that a radical singular event only occurs when time is "out of joint" (1997, 10–24). Deleuze affirms that when a "caesura" occurs "once and for all," time is "unhinged" from its circular, periodic movement and experienced only as a pure empty form of change, marking the before and after of the crack, becoming no longer cardinal but ordinal—the second, third, fourth . . . time 'eternally returning' as 'difference in itself' in its Nietzschean sense (1994, 119–123). Time is then not subordinate to movement, but conditions it; here we see the germ of Deleuze's notion of time-image.

4. The first-ever experience of the cinema is marked in this regard in the well-known anecdote of Georges Méliès's fascination with the moving leaves in the background of the Lumière film *Baby's Meal* (1895) rather than the family centered in the foreground. Along with Griffith's claim for "the beauty of the moving wind in the trees," this cinephiliac sensibility captures the pure cinematic act of indexing nature in its transient appearance, film art thereby going beyond the idée fixe of art as work (Baumbach 2009).

5. "In the midst of beings as a whole an open place occurs. There is a clearing, a lighting . . . Only this clearing grants and guarantees to us humans a passage to those beings that we ourselves are not, and access to the being that we ourselves are" (Heidegger 1971, 53).

6. In mechanics, "molar" properties are those of a mass of matter, as opposed to its parts, atoms or "molecules." By adapting these notions, Deleuze and Guattari suggest that molarity is the site of coded wholes, a making the same that keeps stable equilibrium, whereas molecularity concerns

becoming(-other) rather than being (the same). This pair resonates with, for instance, "tree vs. rhizome" among many similar ones pervasive in their book (Deleuze and Guattari 1987).

7. Deleuze and Guattari expand the notion of BwO from the virtual dimension of an individual body to reality in general, a BwO of "the earth." They write: "This body without organs is permeated by unformed, unstable matters, by flows in all directions, by free intensities or nomadic singularities, by mad or transitory particles" (Deleuze and Guattari 1987, 40).

8. Also see 26–32 and 80–87. This arguable book is both a critique and reevaluation of Deleuze. For Žižek, the Oedipus complex does not as Deleuze and Guattari claim in *Anti-Oedipus* reduce everything to "the mother-father-and-me matrix." The "symbolic castration," rather, deterritorializes the family and helps the subject to enter the social network: "the site of the sterile Sense-Event," which Žižek reads as Deleuze's second virtual in *The Logic of Sense* (1969/1990) written alone without Guattari. The "event" is the "immaterial sense-effect" of "bodily-material process-causes." Thus, if the actualization of the Virtual constitutes reality, out of this reality emerges the virtual of the sense-event. The latter is so affected by incorporeal "quasi-causes," separate from material causes, that it has autonomy from the material world similar to the "grin without a cat," OwB. This quasi-cause is the same as the object cause of desire that is "non-sense" to itself, that is, the *objet petit a*. The Phallus, a pure signifier without signified, signifier of castration, is the point of non-sense around which the Symbolic is formed, deterritorialized from the material world.

9. This Georges Franju title of 1960 (*Les yeux sans visage*) sounds quite pertinent, not only because there is no actual face but because this absence of any visible face (comparable to an identifiable body) suggests that the OwB only belongs to a BwO (comparable to the virtual of the face that Deleuze calls "faciality"). The next chapter will discuss this film and the notion of faciality as interfaciality.

10. Dudley Andrew perhaps offers the clearest overview of these two traditions (1976a). Among the four formativists he examines, I only bring Münsterberg and Arnheim in terms of psychology of illusion (the two others, Balázs and Eisenstein, will be at issue in the next chapter). Also, see Andrew's film concept section on "Perception" (1984, 19–36).

11. Likewise, cinematic movement results from the *phi-phenomenon*: active powers of the mind make sense (motion) out of distinct stimuli. Inadvertently he also means by filmic 'illusion' what the theater cannot create, like "the man transformed into a beast and the flower into a girl" (Münsterberg 2002a, 176).

12. The Neo-Kantian dualism of the outer (practical) and inner (psychical) worlds evokes Henri Bergson's monism of matter and mind with differences. Bergson suggests the 'image' as both the essence of and mediator between matter and mind, while emphasizing mind/memory is conditioned by time in itself. Given Bergson's neglect of cinema, however, Münsterberg was undoubtedly the first theorist of film as mind.

13. I consult Timothy Barnard's new translation of Bazin insofar as it includes what I refer to.

14. As seen in Chapter 2, Maurice Merleau-Ponty's phenomenology of film starts with Gestaltist synthetic perception, which is not subsumed into Cartesian analytical intelligence. From the realist viewpoint, Kracauer makes clear that film "effectively assists us in discovering the material world with its psychophysical correspondences." The turn of psychophysical stimuli into a

Gestalt of the world is the primary perception derived from sensations before a higher degree of mental function (Kracauer 1960, 297).

15. Bazin's realism and/as surrealism has caught critical attention (Keathley 2006, 60–73; Lowenstein 2007, 54–82).

16. If Photorealism emulated analog photography, Hyperrealism uses digital imagery and creates a new sense of reality through the illusion of (more meticulously) manipulated high-resolution images like the Baudrillardian simulation, the imitation of what doesn't really exist (Bredekamp 2006, 1–4). Thus we can see the object of the image becoming less and less real along the line of photography-photorealism-hyperrealism-surrealism, though their indexical effect remains the same in essence.

17. "The evolution of film language" for Bazin is its devolution from the formative viewpoint. Perspective may be the 'original sin of cinema,' and sound reduces film's organic integration of light, gesture, editing, and so forth into dialog-based reality, an impure kind of theater substitute. For Arnheim, it is "a cancer which has destroyed the artistic life of film by distorting its ensemble form" (Andrew 1976a, 35).

18. This is the view of Heinrich Wölfflin, who developed Riegl's haptic/optic dyad in terms of tactile/visual (Aumont 1997, 100–102). David Bordwell meticulously traces this shift (1997, 158–272).

19. Torben Grodal, introduced in Chapter 2, seems to offer the latest version of this formative approach to the complex interaction among physiological givens, cultural conventions, trigger devices, and social needs. Here, subjective relativism is sublated to homeostatic bioculturalism.

20. It is notable that for Metz, cinema is purely visual and not tangible, because of the effect of motion rather than depth. He says: "if we were to reach forward to grasp [a tree on film], our hands would close on an empty play of light and shadow, not on the rough bark . . . movement is never material but is always visual, to reproduce its appearance is to duplicate its reality" (1974a, 8–9).

21. Also, see his article with an expanded chart of perception theories (Allen 1997, 76–94).

22. Allen's project is to refine the classical "suspension of disbelief" in the frame of analytic theory. This mental activity of organizing reality effect is rooted in the formative psychology as mentioned earlier, though Metz criticizes Arnheim for not evaluating it actually (1974b, 12).

23. It should be noted that for Turvey (2008), this revelationism implies the denigration of vision, which he sees as based on a conceptual confusion about seeing. He clarifies it through the Wittgensteinian lens. Martin Jay (1994) offers a larger investigation of the doubt cast on vision in French thought.

24. Not coincidently, Francesco Casetti's *Eye of the Century* (2008) focuses mainly on early revelationist theorists and directors though revelationism is not a defined issue or term—Casetti and Turvey do not refer to each other. I note that the century of the cinema began in the way it became the eye of the century.

25. I refer to Bryson via Sobchack. Bryson introduces Nishida Kitraro and Nishitani Keiji, who criticized Sartre and Lacan for positioning the 'I' as the center of experience, arguing that the Japanese actually dismantle this subject. Notably, Nishitani studied under Heidegger and brought Zen poetry and Buddhism into his work. This line of philosophy appealed to many Western theorists such as Barthes, whose notion of *signifiance* means the very operation of Bryson's *signifier*, and Burch, who views Japanese cinema as a radical alternative to standard classical Hollywood. Putting aside orientalism

lurking here, I point out that this pro-Japanese aesthetic considers 2D surface effects as liberating from the 3D perspective system.

26. The film is a remake of *The War of the Worlds* (Byron Haskin, 1953), which does not have such interface images as I now bring. Both of the films are based on the H. G. Wells story of Martians' attack on Earth.

27. Debord (2000) directly takes the Marxist, Althusserian standpoint of the spectacle as visual commodity. Stars evoke life's alienation from reality, and modernity means the loss of experience, its substitution by spectacle. It is "the nightmare of the imprisoned modern society."

28. Heidegger sees "the pictorial turn" as the historical transformation equivalent to modernization, and hopes for a new epoch in which poetry, not the world picture, opens up Being (1977, 115–154).

29. "*Caligari* combines realistic movement of figures in volumetric sets with a flatness of performance and composition harking back to the 'primitive' tableau" (Bordwell 1997, 100). Bordwell echoes Burch's view expressed in the aforementioned article on haptic cinema (Burch 1990b, 182–184).

30. With regard to this Etna essay, Casetti contrasts Epstein as the observer (shooting the volcano) with Epstein as the observed (seen through mirrors) in terms of interdependence in modernity between the ever-closer intimacy with the surrounding universe and the progressive loss of all certainty. Cinema is an interlocutor, overlapping presences and interweaving gazes (Casetti 2009, 141–144[1]).

31. It should be noted that the film ends with the hero's death, leaving unanswered the question if he succeeded in becoming animal. Deleuze and Guattari's sense of the term is neither the literal adoption of animal behavior in Thierry Zéno's grotesque *Vase de noces* (1974)—a farmer breeds with his pig and later kills the mutant offspring—nor the one-to-one transformations depicted in werewolf films. Far from imitation, becoming animal must get "past the wall" of identity and definition (Deleuze and Guattari 1987, 171).

32. The so-called membrane study sheds light on an intermediary metaphorical matter between solid and liquid: "veil, canvas, tissue, chiffon, fabric, goatskin and sheepskin, known as parchment, the flayed hide of a calf, known as vellum, paper, supple and fragile, linens and silks, all the forms of planes or twists in space, bodily envelopes or writing supports, able to flutter like a curtain, neither liquid nor solid, to be sure, but participating in both conditions. Pliable, tearable, stretchable . . . topological" (Bruno 2002, 40). This view resonates with Bachelard's material imagination based on the image toned and textured by the other senses, and furthermore with Merleau-Ponty's phenomenology of embodiment as seen in Chapter 2. I just note that the illusion of liquid screen is, above all, a cinematic experience of all those half-solid membranes.

33. Here one might recall Maxim Gorky's first impression of the cinema (1896), which he calls the "kingdom of shadows": "Everything there—the earth, the trees, the people, the water and the air—is dipped in monotonous gray . . . The ashen-gray foliage of the trees sways in the wind, and the gray silhouettes of the people . . . glide noiselessly on the gray ground." This seminal film review has been taken from diverse standpoints including Lant's "haptical cinema" we examined; we addressed Lumière's train in terms of tactile attraction/penetration and Burch's haptic space. Now Gorky seems to offer another way of imagining the first-ever screen effect as a gaseous screen of immanent virtuality.

34. Piavoli does so in an idiosyncratic, but more subdued way than Godfrey Reggio's similar trilogy: *Koyaanisqatsi* (1982), *Powaqqatsi* (1988), and *Naqoyqatsi* (2002).

35. Deleuze examines the water-oriented montage of French Impressionism in terms of "the mathematical sublime" and "the liquid perception," and refers to Wilhelm Worringer's theorization of Expressionism in terms of "the dynamic sublime." *Expressionism* is defined as the opposition of vital force to organic representation, invoking the Gothic or Northern decorative line, a broken line passing in a zigzag between things, drawing them into a bottomless and whirling them in a formlessness (Deleuze 1986, 51). Such Gothic lines seem to take on liquid effect in this shot of *Sarabande,* not in relation to the French school.

NOTES TO CHAPTER 4

1. On the surface level, Sai-hee, played by a star, may look more beautiful than Seh-hee despite the latter's order of "just a different face," and it may be true that the former easily catches Ji-woo's eyes by her "somewhat familiar" but prettier face. But the primary motivation of changing the face concerns something deeper than skin, all the more because Ji-woo's transformation rather exposes the loss of his face.
2. Her desire to change identity in the face of the fear of a lover's rejection might evoke Rainer Werner Fassbinder's *In a Year of 13 Moons* (1978), given that Kim Ki-duk has been called a Korean Fassbinder.
3. The two women are shown in a shot and reverse-shot exchange in close-up at the beginning, whereas the two-shot here (fig. 4.1) is taken from the ending, a full shot with only one face exposed.
4. This Gondry film may offer an intriguing comparison with *Time* in their similarity and difference. Here, the hero, heartbroken that his girlfriend erased him from her memory, undergoes the same psychiatric experiment of erasing all his memory of her. But during the procedure he realizes his ongoing love for her and tries to save her, which ends up working through his old traumas and starting over with her as the opening scene repeats later in the narrative. Notably, the idea of memory as the fundamental of identity also came to the fore in cinema along with the postmodern imagination of artificial memory, that is, when memory was put under threat of insertion, deletion, or manipulation. Memorable is the female "replicant" in *Blade Runner* (Ridley Scott, 1982) who believes she is human because of her (implanted) memory of her childhood embalmed in its physical (but fabricated) index: photos as recollection image.
5. I am tempted to associate the name Seh-hee (세희) with its possible Chinese character combination 歲姬, which means a 'woman in (the past) time,' that is, an 'old woman.' And since "Sai" is the pure Korean adjective for 'new,' the name Sai-hee (새희) sounds like a 'new woman.' The ending of Sai-hee's re-surgery back to Seh-hee, however, mingles these two signifiers and thereby their signifieds.
6. The following references resort to the common usage of *period* or *era,* but we reformulate them in terms of paradigm so as to illuminate both their horizons and limitations from a more systematic viewpoint, even if paradigms may look blurred by periods indicated in view of references. My paradigms are proposed after this historical search, in terms of 'directions' of faciality.
7. The face in the Renaissance episteme was, for example, compared to the whole universe: "The human face, from afar, emulates the sky, and just as man's intellect is an imperfect reflection of God's wisdom, so his two eyes, with their limited brightness, are a reflection of the vast illumination spread across the sky by sun and moon; the mouth is Venus, since it gives passage

to kisses and words of love; the nose provides an image in miniature of Jove's scepter and Mercury's staff" (Foucault 1973, 19). In this paradigm of resemblance, every microcosmic signifier is so motivated to echo every macrocosmic signifier that their allegorical correspondence seems the ultimate symbolic signified, just like the mysterious message of Baudelaire's poem "Correspondences": "forests of symbols" give forth "prolonged echoes mingling . . . in a deep and tenebrous unity." On the contrary, the classical paradigm of representation associates every facial signifier with its direct, mechanical signified within the self-closed totality of the facial register.

8. Aumont talks about its film version by Victor Fleming (1941) in light of physiognomic glamour and polyphony, but in terms of the modern face (1992, 63 and 82). I review the film later on.

9. I am tempted to use the word *interpretation* in the place of *codification* (the basis of the Ricoeurian interpretation as the explanation and comprehension of figures or symbols) or in the place of *signification* itself (the umbrella term that could include Barthesian signifiance against codified interpretation) (Andrew 1984, 172–190). However, by the same token, *interpretation* seems too flexible and self-contradictory to be specific or generic for our discussion on the face. Despite similar possible problems, the term *signification* seems better defined from its primary semiotic frame and then readdressed around the root of *sign*, whose subject is finally put in question.

10. Elsaesser (2009) briefly sketches facial discourses in a similar three-stage history marked by (1) Balázs, Epstein, Barthes; (2) Lacan; and (3) Lévinas. These key theorists guide the flow of my discussion as well (though Epstein and Barthes are discussed in the second phase).

11. This optical expression prior to verbal signification enables one to enjoy *Stimmung*, ethereal charm or auratic radiance 'added' to that magnified face—which will soon lead to another facial paradigm.

12. The French version of such glamour may be found in photos of Harcourt Studio actors exhibited as "identity cards" and "masks" (social types and formulated poses). They create what Barthes calls a modern "myth" of stars as gods, doing nothing and only being "caught *in repose*" (1979, 19).

13. As is well known, this double articulation of a sign becoming a signifier to add another signified yields a "myth" in Barthes's semiotic sense of the term. A modern myth is accepted as natural and universal, while obliterating the sociohistorical background of this mechanism (1957, 109–137). Neorealism is on the opposite side of the French bourgeois culture and its myths that Barthes anatomizes, but my point falls on how the Neorealist face naturalizes the way the face internalizes this process of signification.

14. Bresson (1977) had actors repeat each scene until all residues and semblances of "performance" were stripped away so that they reveal their unknown virtual nature, rawness out of habitual subtlety. A "model" was an agent of this effect only to be found in "cinematography" as opposed to "filmed theatre."

15. Albert Camus proposes these three values against "the absurd" in life. As if the myth were screened, his memorable essay on Sisyphus ends with, so to speak, existentialist spectatorship: "The struggle itself toward the heights is enough to fill a man's heart. One must imagine Sisyphus happy" (1955, 123).

16. In passing, I briefly get back to Buñuel's *That Obscure Object of Desire* mentioned at the beginning. In terms of the face, the film itself obscurely oscillates between two facial paradigms. First, a midlife man is frustrated by a young girl who always tantalizes him but never satisfies his desire for her; her body as a whole is a face veil to that male spectator in this regard. Second, the woman is famously played by two actresses, that is, with two

different faces of which one is cool, calm, and serene (the quietly beautiful Carole Bouquet) whereas the other is hot, lustful, and sensuous (the fiery beauty Angela Molena). This bi-faceted character rather confirms the old idea that each face results from its own physiognomic identity.

17. Michel de Certeau proposes "poaching" as a key *tactic* against the power-governed notion of *strategy* (1984). For him, everyday life works by a process of poaching on the territory of others, recombining the established rules and products in unauthorized ways—evoking Lévi Strauss's *bricolage* as Deleuze's schizophrenic *assemblage* of preexisting materials. Casetti 'poaches' this concept to describe the "filmic experience" of creative spectatorship, including touching the screen (2009, 18).

18. No doubt this embodied spectatorship peaks in pornography. Typically a porn star's face attracts the male gaze and provokes the male action with her mouth being a hole, an oral vagina to pierce and fill. In the end, her face becomes an inscriptive surface for her partner's sperm signature, a drain for his ejaculation, and a receptacle for his gifting of that 'holy water' or tasteful nourishment. This asubjective female face, subject to the male actor, often looks at the camera to lure the spectator into a virtual sex act with her, which could conclude in masturbation. Again, this ambivalent tactility of the (inter) face may be, to borrow Bazin, the "genius of the system" that perpetuates the seduction and frustration of the spectator's body.

19. "[A] certain compactness of the courtiers' make-up, thick and insistent for the one, smooth and distinguished for the other; the former's 'stupid' nose, the latter's finely traced eyebrows, his lank blondness, his faded, pale complexion, the affected flatness of his hairstyle suggestive of a wig, the touching-up with chalky foundation talc, with face powder" (Barthes 1977, 53).

20. Aumont sees the time image here, but the actual duration of painting could not directly achieve the time image that is more about the virtual, the past (Aumont 1992, 102). Likewise, *The Mystery of Picasso* (Henri-Geroges Clouzot, 1956) that documents the artist's actual working may not be a Bergsonian film proper in terms of duration, unlike Bazin's view (Bazin 2005a, 2:164–172).

21. The Kuleshov effect seems a barometer by which to gauge different theoretical positions in terms of the face in close-up. Deleuze sees in it the importance of ambiguity that can fit various affects rather than various things (1986, 155), whereas Aumont emphasizes its role of setting diegetic connections (1992, 48–49). Since Kuleshov believed that close-up has its significance solely in montage and no independent value, the effect takes spatiotemporal *différance* as the principal of making meaning, while leaving no room for *signifiance*. Thus at least its original idea concerns only informative and symbolic significations, having nothing to do with the photogenic (Yampolsky 1996).

22. As Herzog often overlaps non-Western ethnography with classical music (mostly opera) ironically, we see here Wodaabe's god-less simulacra slowly dancing while we hear Charles Gounod's Ave Maria.

23. On a different level, Baudrillard's famous example of simulacrum is still noteworthy: "Disneyland is presented as imaginary in order to make us believe that the rest is real, whereas all of Los Angeles and the America that surrounds it are no longer real, but belong to the hyperreal order and to the order of simulation. It is no longer a question of a false representation of reality (ideology) but of concealing the fact that the real is no longer real, and thus of saving the reality principle" (1981, 13). This diagnosis evokes Žižek's persistent argument that reality and illusion are no longer

distinguished because reality itself is in illusion. In Žižek's more political terms, the simulacrum would be a "sublime object of ideology" (still ideology in concealing that there is nothing to conceal), a postmodern Kafkaesque "law" that orders us to wait until allowed to enter the supposedly fantastic dream world. That is, a simulacrum like Disneyland may be a fictionally sutured form of all reality, an interface with this truth as Real.

24. Barthes describes Garbo's face as follows: "Amid all this snow at once fragile and compact, the eyes alone, black like strange soft flesh, but not in the least expressive, are two faintly tremulous wounds" (1957, 56). This analogy between the face and nature insinuates the general application of the white wall/black hole system to anything in the world. But it should be distinguished from Epstein's overlap of the face and the sea that evokes only the immanent BwO of the face.

25. Jesus "invented the facialization of the entire body and spread it everywhere (*The Passion of Joan of Arc,* in close-up)" (Deleuze and Guattari 1987, 176). Then, do such films with (White) Jesus as *The Gospel according to Matthew* (Pier Paolo Pasolini, 1964) reinforce this universal but weakened facial racism?

26. In her book on the face on screen, Therese Davis (2004) argues that unlike Deleuze and Guattari, Michael Taussig emphasizes how defacement sensation is grounded in a specific sociohistorical experience of the face as a particular practice of the image. This resonates more with Sobieszek's approach to the new media era I am now mentioning. So does Adorno's view of cultural critic as physiognomist who reads a hidden future and past behind the present expression. For Adorno disfigurement breaks the spell of unity formed in the circular pattern of the social, though he would have criticized current Hollywood for totalizing the facial culture despite its superficial variety of (digitized) disfigurement.

27. The idea of infinity thus maintains the separation between the other and the same, not integrating them into a totality. Multiple beings as subjects can exist in a totality, but Being itself as the Other is exterior to totality (Lévinas 1979, 83 and 291). Put in another way, it is this exteriority to signification for any type of subjectivity that infinitely makes the Other nonbeing, a "meontological" object.

28. The hero's face in Bresson's *Diary of a Country Priest* (1951), for example, looks like a spiritual face book on which the inner voice is continuously inscribed. A diary is written on this face; its black holes and dark hair are on the verge of being disentangled and transformed into letters on the white paper. For me, that is why this priest, "a prisoner of the Holy Agony," almost wanders on the threshold between the human and the inhuman, rather than the divine itself. Beyond emotional or intellectual expressivity, his face interfaces with what is being written through a voice whose origin can't be seen, a somewhat impersonal voice that blurs the boundary between image and writing, visual and audible. The "model" therein works as a cinematographic agent mingling different media and senses. Everything humanist—religious belief, existential ego, even God—is the second to this calm experiment of a cinematic face book.

29. A more familiar trope would be the smile that turns into death-head grin as in the final images of *Psycho* (Alfred Hitchcock, 1960; remade by Gus van Sant, 1988).

30. The bear is of course anonymous, only numbered as "Bear 141" by the National Park Service like a taxpayer. Elsewhere, I delved into complex questions provoked by *Grizzly Man* on the human's ontological others including the animal, the ghost, and the machine as cinema (Jeong and Andrew 2008).

NOTES TO CHAPTER 5

1. In Charles S. Peirce's famous semiotic triad, the *icon,* like a portrait, resembles or imitates its object by an analogical quality of its own, whereas the *index* is based on physical causality, a real connection like smoke as an index of a fire. The *symbol* consists in an interpretive rule or habit like the language system in which the meaning of a word is not motivated analogically or physically, but dependent on the word's difference from others (1940, 114–119). Saussurean linguistics was about this symbolic system, and the 1960s–1970s film semiotics attempted to build such a structure of convention and communication out of image icons on the screen, hardly paying attention to the indexicality of the image itself.

2. I note that in the largest sense of indication, Peirce also mentions 'symbolic' types of index, including the graphic diagram and linguistic deictics/shifters (I/you/here/now)—marks of enunciation discussed in Chapter 1—though we focus on the index of physical causation. Among many references are Peter Wollen's seminal attention to Peirce over Metz (1998, 116–154), Philip Rosen's lengthy reengagement with Bazin in *Change Mummified* (2001)—the title quoting Bazin—and the special issue of *differences* 18, no. 1, "Indexicality: Trace and Sign," edited by Mary Ann Doane, including her articles (2007a,b).

3. *Para-index* could be called *quasi-index* in terms of degraded indexicality, but the topological implication of *para-* ('beside' the object to be indexed) may be indexically important, as I will argue. *Indexivity* is found as a technical term in computer science, microbiology, and so on, though my usage is recreated for image-indexing cultural activities.

4. This section on Greenaway is slightly modified from my article on his early films (Jeong 2011a, 183).

5. In opposition to the "beautiful" as having boundaries, the "sublime" as boundlessness can be either "dynamic" with enormous power that causes fear or "mathematical" with absolute greatness beyond measurability (Kant 2000, 131–148).

6. This section on Bazin is slightly modified from my article on animals in Bazin (Jeong 2011b, 182–183).

7. Even Bazin's "ontology" essay suggests the "phantomlike" nature of the cinematic image, and Andrew argues that Bazin is "in great part a theorist of absence for whom the clear Sartean categories of presence and absence give way to intermediate concepts with names like 'trace,' 'fissure,' and 'deferral'" (2010, 9). Bazin's attention to "ellipsis" also recognizes the primacy of what is not given on the screen, with cinema being "the art that traffics with absence, often *in absentia*" (37).

8. On the other hand, Claude Lanzman's nine-and-a-half-hour interview-only documentary *Shoah* (1985) presumes the Event as the incomparable catastrophe, the Caesura as a radical historical break irreducible to even any atrocity footage. It is a black box of the negative sublime that must not be even opened. The impossibility of representation then turns into the prohibition of representation. In spite of all this criticism, Didi-Huberman (2008) advocates the image by appreciating four surviving photographs of the camps that depict the actual process of mass killing perpetrated at the gas chambers. Their shaky blurred image may only prove the rare and precious para-indexicality of all the danger situated and embodied by the photographer who was a prisoner himself.

9. This section on Morrison is slightly modified from part of my article on his work (Jeong 2009).

10. The Blanchot work at issue is *When the Time Comes* (1985), a short narrative that details occult relations between two women and the narrator who invades their lives.

11. Deleuze then compares this digital with three other modes that show the gradual independence of the hand (touch) from the eye (sight) roughly along the history of art: the *tactile* (perspective space has depth, contour, relief, and so forth, as in broadly classical paintings), the *haptic* (sight has its own function of touch, and vice versa, as in ancient Egyptian art in Riegl's sense of the term, which Francis Bacon recreates through the self-disfiguring Figure in its own multilayeredness), and the *manual* (a space without form or a movement without rest dismantle the optical as in cubism and action painting, if we want).

12. Tactility colors all the implications of *punctum*: "sting, speck, cut, little hole—and also a cast of the dice . . . that accident which pricks me," if compared to a literary moment, just as a bite of a Madeleine touches the Proust character's mnemonic nerve in *Remembrance of Things Past*.

13. In a rather pacifistic tone, Kracauer wants the film "to touch reality not only with the fingertips but to seize it and shake hands with it" (1960, 297).

14. In this ontological sense, for me, Peirce's triad of icon-symbol-index seems to resonate with Lacan's Imaginary-Symbolic-Real triangle, even though Peirce has nothing to do with psychoanalysis and Lacan started with a Saussurian semiotics. What counts here is a pure taxonomy of signs: there are definitely the image, the language, and that which these two cannot fully represent. On the other hand, one might want to point out that since Peirce's sign types are related to states of consciousness (icon to feeling, index to reaction, and symbol to thought), it might be possible to think that while 'indexical passivity' is more about feeling, the cases of 'indexical activity' to be examined concerns the other two: 'reactive/proactive activity' centers on reaction and 'productive activity' involves thought.

15. The hand would be worth paying attention to in terms of this mimetic faculty. Michel Serres sees the hand not as a part of the body but as a sort of "homunculus" embodying the body's capacity to reach out beyond itself. "It is not an organ, it is a faculty, a capacity for doing, for becoming claw or paw, weapon or compendium. It is a naked faculty" (1997, 34). The hand, or even the finger, is thus a terminus of the body's self-transformative activity oriented and adjusted to the object or event.

16. Zapping could be said to be the reversed *punctum* in that the spectator throws an individually possessed tactile signal to the image/interface. Mulvey's focus on the stillness/movement dynamics enabled by the remote control in viewing films on DVD makes all the more sense, given the potential link of *punctum* to *facinum* that implies killing the flow and fixing the ephemeral (2006, 161–180).

17. Notably, Tom Cruise conducts (PreCrime with the background music of) Schubert's Unfinished Symphony, which might intimate the imperfection of his proaction because he himself is indicated as a killer. This unpredicted element frustrates the system of premediation.

18. The film is a biopic based on the true story of *Elle* editor Jean-Dominique Bauby, who left his memoir written in this way after such steady, frustrating, but persistent efforts of mute dictation.

19. It is an art installation by Neil Brown, Dennis Del Favero, Matthew McGinity, Jeffrey Shaw, and Peter Weibel developed through the iCinema Centre for Interactive Cinema Research at The University of New South Wales in cooperation with ZKM Center for Art and Media, Karlsruhe.

20. This view is found in almost all Rancière works on aesthetics, a term that takes on significantly political implications of dismantling the old "representational regime" that confines art in the artistic domain. At this point, I only highlight that Bourriaud's relationalism seems to be a certain result of what Rancière calls the "ethical turn" of this political aesthetics (2004), the turn by which community artists redistribute the sensible and restore social bonds in ever more homogenized global communities with harmonious differences rather than political antagonism.

21. It is notable that this "digital indexicality" is already incorporated into the IT industry. Dan Provost's iPhone application *Trover* (2009) enables any iPhone user to roam around New York City, viewing and collecting original short videos made by filmmakers, artists, and storytellers about specific areas in the city. This location-based mobile film festival, so to speak, connects the digital data with its location through the user's double indexical activity.

22. I should note that, however, some parts of the film were not real as such but reconstructed, and this controversy may require a different space for discussion.

23. From a political viewpoint, of course, most people were very critical of the newly established administration, but I point out that one of their fundamental motivations may have opened another dimension overlooked or neglected by the power and in the political structure.

24. In this context the digital image seems to have more powerful indexicality. The oppressive regimes, since the war in Kosovo, often dispute its veracity by alleging that they are nothing but special effects.

25. Among others, Žižek's harsh criticism of Tony Blair for pursuing a "stable change in Egypt" (2011) pinpointed Western liberalists' hypocrisy that was exposed between their apparent support for universality and their hidden desire to maintain the longtime alliance with dictatorship in the Third World.

26. Uricchio traces TV's three generations: first, transmission (national, dial interface, real time, programmer dominated); second, cable/satellite/VCR (transnational, remote control, time shifting, viewer controlled); third, DVR/ VOD/IPTV (global, TiVo, on demand, metadata/filters). The last one may refer to the current interface environment in general.

References

Agamben, Giorgio. 1998. *Homo Sacer: Sovereign Power and Bare Life*. Tran. Daniel Heller-Roazen. Stanford, CA: Stanford University Press.

———. 2004. *The Open: Man and Animal*. Stanford, CA: Stanford University Press.

———. 2009. *"What Is an Apparatus?" and Other Essays*. Tran. David Kishik and Stefan Pedatella. Stanford, CA: Stanford University Press.

Allen, Richard. 1995. *Projecting Illusion: Film Spectatorship and the Impression of Reality*. Cambridge: Cambridge University Press.

———. 1997. "Looking at Motion Pictures." In *Film Theory and Philosophy*, ed. Richard Allen and Murray Smith. Oxford: Oxford University Press.

Althusser, Louis. 1971. *Lenin and Philosophy*. Tran. Ben Brewster. New York: Monthly Review Press.

Andrew, Dudley. 1976a. *The Major Film Theories: An Introduction*. London: Oxford University Press.

———. 1976b. "The Neglected Tradition of Phenomenology in Film Theory." In *Movies and Methods: An Anthology*, ed. Bill Nichols, 625–632. Berkeley: University of California Press.

———. 1984. *Concepts in Film Theory*. Oxford: Oxford University Press.

———. 1992. "Merleau-Ponty and Cinema Studies: Sensation, Perception, Histoire." *Iconics* (Japanese Edition) (47): 18–31.

———. 2009. "The Core and the Flow of Film Studies." *Critical Inquiry* 35 (4): 879–915.

———. 2010. *What Cinema Is!: Bazin's Quest and Its Charge*. Chichester, West Sussex, UK: Wiley-Blackwell.

Anzieu, Didier. 1989. *The Skin Ego*. Tran. Chris Turner. New Haven, CT: Yale University Press.

Apichatpong, Weerasethakul. 2010. "Memories, Mysteries: From an Interview with Apichatpong Weerasethakul by Tony Rayns." www.kickthemachine.com/works/Synd_interviews.html.

Arnheim, Rudolf. 1957. *Film as Art*. Berkeley: University of California Press.

———. 1969. *Art and Visual Perception: A Psychology of the Creative Eye*. Berkeley: University of California Press.

Aumont, Jacques. 1992. *Du Visage Au Cinéma*. Paris: Editions de l'Etoile.

———. 1997. *The Image*, ed. Claire Pajackowska. London: British Film Institute.

———. 2003. "The Face in Close-Up." In *The Visual Turn: Classical Film Theory and Art History*, ed. Angela Dalle Vacche, 127–148. New Brunswick, NJ: Rutgers University Press.

Balázs, Béla. 1970. Theory of the Film: Character and Growth of a New Art. Tran. Edith Bone. New York: Dover Publications.

Barker, Jennifer M. 2009. The Tactile Eye: Touch and the Cinematic Experience. Berkeley: University of California Press.

Barthes, Roland. 1957. *Mythologies*. Paris: Editions du Seuil.
———. 1970. *S/Z*. Paris: Éditions du Seuil.
———. 1974. *S/Z*. Tran. Richard Miller. 1st American ed. New York: Hill and Wang.
———. 1977. "The Third Meaning: Research Notes on Some Eisenstein Stills." In *Image, Music, Text*, tran. Stephen Heath, 52–68. New York: Hill and Wang.
———. 1979. *The Eiffel Tower, and Other Mythologies*. Tran. Richard Howard. 1st American ed. New York: Hill and Wang.
———. 1981. Camera Lucida: Reflections on Photography. 1st American ed. New York: Hill and Wang.
Bataille, Georges. 1986. *Erotism: Death & Sensuality*. Tran. Mary Dalwood. San Francisco, CA: City Lights Books.
Baudrillard, Jean. 1981. *Simulacra and Simulation*. Tran. Sheila Faria Glaser. Ann Arbor: University of Michigan Press.
Baudry, Jean-Louis. 1986a. "Ideological Effects of the Basic Cinematic Apparatus." In *Narrative, Apparatus, Ideology: A Film Theory Reader,* ed. Philip Rosen, 286–298. New York: Columbia University Press.
———. 1986b. "The Apparatus: Metapsychological Approaches to the Impression of Reality in the Cinema." In *Narrative, Apparatus, Ideology: A Film Theory Reader,* ed. Philip Rosen, 299–318. New York: Columbia University Press.
Baumbach, Nico. 2009. "Nature Caught in the Act: On the Transformation of an Idea of Art in Early Cinema." *Comparative Critical Studies* 6 (3): 373–383. doi:10.3366/E1744185409000858.
Bazin, André. 2002. "Death Every Afternoon." *In Rites of Realism: Essays on Corporeal Cinema,* ed. Ivone Margulies, 27–31. Durham, NC: Duke University Press.
———. 2005a. *What Is Cinema?* Tran. Hugh Gray. Vol. 2. 2 vols. Berkeley: University of California Press.
———. 2005b. *What Is Cinema?* Tran. Hugh Gray. Vol. 1. 2 vols. Berkeley: University of California Press.
———. 2009. *What Is Cinema?* Tran. Timothy Barnard. Montréal: Caboose.
Bellour, Raymond. 2000. "The Unattainable Text." In *The Analysis of Film,* 21–27. Bloomington: Indiana University Press.
———. 2002. "L'Interruption, L'instant." In *L'entre-Images: Photo, Cinéma, Vidéo,* 110–115. Nouv. éd. rev. et co. Paris: Différence.
———. 2003. "Of an Other Cinema." In *Black Box Illuminated,* ed. Sara Arrhenius, Magdalena Malm, and Cristina Ricupero. Stockholm: Propexus.
Belton, John, ed. 2000. *Alfred Hitchcock's Rear Window.* Cambridge: Cambridge University Press.
Benjamin, Walter. 1968a. "The Work of Art in the Age of Mechanical Reproduction." In *Illuminations: Essays and Reflections,* ed. Hannah Arendt, tran. Harry Zohn, 217–251. New York: Schocken Books.
———. 1968b. *Illuminations: Essays and Reflections,* ed. Hannah Arendt, tran. Harry Zohn. New York: Schocken Books.
———. 1968c. "On Some Motifs in Baudelaire." In *Illuminations: Essays And Reflections,* ed. Hannah Arendt, tran. Harry Zohn, 155–200. New York: Schocken Books.
———. 1978a. "One-Way Street." In *Reflections: Essays, Aphorisms, Autobiographical Writing,* ed. Peter Demetz, tran. Edmund Jephcott, 61–94. New York: Schocken Books.
———. 1978b. "On the Mimetic Faculty." In *Reflections: Essays, Aphorisms, Autobiographical Writing,* ed. Peter Demetz, tran. Edmund Jephcott, 333–336. New York: Schocken Books.
———. 1980. "A Short History of Photography." In *Classic Essays on Photography,* ed. Alan Trachtenberg, 199–216. New Haven, CT: Leete's Island Books.

Benthien, Claudia. 2002. *Skin: On the Cultural Border between Self and the World.* Tran. Thomas Dunlap. New York: Columbia University Press.

Benveniste, Emile. 1971. *Problems in General Linguistics.* Tran. Mary Elizabeth Meek. Coral Gables, FL: University of Miami Press.

Bergson, Henri. 1990. *Matter and Memory.* Tran. Nancy Margaret Paul Paul and W. Scott Palmer. New York: Zone Books.

Blanchot, Maurice. 1981. *The Gaze of Orpheus: And Other Literary Essays,* ed. P. Adams Sitney, tran. Lydia Davis. Barrytown, NY: Station Hill Press.

Bolter, Jay David and Richard Grusin. 1999. *Remediation: Understanding New Media.* Cambridge, MA: MIT Press.

Bordwell, David. 1997. *On the History of Film Style.* Cambridge, MA: Harvard University Press.

———. 2002. "Intensified Continuity: Visual Style in Contemporary American Film." *Film Quarterly* 55 (3): 16–28.

Bordwell, David and Noël Carroll, ed. 1996. *Post-Theory: Reconstructing Film Studies.* University of Wisconsin Press.

Bordwell, David and Kristin Thompson. 2010. *Film Art: An Introduction.* Tran. Jacques-Alain Aumont. 9th ed. New York: McGraw-Hill.

Bourriaud, Nicolas. 2002. *Relational Aesthetics.* Tran. Simon Pleasance and Fronza Woods. Dijon: Les Presses Du Réel.

Brakhage, Stan. 1963. "Metaphors in Vision." *Film Culture* 30.

Branigan, Edward. 1986. "Diegesis and Authorship in Film." *Iris* 7 (4): 37–54.

———. 2006. *Projecting a Camera: Language-Games in Film Theory.* New York: Routledge.

Bredekamp, Horst. 2006. *Hyperrealism: One Step Beyond.* London: Tate Museum Publishers.

Bresson, Robert. 1977. *Notes on Cinematography.* New York: Urizen Books (distributed by E. P. Dutton).

Bruno, Giuliana. 2002. *Atlas of Emotion?: Journeys in Art, Architecture, and Film.* New York: Verso.

Bryson, Norman. 1986. *Vision and Painting: The Logic of the Gaze.* New Haven, CT: Yale University Press.

———. 1988. "The Gaze in the Expanded Field." In *Vision and Visuality,* ed. Hal Foster, 87–114. Seattle, WA: Bay Press.

Buckland, Warren. 1999. "Between Science Fact and Science Fiction: Spielberg's Digital Dinosaurs, Possible Worlds, and the New Aesthetic Realism." *Screen* 40 (2) (June): 177–192.

———. 2012. *Film Theory: Rational Reconstructions.* Routledge.

Burch, Noël. 1990a. "Narrative, Diegesis: Thresholds, Limits." In *Life To Those Shadows,* ed. Ben Brewster, 243–266. Berkeley: University of California Press.

———. 1990b. "Building a Haptic Space." In *Life to Those Shadows,* ed. Ben Brewster, 162–184. Berkeley: University of California Press.

Burt, Jonathan. 2006. "Morbidity and Vitalism: Derrida, Bergson, Deleuze, and Animal Film Imagery." *Configurations* 14 (1–2): 157–179.

Butler, Judith. 2004. *Precarious Life: The Powers of Mourning and Violence.* London; New York: Verso.

Calvino, Italo. 1968. "The Spiral." In *Cosmicomics.* Tran. William Weaver, 141–153. New York: Harcourt, Brace & World.

Camus, Albert. 1955. *The Myth of Sisyphus: And Other Essays.* Tran. Justin O'Brien. New York: Vintage Books.

Casebier, Allan. 1991. *Film and Phenomenology: Towards a Realist Theory of Cinematic Representation.* Cambridge: Cambridge University Press.

Casetti, Francesco. 1995. "Face to Face." In *The Film Spectator: From Sign to Mind,* ed. Warren Buckland, 118–139. Amsterdam: Amsterdam University Press.

———. 1999a. *Inside the Gaze: The Fiction Film and Its Spectator.* Tran. Nell Andrew and Charles O'Brien. Bloomington: Indiana University Press.

———. 1999b. *Theories of Cinema: 1945–1995.* Austin: University of Texas Press.

———. 2002. *Communicative Negotiation in Cinema and Television.* Milan, Italy: Vita e Pensiero.

———. 2008. *Eye of the Century: Film, Experience, Modernity.* Tran. Erin Larkin and Jennifer Pranolo. New York: Columbia University Press.

———. 2009. "Filmic Experience." *Screen* 50 (1) (March): 56–66.

Cavell, Stanley. 1971. *The World Viewed: Reflections on the Ontology of Film.* New York: Viking Press.

Certeau, Michel de. 1984. *The Practice of Everyday Life.* Tran. Steven Rendall. Berkeley: University of California Press.

Chazal, Gérard. 2002. Interfaces: Enquêtes Sur Les Mondes Intermédiaires. Seyssel, France: Champ Vallon.

Christiane, Paul, ed. 2008. New Media in the White Cube and Beyond: Curatorial Models for Digital Art. Berkeley: University of California Press.

Connor, Steven. 1998. "Fascination, Skin and the Screen." *Critical Quarterly* 40 (1) (April): 9–24.

———. 2004. *The Book of Skin.* London: Cornell University Press.

Copjec, Joan. 1982. "The Anxiety of the Influencing Machine." *October* 23 (December): 43–59. doi:10.2307/778584.

Cowie, Elizabeth. 1997. *Representing the Woman: Cinema and Psychoanalysis.* Minneapolis: University of Minnesota Press.

Cramer, Florian and Matthew Fuller. 2008. "Interface." In *Software Studies: A Lexicon,* ed. Matthew Fuller, 149–152. Cambridge, MA: MIT Press.

Creed, Barbara. 1993. *The Monstrous-Feminine: Film, Feminism, Psychoanalysis.* London: Routledge.

Crimp, Douglas. 1999. "Face Value." In *About Face: Andy Warhol Portraits,* 110–125. Hartford, CT: Wadsworth Atheneum.

Cubitt, Sean. 2004. *The Cinema Effect.* Cambridge, MA: MIT Press.

Daney, Serge. 2002. "The Screen of Fantasy (Bazin and Animals)." In *Rites of Realism: Essays on Corporeal Cinema,* ed. Ivone Margulies, tran. Mark A. Cohen, 32–41. Durham, NC: Duke University Press.

———. 2007. *Postcards from the Cinema.* Tran. Paul Douglas Grant. Oxford: Berg.

Davis, Therese. 2004. *The Face on the Screen: Death, Recognition and Spectatorship.* Bristol, UK: Intellect Books.

Dayan, Daniel. 1974. "The Tutor-Code of Classical Cinema." *Film Quarterly* 28 (1): 22–31.

Debord, Guy. 2000. *The Society of the Spectacle.* New York: Black and Red.

Deleuze, Gilles. 1983. "Plato and the Simulacrum." Tran. Rosalind Krauss. *October* 27: 45–56.

———. 1986. *Cinema 1: The Movement-Image.* Tran. Hugh Tomlinson and Barbara Habberjam. Minneapolis: University of Minnesota Press.

———. 1989. *Cinema 2: The Time-Image.* Tran. Hugh Tomlinson and Robert Galeta. Minneapolis: University of Minnesota Press.

———. 1969/1990. *The Logic of Sense,* ed. Constantin V. Boundas, tran. Mark Lester and Charles Stivale. New York: Columbia University Press.

———. 1994. *Difference and Repetition.* Tran. Paul Patton. New York: Columbia University Press.

———. 1995. "Postscript on Control Societies." In *Negotiations,* 177–182. New York: Columbia University Press.

———. 2003. *Francis Bacon: The Logic of Sensation.* Tran. Daniel W. Smith. Minneapolis: University of Minnesota Press.

Deleuze, Gilles and Félix Guattari. 1987. *A Thousand Plateaus: Capitalism and Schizophrenia.* Tran. Brian Massumi. Minneapolis: University of Minnesota Press.

Del Rio, Elena. 1996. "The Body as Foundation of the Screen: Allegories of Technology in Atom Egoyan's Speaking Parts." *Camera Obscura* 38 (2): 92–115.

———. 2000. "The Body of Voyeurism: Mapping a Discourse of the Senses in Michael Powell's Peeping Tom." *Camera Obscura* 15 (3): 115–149.

———. 2005. "Alchemies of Thought in Godard's Cinema: Deleuze and Merleau-Ponty." *SubStance* 34 (3): 62–78.

Derrida, Jacques. 1976. *Of Grammatology.* Tran. Gayatri Chakravorty Spivak. Baltimore, MD: Johns Hopkins University Press.

———. 1978. "Freud and the Scene of Writing." In *Writing and Difference.* Tran. Alan Bass, 196–224. Chicago, IL: University of Chicago Press.

———. 1982. *Margins of Philosophy.* Tran. Alan Bass. Chicago, IL: University of Chicago Press.

———. 1992. "The First Session." In *Acts of Literature,* ed. Derek Attridge, tran. Barbara Johnson, 127–180. New York, NY: Routledge.

———. 1997. *Politics of Friendship.* Tran. George Collins. New York: Verso.

———. 2002. *Positions.* Tran. Alan Bass. London: Continuum.

Didi-Huberman, Georges. 1998. *Phasmes: Essais Sur L'apparition.* Paris: Editions de Minuit.

———. 2008. *Images in Spite of All: Four Photographs from Auschwitz.* Chicago, IL: University of Chicago Press.

Doane, Mary Ann. 1991. *Femmes Fatales: Feminism, Film Theory, and Psychoanalysis.* New York: Routledge.

———. 2002. *The Emergence of Cinematic Time: Modernity, Contingency, The Archive.* Cambridge, MA: Harvard University Press.

———. 2003. "The Close-Up: Scale and Detail in the Cinema." *Differences* 14 (3): 89–111.

———. 2007a. "Indexicality: Trace and Sign: Introduction." *Differences* 18 (1) (January): 1–6.

———. 2007b. "The Indexical and the Concept of Medium Specificity." *Differences* 18 (1) (January): 128–152.

"Dossier Suture: Introductory Note." 1977. *Screen* 18 (4): 23.

Dubois, Philipe. 1987. "Photo Tremblée Et Le Cinéma Suspendu." *La Recherche Photographique* (December).

Dufrenne, Mikel. 1989. *The Phenomenology of Aesthetic Experience.* Tran. Edward S. Casey. Evanston, IL: Northwestern University Press.

Eberwein, Robert T. 1984. *Film and the Dream Screen: A Sleep and a Forgetting.* Princeton, NJ: Princeton University Press.

Eckmann, Sabine and Lutz Koepnick. 2007. *Window / Interface.* St. Louis, MO: Mildred Lane Kemper Art Museum.

Eisenstein, Sergei. 1988a. *Towards a Theory of Montage,* ed. Richard Taylor, tran. Michael Glenny. Bloomington, London: British Film Institute.

———. 1988b. *Eisenstein On Disney.* London: Methuen.

Elsaesser, Thomas. 2006. "Discipline through Diegesis: The Rube Film between 'Attraction' and 'Narrative Integration.'" In *The Cinema of Attractions Reloaded,* ed. Wanda Strauven, 205–223. Amsterdam: Amsterdam University Press.

———. 2009a. "The Mind-Game Film." In *Puzzle Films: Complex Storytelling in Contemporary Cinema,* ed. Warren Buckland, 13–41. Chichester, UK: Wiley-Blackwell.

———. 2009b. "Fiona Tan: Place after Place." In *Fiona Tan—Disorient: Dutch Pavilion, La Biennale Di Venezia,* 2.20–2.33. Heidelberg: Kehrer.

——. 2009c. "Archeologies of Interactivity: Early Cinema, Narrative and Spectatorship." In *Film 1900: Technology, Perception, Culture, 9–21*. New Barnet, UK: John Libbey.

——. 2009d. "Freud as Media Theorist: Mystic Writing-Pads and the Matter of Memory." *Screen* 50 (1) (March): 100–113.

Elsaesser, Thomas and Warren Buckland. 2002. *Studying Contemporary American Film: A Guide to Movie Analysis*. Bloomsbury USA.

Elsaesser, Thomas and Malte Hagener. 2010. *Film Theory: An Introduction through the Senses*. New York: Routledge.

Elsaesser, Thomas and Kay Hoffmann, ed. 1998. *Cinema Futures: Cain, Abel or Cable?: The Screen Arts in the Digital Age*. Amsterdam: Amsterdam University Press.

Epstein, Jean. 1926. *Le Cinématographe Vu De l'Etna*. Paris: Les Ecrivains Réunis.

——. 1977. "Magnification and Other Writings." Tran. Stuart Liebman. *October* 3: 9–25.

——. 1988a. "Photogénie and The Imponderable." In *French Film Theory and Criticism: A History/Anthology 1907–1939*. Tran. Richard Abel, 2: 188–192. Princeton, NJ: Princeton University Press.

——. 1988b. The Senses 1 (b), "On Certain Characteristics of Photogénie." In *French Film Theory and Criticism: A History/Anthology 1907–1939*. Tran. Richard Abel, 1: 241–246 and 314–318. Princeton, NJ: Princeton University Press.

Esquenazi, Jean-Pierre. 1994. *Film, Perception Et Mémoire*. Paris: L'Harmattan.

Ezra, Elizabeth and Jane Sillars. 2007. "Hidden in Plain Sight: Bringing Terror Home." *Screen* 48 (2) (June): 215–221.

Farman, Jason. 2011. *Mobile Interface Theory: Embodied Space and Locative Media*. Routledge.

Foucault, Michel. 1973. *The Order of Things: An Archaeology of The Human Sciences*. New York: Vintage Books.

Frampton, Daniel. 2006. *Filmosophy*. London: Wallflower.

Freud, Sigmund. 1961. "A Note upon the 'Mystic Writing-Pad'" (1925). In *The Standard Edition of The Complete Psychological Works of Sigmund Freud*, ed. James Strachey, tran. James Strachey, 227–232. London: Hogarth Press.

Friedberg, Anne. 2000. "The End of Cinema: Multimedia and Technological Change." In *Reinventing Film Studies*, ed. Christine Gledhill and Linda Williams, 438–452. New York: Oxford University Press.

——. 2006. *The Virtual Window: From Alberti to Microsoft*. Cambridge, MA: MIT Press.

Galloway, Alexander R. 2013. *The Interface Effect*. Cambridge, UK: Polity.

Gane, Nicholas and David Beer. 2008. *New Media: The Key Concepts*. Berg Publishers.

Gaudreault, André and Tom Gunning. 2006. "Early Cinema as a Challenge to Film History." In *The Cinema of Attractions Reloaded*, ed. Wanda Strauven, 365–380. Amsterdam: Amsterdam University Press.

Genette, Gérard. 1980. *Narrative Discourse: An Essay in Method*. Tran. Jane E. Levin. Ithaca, NY: Cornell University Press.

Gidal, Peter. 1976. *Structural Film Anthology*. London: British Film Institute.

Gilroy, Paul. 2007. "Shooting Crabs in a Barrel." *Screen* 48 (2) (June): 233–235.

Godard, Jean Luc. 1986. *Godard on Godard: Critical Writings by Jean-Luc Godard*, ed. Tom Milne. New York: Da Capo Press.

Gombrich, E.H. 1960. *Art and Illusion; A Study in the Psychology of Pictorial Representation*. New York: Pantheon Press.

Gorky, Maxim. 1896. "The Lumiere Cinematograph." http://www.seethink.com/stray_dir/kingdom_of_shadows.html.

Graham-Rowe, Duncan. 2009. "The Best Computer Interfaces: Past, Present, and Future." *Technology Review* (April 6). http://www.technologyreview.com/computing/22393/page1/?a = f.

Grodal, Torben Kragh. 2009. *Embodied Visions: Evolution, Emotion, Culture, and Film.* Oxford: Oxford University Press.

Grusin, Richard A. 2010. *Premediation: Affect and Mediality after 9/11.* Basingstoke, England: Palgrave Macmillan.

Gunning, Tom. 1997. "In Your Face: Physiognomy, Photography, and the Gnostic Mission of Early Film." *Modernism/modernity* 4 (1): 1–29.

———. 2006. "The Cinema of Attraction[s]: Early Film, Its Spectator and the Avant-Garde." In *The Cinema of Attractions Reloaded,* ed. Wanda Strauven, 381–388. Amsterdam: Amsterdam University Press.

———. 2007. "Moving away from the Index: Cinema and the Impression of Reality." *Differences* 18 (1) (January): 29–52.

Habib, André. 2004a. "Thinking in the Ruins: Around the Films of Bill Morrison." *Offscreen* (November). http://www.horschamp.qc.ca/new_offscreen/cinematic_ruins.html.

———. 2004b. "Matter and Memory: A Conversation with Bill Morrison." *Offscreen* (November). http://www.horschamp.qc.ca/new_offscreen/interview_morrison.html.

Hansen, Mark. 2000. *Embodying Technesis: Technology beyond Writing.* Ann Arbor: University of Michigan Press.

———. 2006a. *New Philosophy for New Media.* Cambridge, MA: MIT Press.

———. 2006b. *Bodies in Code: Interfaces with New Media.* London: Routledge.

Hansen, Miriam. 1987. "Benjamin, Cinema and Experience: 'The Blue Flower in The Land of Technology.'" *New German Critique* (40): 179–224.

———. 1991. *Babel and Babylon: Spectatorship in American Silent Film.* Cambridge, MA: Harvard University Press.

———. 1993. "Of Mice and Ducks: Benjamin and Adorno on Disney." *South Atlantic Quarterly* 92 (1): 27–61.

Hayles, N. Katherine. 1999. *How We Became Posthuman: Virtual Bodies in Cybernetics, Literature, and Informatics.* Chicago, IL: University of Chicago Press.

Heath, Stephen. 1981. *Questions of Cinema.* Bloomington: Indiana University Press.

Heidegger, Martin. 1949. "What Is Metaphysics?" In *Existence and Being.* Tran. R. F. C. Hull and Alan Crick, 333–334. Chicago, IL: H. Regnery Co.

———. 1971. "The Origin of the Work of Art." In *Poetry, Language, Thought.* Tran. Albert Hofstadter. Harper Colophon. New York: Harper & Row.

———. 1977. "The Age of the World Picture." In *The Question Concerning Technology, and Other Essays.* Tran. William Lovitt, 115–154. New York: Harper & Row.

Irigaray, Luce. 1993. *An Ethics of Sexual Difference.* Tran. Carolyn Burke and Gillian C. Gill. Ithaca, NY: Cornell University Press.

Jameson, Fredric. 1991. *Postmodernism, or, The Cultural Logic of Late Capitalism.* Durham, NC: Duke University Press.

Jardine, Alice A. 1985. *Gynesis: Configurations of Woman and Modernity.* Ithaca, NY: Cornell University Press.

Jay, Martin. 1994. *Downcast Eyes: The Denigration of Vision in Twentieth-Century French Thought.* Berkeley: University of California Press.

Jeong, Seung-hoon. 2009. "Postmortem Evolution of (In-) Organic Life: Peter Greenaway, Bill Morrison, and Film Biochemistry." *Offscreen* 13 (6). http://www.offscreen.com/index.php/pages/essays/postmortem_evolution/.

———. 2011a. "Systems on the Verge of Becoming Birds: Peter Greenaway's Early Experimental Films." *New Review of Film and Television Studies* 9 (2): 170–187. doi:10.1080/17400309.2011.556940.

———. 2011b. "Animals: An Adventure in Bazin's Ontology." In *Opening Bazin: Postwar Film Theory and Its Afterlife,* ed. Dudle Andrew and Hervé Joubert-Laurencin, 177–185. New York: Oxford University Press.

Jeong, Seung-hoon and Dudley Andrew. 2008. "Grizzly Ghost: Herzog, Bazin and the Cinematic Animal." *Screen* 49 (1) (March): 1–12.

Johnson, Steven. 1997. *Interface Culture: How New Technology Transforms the Way We Create and Communicate.* San Francisco, CA: HarperEdge.

Jost, Francois. 1995a. "The Authorized Narrative." In *The Film Spectator: From Sign to Mind,* ed. Warren Buckland, 164–180. Amsterdam: Amsterdam University Press.

———. 1995b. "The Polyphonic Film and the Spectator." In *The Film Spectator: From Sign to Mind, ed. Warren Buckland,* 181–191. Amsterdam: Amsterdam University Press.

Jovanovic, Stefan. 2003. "The Ending(s) of Cinema: Notes on the Recurrent Demise of the Seventh Art." *Offscreen* 7 (4) (April). http://www.horschamp.qc.ca/new_offscreen/death_cinema.html.

Kant, Immanuel. 1998. *Critique of Pure Reason.* Cambridge: Cambridge University Press.

———. 2000. *Critique of the Power of Judgment,* ed. Paul Guyer, tran. Pau Guyer and Eric Matthews. Cambridge: Cambridge University Press.

Keathley, Christian. 2006. *Cinephilia and History, or, The Wind in the Trees.* Bloomington: Indiana University Press.

Kerckhove, Derrick De. 1995. *The Skin of Culture: Investigating the New Electronic Reality,* ed. Christopher Dewdney. Toronto: Somerville House Publishing.

Kracauer, Siegfried. 1960. *Theory of Film: The Redemption of Physical Reality.* Princeton, NJ: Princeton University Press.

Krauss, Rosalind. 1986. "Antivision." *October* 36: 147–154.

Kristeva, Julia. 1982. *Powers of Horror: An Essay on Abjection.* Tran. Leon S. Roudiez. New York: Columbia University Press.

Kuntzel, Thierry. 1976. "A Note upon the Filmic Apparatus." *Quarterly Review of Film and Video* 1 (3): 266–271.

———. 1980. "The Film—Work, 2." Tran. Nancy Huston. *Camera Obscura: Feminism, Culture, and Media Studies:* 6–69.

Lacan, Jacques. 1998. *The Four Fundamental Concepts of Psycho-Analysis,* ed. Jacques-Alain Miller, tran. Alan Sheridan. New York: W. W. Norton.

Lant, Antonia. 1995. "Haptical Cinema." *October* 74: 45–73.

Lévi-Strauss, Claude. 1973. *Tristes Tropiques.* Tran. John and Doreen Weightman. London: Cape.

Lévinas, Emmanuel. 1979. *Totality and Infinity: An Essay on Exteriority.* Tran. Alphonso Lingis. Boston, MA: Nijhoff Publishers.

Lévy, Pierre. 2001. Cyberculture. Minneapolis: University of Minnesota Press.

Lewin, Bertram. 1946. "Sleep, The Mouth, and the Dream Screen." *Psychoanalytic Quarterly* 15: 419–434.

———. 1948. "Inferences from the Dream Screen." *International Journal of Psychoanalysis* 29: 224–231.

Lindsay, Vachel. 2000. *The Art of the Moving Picture.* Mumbai: Tuis Digital Publishing.

Lippit, Akira Mizuta. 2002. "The Death of an Animal." *Film Quarterly* 56 (1): 9–22.

Lister, Martin. 2005. "Dangerous Metaphors and Meaning on Immersive Media." In *Screen Methods: Comparative Readings in Film Studies,* ed. Jacqueline Furby and Karen Randell, 38–47. London: Wallflower.

Lowenstein, Adam. 2007. "The Surrealism of the Photographic Image: Bazin, Barthes, and the Digital Sweet Hereafter." *Cinema Journal* 46 (3): 54–82.

Lowgren, Jona. 2006. "Articulating the Use Qualities of Digital Designs." In *Aesthetic Computing,* ed. Paul A. Fishwick, 383–403. Cambridge, MA: MIT Press.

Luhmann, Niklas. 1995. *Social Systems.* Tran. John Bednarz Jr. and Dirk Baecker. Stanford, CA: Stanford University Press.

Lyotard, Jean-François. 1993. "Excerpts from 'Discourse, Figure.'" In *The Merleau-Ponty Aesthetics Reader: Philosophy and Painting,* ed. Galen A. Johnson, tran. Michael B. Smith, 310–313. Evanston, IL: Northwestern University Press.

Manovich, Lev. 2001. *The Language of New Media.* Cambridge, MA: MIT Press.

Marchessault, Janine and Susan Lord, ed. 2007. *Fluid Screens, Expanded Cinema.* Toronto: University of Toronto Press.

Marion, Jean-Luc. 1995. *God without Being: Hors-Texte.* Tran. Thomas A. Carlson. Chicago: University of Chicago Press.

Marks, Laura U. 2000. *The Skin of the Film: Intercultural Cinema, Embodiment, and the Senses.* Durham, NC: Duke University Press.

Massumi, Brian. 2002. *Parables for the Virtual: Movement, Affect, Sensation.* Durham, NC: Duke University Press.

McLuhan, Marshall. 2003. *Understanding Media?: The Extensions of Man,* ed. W. Terrence Gordon. Corte Madera, CA: Gingko Press.

Mekas, Jonas. 1957. "Hans Richter on the Nature of Film Poetry." *Film Culture* 3 (11): 5–8.

Merleau-Ponty, Maurice. 1964. "The Film and the New Psychology." In *Sense and Non-Sense.* Tran. Patricia A. Dreyfus and Herbert L. Dreyfus, 48–59. Evanston, IL: Northwestern University Press.

———. 1968. *The Visible and the Invisible,* ed. Claude Lefort and Alphonso Lingis. Evanston, IL: Northwestern University Press.

———. 1993. *The Merleau-Ponty Aesthetics Reader,* ed. Galen A. Johnson, tran. Michael B. Smith. Evanston, IL: Northwestern University Press.

Metz, Christian. 1972. "Au-dela De L'analogie, L'image (1969)." In *Essais Sur La Signification Au Cine'ma* 2, 153–154. Paris: Klincksieck.

———. 1974a. "On the Impression of Reality in Cinema." In *Film Language: A Semiotics of the Cinema.* Tran. Michael Taylor, 3–15. New York: Oxford University Press.

———. 1974b. *Film Language: A Semiotics of the Cinema.* Tran. Michael Taylor. New York: Oxford University Press.

———. 1982. *The Imaginary Signifier: Psychoanalysis and the Cinema.* Tran. Celia Brittan, Annwyl Williams, Ben Brewster, and Alfred Guzzetti. Bloomington: Indiana University Press.

———. 1995. "The Impersonal Enunciation, or the Site of Film: In the Margin of Recent Works on Enunciation in Cinema." In *The Film Spectator: From Sign to Mind,* ed. Warren Buckland, 140–163. Amsterdam: Amsterdam University Press.

Miller, Jacques-Alain. 1977. "Suture (Elements of the Logic of the Signifier)." *Screen* 18 (4) (December): 24–34.

Mitchell, Stephen A. 2003. *Relationality: From Attachment to Intersubjectivity.* New York: Routledge.

Mitchell, William J. 1992. *The Reconfigured Eye: Visual Truth in the Post-Photographic Era.* Cambridge, MA: MIT Press.

Mondloch, Kate. 2010. *Screens: Viewing Media Installation Art.* Minneapolis: University of Minnesota Press.

Morin, Edgar. 2005. *The Cinema, or, The Imaginary Man.* Tran. Lorraine Mortimer. Minneapolis: University of Minnesota Press.

Morse, Margaret. 1998. *Virtualities: Television, Media Art, and Cyberculture.* Bloomington: Indiana University Press.

Mulvey, Laura. 1986. "Visual Pleasure and Narrative Cinema." In *Narrative, Apparatus, Ideology: A Film Theory Reader,* ed. Philip Rosen, 198–209. New York: Columbia University Press.

———. 2006. *Death 24x A Second: Stillness and The Moving Image.* London: Reaktion Books.

Münsterberg, Hugo. 2002a. "Why I Go to the Movies." In *Hugo Münsterberg on Film?: The Photoplay—A Psychological Study and Other Writings,* ed. Alan Langdale, 171–191. New York: Routledge.

———. 2002b.*The Photoplay: A Psychological Study and Other Writings,* ed. Allan Langdale. New York: Routledge.

Murray, Timothy. 2008. *Digital Baroque: New Media Art and Cinematic Folds.* Minneapolis: University of Minnesota Press.

Musser, Charles. 1994. *The Emergence of Cinema: The American Screen to 1907.* Berkeley: University of California Press.

———. 2006. "Rethinking Early Cinema: Cinema of Attractions and Narrativity." In *The Cinema of Attractions Reloaded,* 389–416. Amsterdam: Amsterdam University Press.

Nake, Frieder and Susanne Grabowski. 2006. "The Interface as Sign and as Aesthetic Event." In *Aesthetic Computing,* ed. Paul A. Fishwick, 53–70. Cambridge, MA: MIT Press.

Nancy, Jean-Luc. 2002. "L'Intrus." Tran. Susan Hanson. *CR: The New Centennial Review* 2 (3): 1–14.

Oudart, Jean-Pierre. 1977. "Cinema and Suture." *Screen* 18 (4): 35–47.

Panofsky, Erwin. 1996. *Perspective as Symbolic Form.* Tran. Christopher S. Wood. Zone. New York: Zone Books.

Paterson, Mark. 2007. *The Senses of Touch: Haptics, Affects, and Technologies.* New York: Berg Publishers.

Peirce, Charles S. 1940. *The Philosophy of Peirce: Selected Writings,* ed. Justus Buchler. London: K. Paul, Trench, Trubner & Co. ltd.

Rancière, Jacques. 2004. "The Ethical Turn of Aesthetics and Politics." In *Aesthetics and Its Discontents,* 109–132. Cambridge: Polity Press.

———. 2007. *The Future of the Image.* Tran. Gregory Elliott. London: Verso.

Rieser, Martin and Andrea Zapp, ed. 2001. *New Screen Media: Cinema/Art/ Narrative.* London: British Film Institute.

Rodowick, David N. 1995. *The Crisis of Political Modernism: Criticism and Ideology in Contemporary Film Theory.* Durham, NC: University of California Press.

———. 2001. *Reading the Figural, or, Philosophy after the New Media.* Durham, NC: Duke University Press.

———. 2007a. *The Virtual Life of Film.* Cambridge, MA: Harvard University Press.

———. 2007b. "An Elegy for Theory." *October* (122): 91–109.

Rosen, Philip. 2001. *Change Mummified: Cinema, Historicity, Theory.* Minneapolis: University of Minnesota Press.

Rugg, Linda Haverty. 2001. "Carefully I Touched the Faces of My Parents': Bergman's Autobiographical Image." *Biography* 24 (1): 72–84.

Sartre, Jean-Paul. 1962. *Imagination?: A Psychological Critique.* Ann Arbor: University of Michigan Press.

Saxton, Libby. 2007. "Secrets and Revelations: Off-Screen Space in Michael Haneke's Caché (2005)." *Studies in French Cinema* 7 (1) (February): 5–17.

Scarry, Elaine. 1985. *The Body in Pain: The Making and Unmaking of the World.* New York: Oxford University Press.

Schaub, Joseph. 1998. "Presenting the Cyborg's Futurist Past: An Analysis of Dziga Vertov's Kino-Eye." *Postmodern Culture* 8 (2) (January). http://muse.jhu.edu/ journals/postmodern_culture/v008/8.2schaub.html.

Schwartz, Louis-Georges. 2005. "Typewriter: Free Indirect Discourse on Deleuze's 'Cinema'." *SubStance* 34 (3): 107–135.

Sekula, Allan. 1986. "The Body and the Archive." *October* 39: 3–64.

Serres, Michel. 1985. *Les Cinq Sens.* Paris: Grasset.

———. 1997. *Genesis.* Ann Arbor: University of Michigan Press.

Shaviro, Steven. 1993. *The Cinematic Body.* Minneapolis: University of Minnesota Press.

———. 2003. *Connected, or, What It Means to Live in the Network Society.* Minneapolis: University of Minnesota Press.

———. 2008. "The Cinematic Body REDUX." *Parallax* 14 (1): 48–54.

Shaw, Jeffrey and Peter Weibel, ed. 2003. *Future Cinema: The Cinematic Imaginary after Film.* Cambridge, MA: MIT Press.

Shklovsky, Viktor Borisovich. 1990. *Theory of Prose* (1929). Tran. Benjamin Sher. Elmwood Park, IL: Dalkey Archive Press.

Silva, Adriana de Souza e and Jordan Frith. 2012. *Mobile Interfaces in Public Spaces: Locational Privacy, Control, and Urban Sociability.* Routledge.

Silverman, Kaja. 1984. *The Subject of Semiotics.* New York: Oxford University Press.

———. 1988. *The Acoustic Mirror: The Female Voice in Psychoanalysis and Cinema.* Bloomington: Indiana University Press.

———. 1996. *The Threshold of the Visible World.* New York: Routledge.

———. 2002. "The Dream of the Nineteenth Century." *Camera Obscura* 17 (3): 1–29.

Simmel, Georg. 1959. *Georg Simmel, 1858–1918: A Collection of Essays, with Translations and a Bibliography,* wd. Kurt H. Wolff. Columbus: Ohio State University Press.

Sitney, P. Adams. 2002. *Visionary Film: The American Avant-Garde, 1943–2000.* New York: Oxford University Press.

Sobchack, Vivian. 1992. *The Address of the Eye: A Phenomenology of Film Experience.* Princeton, NJ: Princeton University Press.

———. 2004. *Carnal Thoughts: Embodiment and Moving Image Culture.* Berkeley: University of California Press.

Sobieszek, Robert A. 1999. *Ghost in the Shell: Photography and The Human Soul, 1850–2000, Essays on Camera Portraiture.* Los Angeles, CA: Los Angeles County Museum.

Sontag, Susan. 2004. *Regarding the Pain of Others.* New York: Picador.

Staiger, Janet. 2000. *Perverse Spectators: The Practices of Film Reception.* New York: New York University Press.

Stam, Robert. 2000. *Film Theory: An Introduction.* Malden, MA: Blackwell.

Stam, Robert and Roberta Pearson. 1986. "Hitchcock's Rear Window: Reflexivity and the Critique of Voyeurism." In *A Hitchcock Reader,* ed. Marshall Deutelbaum and Leland Poague, 193–206. Ames: Iowa State University Press.

Stewart, Garrett. 1979. "Keaton through the Looking Glass." *The Georgia Review*: 348–367.

———. 1990. *Reading Voices: Literature and the Phonotext.* Berkeley: University of California Press.

———. 1999. *Between Film and Screen: Modernism's Photo Synthesis.* Chicago, IL: University of Chicago Press.

———. 2007. *Framed Time: Toward a Postfilmic Cinema.* Chicago, IL: University of Chicago Press.

Strauven, Wanda. 2005. "Re-disciplining the Audience: Godard's Rube-Carabinier." In *Cinephilia: Movies, Love and Memory,* ed. Marijke de Valck and Malte Hagener, 125–133. Amsterdam University Press.

Themroc. 2010. "RoGoPaG." *Eye For Film.* http://www.eyeforfilm.co.uk/reviews.php?id = 5766.

Todorov, Tzvetan. 1973. *The Fantastic: A Structural Approach to a Literary Genre.* Cleveland: Press of Case Western Reserve University.

Trotter, David. 2004. "Stereoscopy: Modernism and the 'Haptic.'" *Critical Quarterly* 46 (4) (December): 38–58.

Turvey, Malcolm. 2007. "Theory, Philosophy, and Film Studies: A Response to D. N. Rodowick's 'An Elegy For Theory'." *October* (122): 110–120.

———. 2008. *Doubting Vision: Film and the Revelationist Tradition*. Oxford: Oxford University Press.

Uricchio, William. 2004. "Television's Next Generation: Technology / Interface Culture / Flow." In *Television after TV: Essays as a Medium in Transition*, ed. Lynn Spigel and Jan Olsson, 163–182. Durham, NC: Duke University Press.

Vertov, Dziga. 1984. *Kino-Eye: The Writings of Dziga Vertov*, ed. Annette Michelson, tran. Kevin O'Brien. Berkeley: University of California Press.

Vries, Hent de. 2001. "Of Miracles and Special Effects." *International Journal for Philosophy of Religion* 50 (1–3) (December): 41–56.

Wegenstein, Bernadette. 2006. *Getting under the Skin: The Body and Media Theory*. Cambridge, MA: MIT Press.

Wilden, Anthony. 1972. *System and Structure: Essays in Communication and Exchange*. London: Tavistock Publications.

Williams, Linda. 1999. *Hard Core?: Power, Pleasure, and the "Frenzy Of The Visible"*. Berkeley: University of California Press.

Wollen, Peter. 1998. *Signs and Meaning in the Cinema*. 2nd ed. British Film Inst.

Yampolsky, Mikhail. 1996. "Kuleshov's Experiments and the New Anthropology of the Actor." In *Silent Film*, ed. Richard Abel, 45–70. New Brunswick, NJ: Rutgers University Press.

Youngblood, Gene. 1970. *Expanded Cinema*. New York: Dutton.

Žižek, Slavoj. 1991. *Looking Awry: An Introduction to Jacques Lacan through Popular Culture*. Cambridge, MA: MIT Press.

———. 2001. *The Fright of Real Tears: Krzysztof Kieslowski between Theory and Post-Theory*. Indiana: British Film Institute/Indiana University Press.

———. 2004. *Organs without Bodies: Deleuze and Consequences*. New York: Routledge.

———. 2011. "Why Fear the Arab Revolutionary Spirit?" Guardian.co.uk. http://www.guardian.co.uk/commentisfree/2011/feb/01/egypt-tunisia-revolt.

Index